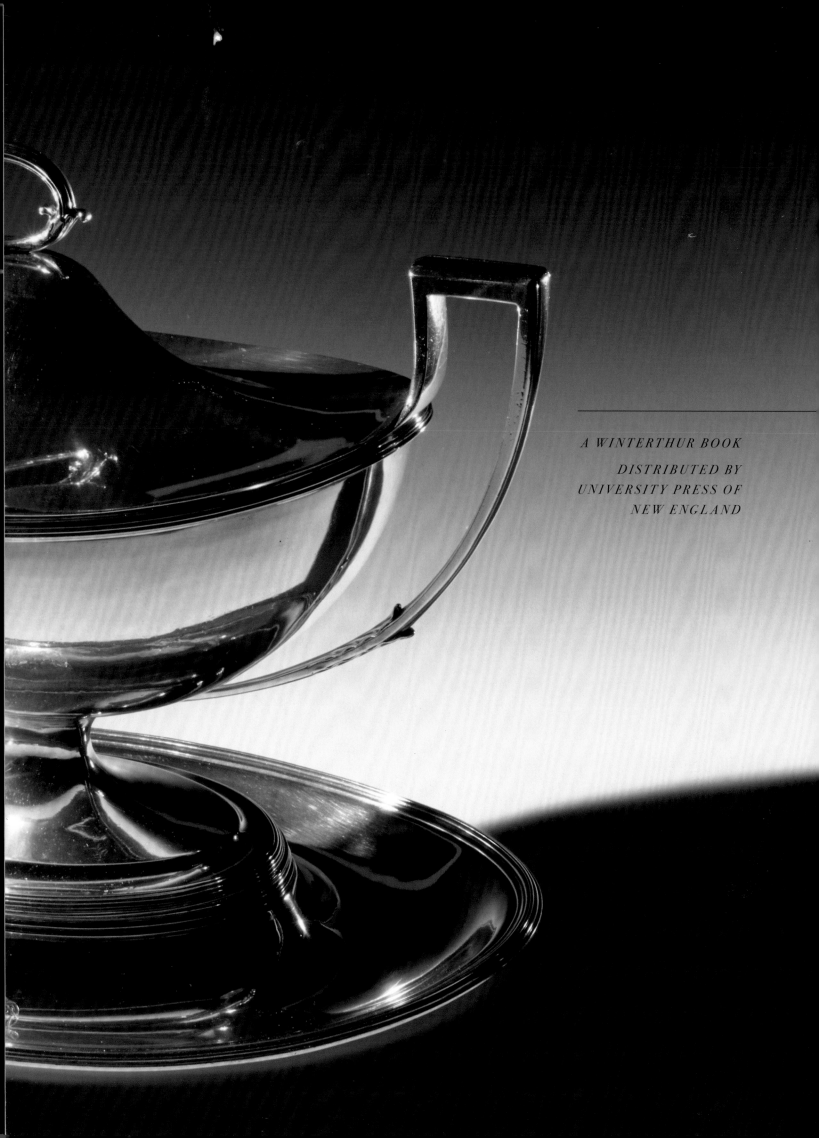

A WINTERTHUR BOOK

DISTRIBUTED BY
UNIVERSITY PRESS OF
NEW ENGLAND

DONALD L. FENNIMORE
PATRICIA A. HALFPENNY

WITH KATE DUFFY AND
JANICE CARLSON

CAMPBELL COLLECTION OF SOUP TUREENS AT WINTERTHUR

LIBRARY OF CONGRESS CATALOGING-IN-PUBLICATION DATA
Henry Francis du Pont Winterthur Museum.
Campbell collection of soup tureens at Winterthur / Donald L. Fennimore and Patricia A. Halfpenny with Kate Duffy and Janice Carlson.

Includes bibliographical references and index.
ISBN 0-912724-55-2
1. Tureens—Catalogs. 2. Tureens—Delaware—Winterthur—Catalogs.
3. Henry Francis du Pont Winterthur Museum—Catalogs.
I. Fennimore, Donald L. II. Halfpenny, P.A. (Pat A.) III. Title.

NK4695.T87 H45 2000
738—dc21

99-046851

FRONT COVER
See No. 55

BACK COVER
See Nos. 5, 77, 83

FRONTISPIECE
See No. 19

COPYRIGHT PAGE
Food arrangement, dated 1741, from the dinner book of Robert Jocelyn, first viscount Jocelyn and Lord Chancellor of Ireland. (Downs Collection, Winterthur Library.)

Content editor: Onie Rollins
Copy editor: Teresa A. Vivolo
Designed and produced by studio blue, Chicago

Printed by Balding + Mansell
Distributed by University Press of New England

Contents

Foreword

On the evening of May 22, 1997, Winterthur welcomed friends, colleagues, and donors to celebrate the opening of the Dorrance Gallery, the new home of the Campbell Collection of Soup Tureens. The display was dazzling. Breathtaking objects of superb craftsmanship seemed to float in space, set within elegant glass cases in a glass-walled gallery that overlooks the garden. As viewers strolled through the gallery, they marveled at masterpieces of silver, pewter, pottery, and porcelain. Whimsical tureens in the shapes of rabbits or swans vied for attention with graceful ladles and decorative bowls. But a common theme united them all—the story of the presentation of soup, from its humble origins in simple vessels to its grand display in imposing tureens.

The history of the collection began just thirty-four years ago. In 1966 John T. (Jack) Dorrance Jr., chairman of the Campbell Soup Company, and W. B. (Bev) Murphy, the company's president, made the initial decision to begin collecting. Guided by a desire to focus on the arts of dining over the centuries, Murphy secured a charter for a new museum and asked William Parker, director of public relations at Campbell, to serve as its first president. Parker later confessed that at first he was reluctant, explaining that he knew very little about eighteenth-century decorative arts, not to mention the complex and sometimes mysterious world of auction houses, antiques dealers, and collectors. He quickly recognized the need for help in forming the collection. A call to Carlisle Hummelsine, president of Colonial Williamsburg, yielded the name of John Graham, Williamsburg's director of collections. Nearing retirement, Graham agreed to take on the responsibility. Over a period of seven years, Graham and Parker traveled to fifteen countries and purchased hundreds of items, most dating between 1720 and 1840. Their first acquisition—a silver tureen that was reputed to have descended in the family of George Washington's mother—cost $8,000. Although a modest amount today, the figure seemed high to Parker and prompted him to question whether the company's leaders, Murphy and Dorrance, truly understood how much funding was needed to build a world-class collection. Parker arranged for the two to accompany Graham on the next buying trip to New

York. In a flurry of activity, the group spent more than a quarter of a million dollars on six tureens. Parker's doubts about the company's commitment immediately disappeared.

The collection grew rapidly, and by late 1969 the first exhibition of the tureens was mounted at the Philadelphia Museum of Art. In February 1970, the collection traveled to Colonial Williamsburg, where it was shown during the Antiques Forum, as a tribute to Graham. Before the end of that year, the Campbell Soup Company had developed a museum facility at its headquarters in Camden, New Jersey, where the tureens were displayed against a rich backdrop of red velvet within luxuriously lighted hanging cabinets. The striking installation attracted considerable interest; indeed, I vividly remember my first visit, just after the museum opened. The drama of the display stood out. Fabulous objects were arranged perfectly within a theatrical setting.

To broaden the impact of the collection, the Campbell Museum organized a traveling show of many of the best pieces and offered it at no charge to museums throughout the country. The touring exhibition became an immediate success, introducing millions of visitors to the collection and, by extension, to the artistry of decorative tablewares. In the 1990s alone, the show reached more than thirty museums—from major institutions to modest community organizations and local historical societies. For many museumgoers the Campbell Collection of Soup Tureens provided an unforgettable orientation to the world of decorative arts.

William Parker remained the president of the Campbell Museum until 1973. His successor, Ralph Collier, guided the museum until 1992. During Collier's tenure the collection benefited from the generosity of several donors. Mrs. Elinor Dorrance Ingersoll, Mr. and Mrs. Edward M. Pflueger, and Mr. Myron A. Wick Jr. provided key pieces, and Jack Dorrance continued to contribute rare tureens that broadened the scope of the collection. His gift of a yel-low faience tureen from Marseilles in 1982 (No. 98) and a faience tureen from Strasbourg in the form of a turkey a year later (No. 97) lent even greater variety to what had become the finest collection of its kind in the world. Contemporary tureens have added a further dimension. Two came as a result of competitions sponsored by the museum and offer a humorous counterpoint to the stately formality of the most monumental eighteenth- and nineteenth-century examples. Today the Campbell collection numbers nearly three-hundred objects and includes works from twenty-one countries.

By the early 1990s, declining attendance at the Campbell Museum led staff to conclude that the collection would benefit from transfer to a museum where the tureens would receive greater public attention and more scholarly scrutiny. J. Neil Stalter, vice president for public affairs at the Campbell Soup Company, and Catherine Magee, director of the Campbell Museum, coordinated the transfer. They initiated discussions with Winterthur in the summer of 1994. Samuel Schwartz, then chairman of the Board of Trustees, assisted by a committee that consisted of myself, deputy director Brock Jobe, and trustees Bruce Perkins and Walter Laird, represented Winterthur. From the start the committee enthusiastically pursued the collection, convinced that Winterthur was a fitting site; after all Jack Dorrance had served as a Winterthur trustee from 1979 until 1985, and the museum already had articles relating to the service of soup and welcomed the opportunity to focus further attention on dining and decorative arts. Furthermore, Winterthur's rich academic resources held the promise of renewed study of the collection. An unparalleled research library, outstanding graduate programs in early American culture and conservation, and funding for visiting scholars would provide the ideal environment for fully revealing the histories of these exceptional objects. Finally, Winterthur could offer the curatorial, conservation, and exhibitions staff to ensure that the collection would be catalogued, cared for, and displayed properly. Winterthur indeed was the most appropriate home for the tureens.

Negotiations between the Campbell Museum and Winterthur concluded with the gift of the collection in March 1996. Tied to the gift were commitments to display the majority of the collection in a single gallery,

to close the traveling show in 1998 and bring the objects to Winterthur, and to publish a new catalogue in 2000. The extraordinary generosity of many individuals has made it possible to meet these commitments. An initial contribution from the Campbell Soup Company provided critical support in the earliest stage of the project, and later, gifts from MBNA and an anonymous donor topped off the campaign. In between came donations from the Dorrance family. Eight members deserve our deepest thanks: Mrs. Samuel M. V. Hamilton, Tristram C. Colket Jr., Mrs. Hope H. van Beuren, Bennett Dorrance, George Strawbridge, Mrs. Charlotte C. Weber, Mrs. Diana S. Wister, and Mrs. Mary Alice Malone. Museum mergers are often complicated affairs that test everyone's patience and goodwill. In this case, the Dorrance family remained steadfast in its charge. Their contributions celebrate Jack Dorrance's achievement in form

ing the tureen collection; the Dorrance Gallery is named in their honor.

The Campbell Museum published its first catalogue in 1969 to coincide with the exhibition at the Philadelphia Museum of Art. Four editions and many thousands of copies later, the volume has become a classic. The most recent version, produced in 1983, highlights 150 items and provides succinct commentary on each by Kathryn Buhler (silver), John Austin (ceramics), and Carl Dauterman (ceramics and silver added to the collection since 1978).

The Winterthur catalogue builds upon the scholarship of these esteemed experts. Curators Patricia A. Halfpenny and Donald L. Fennimore have carefully examined every item. In collaboration with staff conservators, they determined the condition of the objects, studying them within the light of current scholarship. Their findings yield new insights and, in some cases, new attributions. In the process, they have sought to focus attention once again on this national treasure and to share the excitement that they have felt for this extraordinary collection. We promise a feast for the eyes as a parade of birds, beasts, figures, and flowers passes by on the pages that follow. So soup's on, and it's "M'm! M'm! Good!" Enjoy the beauty of the world's most decorative tablewares.

DWIGHT P. LANMON
DIRECTOR AND CEO

Acknowledgments

Researching and writing about the metal tureens and related objects in this catalogue has been a considerable challenge. Most of the objects were made in Europe and England for royal or aristocratic patrons. Although related to American metalwork, they represent a higher plane of consumption because of their considerable cost, complex fabrication, and use in sumptuous rituals centered around the dining table. From the outset, I did not want readers to lose sight of a now largely extinct class of patrons who commissioned these objects for elaborate and formal ceremonies.

Compounding the challenge has been the lack of substantive information about objects of this type in English-language publications. I, therefore, found it necessary to delve into various European publications. To do so, I sought the good will of many colleagues, all of whom have been gracious in their response.

I express considerable gratitude to Patricia A. Halfpenny, who has been an unfailing helpmate as I worked through my part of this catalogue. I have also sought the counsel of Kevin Tierney and Ian Irving, whose knowledge of silver is extensive. More important, they have been familiar with the Campbell collection since its inception, which has proven to be invaluable.

Many others have also provided information and insight that has added greatly to the quality of the metal entries in this catalogue. They have my sincere gratitude: Sandy Arcey, Victor Franco de Baux, Princesse de Beauvau-Craon, Roger M. Berkowitz, Doris Boyd, Alex Chanter, Juliet Chase, Peter Collingridge, Clare Le Corbeiller, Gerald Cully, J. Culverhouse, Michael von Essen, Cristina Esteras, Bisse Evers, Joseph J. Greco, Kathryn B. Heisinger, David S. Howard, John A. Hyman, Marcia Jebb, Daniëlle O. Kisluk-Grosheide, Wolfram Koeppe, Michael Krapf, Georg Kugler, Maggie McKean, Waltraud Neuwirth, Susan Newton, Christian Holmstead Olesen, Lori Ott, Cilla Robach, Mark A. Schaeffer, Elisabeth Schumuttermeier, Jeanne V. Sloane, D. Albert Soeffing, Neville Thompson, Deborah D. Waters, Gillian Wilson, and Brigitte Winsor.

I also express my thanks to Onie Rollins and Teresa A. Vivolo for their careful and considered editing of the manuscript.

DONALD L. FENNIMORE

The Campbell Collection of Soup Tureens at Winterthur is an eclectic group of soup plates, bowls, spoons, ladles, and tureens. The ceramic pieces range in date from about 1730 to 1986 and include all major body and glaze types. The geographical origins are widespread, involving factories in thirteen countries as far apart as England, Russia, and the United States.

The problems of cataloguing such a diverse and important collection were many and varied, and I thank colleagues in both England and the United States for their assistance. In particular I acknowledge Sheila Tabakoff, who, in the midst of her own catalogue research, took time to discuss the Campbell collection, offer innumerable comments, supply reference material, and share her invaluable knowledge. Letitia Roberts has known the collection since it was first begun, and I am most grateful to her for her comprehensive evaluation of the manuscript as well as for allowing me access to her research files.

Many others have also assisted: Betty Anderson, David Barker, Victor Franco de Baux, Juliet Chase, Clare Le Corbeiller, Grace Eleazer, Ronald Fuchs III, Jonathan Grey, Felice Jo Lamden, Catherine Magee, William Parker, Marianna Poutasse, William Stewart, and Maja Teufer.

Last, but not least, I thank my colleague Donald Fennimore for his sensitive, thoughtful, and provocative comments about the tureens and for his unfailing good humor throughout this project.

PATRICIA A. HALFPENNY

Notes to the catalogue

This catalogue does not illustrate every object in the Campbell Collection of Soup Tureens at Winterthur. The authors have selected those examples they feel represent the best in the collection and serve to highlight its depth.

The entries are organized by section: the first addresses metalwork; the second deals with ceramic objects, including porcelain, earthenware, and stoneware. Within each section, entries are arranged alphabetically by country of origin and chronologically (by date of fabrication) within each country. The ceramics section is further organized by factory affiliation, with an essay on the factory preceding multiple entries.

About the object includes stylistic and technical notes, as well as information about any marks on the object.

Notes are numbered sequentially and follow the sum total of the entries as endnotes. Short-title forms are used in the Literature references within each entry and in the notes. Full publication data may be found in the bibliography, which is divided into metalwork and ceramics sections.

The appendixes include an essay describing the XRF analysis carried out on the metal objects, data (in table format) derived from the analysis, and commentary that interprets that data.

A glossary of terms, divided by section, can be found at the back of the book.

All the metal tureens and many of the ceramic tureens in this catalogue were originally fitted with stands, some of which are now lost. To properly understand the appearance, function, and purpose of the soup tureen in its original context, readers should presume that stands accompanied most, if not all, tureens illustrated in this volume.

List of makers and manufacturers

Introduction
Of soup and love, the first is the best

The English proverb "Of soup and love, the first is the best" dates from the early years of the eighteenth century. The sentiment may be a little overstated, but it suggests that soup was considered to be a fundamental necessity of life.

In early history, food was cooked in a single vessel over an open fire. The communal pot contained water to boil various ingredients that might include grains, vegetables, meat, and fish. Members of the family helped themselves, and all ate directly from the "stock pot." From these humble origins, soup, and eventually soup tureens, emerged to become part of lavish dinner parties and royal banquets.

From the seventeenth century onward, we can document changes in lifestyle that included new ways of dining and entertaining. In the 1600s the splendid public feasts that had been an indispensable expression of power on the part of medieval monarchs and noblemen were displaced by more private dining practices (fig. 1). A new political, religious, and social order meant that a landowner no longer needed to keep great retinues of supporters to secure his estates on a daily basis. With an increasing degree of stability, life became more regular, more ordered, and more family oriented. Houses changed to accommodate new social requirements. Formal dining, which had taken place in the great hall with the whole household in attendance, became a less public affair. Parlors were used, and eventually separate dining rooms were introduced into house plans.

By 1700 dinner *à la française* was the fashion. Previously, every dish of a meal had been placed on the table at one time. Dining *à la française,* however, stipulated that the meal be divided into several courses. Dinner began with a table laid with the first-course dishes only; these were set out before the diners were seated. Food, candles, salts, table ornaments, and plates were all arranged with careful attention to a strict hierarchy of dishes and established symmetry.

1 *Duke of Lancaster Dines with the King of Portugal.* From Jean de Batard Wavrin, *Chronique d'Angleterre*, vol. 3, *From the Coronation of Richard II to 1387* (15th century). (Roy 14 E IV f.244v. British Library, London, UK/Bridgeman Art Library, London/New York.)

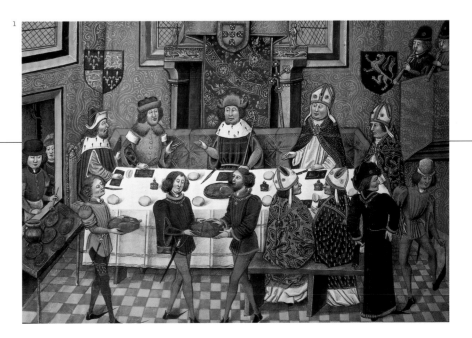

Soup was part of the first course, and it was usual to offer at least two kinds. For large dinners, one set of tureens might hold a clear soup, and an additional set might be filled with a thicker dish that resembled ragout (fig. 2). Documentary evidence relating to soup often makes no distinction between thick soup, potage, ragout, or casserole. Served at the beginning of a meal, soup was intended to take the edge off everyone's hunger. The corollary is that hosts were not to serve too much of it. A nineteenth-century English etiquette guide suggests that "to fill or even to half fill, a soup plate with soup would be in very bad style."[1] A full bowl might indicate that a host was too parsimonious to provide substantial additional courses.

After the soup had been eaten, tureens and soup plates were removed, and the soup course was replaced with another dish—often fish (fig. 3). The replacement dish was known as a "remove." During the meal, guests helped themselves from the choice of dishes within reach. Servants assisted by passing condiments, wineglasses, and drinks from the sideboard as required. To be sure of attentive service, diners were often advised to give the servants a hefty tip before the meal began.

Banquets, dinner parties, suppers, and balls were a way of establishing one's place in society and impressing others with one's superior taste, great wealth, and fashionable practices. Early in the eighteenth century, dinner might have begun at midday; gradually the meal was served later and later, until three or four o'clock was the norm. The event might then last seven or eight hours. Part of the enter-

tainment was to decorate the table with interesting food and ornamental devices to amuse the guests and stimulate conversation. To make a grand and dramatic first impression there was no more suitable vessel than the soup tureen.

The earliest of the tureens in the Campbell Collection of Soup Tureens at Winterthur are metal— silver, silver-gilt, and gilt brass—indicating the precious nature of the vessel. The soup tureen was part of the rich man's plate, to be used and to be exhibited. As porcelain became more widely available, that precious material was also used in the creation of magnificent table services.

The most impressive of the tureens in the Campbell collection is a flamboyant, gilt-brass example made for Prince Marc de Beauvau-Craon, who was High Constable of Lorraine and Viceroy of Tuscany from 1736 to 1748 (fig. 4, No. 5). Although its exact origins are unknown, the tureen was probably made in France in the period 1720–40. The bold, sculptural qualities of this powerfully modeled form exhibit architectural features such as S scrolls, friezes, caryatid figures, and acanthus, all of which are typical of the baroque style. This tureen evolved not merely as a utilitarian article for the service of soup; it was an expression of wealth and of fashionable style. It was a statement that the owners were embracing the latest developments in serving, eating, and table etiquette and had acquired the requisite new tablewares and furnishings that signified a greater sophistication of domestic rituals.

The term *baroque* was coined in the eighteenth century by art critics and historians as a pejorative epithet to define the highly ornate designs of the seventeenth and eighteenth century that they considered aesthetically unpleasing. The heavy style eventually became lighter, and elements of fantasy were incorporated into designs. However, a similar term of ridicule was also coined for the next major international style of architecture and design—*rococo*. Through the work of French painters and designers such as Watteau and Meissonnier, there was an emphasis on the picturesque that was fostered by the production of ornamental prints, designs, and pattern books (fig. 5). In the decorative arts, rococo is exemplified by the

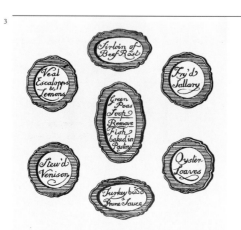

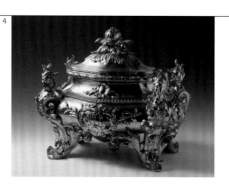

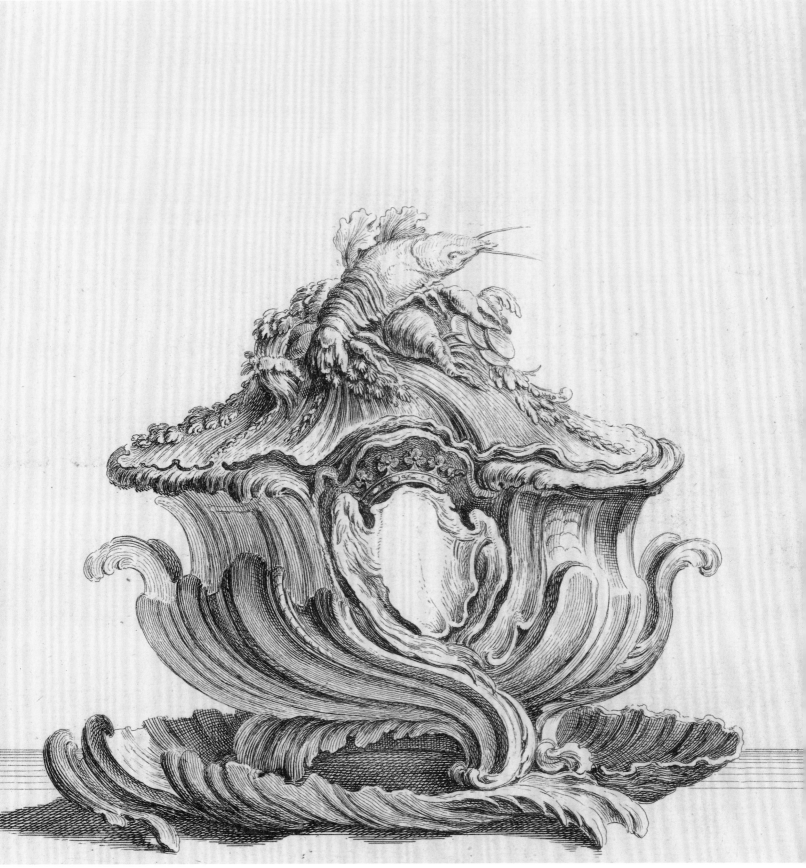

2 Table de quinze à seize couverts *(table setting plan for a supper). From Vincent La Chapelle,* Le Cuisinier moderne *(The Hague, 1742). (Schlesinger Library, Radcliffe College.)*

3 *An elegant dinner setting. From Jennifer Stead,* Food and Cooking in Eighteenth-Century Britain: History and Recipes *(London: English Heritage, 1985), p. 16. (Drawing, Peter Brears.)*

4 *Maker unknown, gilt-brass tureen, France, 1720–40.*

5 Terrine. *From Juste-Aurèle Meissonnier,* Oeuvre de … peintre, sculpteur, architecte et dessinateur… *(Paris: Gabriel Huquier, 1750), pl. 62. (Printed Book and Periodical Collection, Winterthur Library.)*

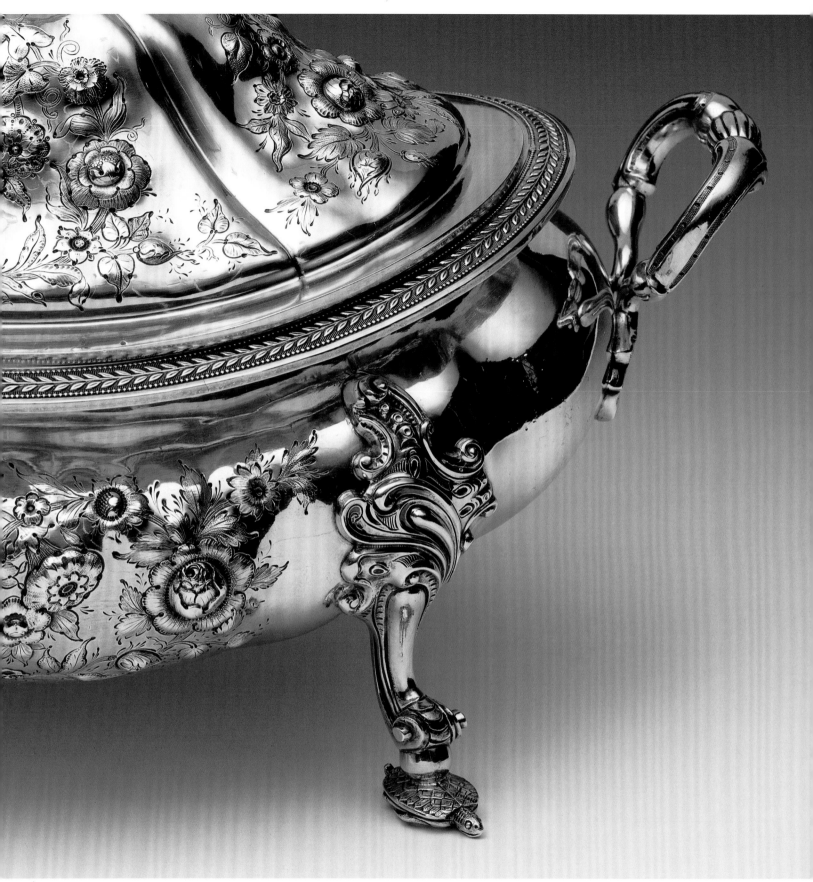

6

6 *William Forbes, silver tureen, New York, 1839–51.*

7 *John Edwards II, silver tureen, London, 1746–47.*

8 *Porcelain tureen, attributed to Chelsea porcelain factory, London, ca. 1754.*

fantastic, sometimes bizarre use of ornament. The principal elements are a dependence on asymmetry; the use of cartouches made from C- and S-shape scrolls; an interest in natural, organic forms; and an emphasis on the grotesque—grottoes and ruins—on shells and marine crustacea, and on flowers and follies.

In 1745 the first major attack on the rococo style noted, "They heap cornices, bases, columns, cascades, rushes, and rocks in a confused manner, one upon the other and in some corner of this chaos, they will place a cupid in a great fright, and have a festoon of flowers above the whole. And this is what they call designs of a new taste."[2]

The great strength of the Campbell collection lies in the eighteenth century and in the rococo style. A standard, ovoid shape was used for many ceramic and metal tureens created during the middle of the eighteenth century, and the basic form was ornamented in various ways to conform to the demands of rococo fashion. The simplest method was to apply fanciful feet and frivolous handles. The most common handle form is composed of looped or entwined leaves and branches, but shells, boars' heads, lions' heads, deer heads, and caryatid figures are among the curious subjects that may also be found. The most practical and economical base for a tureen is a flat surface that sits securely on a stand or table; however, many of the Campbell tureens have ornamental feet—"hairy paws," lions' pads, or cloven hooves. More commonly the feet are formed from scrolling foliage. Some of the more singular designs include a range of marine subjects such as mermaids, dolphins, and tiny turtles (fig. 6, No. 35).

A question that is commonly asked about tureens is whether the design of their finials is related to their contents. Given that finials encompass a wide range of fantastic subjects from crayfish to cabbages, frogs to flowers, and putti to pomegranates, one would hope

that this is not always the case. Indeed, what we know of dining practices suggests that table services usually included soup tureens in multiples of two, with particularly large services having six. The typical dinner party offered a choice of two soups, one clear and one cream. As the tureens would have been a matching pair and the soups were different, it is likely that most finials were merely intended to be decorative.

John Edwards II of London created a silver tureen in 1746–47 (fig. 7, No. 12). It is typically rococo, with the basic oval form covered by an assortment of amazing natural detail embracing a range of decorative techniques. The cover has repoussé bands of scrolling leaves that freely swirl and intertwine. The finial is cast in the form of a crayfish, or lobster. On each side, the body of the tureen has a band of applied scrolling flowers and leaves supporting an asymmetrical cartouche finely engraved with the coat of arms of Gould impaling Shaw. The whole is supported by four dolphin feet, and the handles are in the form of boars' heads. The incongruity of the individual parts is somehow overcome by the unifying theme of swirling asymmetrical detail.

The form and surface patterns of the Edwards tureen are echoed in a porcelain tureen made at the Chelsea factory in London about 1754 (fig. 8, No. 79). Nicholas Sprimont, the artistic driving force behind the Chelsea porcelain company, was a trained silversmith. This piece particularly reflects the sculptural

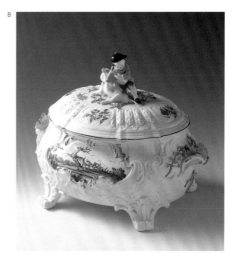

8

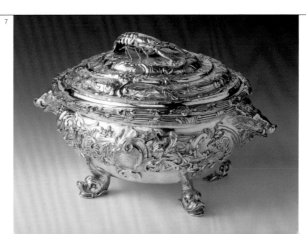

7

qualities normally associated with the finest, most fashionable silver examples. Ceramic tureens are sometimes less elegant than silver ones, perhaps because they often rely on color for decoration rather than form. Within the Campbell collection, however, three eighteenth-century unpainted ceramic tureens do rely on intricate form. A white porcelain example from the Bow factory has applied decoration of prunus sprays in imitation of the Chinese (No. 72). This interest in the Orient was a branch of rococo that expressed a curiosity about the fantastic and exotic. Two white, salt-glazed stoneware tureens from Staffordshire follow more naturalistic themes. One is shaped and modeled to resemble a melon (fig. 9, No. 105); the other is a more standard shape but with surface molding depicting intertwining fruiting currant branches (No. 106). As with silver tureens, the appeal of these white examples lies in the overall form, including a surface texture of molding or embossing.

Many decorated ceramic tureens have modeling on the surface, often of S- and C-shape scrolls that form panels or cartouches to frame exquisitely painted designs. From naturalistic flower sprays to Chinese gardens, rococo artists created a range of patterns to excite and please every taste and test the skills of manufacturers.

German artisans were the first to triumph with creating porcelain tureens. From the early years of the eighteenth century, they acquired skills that allowed them to produce some of the most technically difficult pieces ever made. A small, covered soup bowl created at the Meissen factory about 1740–45 demonstrates

how technical excellence and rococo extravagance came together to create a masterpiece (fig. 10, No. 64). The flower-encrusted surface is in the *Schneeballen* tradition; each handmade flower was applied individually to the surface of the bowl and cover, resulting in the snowball of white guelder roses. At a later date, molded versions were produced, but in the 1740s the work was all done by hand. The finial is in the form of a classical goddess wearing a plumed helmet and metallic breastplate. The figure is Minerva as goddess of war, and it is only when we look closely at the meticulously hand-painted panels on the bowl that we realize that she is presiding over battlefields. The military scenes are thought to have been inspired by engravings of the War of Austrian Succession (1740–48) as recorded by war artist Georg Philipp Rugendas.

Small, covered broth and soup bowls are uncommon in English ceramics, but they were widely made and used on the Continent. The French royal manufactory at Sèvres produced individual bowls, called écuelles, from about 1752. They came in several different shapes and sizes. Écuelles were not intended to be part of a dinner set; they were sold as separate pieces for serving breakfast bouillon or nourishing refreshments in the seclusion of private rooms or apartments. The conventional way of using an écuelle was to drink the liquid directly from it, picking it up by the two handles. Écuelles usually had stands, or *plateaux,* to hold bread and a napkin, which accompanied the soup (No. 51).

Perhaps the most remarkable rococo tureens were those that reflected an interest in naturalistic forms. Vegetables, fish, and animals were realistically portrayed in both porcelain and earthenware. A rare survival of this fashion is a particularly grisly tureen in the form of a severed boar's head (fig. 11, No. 80).

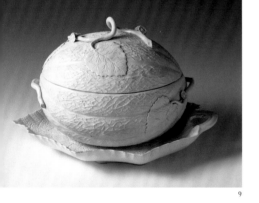

9

9 *Maker unknown, stoneware tureen and stand, Staffordshire, ca. 1760.*

10 *Porcelain covered soup bowl and stand, attributed to Meissen porcelain factory, Germany, 1740–45.*

11 *Porcelain tureen and stand, attributed to Chelsea porcelain factory, London, ca. 1755.*

12 *Elijah Mayer, creamware tureen, stand, and ladle, Staffordshire, 1790–1804.*

13 *Hugh Wishart, silver tureen, New York, 1793–1810.*

10

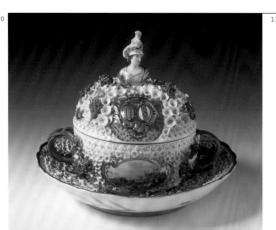

11

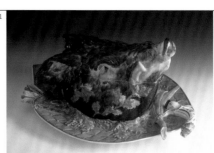

When the tureen is full of hot soup, steam rises through the pierced nostrils, creating a representation of a recently killed animal. The Chelsea porcelain example, made about 1755, is exceptionally realistic, with trickles of red enamel simulating blood dripping from the eyes and nostrils.

The exuberance and whimsical nature of the rococo style began to pall by the middle of the eighteenth century. Its frivolity and excess eventually gave way to the symmetry and order of what contemporaries called the "true" or "correct" style. A return to familiar classical shapes and ornaments was advocated, and classical taste was exemplified by souvenirs from the grand tour and extensive collections from excavations at Herculaneum and Pompeii.

This classical revival, first manifest in new architectural styles, filtered down to the decorative arts that were needed to ornament rooms and serve as functional items. A cream-color earthenware tureen from Elijah Mayer of Staffordshire has a simple shape and formal border pattern that echo the new demands for classical restraint (fig. 12, No. 109). It was probably made in the last decade of the eighteenth century. Tablewares of this kind were made for the well-to-do. Royalty, nobility, and wealthier members of the middle classes began to buy creamware dinner services in the late 1760s, particularly in England, where porcelain was still passing through its experimental stages and dinner services with large flat dishes and big tureens were technically difficult to produce. Although Chinese porcelain was suitable for dinnerwares, it was no longer fashionable in Europe by the end of the eighteenth century; the neoclassical earthenware dinner service reigned supreme. To complement such a dinner service, it was possible to buy soup tureens in silver that had large, plain surface areas embellished with extremely restrained ornament that accented the elegance of form. A silver tureen with the mark of New York silversmith Hugh Wishart exhibits archetypal neoclassical qualities (fig. 13, No. 33).

From about 1800, rigorous classicism relaxed. More complex forms emerged, but decoration was restrained, with an emphasis on simple foliage, flower sprays, and sprigs. There was a new interest in the picturesque and the countryside that led to a quiet, comfortable calm after the excesses of rococo and the constraints of neoclassicism. Of course, the very nature of society is that it is always evolving. In the nineteenth century there were numerous middle-class families that aspired to upper-class lifestyles. To cater to this market, pottery manufacturers supplied earthenware dinner services with fashionable but inexpensive styles of decoration. Costly silver and exquisite hand-painted porcelains served the tables of the wealthy while printed pottery served the middle-classes (No. 113).

The quiet, gentrified qualities of early nineteenth-century styles were challenged in the late 1820s, when there was a renewed interest in decorative motifs of the mid eighteenth century and florid rococo styles were revived. A silver tureen overwhelmed by maritime imagery is an astonishing example of the revived rococo style (fig. 14, No. 24). The tureen was made by Robert Garrard Jr. of London in 1824–25. Garrard's successors are currently crown jewelers and goldsmiths. The body of the tureen is embossed with shell-molded flutes. The sculptured handles of a triton and mermaid have double fish tails; the applied border is made up of a variety of shells; and the finial is a lobster amid shells and seaweed. The whole is set

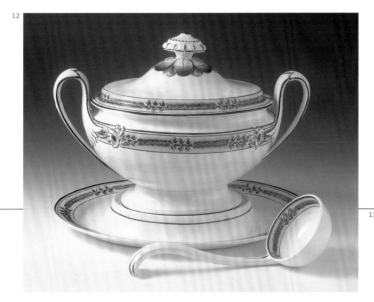

12

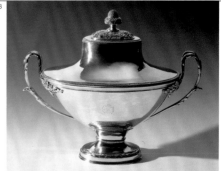

13

on a rolling sea of silver—the elaborately wrought flutes and scrolls simulate cresting waves. This kind of skillful, but perhaps excessive, ornamentation characterizes the expensive high style of mid nineteenth-century decorative arts. For more modest households, the range of mass-produced goods increased.

As decorative fashions changed, so did patterns of eating and dining. In the nineteenth century, service *à la française* gave way to service *à la russe*. This new way of conducting a dinner party was intended to be more streamlined. Meat was carved at a sideboard, and accompanying dishes were held by servants and offered to guests individually. It was no longer considered polite to help oneself or one's fellow guests to partake of the meal. Serving dishes were not placed on the table, allowing more room for table centerpieces and decorations.

For economic and social reasons, the use of tureens declined in the second half of the nineteenth century. Wealthy families dining *à la russe* did not require splendid tureens on the table. Servants at the sideboard ladled soup into soup plates, which were then placed before the dinner guests; there was no need to acquire a tureen as a grand, stylish gesture.

Only in the more recent decades of the twentieth century has the use of tureens come full circle. Those devising plans for table decorations have come to realize their many possibilities. Large ornamental pieces, particularly those in a figurative style (fig. 15, No. 121), easily demonstrate that the qualities of craftsmanship, design, humor, and exuberance were not the exclusive properties of past masters; they are indeed alive and quite evident in the work of contemporary artists as well.

NOTES

1 Margaret Visser, *The Rituals of Dinner* (New York: Grove Weidenfeld, 1991), p. 220.

2 Victoria and Albert Museum, *Rococo Art and Design in Hogarth's England* (London: By the museum, 1984).

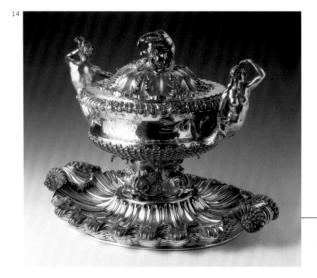

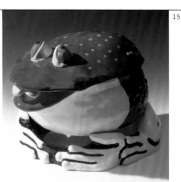

14 *Robert Garrard Jr., silver tureen, London, 1824–25.*

15 *Maker unknown, earthenware tureen, United States, 1986.*

METALWORK

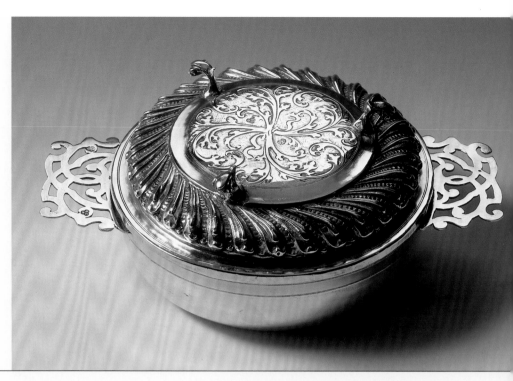

AUSTRIA

1 Écuelle

GEORG CASPAR MEIKL VIENNA, AUSTRIA, 1706

Maker, artist, craftsman

Georg Caspar Meikl was active as a silversmith and goldsmith between 1702 and 1728.

About the object

The porringer, a shallow, circular bowl with a handle and sometimes a lid, was commonly used for eating and drinking throughout continental Europe and Great Britain during the seventeenth and eighteenth centuries. When fitted with two handles, it is called an *écuelle* in France, a *quaich* in Scotland, and a *kleine terrine* in Germany. Two-handled porringers were very popular in France and were most widely made there.

This écuelle was possibly once part of a cased travel set. Those who could afford it (a small percentage of the population) had boxed sets of utensils that they used when traveling. In fact, such boxed sets were only part of their entourage, which could consist of numerous trunks and retinue, depending upon one's wealth.

Stylistically, the écuelle relates to French counterparts made during the last quarter of the seventeenth

century, particularly in the use of a pinwheel of swirling acanthus leaves to decorate the center of the lid. This feature, created either as repoussé or cut-card work, was used on many lids made in Paris and other French metropolitan centers. Like the écuelle itself, the feature was imitated in Austria.[1]

The lid and bowl are wrought. The lid features chased and repoussé ornament. Projecting from its center are three cast, chased, and soldered lugs. Two wrought and saw-pierced handles are soldered to the bowl.

Two marks are stamped into the lid and one handle, identifying the maker, place, and date of fabrication, and adherence to the Viennese standard of 13 lötiges, the equivalent of 81.25 percent pure silver.

Parcel-gilt silver; 11 oz
17 dwt
Height 3 1/8 in (79 mm)
Width 8 5/8 in (219 mm)
Diameter 6 1/8 in (155 mm)
96.4.147

PROVENANCE
The Campbell Museum purchased this écuelle in 1972 from antiques dealer Herbert M. Ritter, Munich.

LITERATURE
Selections from the Campbell Museum Collection 1978, no. 33; 1983, no. 1.

A *Mark identifying place and date of fabrication and adherence to the appropriate standard*

B *Mark identifying the maker*

A

B

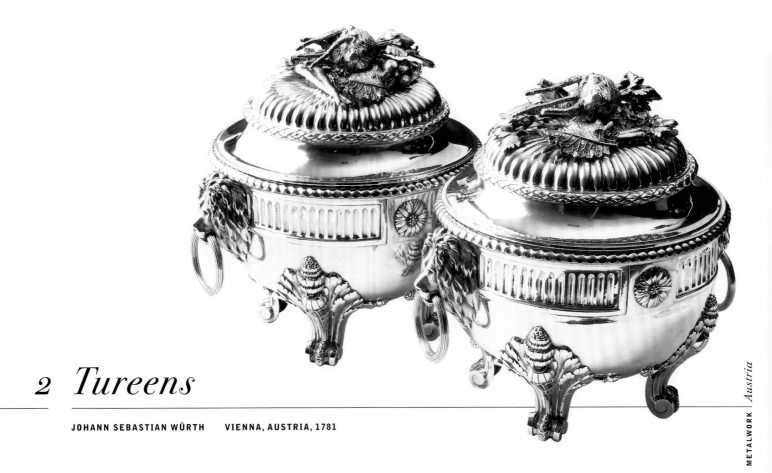

2 Tureens

JOHANN SEBASTIAN WÜRTH VIENNA, AUSTRIA, 1781

Maker, artist, craftsman

Johann Sebastian Würth registered his mark with the Goldsmiths' Company in Vienna in 1768. He remained active there as a silversmith through 1781.

About the objects

The lids of these tureens are embellished with a still-life trophy of vegetables (turnip, carrots, spinach leaves, mushrooms, and celery) that may allude to the intended contents of the vessels. An architectural frieze in the Doric order encircles the lip of each tureen. It consists of a band of modified triglyphs alternating with rose-decorated metopes. Leaf-decorated scrolled feet support the circular bodies. These features take their cue from Parisian silver made by Pierre Germain, Robert-Joseph Auguste, and Pierre-François Gogly, among others, during the third quarter of the eighteenth century. [2]

The lids and tureens are wrought. Multipart cast and chased finials are bolted to the lids. Each is surrounded by a collar of chased ornament. Cast and chased feet are soldered to the tureens, while similarly fabricated handles and ornaments are bolted in place, alternating with panels of chased ornament. These tureens were probably originally fitted with wrought removable liners and stands, which are now missing.

The Roman numeral "I" is engraved on the underside of one lid and inside its companion tureen; a "II" is engraved the same way on its mate. Two marks are stamped on the underside of each tureen, identifying the maker, place of origin, date of fabrication, and adherence to the Viennese standard of 13 lötiges, the equivalent of 81.25 percent pure silver. A swan stamped into the lids and bodies indicates that they were imported into France after 1893. [3]

Silver; 174 oz 10 dwt (.1)
and 175 oz (.2)
Height 12 in (304 mm)
Length 13 ⅛ in (333 mm)
Diameter 10 ⅞ in (276 mm)
96.4.230.1, .2

LITERATURE

Banister, "Silver Soup Tureens," p. 103, fig. 2.

Buhler, "Silver Tureens," p. 908, fig. 12.

Selections from the Campbell Museum Collection 1969, no. 19; 1972, no. 17; 1976, no. 17; 1978, no. 18; 1983, no. 5.

A

B

A *Marks identifying the maker, date, place of fabrication, and adherence to the proper standard*

B *French import mark*

Design for a vase. From Charles Percier and Pierre F. L. Fontaine, *Recueil des Décorations Intérieures* (Paris, 1812), pl. 46. (Winterthur Library.)

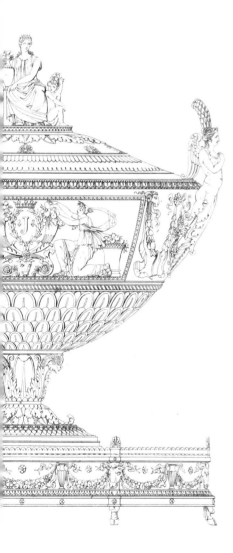

3 *Tureen*

FRANZ HELLMAYER VIENNA, AUSTRIA, 1800

Maker, artist, craftsman

Franz Hellmayer entered the Viennese Goldsmiths' Company in 1788 and remained an active craftsman until 1819.

About the object

This tureen is modeled on the ancient Greek kylix, a broad, shallow-footed bowl used for drinking wine. The ornament, by contrast, relates more closely to Roman prototypes. During the late eighteenth century, European designers often adapted Grecian forms and decorated them with Roman ornament. Many of them published volumes of their designs in this "antique" style. The most influential work was Charles Percier and Pierre F. L. Fontaine's *Recueil des Décorations Intérieures*. This tureen's shape and all major ornamental components—human profiles in roundels, symmetrical compositions of leafy scrolls with humans and animals, and winged bare-breasted monopods—owe allegiance to the work of these two designers.[5]

The lid is wrought with a cast and chased finial bolted in place, encircled by one chased and one engraved border. A bezel is soldered to the bottom of the lip. The tureen and pedestal are wrought and

Silver; 292 oz
Height 20½ in (521 mm)
Width 16⅞ in (429 mm)
Diameter 13 in (33 cm)
96.4.187

PROVENANCE
This tureen is believed to have been made for Archduke Albert von Sachsen-Teschen (1738–1822), son of Augustus III, who was Elector of Saxony and King of Poland from 1733 until 1763. The Campbell Museum purchased it from antiques dealer Czeslaw Bednarczyk, Vienna, in 1970.

LITERATURE
Selections from the Campbell Museum Collection 1972, no. 18; 1976, no. 18; 1978, no. 19; 1983, no. 7.

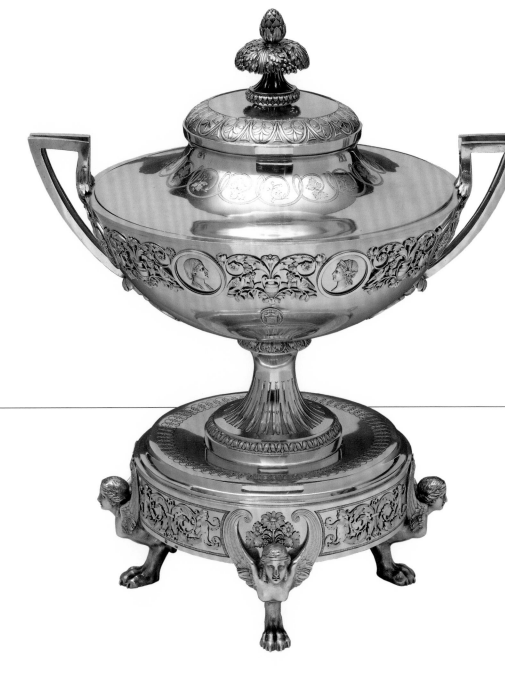

bolted together. The handles, ornamental border, and eight different human profiles are cast and chased; the handles are soldered in place; the borders and profiles are bolted in place. The pedestal is decorated with chasing. The multipart stand is wrought and soldered together. The feet and ornamental panels are cast, chased, and bolted in place; an engraved border ornaments the top surface.

The coat of arms of the Royal House of Saxony, with an archduke's crown as the crest, is cast within an oval shield, chased, and soldered to the tureen.

Various parts are stamped with a total of four different marks: two identify the maker, place, date of origin, and adherence to the Viennese standard of 13 lötiges, the equivalent of 81.25 percent pure silver. The other two marks were struck between 1806 and 1824: one indicates that a tax of 12 Kruzer was due the State; the second indicates that the tureen was free from being confiscated by the State.[6] The numerals "O," "I," "III," and "X" are chased into the back of each leg, suggesting this tureen may have originally been part of a larger set.

A *Mark indicating that a tax was paid and the object was not to be confiscated*

B *Mark indicating that a tax was due*

C *Marks identifying the maker, date, place of fabrication, and adherence to the proper standard*

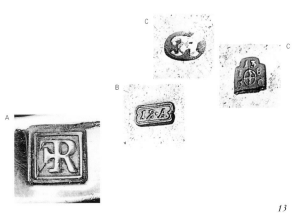

DENMARK

4 *Tureen*

ANTON MICHELSEN **COPENHAGEN, DENMARK, 1866**

Maker, artist, craftsman

Anton Michelsen apprenticed in Odense, the town of his birth. He undertook additional study in Berlin, Paris, and finally Copenhagen, where he was granted freedom to practice silversmithing in 1841. Through talent and connections, he was appointed goldsmith, jeweler, and medalist to the Danish Royal Court in 1848, a position he held until his death in 1877. His son Carl succeeded him; when Carl died in 1921, *his* son, Paul, assumed responsibility for the firm. The company continues to operate under the Michelsen name, although purchased by Royal Scandinavia in 1968.[7]

About the object

The hunting of bear is the decorative theme of this tureen. Clubs, lances, and pole axes—the ancient implements used in Scandinavia for killing this prey—encircle the stand. White oak boughs, cast from actual leaves, are interspersed among them. The large and realistic scene of a brown bear bedeviled by hounds makes clear that, during the chase, dogs were frequent helpmates, which when "well trained to the sport … tease him by repeated attacks from behind, dexterously avoiding him as he wheels about to defend himself." This tureen is so close in form and ornament to one made by Copenhagen silversmith

Niels Gram (ca. 1720–58) that the Gram tureen must have been its direct inspiration.[8] It was available to Michelsen in the Danish Royal Collection.

The four cartouches on this tureen and stand are unadorned but may have contained the engraved identity of the owner. Although that name has been lost, two cartouches are surmounted by a ducal coronet, indicating that the owner was a duke.

The lid, tureen, and stand are wrought. Cast and chased mounts are soldered to the edge of the lid; a cast and chased finial is bolted in place. Cast and chased legs, handles, cartouches, and a border are soldered to the tureen, embellished with sprays of chased leafage. A cast and chased coronet is riveted to two sides of the tureen above the cartouches. The four legs, leaves, acorns, and hunting weapons are cast, chased, and bolted to the stand; a cast and chased molding is soldered to the edge.

Five separate marks are stamped into the lid, tureen, and stand. Two identify the maker; the other three identify the place of origin, date of fabrication, and identity of the assayer, Simon Groth.

A

B

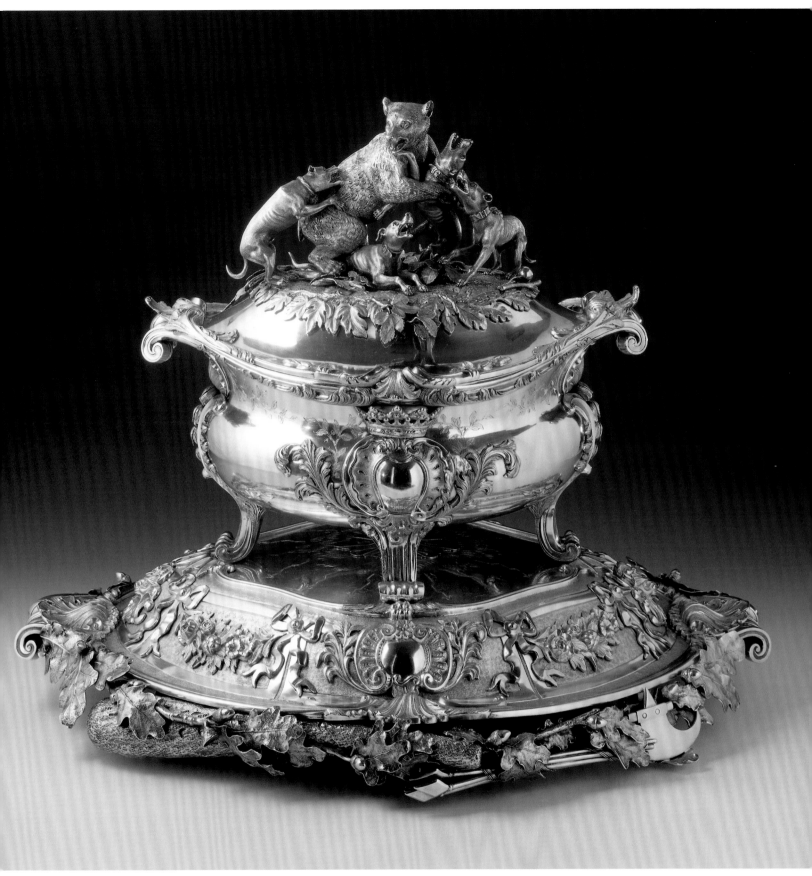

A Marks identifying the maker

B Marks identifying the assayer, date, and place of fabrication

Silver; 449 oz 7 dwt
Height 17 ½ in (444 mm)
Length 22 ⅝ in (575 mm)
Width 18 in (457 mm)
96.4.6

PROVENANCE
The Campbell Museum
purchased this tureen
at Sotheby's, London,
February 24, 1972, lot 43.

LITERATURE
Culme, *Nineteenth-Century
Silver*, p. 177.

*Selections from the Campbell
Museum Collection* 1978,
no. 23; 1983, no. 24.

5 *Tureen*

MAKER UNKNOWN PROBABLY PARIS, FRANCE, 1720–40

Maker, artist, craftsman

The initial "H," probably that of the brass founder, is present on the backs of the legs and leafy ornaments attached to the tureen's body. The identity of this craftsman has not been ascertained, but there were at least twenty-six brass founders whose surnames began with the letter H working in Paris at the time this tureen was made. One of them, Arnould Heron, might be considered a reasonable candidate for attribution. He worked for the Bâtiments du Roi at the beginning of Louis XV's reign, made ormolu for the king's library at Versailles, and gilded a fireplace fender for Fontainbleau.[9]

About the object

The scrolled legs with human busts, two male and two female, that support this tureen are its most pronounced feature. They are conceptually similar to a design created by either Jean Berain I (1640–1711) or Jean Berain II (1678–1726) for the Petite Gallerie at Versailles and undoubtedly ultimately derive from late baroque French design. A more immediate source for their inspiration appears in the work of Parisian designer Nicolas Pineau (1684–1754). His design for a console table, with legs in the form of S-shape scrolls topped with male and female busts, is strikingly similar.[10] Pineau also favored elliptic cartouches framed by flowerlike petals, as seen on the shoulder of this tureen, between the two horizontal borders.

The lid and tureen are each cast in one piece. The acanthus leaves that ornament the lid are cast integrally; the finial is a multipart casting that has been chased and bolted in place. The legs and other ornamental features are cast individually, chased, and bolted in place. All parts are mercury-gilded.

Maker's mark

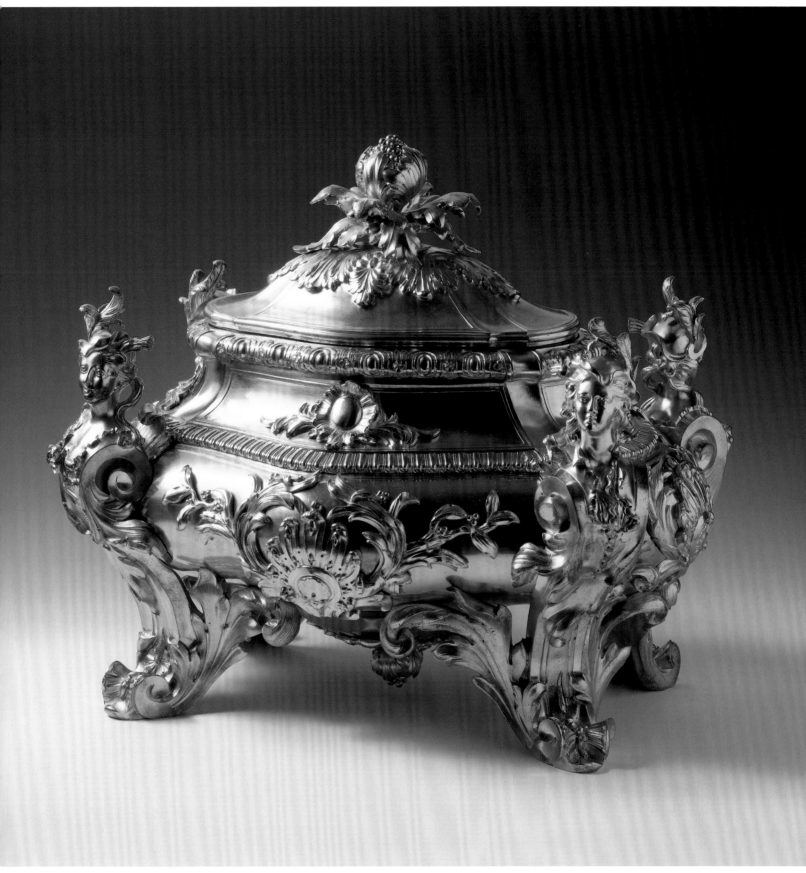

Gilt brass
Height 16 ¾ in (426 mm)
Length 19 ¼ in (489 mm)
Width 12 ⅞ in (327 mm)
96.4.201

PROVENANCE
Prince Marc de Beauvau-
Craon (1679–1754), high
constable of Lorraine and
viceroy of Tuscany, originally
owned this tureen. It passed
by descent to Prince Marc
de Beauvau-Craon, who con-
signed it to Sotheby Parke
Bernet, Monaco. They sold
it to antiques dealer Albrecht
Neuhaus, Wurtzburg, Ger.,
on June 24, 1976, lot 144.
It was then purchased by
the Campbell Museum with
funds provided by John T.
Dorrance Jr.

LITERATURE
Selections from the Campbell
Museum Collection 1978,
cover and no. 1; 1983,
no. 116.

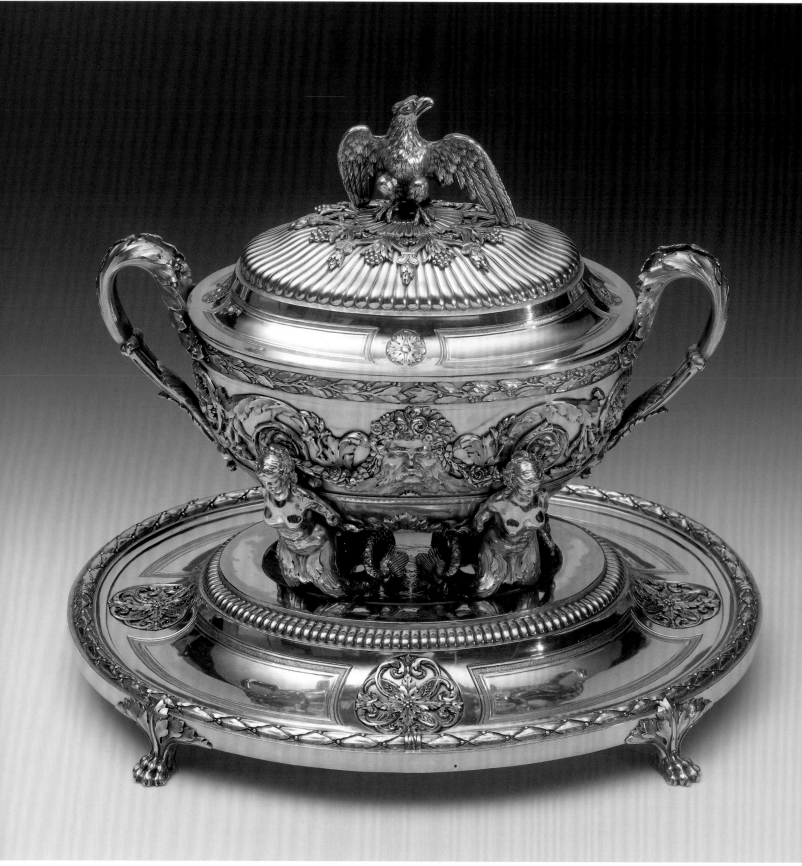

Silver; 558 oz
Height 14 ½ in (368 mm)
Length 17 ⅜ in (441 mm)
Width 15 in (381 mm)
96.4.170

PROVENANCE
Francesco Pignatelli
(1775–1853) is the first
recorded owner of this
tureen. He was born in Naples
and traveled to Paris in 1798
as a brigade general in the
Napoleonic army. He probably
acquired this tureen as booty
confiscated from one of Louis
XVI's ministers during the
revolution.[14] The Campbell
Museum purchased the
tureen in 1966 from New York
City silver dealer S. J.
Shrubsole, who, at that time,
stated the tureen had been
obtained from a member of
the Pignatelli family.

LITERATURE
Banister, "Silver Soup
Tureens," p. 105, fig. 6.

Buhler, "Silver Tureens,"
p. 907, fig. 7.

Selections from the Campbell
Museum Collection 1969,
no. 17; 1972, no. 19; 1976,
no. 19; 1978, no. 20; 1983,
no. 80.

Taylor, "Campbell
Collection," p. 23.

6 Tureen

JACQUES-CHARLES MONGENOT PARIS, FRANCE, 1783

Maker, artist,
craftsman

Jacques-Charles Mongenot apprenticed to Parisian silversmith Étienne Guyart on September 15, 1751, but completed his training with Jean Caron. He was recorded as a master silversmith in Paris in 1775 and worked at various addresses there until 1790.[11]

About the object

The vigorously sculpted mermaids, spread eagle, human masks, and flora on this tureen derive from ancient Roman prototypes. During the mid eighteenth century, these and other classical motifs became fashionable. The designs of Parisian architect, sculptor, and ornamental engraver Gilles-Paul Cauvet (1731–88) bear a striking similarity to the principal motifs on this tureen and may have served as source material.[12]

The coat of arms of the Pignatelli family of Naples is engraved on the lid, tureen, and stand. The Pignatellis had been a prominent and active part of Neapolitan culture and politics since the twelfth century. Even though its members sometimes fell from favor because of revolutionary sentiments, the family maintained their social stature well into the late nineteenth century.

The lid, tureen, and stand are each wrought of a single piece. A multipart cast and chased finial is riveted in place; a wrought bezel is soldered to the edge of the lid, which has chased and repoussé ornament. Cast and chased legs are bolted in place; cast and chased handles and the topmost ornamental border are soldered in place; the principal ornamental cast and chased border is riveted to the tureen, which has repoussé ornament. Cast and chased feet and an ornamental border are soldered in place; cast and chased ornaments are riveted to the stand, which is decorated with chased ornament.

Four marks are stamped into each component. One identifies the maker; a second records adherence to the Paris standard (95.8 percent silver), place of origin, and date. The third is a charge mark indicating that a tax on the object was due the Crown; the fourth indicates that tax was waived. The latter two were stamped by tax collector Henri Clavel. The mark waiving a tax (the crown) is extremely rare and appears only intermittently on Parisian silver during the eighteenth century. It represents a royal prerogative "granted to ministers of the king and to those of foreign courts residing in France."[13]

A *Pignatelli family coat of arms*

B *Marks identifying the maker, date, place of origin, adherence to the proper standard, a tax due the Crown, and the waiving of that tax*

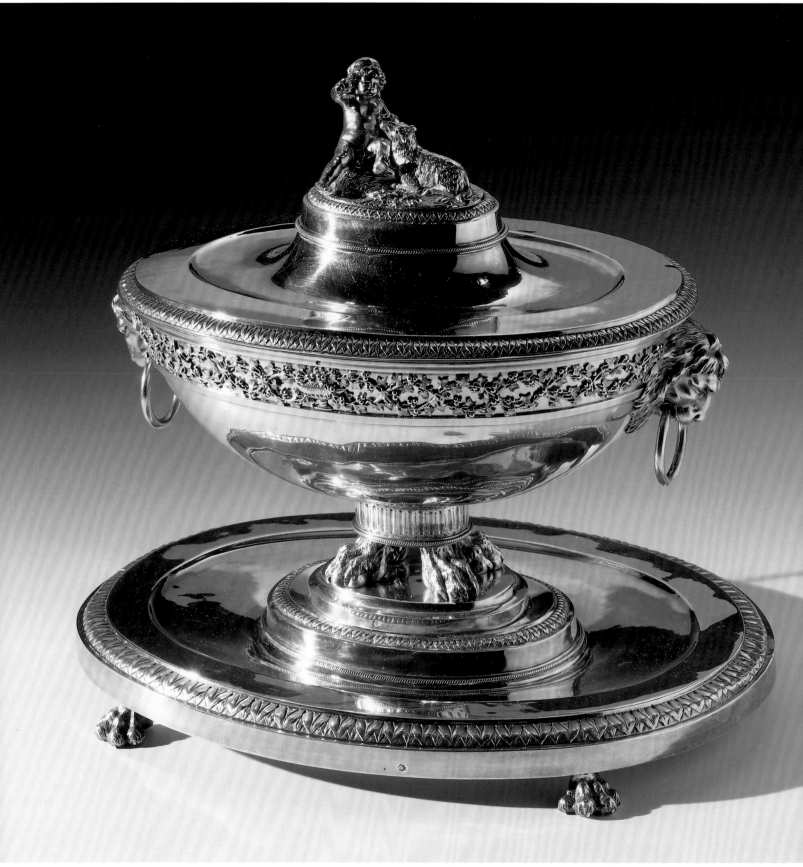

Silver; 153 oz 10 dwt
Height 13 ½ in (343 mm)
Length 16 ⅞ in (428 mm)
Width 12 ⅞ in (327 mm)
96.4.227

PROVENANCE
This tureen originally
belonged to Mathieu de
Montholon, comte de Lee,
called the Marquis de

Montholon (1753–88), and
his wife, Angélique-Aimée
de Rostaing (1757–1842).
They were married in 1773.
Angélique retained ownership
of the tureen after her
husband's death, when she
married Charles-Louis
Huguet, comte de Sémonville
(1759–1839). The Campbell
Museum purchased the tureen
from Paris dealer Jacques
Kugel in 1966.

LITERATURE
Buhler, "Silver Tureens,"
p. 907, fig. 8.

*Selections from the Campbell
Museum Collection* 1969,
no. 18; 1972, no. 20; 1976,
no. 20; 1978, no. 21; 1983,
no. 81.

7 *Tureen*

IGNACE-JOSEPH CRAISME PARIS, FRANCE, 1787

Maker, artist, craftsman

Ignace-Joseph Craisme became a master silversmith in 1777, but his career was apparently short. He was located at rue de la Barillerie from 1781 until 1785; at rue de la Monnaie between 1786 and 1787; and at cour Lamoignon from 1788 to 1790.[15]

About the object

The broad, shallow shape of this tureen was popular in France during the last decade of the eighteenth century as an adaptation of ancient Greek and Roman vessels. Architect Charles Percier (1764–1838), who rose to prominence before and during Napoleon's reign, was a prolific designer who created a number of designs for tureens that relate closely to this example. Parisian silversmiths Martin Guillaume Biennais and Henry Auguste also made tureens based on Percier's designs.[16]

Two related coats of arms are engraved into the underside of the lid, the bottom of the liner, and under the stand. One belongs to Angélique-Aimée de Rostaing and her first husband, Mathieu de Montholon. The other belongs to Angélique and her second husband, Charles-Louis Huguet.

The lid, liner, bowl, and stand consist of wrought components soldered together. A multipart cast and chased finial is bolted to the lid, which is also decorated with chased ornamental borders and fitted with a bezel on the bottom edge. The liner has two cast handles and a drawn molding soldered to the lip. Cast and chased handles with loosely fitted, pendant rings and a cast and chased drum fitted with similarly fabricated feet are soldered in place on the bowl. A cast and chased border is bolted to the lip of the bowl between drawn moldings, which are soldered in place. Chased ornamental borders are worked into the stand, which has cast and chased feet soldered in place. The bowl is bolted to the stand.

Five marks are stamped into the lid, liner, bowl, and stand identifying the maker, assessment of a tax to the Crown, subsequent payment of that tax, and adherence to the Paris standard of purity. The last of these also serves as a date mark. Stamped into all four parts is an additional mark, which records that they were assayed when sold as secondhand goods in France after 1838. This tureen was originally one of a pair.[17]

A *Marks identifying the maker, date, place of fabrication, and assessment and payment of a tax*

B *Owner's coat of arms*

C *Mark indicating assay as secondhand goods*

8 Tureen

PAUL INGERMANN **DRESDEN, GERMANY, 1733–47**

Maker, artist, craftsman

Paul Ingermann became a master silversmith in 1698. By 1717 he took on the responsibility of overseeing the marking of wares by members of the goldsmith's guild in Dresden. He became a warden for inspecting silver between 1719 and 1722; he served a second term between 1726 and 1729, and was ultimately elevated to supervising inspector in 1738 and 1739.[18]

About the object

This tureen and its lid both have an undulating curved profile that twists in a spiral fashion. The maker purposely incorporated these features into the design to heighten its attractiveness. In so doing he created an object that fit the mid eighteenth-century notion of what makes beauty in art and nature. English artist, author, and social critic William Hogarth (1697–1764) codified and defined this concept of beauty in a book entitled *The Analysis of Beauty*. He identified objects such as this tureen as being "Compositions with the Serpentine-Line" and stated that they were the height of grace and elegance.[19]

The monogram "A3R," meaning Augustus 3rd Rex (king), is engraved on the underside of the tureen and stand.

The lid, tureen, and stand are wrought. A cast and chased finial is soldered to the lid and surrounded by a collar of chased leaves. Cast and chased legs and handles are soldered in place on the tureen; cast and chased handles and a drawn molding are soldered to the stand. All parts are completely gilded.

Two marks are stamped into the tureen and stand: one identifies the maker; the other indicates the place of origin and adherence to the German standard of 13 lötiges, equivalent to 81.25 percent pure silver. A French mark, a swan, is stamped into the lid and tureen and twice on the stand, indicating that the three pieces were imported into France after 1893. The numeral "1" is engraved on the underside of the lid, the bottom of the tureen, and under the stand, indicating that this was originally one of a pair.[20] The monogram and numeral "1" are both engraved a second time on the bottom of the stand, replacing the originals, which were partially removed when the stand was cut down from a larger diameter. This suggests that the stand was modified by Ingermann at a later date.

A *Marks identifying the maker, place of origin, and adherence to the proper standard*

B *French import mark*

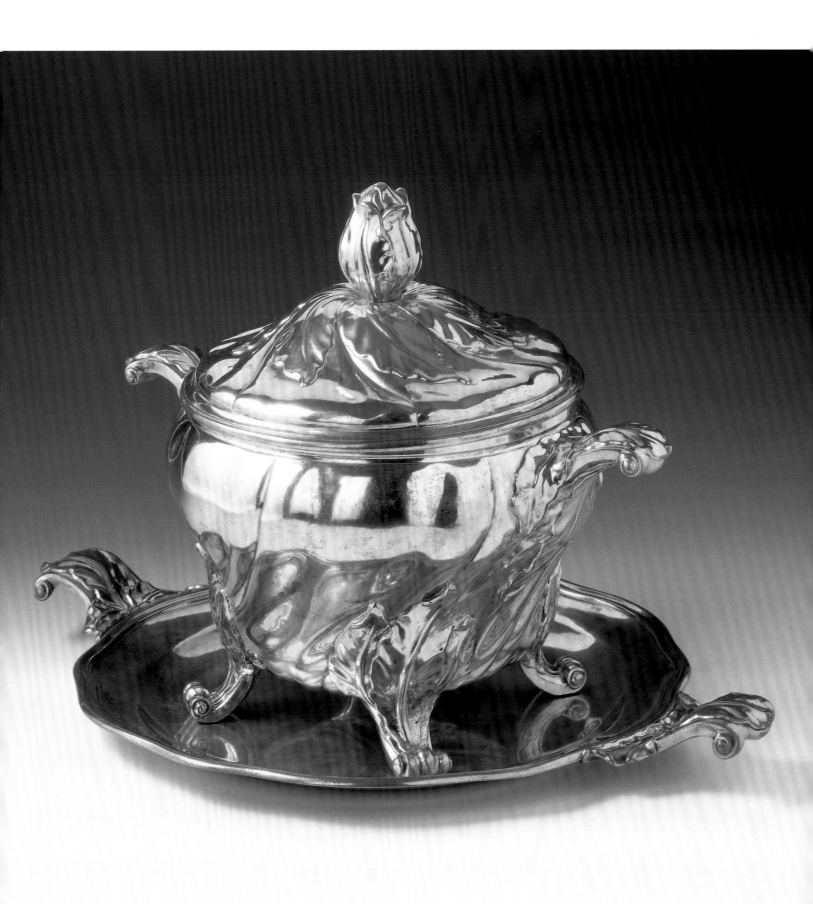

Silver gilt; 231 oz
Height 11 5/8 in (295 mm)
Width 20 7/8 in (530 mm)
Diameter 15 in (381 mm)
96.4.204

PROVENANCE
This tureen and its mate
were made for Augustus III
(Frederick Augustus II)
(1696–1763), king of Poland
from 1733 until his death in
1763. The Campbell Museum
purchased the tureen from
Paris antiques dealer Jacques
Kugel in 1966.[21]

LITERATURE
Arnold, *Dresdner Hofsilber*,
p. 19, fig. 9.

Buhler, "Silver Tureens,"
p. 907, fig. 9.

*Selections from the Campbell
Museum Collection* 1969,
no. 1; 1972, no. 34; 1976,
no. 34; 1978, no. 34; 1983,
no. 90.

9 *Écuelles*

DAVID WILLAUME I LONDON, ENGLAND, 1721–22

Maker, artist, craftsman

David Willaume was born in Metz, France. He trained as a silversmith, presumably under his father, and subsequently moved to England, where he became a citizen in 1687. He was granted freedom to practice his craft in London in 1693 and registered his first mark as a silversmith about 1697. He was not only an excellent metalworker but also an experienced banker. Both careers brought him into contact with wealthy and influential clients who patronized him until his retirement about 1728.[22] Prior to that time, he took one of his sons, also named David, into his firm. When the elder David retired, the son registered his own mark with the Goldsmiths' Company and took over the business. While both were fine silversmiths, the elder's work is ranked among the best of its type produced in England during that period.

About the objects

The écuelle, a relatively straight-sided, lidded bowl with two tabular handles, is believed to have evolved in mid seventeenth-century France, where it remained in widespread use for more than 150 years. Like so many fashionable French forms, the style did appear in England but was never made in great numbers there. The English seem to have preferred the porringer, a lidless bellied bowl with a single tabular handle. The handles shown here, in the form of scallop shells, trace their presence in the arts to antiquity and have been used in English silver design since the reign of Elizabeth I. These are a somewhat unusual interpretation, having three overlapping layers that radiate out from the bowls. The feature has a Parisian counterpart, on a similar écuelle by Antoine Plot.[23]

Silver; 17 oz 7 dwt (.1)
and 17 oz (.2)
Height 3 ⅝ in (92 mm)
Length 9 ⅜ in (238 mm)
Diameter 5 ⅞ in (149 mm)
96.4.262.1, .2

PROVENANCE
The Campbell Museum
purchased these écuelles
in 1970 from Firestone
and Parson, Boston.[24]

LITERATURE
*Selections from the Campbell
Museum Collection* 1972,
no. 1; 1976, no. 1; 1978,
no. 2; 1983, no. 25.

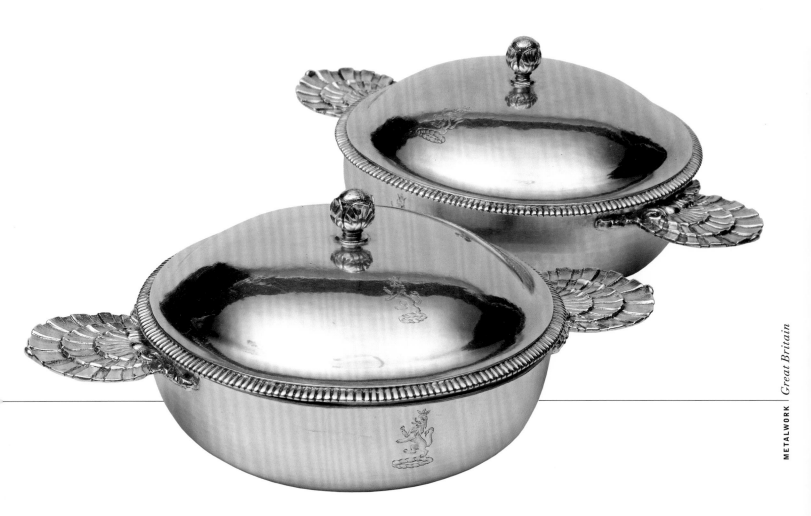

The bowl and lid of each tureen are wrought, with a bezel soldered to the underside of each lid. The bowls' handles and the finials and borders on the lids are all cast, chased, and soldered in place. Engraved into each piece is a crest that could belong to the surnames Lilly, Lyddel, Pauncefote, or Villiers.

The underside of each écuelle is stamped with four marks that identify the maker, date, place of origin, and adherence to the English Britannia standard of 95.8 percent pure silver. The absence of marks on the lids suggests they may have been made as a slightly later addition at the request of the owner. The Troy weight of 17 oz. 11 dwt. is engraved on the underside of the lid and bowl of one of the écuelles, and 17 oz. 4 dwt. is engraved on its counterpart.

A *Owner's crest* A

B *Marks indicating maker, date, place of origin, and adherence to the proper standard*

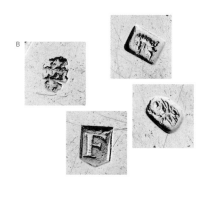

10 Tureen

PAUL DE LAMERIE LONDON, ENGLAND, 1738–39

Maker, artist, craftsman

Paul de Lamerie, one of England's most celebrated silversmiths, was born in 's Hertogenbosch, Holland. He emigrated with his parents to London, where he was apprenticed in 1703 to another Huguenot emigré, goldsmith Peter Plattell. De Lamerie went into business for himself in 1712 and continued working for thirty-nine years.[25] Although no substantial body of de Lamerie's business records remains, a large number of remarkable objects bearing his marks can be documented to aristocratic and well-to-do patrons—indicating his level of renown. Similarly, records of the Goldsmiths' Company, where he held several responsible offices, indicate the esteem with which he was held by his colleagues.

About the object

This tureen has numerous dramatic cast ornamental components. Prominent among them are the cartouches that frame the engraved coat of arms on each side. In the eighteenth century few silversmiths attempted to cast such cartouches, preferring to engrave them instead. The pronounced asymmetric projections of curving scrolled elements interspersed with vegetable and animal forms on these cartouches appear to derive from designs by Paul van Somer (1649–94), whose work had been published in London.[26]

The coat of arms of Edward Madden and Charlotte Creighton of Dublin, is engraved twice on the tureen. Their crest is engraved on the lid. Madden was a successful silk manufacturer and the fourth son of celebrated philanthropist and cleric Rev. Samuel Madden.

The lid and body are wrought, the latter of several parts. The lid has chased ornament, a cast and chased handle soldered in place, and a bezel, also soldered in place. The body is fitted with legs, handles, cartouches, and a border at the lip—all cast, chased, and soldered in place.

Four marks identifying the maker, date, place of origin, and adherence to the English sterling standard of 92.5 percent are stamped into the lid and body.

Silver; 140 oz
Height 10 9/16 in (268 mm)
Length 17 3/8 in (441 mm)
Width 10 in (254 mm)
96.4.270

LITERATURE
Banister, "Silver Soup Tureens," p. 103.

Buhler, "Silver Tureens," p. 904, fig. 1.

Phillips, *Paul de Lamerie*, p. 102, fig. 120.

Selections from the Campbell Museum Collection 1969, no. 3; 1972, no. 3; 1976, no. 3; 1978, no. 3; 1983, no. 28.

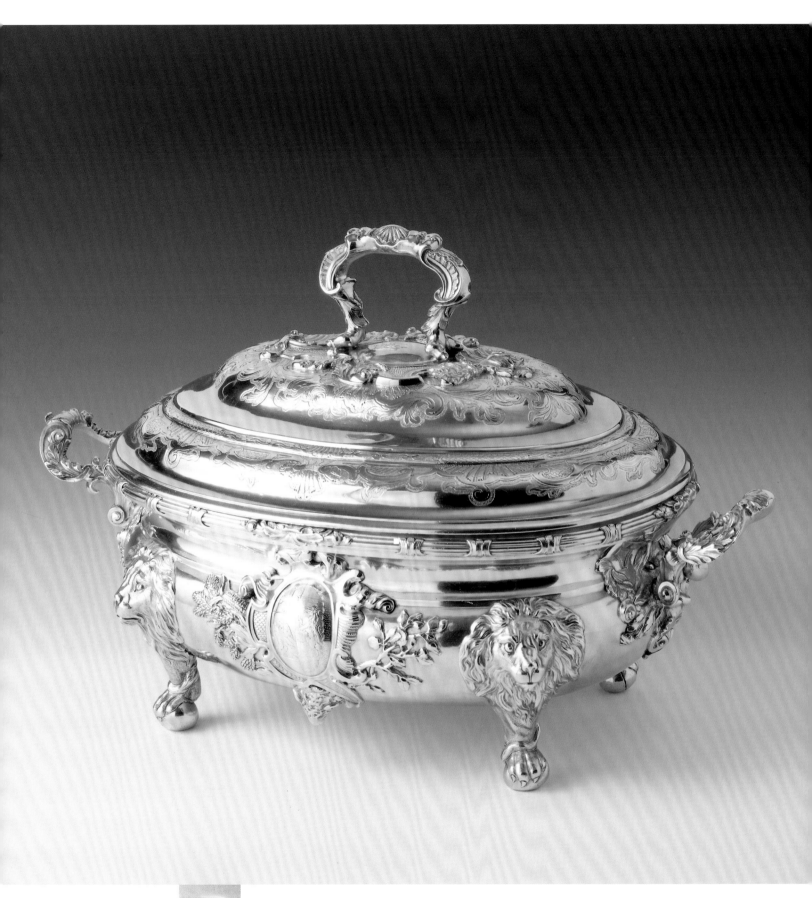

Marks identifying the maker, date, place of origin, and adherence to the proper standard

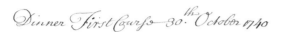

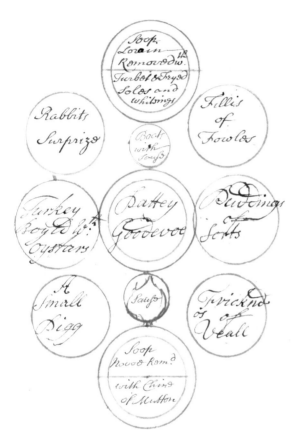

11 *Tureen*

HENRY HEBERT LONDON, ENGLAND, 1738–39

Retailer Henry Hebert (Herbert) is an enigmatic figure, even
though he was actively involved in silversmithing
circles in London between 1734 and 1748. He served as
Subordinate Goldsmith to the King between 1736
and 1740. Although he registered four separate marks
with the Goldsmiths' Company, he is believed to have
done so as a retailer of silver goods rather than as a
manufacturing silversmith.[27]

About the object The body of this vessel is circular. The French, who
invented the form in the seventeenth century, called it
a *pot-à-oille*. By contrast, they referred to its oval
counterpart, developed slightly later, as a terrine. Both
are called tureens today.

The maker decorated this example with motifs
drawn from French baroque design. The most notable
are the alternating plain and articulated vertical straps
that encircle the body and lid—a form created by
celebrated Parisian designers such as Jean Berain (ca.
1638–1711) and favored by less-well-known designers
as well.[28] Acanthus leaves and palmettes, which

Silver; 156 oz
Height 11 ¾ in (298 mm)
Length 13 ½ in (343 mm)
Diameter 11 7/16 in (291 mm)
96.4.236

PROVENANCE
This tureen and its mate were
issued to Benjamin Mildmay,
Earl Fitzwalter, for formal
entertaining when he was
appointed Treasurer of the
Royal Household in 1739.[29]
In this century they became
part of the inventory of New
York City silver dealer James
Robinson, who sold them to

Charles E. Dunlap, New York.
Dunlap sold them at Parke-
Bernet Galleries, New York,
April 13, 1963, lots 71 and
72. James Robinson, Inc.,
repurchased the tureens at
that time and sold this one to
the Campbell Museum in
1966.

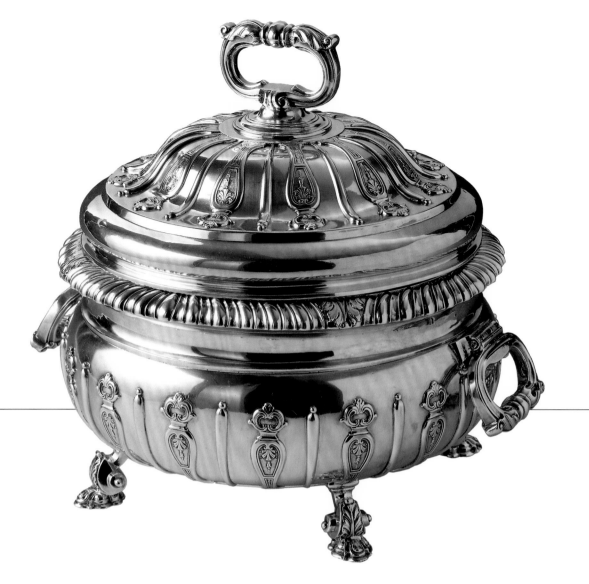

ultimately derive from ancient Greek architecture, accent the handles, strapwork, gadrooning, and feet.

The British royal coat of arms and motto, *Honi soit qui mal y pense* (evil to him who evil thinks), are engraved on the body and lid, indicating that the tureen was owned by the Crown and used by its representatives when entertaining foreign visitors and important dignitaries at the dining table.

The body of this tureen is wrought of one piece to the incurved neck, which is separately wrought and soldered in place. The cast gadrooned border with chased detail is soldered and pinned to the lip. The two hinged bail handles and four feet are multipart castings with chased detail, soldered to the body. The strapwork, also soldered in place, is either die stamped or cast and chased. The lid is wrought of one piece

with a wrought bezel soldered to the edge. The handle is cast, chased, and soldered in place. The strapwork on the lid is identical in size, design, fabrication, and method of application to its counterpart on the body.

Four marks are stamped on the underside of the body and again inside the lid, confirming retailer, date, location of fabrication, and English sterling standard of 92.5 percent. The Troy weight of the lid, 51 oz., is engraved on its bezel, and that of the tureen, 105 oz. 14 dwt., is engraved on the underside of the body.

LITERATURE

Banister, "Silver Soup Tureens," cover.

Selections from the Campbell Museum Collection 1969, no. 2; 1972, no. 2; 1976, no. 2; 1978, no. 4; 1983, no. 26.

Wills, *Silver for Pleasure*, p. 156.

A

B

A *Owner's coat of arms*

B *Marks identifying the retailer, date, place of origin, and adherence to the proper standard*

12 *Tureen*

JOHN EDWARDS II LONDON, ENGLAND, 1746–47

Maker, artist, craftsman John Edwards II apprenticed to Thomas Prichard in 1708. Although the standard term for apprenticeship was seven years, Edwards did not assume freedom to practice silversmithing in London until 1723. He registered his mark in Goldsmiths' Hall at that time in partnership with George Pitches but was on his own within one year. He appears to have practiced his craft until about 1753. He held the title of Subordinate Goldsmith to the King between 1723 and 1743.[30] Surviving silver that bears his mark is competently made and demonstrates a good understanding and use of the rococo style.

About the object The creatures shown on this tureen are common inhabitants of the naturalistic landscape depicted on rococo silver. Lobsters and boars also made desirable soups and so were likely candidates to appear on tureens in England and on the Continent. A cook could season lobster meat with mace or nutmeg, grated lemon peel, and cayenne, mix it with egg yolk and

A

B

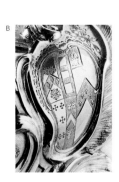

A *Marks identifying the maker, date, place of origin, and adherence to the proper standard*

B *Owner's coat of arms*

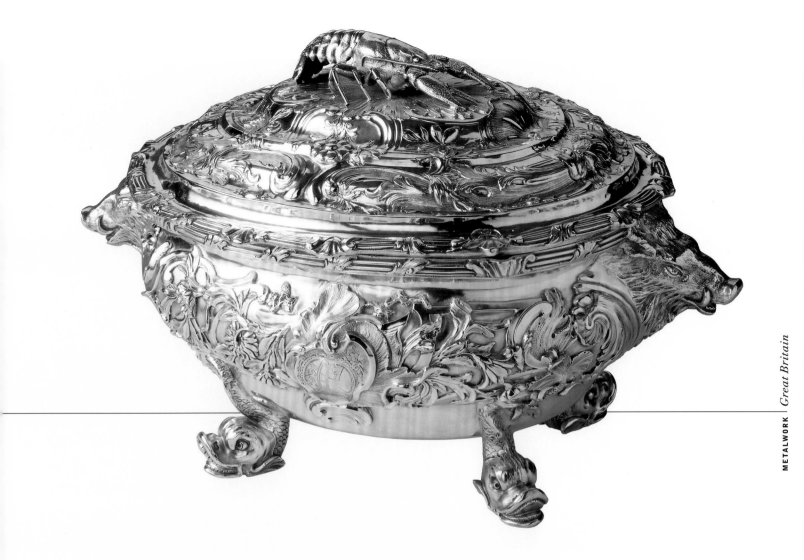

flour in veal stock, simmer, and "pour it into a tureen and add the juice of a lemon and a little essence of anchovy."³¹

Flowers are also an important part of this tureen's visual impact. Chrysanthemums, daisies, lilies, and Austrian roses are interspersed among the many leaves and scrolls on the body and lid in an arrangement that is identical on both sides. Their design appears to relate closely to images in *The Flower-Garden Display'd* (1732), stated to be "very useful not only for the Curious in Gardening, but the prints likewise for Painters, Carvers, Japaners, &c."³²

The coat of arms signifying the marriage of a Mr. Gold (Gould) of Alarston in Wiltshire, and Miss Shaw of Ardsley in Yorkshire is engraved within the asymmetric cartouche on both sides of the tureen.³³

The body and lid are wrought with chased decoration. A cast and chased finial, cast and chased ornamental border, and wrought bezel are soldered to the lid. Cast and chased feet and handles are soldered in place on the body.

The Troy weight of the lid, 35 oz. 16 dwt., is engraved on its underside, and that of the body, 98 oz. 7 dwt., appears on the underside of the tureen. Four marks are stamped on the lid and tureen indicating the identity of the maker, date, place of origin, and adherence to the English sterling standard of 92.5 percent.

Silver; 135 oz
Height 9 in (229 mm)
Length 15 3/8 in (391 mm)
Width 9 3/4 in (248 mm)
96.4.237

PROVENANCE
This tureen was sold through the London auction house of Knight, Frank, and Rutley's in 1966. That same year the Campbell Museum purchased it from a London silver dealer through Garrard and Company.

LITERATURE
Banister, "Silver Soup Tureens," p. 104, fig. 5.

Buhler, "Silver Tureens," p. 905, fig. 2.

Frank Davis, "Tributes to the Impressionists," *Country Life* 140, no. 3619 (July 14, 1966): 73, fig. 3.

Halfpenny, "High Style: Fashionable Taste," p. 55, fig. 1.

Selections from the Campbell Museum Collection 1969, no. 4; 1972, no. 4; 1976, no. 4; 1978, no. 5; 1983, no. 27.

13 *Tureen*

WILLIAM CRIPPS LONDON, ENGLAND, 1752–53

Maker, artist, craftsman

William Cripps apprenticed to David Willaume, the younger, on January 8, 1731. He gained his freedom to practice silversmithing on May 2, 1738. The good quality and substantial quantity of his surviving work indicate that he was successful during his twenty-nine-year career. His best work appears to be in the rococo style.

About the object

The pomegranate, as finial, plays a dominant role on this tureen. The tree, native to North Africa, was so widely cultivated in Granada, Spain, that the fruit came to be known as the apple of Granada and was incorporated into the city's coat of arms. The pomegranate was introduced to England through Catherine of Aragon (1485–1536), Henry VIII's first wife, when they married in 1506.

The fruit, filled with dozens of seeds, each covered with a succulent red coating, has long symbolized fecundity and was "never born in Arms but with a broken or burst side, to shew their Seed within them."[34] In this instance, the pomegranate finial was probably intended merely as an ornamental embellishment.

A coat of arms depicting Child quartering Wheeler is engraved on either side of the tureen. The attendant crest is engraved on each side of the lid. In the past this crest has been ascribed to a purported marriage in 1671 between Francis Child and Elizabeth Wheeler, both said to be of London banking families. The arms do belong to these surnames, but no such marriage is presently known to have taken place.

The lid and tureen are both wrought. A cast and chased multipart finial is bolted to the lid. A similarly fabricated and finished border and ornamental sprigs are soldered in place. Chased outlines surround the sprigged ornament, and a bezel is soldered to the bottom edge. Cast and chased feet, handles, and border are soldered in place on the tureen.

The Troy weight, 143 oz. 4 dwt., is engraved into the underside of the tureen. Also engraved is "No 1," indicating this tureen was originally one of a pair. Four marks are stamped into the lid and again into the tureen, identifying the maker, date, place of fabrication, and adherence to the English sterling standard of 92.5 percent.

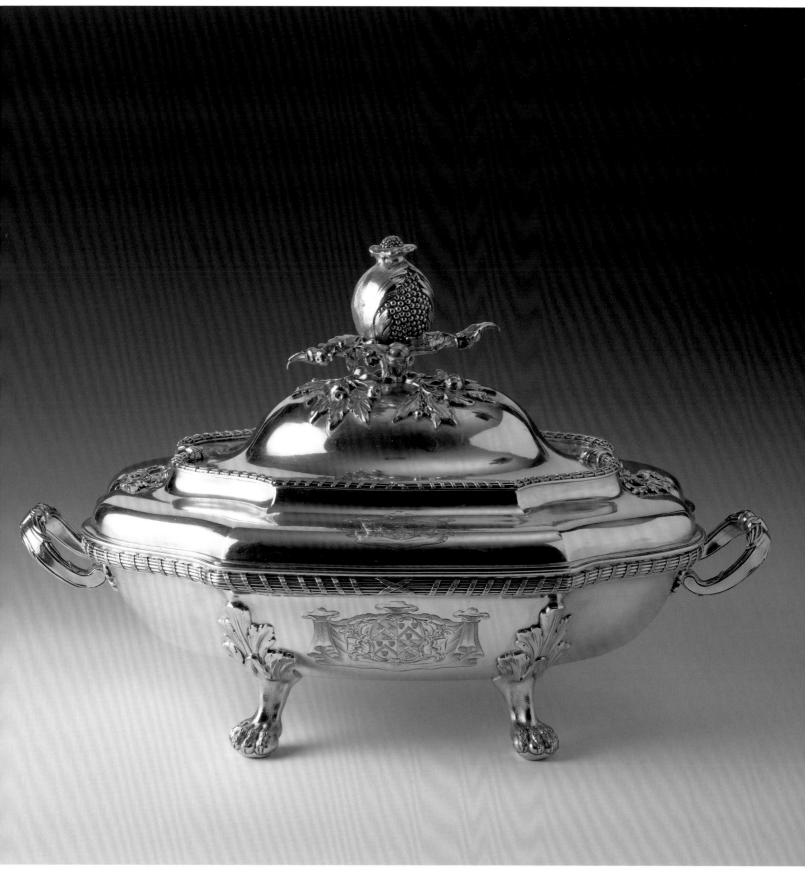

A Owner's crest and coat of arms

B Marks identifying the maker, date, place of fabrication, and adherence to the proper standard

Silver; 139 oz
Height 11 ½ in (292 mm)
Length 18 ¼ in (463 mm)
Width 11 ⅜ in (289 mm)
96.4.233

PROVENANCE
Sir Francis Child, who was knighted in 1732, may have owned this tureen.[35] It was offered at Christie's, London, March 23, 1966, lot 31. The Campbell Museum purchased it at that time through New York silver dealer S. J. Shrubsole.

LITERATURE
Banister, "Silver Soup Tureens," p. 102, fig. 1.

Clayton, *Collector's Dictionary*, p. 268, fig. 537.

Selections from the Campbell Museum Collection 1969, no. 5; 1972, no. 5; 1976, no. 5; 1978, no. 6; 1983, no. 29.

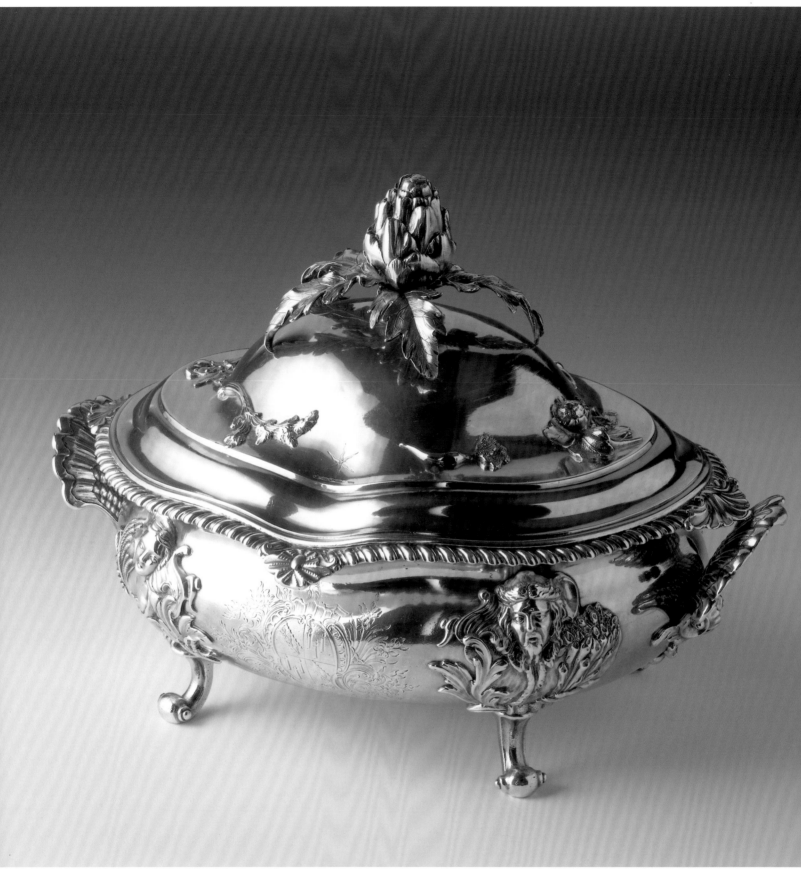

Silver; 101 oz.
Height 9 9/16 in (244 mm)
Length 14 in (356 mm)
Width 9 1/2 in (241 mm)
96.4.267

PROVENANCE
Thomas Dawson, viscount
Cremorne (d. 1813),
originally owned this
tureen.[38] The Campbell
Museum purchased it at
Parke-Bernet Galleries,
New York, on March 20,
1970, lot 244.

LITERATURE
*Selections from the Campbell
Museum Collection* 1972,
no. 6; 1976, no. 6; 1978,
no. 7; 1983, no. 33.

A *Owner's crest and coat of
arms*

B *Marks identifying the maker,
date, place of fabrication,
and adherence to the proper
standard*

14 *Tureen*

PETER ARCHAMBO JR. AND PETER MEURE LONDON, ENGLAND, 1754–55

Maker, artist, craftsman

Peter Archambo Jr., son of the silversmith of the same name, was apprenticed to Paul de Lamerie on December 5, 1738. He then worked with his father, was freed to practice his craft on February 3, 1747, and entered into partnership with his cousin, Peter Meure, on January 18, 1750. Little is known of Meure except that following Archambo's death, he continued in business on his own. He remained active as late as 1773.[36]

About the object

The artichoke was introduced into England during the reign of Henry VIII. English cooks have admired it as a delicacy since that time. Its favor among the English is suggested by its prominent use as a finial on this tureen. It is surrounded by carrots, leeks, onions, and turnips, all of which were routinely used as the foundation for soups and broths in England. Each scrolled leg is surmounted by a human mask surrounded with emblems symbolizing the four seasons. Those representing autumn and winter are male; spring and summer are female. They relate closely to and appear to derive from printed designs created by French architect Daniel Marot (ca. 1663–1752).[37]

The coat of arms and motto *Toujours propice* (always propitious) are engraved on both sides of the body. A crest is engraved on both sides of the lid. Both belong to Thomas Dawson, viscount Cremorne, of Dartrey, County Monaghan, Ireland. He was a member of Parliament from 1749 until 1768.

The body and lid are wrought. The finial and ornaments on the lid, border, handles, and legs are all cast and chased. The finial is bolted to the lid; the remainder are soldered in place. A bezel is soldered to the underside of the lid.

Four marks are stamped into the underside of the lid and body, identifying the makers, date, place of origin, and adherence to the English sterling standard of 92.5 percent pure silver. "No. 1" is engraved on the bezel and again inside the lip of the body, indicating this tureen was originally one of a pair. The Troy weight, 109 oz. 8 dwt., is engraved on the underside of the body.

15 *Tureen*

THOMAS GILPIN **LONDON, ENGLAND, 1755–56**

Maker, artist, craftsman

Thomas Gilpin's birth and death dates are unknown; however, he is recorded in Goldsmiths' Hall as apprenticing to John Wells in London on January 7, 1720. He entered his first mark with the Goldsmiths' Company on September 24, 1730, and remained active at various addresses in London through 1773.[39] Another silversmith, Paul Storr, made the removable silver liner for this tureen in London in 1834–35, probably as a replacement for a lost original.

About the object

The body of this compact tureen is a modified ellipse designed as a series of cyma-recta and -reversa curves—a favored interpretation of the S-shape profile that was so popular during the mid eighteenth century for this type of vessel. Lion-head monopods were also widely used, inspired by the prominence of the lion in ancient art and by its association with British royalty.

Although their imagery is more enigmatic, the handles with birds' heads serving as the upper attachment to the body were also used with some frequency on London-made tureens during the 1740s and 1750s.[40]

The coat of arms, crest, and motto *Frangas non flectes* (you may break, you shall not bend me), engraved on each side of the body and twice on the lid, belong to Granville Leveson-Gower and his second wife, Louisa Egerton. He was a wealthy and influential member of Parliament, twice holding the post of Lord President of the Council in the House of Lords.

The coat of arms and crest and the motto *Nil nisi cruce* (nothing without the cross) were engraved on the liner in the twentieth century. Its familial association has not been determined.

The lid, body, and liner are wrought. A cast and chased handle and wrought bezel are soldered to the lid. Cast and chased handles, feet, and molding are soldered in place on the tureen. A drawn molding and

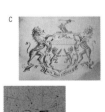

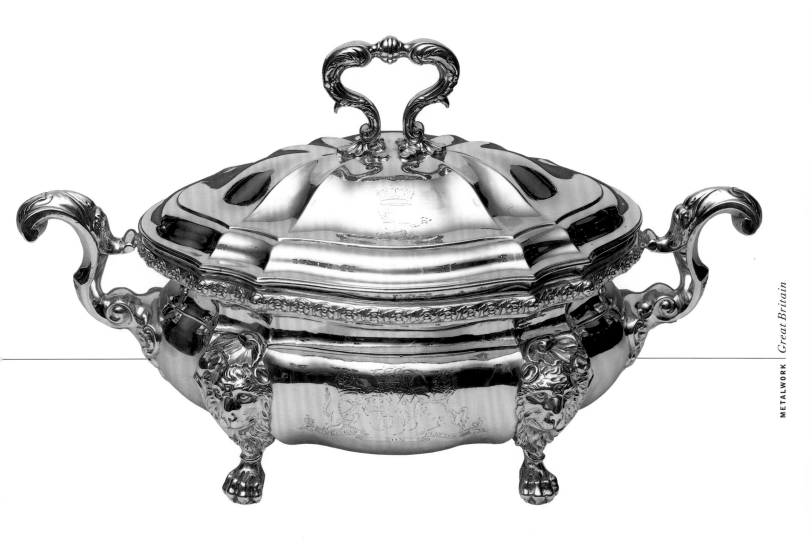

cast and chased handles are soldered to the lip of the liner.

Four marks are stamped on the lid and body (another four on the liner), identifying the makers, dates, place of fabrication, and adherence to the English sterling standard of 92.5 percent pure silver. "No. 1" is engraved on the underside of the tureen and "No. 2" on the lid's bezel, indicating these are mismatched parts of what was originally a pair. Engraved on the underside of the

body is the Troy weight, 73 oz. A numeral "81" stamped on the liner may be a work-order number.

A *Marks identifying the makers, dates, place of fabrication, and adherence to the proper standard*

B *Owner's crest and coat of arms on tureen and lid*

C *Coat of arms and work-order number on liner*

Silver; 89 oz 10 dwt
Height 8 ¾ in (222 mm)
Length 15 ⅛ in (384 mm)
Width 7 ⅜ in (187 mm)
96.4.192

PROVENANCE
This tureen was owned by Granville Leveson-Gower, second earl Gower (1721–1803), and his second wife, Lady Louisa Egerton. It was offered by Sotheby's, London, June 2, 1966, lot 172. The Campbell Museum purchased it from New York dealer James Robinson in 1977.

LITERATURE
Selections from the Campbell Museum Collection 1978, no. 8; 1983, no. 36.

16 Tureen

THOMAS HEMING LONDON, ENGLAND, 1763–64

Maker, artist, craftsman

Thomas Heming was apprenticed to London silver-smith Peter Archambo in 1738. He gained freedom to practice his craft in 1746 and immediately began his own business. The high quality of his work and apparent ease with which he associated with wealthy clientele led to his appointment as Principal Goldsmith to the King (George III) in 1760. He held that title until 1782. Heming is believed to have died between 1795 and 1801.[41]

About the object

The most recognizable feature of this tureen is the cauliflower finial. This vegetable has long been associated with soup, as indicated by an 1870 recipe recommending that a cook boil and drain two cauliflowers; put them into a mixture of béchamel maigre, egg yolks, butter, salt, pepper, and nutmeg; cut into pieces, roll in flour, and fry in clarified butter.

Then "put them in your soup-tureen, and pour over them some rich consommé."[42]

The shallow elliptical shape of this tureen embel-lished with naturalistic vinelike handles and scrolled feet derives from a design created by Parisian gold-smith Jacques Roëttiers (1720–84), which was pub-lished about 1750 in London in a volume of designs for silver tableware. The design was apparently a favorite of Heming's, for he included an image of what appears to be this very tureen on his trade card.[43]

The English royal coat of arms, crest, and mottoes *Honi soit qui mal y pense* (evil to him who evil thinks) and *Dieu et mon droit* (God and my right) are engraved on one side of the tureen and in abbreviated form on the inside bottom of the liner. They indicate that the tureen was owned by the Crown and was issued to political appointees to be used when formally entertaining foreign dignitaries and other notables.

The coat of arms, crest, and motto *Nunquam non paratus* (never unprepared) are engraved on the opposite side of the tureen, replacing an earlier

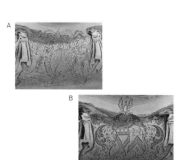

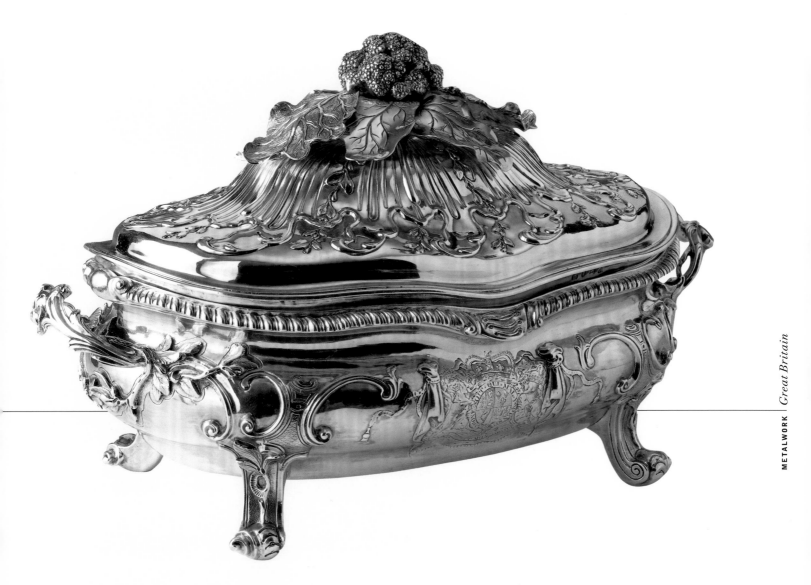

engraving that has been erased. The new engraving represents the surnames Johnstone (Johnston) and Collyer, but its veracity is problematic; the motifs and motto of the arms appear in a combination that was never issued or authorized by the College of Arms.[44]

The lid and tureen are wrought. A multipart cast and chased finial is bolted to the lid and is surrounded by a pattern of chased ornament. A bezel is soldered in place on the underside of the lip. Cast and chased legs, handles, and gadrooned border are soldered to the tureen, which is decorated with chased orna-

ment. The tureen is fitted with a removable wrought liner, which has two cast handles and a wrought molding soldered to the lip.

Four marks are stamped into each piece identifying the maker, place, date of manufacture, and adherence to the English sterling standard of 92.5 percent pure silver. A single dot is punched in the lid's bezel, one end of the liner, and lip of the tureen, indicating that it was probably one of a pair.

A *Royal coat of arms*

B *Owner's coat of arms*

C *Marks identifying the maker, date, place of fabrication, and adherence to the proper standard*

Silver; 153 oz
Height 9 ¾ in (248 mm)
Length 16 ½ in (419 mm)
Width 9 ¼ in (235 mm)
96.4.235

PROVENANCE
The Campbell Museum purchased this tureen from Garrard and Company, London, in 1966.

LITERATURE
Buhler, "Silver Tureens,"
p. 905.

Hodgson, "Soup … Soup," p. 8.

Selections from the Campbell Museum Collection 1969,
no. 6; 1972, no. 7; 1976,
no. 7; 1978, no. 9; 1983,
no. 38.

17 *Ladle*

JAMES GILSLAND AND DANIEL KER EDINBURGH, SCOTLAND, 1767–CIRCA 1773

Maker, artist, craftsman

James Gilsland entered his mark with the Edinburgh Goldsmiths' Company on May 12, 1748, thus giving him the right to practice silversmithing in that city. Daniel Ker did the same on February 21, 1764.[45] They subsequently entered their joint mark in 1767. Although it is not known precisely how long they worked together, Williamson's directory for the city of Edinburgh records them as partners in 1773–74. Presumably, their partnership did not extend far beyond that date, judged in part by the lack of silver bearing their joint mark. None of their hollowware has previously been published; the ladle shown here appears to be the principal example of flatware bearing their mark.

About the object

The florid handle terminal and articulated bowl make this ladle most unusual. A scrolled tendril sprouting naturalistic acanthus leaves, which are pierced and textured with chasing, fully envelops the end of the handle. The exterior of the bowl is worked in radiating tapered gadroons, with alternating convex and concave curves that carry through to shape the lip.[46]

The crest and motto of the surname Dundas—a crowned leopard's head on a torse, or twisted silk band, all under the motto *Essayez* (try)—are engraved on the back of the bowl at the juncture with the handle.

The ladle was fabricated in two parts. The substantial handle was cast and subsequently silver-soldered to the wrought bowl. Its hefty weight is about twice what might be expected for a wrought ladle of this size.

Gilsland and Ker stamped their script initials "G&K" in a rectangle four times on the handle back. Three are deliberately double-struck askew, probably to suggest marks that indicate where and when the ladle was made and its adherence to the English sterling standard of 92.5 percent pure silver, as stipulated by the Goldsmiths' Company in Edinburgh.

A *Owner's crest and motto*

B *Mark identifying the makers, stamped repeatedly*

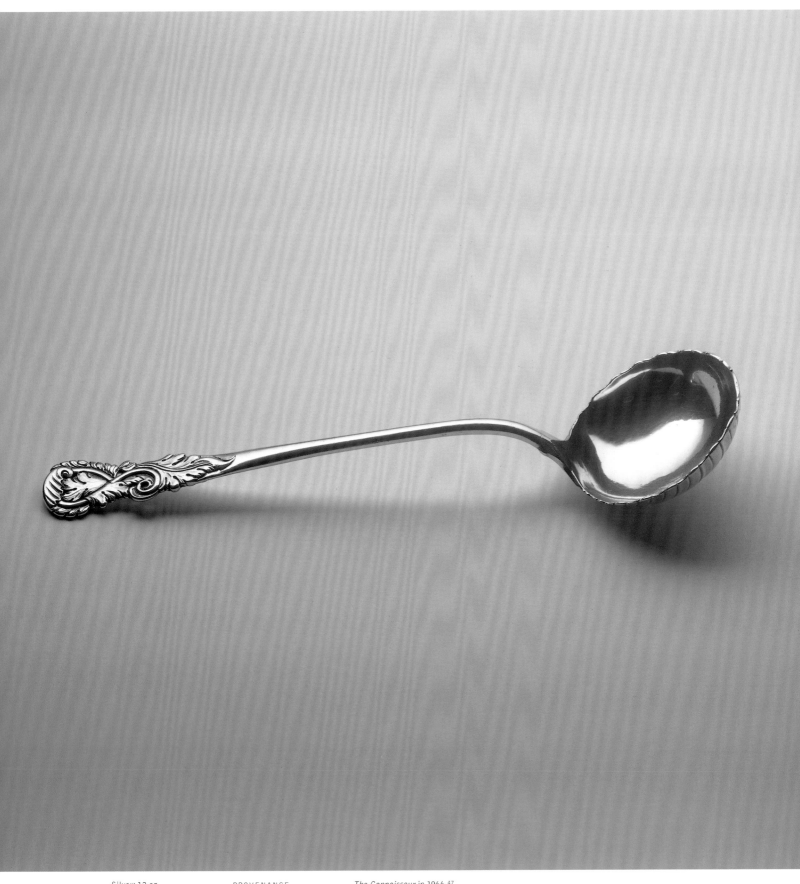

Silver; 12 oz
Length 14 in (356 mm)
Width 3 5/8 in (92 mm)
Depth 2 1/4 in (57 mm)
96.4.59

PROVENANCE
This ladle was owned by a
member of the Dundas family
of Fingask, Scot.—possibly
Thomas Dundas (d. 1806). It
was sold by The Most
Honorable the Marquess of
Zetland at Sotheby's,
London, in 1965. Antiques
dealers Wilson and Sharp of
Edinburgh advertised it in

The Connoisseur in 1966.[47]
The Campbell Museum
purchased it at that time.

LITERATURE
*Selections from the Campbell
Museum Collection* 1969,
no. 8; 1972, no. 9; 1976, no. 9.

18 Tureen

Maker, artist, craftsman

Patrick Robertson began silversmithing in Edinburgh on May 15, 1751. He worked with Edward Lothian from about that time until 1771, and possibly later. Robertson fabricated numerous stylish examples of household silver, including hot water urns, coffeepots, salvers, sauce tureens, punch bowls, dredgers, two-handled cups, and bannock, or unleavened bread, racks.

During the 1770s, Robertson corresponded with Matthew Boulton in Birmingham, England, regarding the wholesale purchase of Boulton's silver and silverplate for resale in Edinburgh. He apparently inquired about buying the silver unmarked, as suggested in a letter from Boulton dated July 13, 1776, stating that although it was illegal to do so, "we are willing to strain a point to oblige you." Although Boulton was eager to expand his business, he was not encouraging about selling large items, as recorded in a letter written in 1774: "As to Epargne Terrines, Coffee pots, Waiters & other large plate [it] will not be so convenient to send as smaller thing[s]." [48] Although Boulton and other such English silver manufacturers did actively market their wares in Scotland, this tureen was probably not an import. The written record, as well as the fact that the design of this tureen differs from all comparable images in Boulton's pattern books, strongly suggests that Robertson was the maker.

About the object

The double-bellied body of this tureen is embellished with scrolled legs and handles, all terminating in a flourish of asymmetric leafy scrolls. The gadrooned borders and artichoke finial with leafy collar are of rococo design, which by the 1770s had been supplanted by the classical taste, except in outlying areas such as Edinburgh.

The coat of arms, crest, and motto *Essayez* (try), engraved on the body and lid, are those of Thomas

Silver; 143 oz
Height 11 9/16 in (293 mm)
Length 16 1/8 in (410 mm)
Diameter 11 5/8 in (295 mm)
96.4.238

PROVENANCE
This tureen was made for Thomas Dundas (d. 1806) of Fingask, Scot. It was sold by The Most Honorable the Marquess of Zetland at Sotheby's, London, in 1965. Antiques dealers Wilson and Sharp of Edinburgh subsequently advertised it in 1966, when the Campbell Museum purchased the tureen. [49]

LITERATURE
Buhler, "Silver Tureens," p. 906, fig. 6.

Clayton, *Collector's Dictionary*, p. 269.

Selections from the Campbell Museum Collection 1969, no. 9; 1972, no. 10; 1976, no. 10; 1978, no. 10; 1983, no. 134.

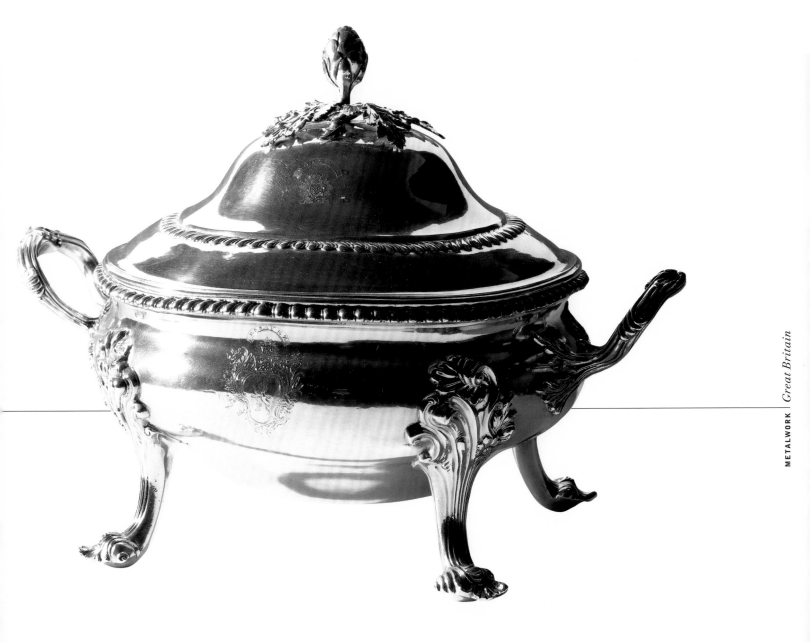

Dundas, the only son and heir of Sir Laurence Dundas of Upleatham, County York. He was a member of Parliament for the county of Stirling from 1769 to 1794.

The lid and body are wrought. The finial and leafy collar are cast, chased, and bolted in place on the lid with two alignment pins. The handles, legs, and larger diameter border of gadrooning, also cast and chased, are soldered in place. The smaller diameter border of gadroons is chased in the lid. A bezel is soldered to the lower lip of the lid.

Four marks are stamped on the underside of the body and lid identifying the maker, place, date of fabrication, and adherence to the English sterling standard of 92.5 percent pure silver. The Troy weight, 143 oz., is engraved on the underside of the body.

A Marks identifying the maker, date, place of fabrication, and adherence to the proper standard

B Owner's coat of arms and crest

B

A

19 Tureen

ROBERT MAKEPEACE **LONDON, ENGLAND, 1795–96**

Maker, artist, craftsman

Robert Makepeace began silversmithing in London on April 4, 1759. He worked alone for most of his career but also partnered with Richard Carter for a short time and with his two sons, Robert II and Thomas II, as Robert Makepeace and Sons, following completion of their apprenticeships with him. He is believed to have died between 1795 and 1801.[50]

About the object

No single ancient form seems to have provided a richer source of inspiration for late eighteenth-century silversmiths than the vase. Innumerable examples were available for study through published images in design books, which their authors intended as "an agreeable present to our manufacturers of earthenware and china and to those who make vases in silver, copper, glass, marble, etc." [51] This tureen is a handsomely designed and well-executed interpretation of an antique vase modeled on the kylix, a two-handled drinking cup with a comparatively shallow bowl on a high central foot. Although the kylix was first used for drinking wine, it was later adapted by Europeans for other purposes, such as sauce and soup tureens.

The coat of arms, crest, and motto *Crescent* (they increase), belonging to William Tatton, are engraved twice each on the lid, body, and stand. This tureen is almost certainly part of a group of silver commissioned by Tatton in 1795 during the extensive refurbishing of his residence, Wythenshawe Hall, in Cheshire.

The lid, body, pedestal, and stand are each wrought of a single piece of metal. The handles on lid and body are multipart castings that have been chased and soldered in place. The reeded moldings on body and stand are drawn and soldered to their respective parts.

The Troy weight of the tureen, 109 oz. 2 dwt., is engraved under the pedestal; that of the stand, 62 oz. 12 dwt., is engraved on its underside. The numeral "1" is engraved on the outside edge of the pedestal and also on the center of the stand, indicating this tureen was probably one of a pair. There are five marks stamped into the stand and pedestal and four in the lid; these identify the maker, date, place of origin, adherence to the English sterling standard of 92.5 percent pure silver, and payment of a tax to the Crown.

B

A

A *Owner's coat of arms and crest*

B *Marks identifying the maker, date, place of fabrication, adherence to the proper standard, and payment of a tax*

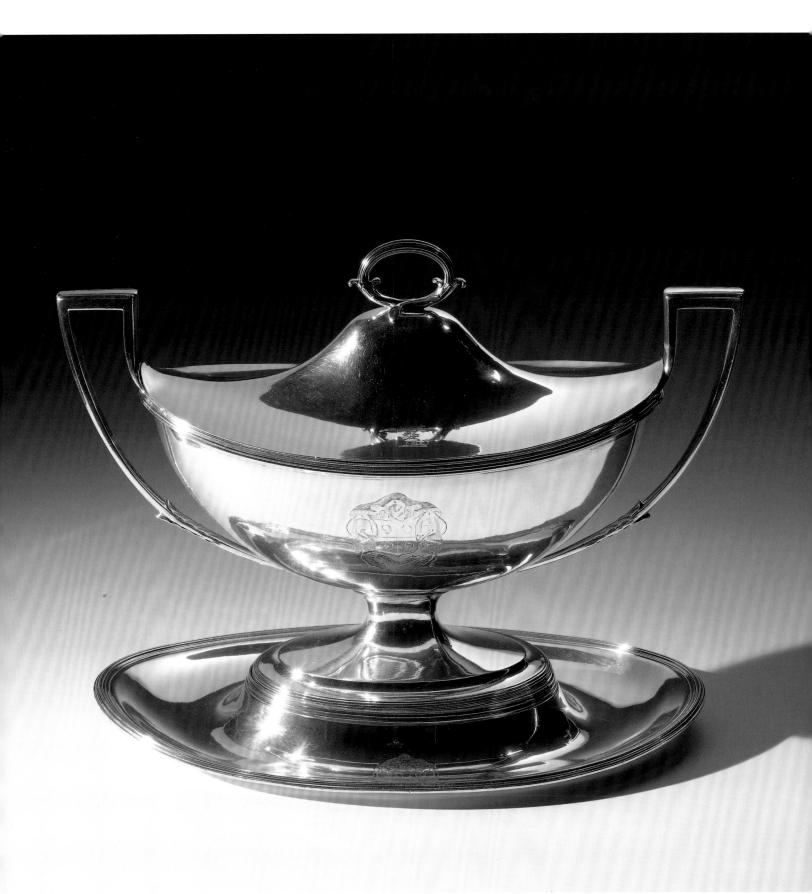

Silver; 167 oz
Height 13 ¼ in (337 mm)
Length 18 ⁵⁄₁₆ in (465 mm)
Width 11 ⅜ in (209 mm)
96.4.207

PROVENANCE
William Tatton (1774–99)
acquired this tureen from
Makepeace in 1795. When
Tatton died, it passed to his
half-brother, Thomas William
Tatton (1783–1827).[52]
The tureen was offered by
Sotheby's, London, on
December 13, 1962, lot 98.

The Campbell Museum
subsequently purchased it
from New York dealer
James Robinson in 1966.

LITERATURE
Buhler, "Silver Tureens,"
p. 906, fig. 4.

Selections from the Campbell
Museum Collection 1969,
no. 11; 1972, no. 11; 1976,
no. 11; 1978, no. 11; 1983,
no. 54.

The Mock Turtle sighed deeply, and began, in a voice choked with sobs, to sing this :—

" Beautiful Soup, so rich and green,
Waiting in a hot tureen !
Who for such dainties would not stoop ?
Soup of the evening, beautiful Soup !
Soup of the evening, beautiful Soup !
 Beau—ootiful Soo—oop !
 Beau—ootiful Soo—oop !
Soo—oop of the e—e—evening,
 Beautiful, beautiful Soup !

" Beautiful Soup ! Who cares for fish,
Game, or any other dish ?
Who would not give all else for two p
ennyworth only of beautiful Soup ?
Pennyworth only of beautiful Soup ?
 Beau—ootiful Soo—oop !
 Beau—ootiful Soo—oop !
Soo—oop of the e—e—evening,
 Beautiful, beauti—FUL SOUP !"

20 *Tureen*

MAKER UNKNOWN PROBABLY BIRMINGHAM, ENGLAND, 1800–1830

*Maker, artist,
craftsman*

Thomas Boulsover's invention of fused plate in Sheffield, England, about 1740 spawned a large industry that supplied consumers of luxury goods with an inexpensive substitute for household and personal silver. As many as 137 fused-plate makers worked in the cities of Sheffield, Birmingham, and the surrounding area prior to 1830. Among the better known were Matthew Boulton, Thomas Law, Joseph Rodgers, and Joseph Hancock, but they and their less-well-known competitors often did not mark their wares.[55] This tureen could have been made by any one of them.

About the object

The "green turtle leads all other varieties [and] is highly esteemed for the delicacy and rich character of its meat [which] is used in the form of steaks, stews, soups, etc."[54] The heyday of green turtle soup, the most popular of all turtle soups, occurred during the eighteenth and early nineteenth centuries. The soup was normally dispensed from tureens of standard design, but sometimes the vessels were made in the form of the animal itself.

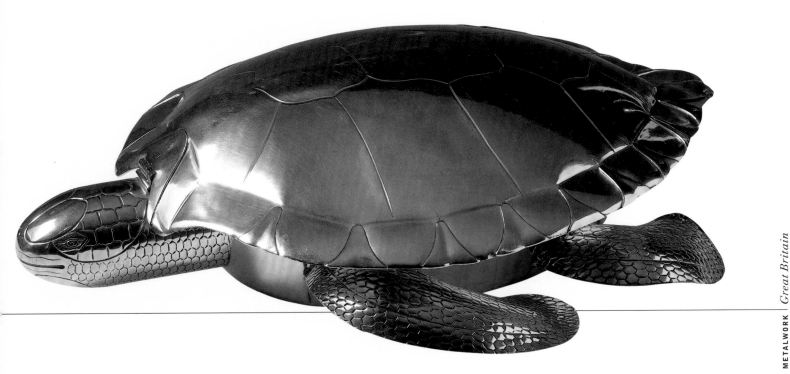

Perhaps the most spectacular example is a silver tureen made by Paul de Lamerie in 1750. It is in the form of a green turtle on its back (the way they were shipped to market) with a young turtle standing on its underside. A second mid eighteenth-century English example in silver, incorporating an actual turtle shell, was made by de Lamerie's contemporary, Paul Crespin. The tureen illustrated here depicts the turtle as if it were swimming. It is one of six turtle tureens in fused silver plate currently known to exist.[55]

Fused silver plate consists of copper sheets to which thin layers of silver have been fused using heat and a rolling mill. This tureen is made of components that were cut and shaped from fused plate.[56]

The body is in the form of a bowl stamped to shape with a drawn molding soldered to the lip. The head, flippers, and tail, all with hand-chased detail, are soldered in place. The lid, in the form of a shell with

hand-chased detail, is attached to the back of the head with a soldered and riveted hinge. A stepped circular button is soldered to the underside of the body behind the head. The various components are plated on both sides, with narrow strips of sheet silver bent around and soldered to the edges.

An incompletely struck "P 71" is stamped into one plate of the hinge and the underside of the body. The number "2" is stamped into the edge of the lip, suggesting this was probably originally one of a pair. A number with several illegible components is stamped twice into the tureen. The upper group is probably a trade catalogue number; the lower symbol most likely identifies the workman who made the tureen.

Fused silver plate
Length 16 ½ in (419 mm)
Width 17 ¼ in (235 mm)
Height 9 ¾ in (248 mm)
96.4.54

PROVENANCE
Mrs. Charles H. Norris Jr.,
Palm Beach, Fla., gave this
tureen to the Campbell
Museum in 1989 through
the Margaret Dorrance
Strawbridge Foundation II.

*Manufacturer's
identification number*

21 Tureen

Maker, artist, craftsman

Paul Storr was apprenticed to London silversmith Andrew Fogelberg about 1785, when he was fourteen years old. He served his master for seven years and then went into business with William Frisbee. Their partnership was short-lived; within a year, Storr struck out on his own and remained in business for himself at various addresses until 1807. He was then persuaded to align himself with John Bridge and Philip Rundell, who sought him out because of his considerable repute as an excellent silversmith among wealthy patrons in Great Britain (including George III) and for his efficiency as a workshop manager. Their business relationship continued through 1819, when Storr again worked on his own.[57]

About the object

The squat, bulbous, circular body of this tureen relies on bold and graphic embellishments for visual impact.

This philosophy was well expressed by London antiquarian and connoisseur Thomas Hope, who wrote about the importance of "symbolic personages, of attributes and of insignia of gods and men ... [that] once gave to every piece of Grecian and Roman furniture so much grace, variety, movement, expression and physiognomy." He further observed that "the association of all the elegancies of antique forms and ornaments, with all the requisites of modern customs and habits" was a desirable and worthy goal. The convoluted handles, designed as paired winged serpents, and the massive paw feet flanked by volutes and anthemia graphically illustrate his philosophical approach to good design.[58]

The coat of arms of Sir Wilfred Lawson and his wife, Anne Hartley, is cast and soldered to each side of the body. Their crest serves as the finial. Lawson was tenth baronet of Brayton House, Isell, County Cumberland, Ireland.

The lid, body, and stand are each wrought of one piece. All appendages, including finial, beaded and

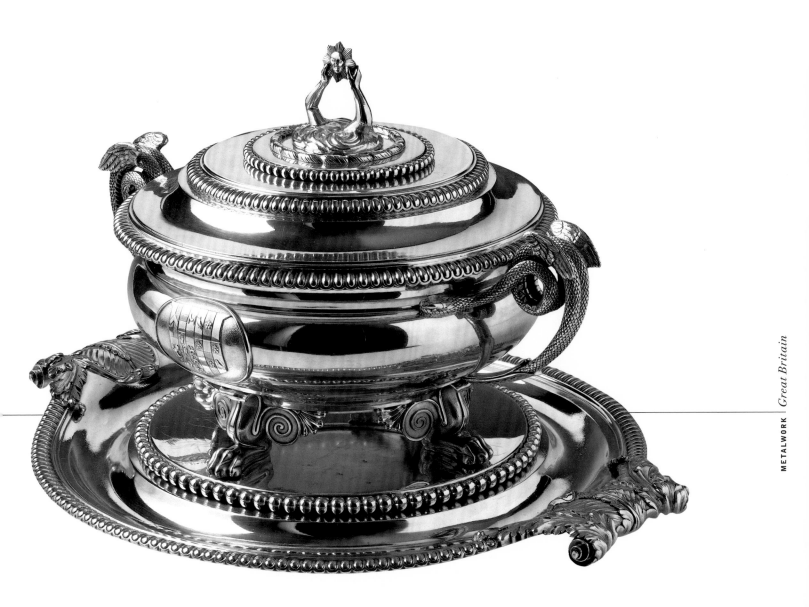

gadrooned borders, handles, and feet, are cast with chased detail, except for the gadrooned border on the lid, which is hammered up. All are soldered in place, except for the finial, which is bolted to the lid with alignment pins. The body is fitted with a removable wrought liner that has two cast and chased handles soldered to the lip.

The number "2" is stamped into the lid's bezel; the roman numeral "I" is stamped into the lip of the body and again on the top of the stand. This tureen is one of a pair; the lid and that of its mate apparently were switched. A series of five marks is stamped into the various parts, indicating the maker, date, place of origin, adherence to the English sterling standard of 92.5 percent pure silver, and payment of a tax to the Crown.

A *Owner's coat of arms*

B *Marks identifying the maker, date, place of fabrication, adherence to the proper standard, and payment of a tax*

Silver; 333 oz 15 dwt
Height 11 ¼ in (286 mm)
Length 19 ½ in (495 mm)
Diameter 16 ⅜ in (416 mm)
96.4.105

PROVENANCE
This tureen was made for Sir Wilfred Lawson (d. 1806) and his wife, Anne Hartley. Elinor Dorrance Ingersoll owned it in this century. The Campbell Museum purchased it from her estate in 1977, with funds provided by John T. Dorrance Jr.[59]

LITERATURE
Selections from the Campbell Museum Collection 1978, no. 12; 1983, no. 55.

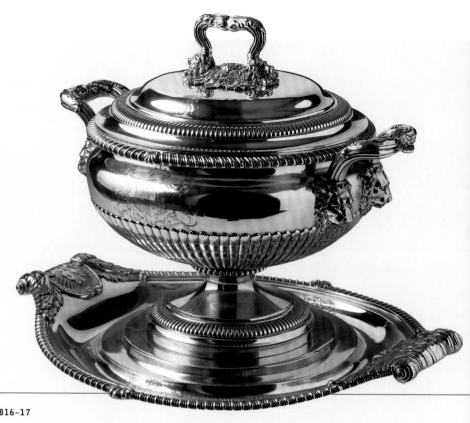

22 Tureen

PAUL STORR LONDON, ENGLAND, 1816–17

Maker, artist, craftsman

Paul Storr was a talented craftsman who built a considerable reputation as a manufacturing goldsmith between 1796 and 1807. After he joined forces with the firm of Rundell, Bridge and Rundell as supervising silversmith, he continued to add to his reputation by executing silver from designs by John Flaxman and others. In spite of impressive success and wealth, Storr felt his creativity was stifled and so went into business for himself. In 1822 he formed a partnership with retailer John Mortimer that lasted until Storr's retirement in 1838.[60]

About the object

This vessel might be most accurately described as an urn, which the influential furniture designer Thomas Sheraton (1751–1806) stated to be "a kind of vase of roundish form, with a large swell in the middle." Here it is given visual drama with six lion masks. The lion was the most frequently encountered animal in English heraldry. It was considered a desirable adjunct at aristocratic tables because it personified power. In addition, this tureen is embellished with gadrooning, reeding, acanthus leaves, and palmettes—motifs that had routinely been used on stylish table silver as early as the seventeenth century.[61]

The coat of arms and motto *Ride through,* belonging to Robert Hamilton, eighth baron of Belhaven and Stenton, and his wife, Hamilton Campbell (married in 1815), are engraved twice on the body and stand. The attendant crest is engraved twice on the lid.

The lid is wrought with a bezel soldered near the edge. The handle is cast, chased, and bolted in place with alignment pins. The body and pedestal are wrought and soldered together. The reeded areas are hammered up from the body. The gadrooned border at the lip, water leaves at juncture of body and pedestal, and handles are all cast, chased, and soldered in place. The stand is also wrought; the handles and gadrooned border are cast, chased, and soldered in place.

A series of up to five marks is stamped into various parts, identifying the maker, place, date, adherence to the English sterling standard of 92.5 percent pure silver, and payment of a tax to the Crown. The number "798" is stamped incuse into the underside of one handle of the stand. The letter "B" is lightly scratched into the underside of the pedestal.

A *Marks identifying the maker, date, place of fabrication, adherence to the proper standard, and payment of a tax*

B *Owner's coat of arms and crest*

Silver; 239 oz
Height 13 3/8 in (340 mm)
Width 15 1/2 in (391 mm)
Length 19 1/16 in (486 mm)
96.4.104

PROVENANCE
This tureen was made for Robert Hamilton (1793–1868), eighth baron of Belhaven and Stenton, and his wife, Hamilton

Campbell (d. 1873). It was offered at Christie's, London, April 20, 1966, lot 4. The Campbell Museum purchased it from New York City silver dealer S. J. Shrubsole in 1966.

LITERATURE
Selections from the Campbell Museum Collection 1969, no. 12; 1972, no. 13; 1976, no. 13; 1978, no. 14; 1983, no. 57.

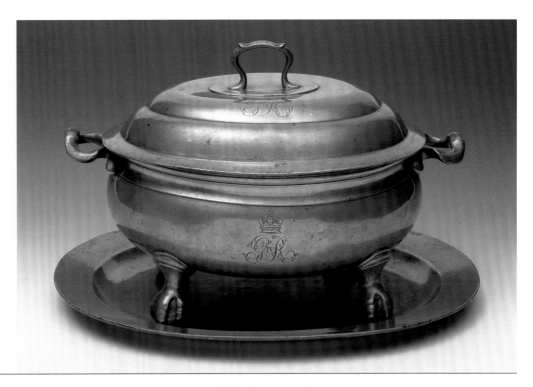

23 *Tureen*

THOMAS ALDERSON LONDON, ENGLAND, 1821

Maker, artist, craftsman

Little is known about Thomas Alderson even though he supplied all the pewter used at George IV's coronation banquet. His involvement with pewtering can be traced to John Alderson, who was granted yeomanry in the Worshipful Company of Pewterers of London in 1764.[62] John practiced his craft at 33 Carnaby Street until about 1795, when Mary Alderson took over the business. In 1805 she expanded to 16 Great Marlborough Street. She listed herself in London city directories as pewterer and patent lead pipe manufacturer. In 1816 she was joined by George and Thomas Alderson, listed as manufacturers of white lead, milled and sheet lead, and patent lead pipe. Mary appears to have retired from business about 1832. George and Thomas continued until about 1833, when the firm name changed to George D. Alderson and Company.

About the object

This tureen is of standard elliptical shape, with massive ball-and-claw feet. The lid, body, and stand are all engraved "GR IV" under a royal crown, representing George IV (1762–1830). The number "35" is engraved on one end of the lid. The tureen was one of at least thirty-five tureens and other forms that made up a large service created for the banquet celebrating the coronation of the king in 1821. It or one of its mates stood on the banqueting table in front of the king, who asked that Lord Denbigh "help him to some turtle soup" from it.[63]

At the end of the banquet, after the king had departed, "the gathering crowd, by a simultaneous rush, in a moment surrounded the Royal table ... to be the first to commence the scene of plunder ... for the purpose of obtaining some trophy commemorating the occasion [including] the plates and dishes [which] were of pewter, engraved with the Royal arms and the letters 'Geo. IV,' and were therefore greatly coveted."[64]

The lid, body, and stand are cast. The lid is fitted with a cast handle and bezel, both soldered in place. Cast handles and feet are soldered to the body.

The body and stand each have three stamped marks, which identify the maker, where they were made, and use of the best quality metal. British pewter of superfine hard-metal quality was mixed in a ratio of 100 pounds of tin to 17 pounds of antimony.[65]

Pewter
Height 9⅜ in (238 mm)
Length 16 in (406 mm)
Width 12⅝ in (321 mm)
96.4.100.1

PROVENANCE
The Campbell Museum purchased this tureen and 2 accompanying soup plates in 1970 from Thomas and Constance Williams, pewter dealers in Litchfield, Conn.

LITERATURE
Selections from the Campbell Museum Collection 1972, no. 38; 1976, no. 38; 1978, no. 37.

A *Marks identifying the maker and adherence to the proper standard*

B *George IV's monogram*

24 *Tureen*

ROBERT GARRARD JR. LONDON, ENGLAND, 1824–25

Retailer This tureen bears the mark of Robert Garrard Jr., who apprenticed to his father as a businessman and administrator. He ran the silversmithing firm R., J., & S. Garrard following his father's death in 1818 and struck his mark on this tureen as the business owner, not the fabricator. Silversmith Paul Storr had a working relationship with the Garrards during the 1820s and 1830s. Three pairs of virtually identical tureens are recorded that bear Storr's mark (dated 1820, 1821, 1822), making it reasonable to presume that Storr was the maker of this example.[66]

About the object Following Admiral Lord Horatio Nelson's spectacular naval victories over France and Spain at the Battle of the Nile in 1798 and the Battle of Trafalgar in 1805, marine motifs figured visibly in England's celebratory arts. The energetic and dramatic design of this tureen expresses that sentiment well, from its cresting wavelike stand, base in the form of dolphins, wavelike borders flanked by sculpted figures of a triton and mermaid, and finial of crustacea and vegetables on a bed of kelp.

The coat of arms and motto *Avi numerantur avorum* (the forefathers of our forefathers are numbered) of Fletcher Norton are engraved twice on the tureen. The attendant crest is engraved on the lid and liner. Norton was educated at Sandhurst, became an officer in the Greenwich Guards, and participated in the 1815 battles of Quatre Bras and Waterloo.

The lid is wrought with repoussé ornament and a soldered-on bezel. The finial is a multipart casting, chased and bolted in place with an alignment pin. The body is wrought. The rim and handles are cast, chased, and soldered in place. There is a removable wrought liner. The dolphins are cast, chased, and bolted to a cast pedestal. The stand is wrought. The handles are cast, chased, and soldered in place.

Multiple marks are stamped into various pieces, indicating the identity of the merchant, date and place of fabrication, adherence to the English sterling standard of 92.5 percent pure silver, and payment of a tax to the Crown. The number "2" is stamped into the bezel and finial of the lid; "1" is stamped into the lip of the body and top of the stand, indicating these are mismatched parts of what was originally a pair.

Silver; 507 oz
Height 15 $^{11}/_{16}$ in (399 mm)
Length 21 in (533 mm)
Width 15 ½ in (393 mm)
96.4.254

PROVENANCE
Fletcher Norton
(1798–1875), Baron Grantley
of Markenfield, Eng., is the
first recorded owner of this
tureen. The Campbell
Museum purchased it from
New York City silver dealer
S. J. Shrubsole in 1968.[67]

LITERATURE
Banister, "Silver Soup
Tureens," p. 105.

Buhler, "Silver Tureens,"
p. 906, fig. 5.

Clayton, *Collector's
Dictionary*, p. 269.

Culme, *Nineteenth-Century
Silver*, p. 138.

Halfpenny, "High Style: Fashionable Taste," p. 57, fig. 4.

Honour, *Goldsmiths and
Silversmiths*, p. 245.

Lever, "Garrard & Co.,"
p. 96.

*Selections from the Campbell
Museum Collection* 1969,
no. 13; 1972, no. 14; 1976,
no. 14; 1978, no. 15; 1983,
no. 59.

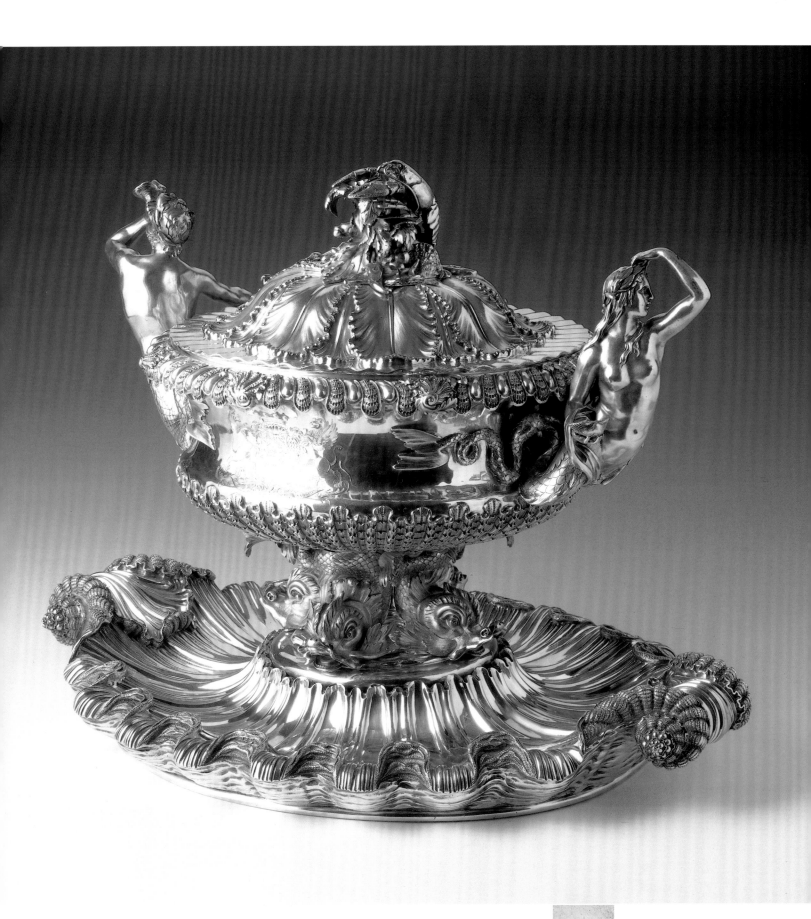

A Owner's coat of arms and
crest

B Marks identifying the
retailer, date, place of
fabrication, adherence to the
proper standard, and
payment of a tax

25 *Tureen*

JOHN BRIDGE LONDON, ENGLAND, 1828–29

Retailer

John Bridge took a job as a shopman with the London goldsmithing firm of Pickett and Rundell in 1777 following an eight-year apprenticeship with jeweler William Rogers in Bath. By 1788 he formed a new partnership with Philip Rundell. Their firm, Rundell and Bridge, later Rundell, Bridge and Rundell, was appointed Goldsmiths and Jewelers to the King in 1797. During the ensuing thirty years, the partners guided the firm to dominance in the supply of domestic and presentation silver for the fashionable market throughout England.[68] This tureen was made by several of the numerous silversmiths in their employ.

About the object

This tureen takes its stylistic cue from the Warwick Vase, the most celebrated and copied ancient vessel of its day. The original, an eight-and-one-half-ton marble behemoth, was described by its first English owner, Sir William Hamilton (1730–1803), as "universally avow'd to be the finest vase in the world."[69] Its fragments were excavated from the grounds of Hadrian's villa near Tivoli, Italy, reconstructed,

and sent to England by 1778, where it was widely published. The maker of this tureen eliminated the human profiles that adorn the original but retained the vigor of shape and character of the decorative embellishments.

The coat of arms, crest, and motto *Nomen extendere factis* (to perpetuate one's name by deeds) of Joseph Neeld Jr. are engraved twice on the body and applied twice on the lid and stand. Neeld was Philip Rundell's great nephew and principal heir, inheriting a fortune of £900,000 when Rundell died in 1827.

The body, pedestal, lid, and stand are each wrought of one piece. The cast and chased finial designed as intertwined limbs is bolted to the lid with an alignment pin. The flanking coats of arms with crest are also cast, chased, and bolted in place. The two borders are cast segments, chased and soldered in place.

A

B

A *Marks identifying the retailer, date, place of fabrication, adherence to the proper standard, and payment of a tax*

B *Owner's coat of arms*

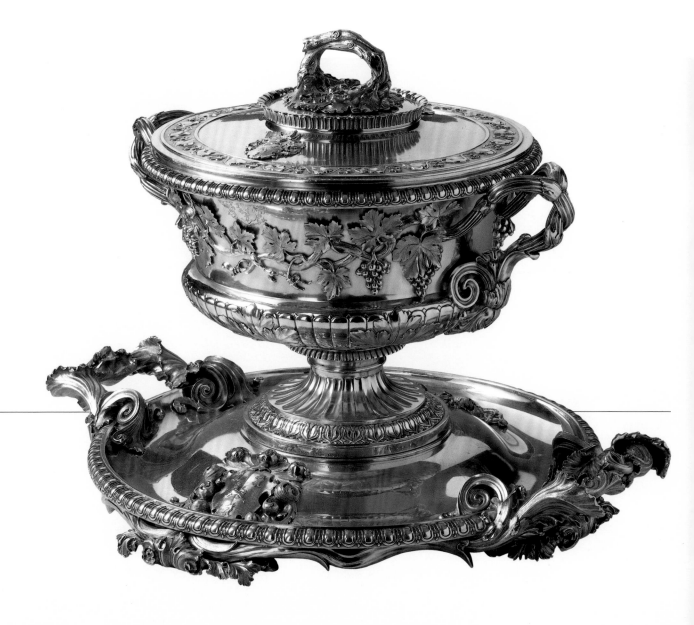

Intertwined grapevine handles and tendrils are cast, chased, and soldered to the body, as is the egg-and-dart border at the lip. Acanthus leaves, reeds, flutes, and leaf tip borders on the body and pedestal are hammered and chased; the two armorial cartouches are engraved. The handles, border, and feet on the stand are cast, chased, and soldered in place. The similarly made armorial cartouches are bolted in place. All parts are completely gilded.

A "2" is stamped into the bezel of the lid and lip of the body, indicating the tureen was at least one of a pair. Five separate marks are stamped in varying arrangements on all the separate parts, identifying the retailer, place, date of fabrication, adherence to the English sterling standard of 92.5 percent pure silver, and payment of a tax to the Crown. "RUNDELL BRIDGE ET RUNDELL AURIFICES REGIS LONDINI" (Rundell Bridge and Rundell Goldsmiths to the King London) is stamped on the underside of the stand and base rim of the pedestal.

Silver gilt; 404 oz
Height 14 in (356 mm)
Length 21 1/8 in (536 mm)
Width 17 5/8 in (448 mm)
96.4.252

PROVENANCE
This tureen was made for Joseph Neeld Jr. (1789–1856). It passed by descent to L. W. Neeld, who sold it at Sotheby's, London, February 11, 1943, lot 36. The Campbell Museum purchased it from the London firm of Frank Partridge and Sons in 1968.

LITERATURE
Selections from the Campbell Museum Collection 1969, no. 14; 1972, no. 36; 1976, no. 36; 1978, no. 36; 1983, no. 60.

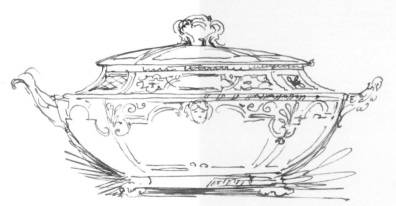

26 Tureen

ROBERT GARRARD JR. LONDON, ENGLAND, 1834–35

Retailer Present-day Garrard and Company traces its origins to
silversmith George Wickes, who commenced business
in London in 1722. There followed a series of partner-
ships, which led to the hiring of Robert Garrard
(1758–1818) in 1780 to administer the business. Garrard
took sole control in 1802, and brought his three
eldest sons—Robert Jr., James, and Sebastian—into
the firm as they came of age. They, in turn, assumed
control upon their father's death and, through astute
business acumen, rose to be Goldsmiths and Jewelers
to the Crown, in place of their competitor Rundell,
Bridge and Rundell.[70]

Robert Garrard Jr. registered his first mark with
the Goldsmiths' Company in 1818. He registered his
second, that which appears on this tureen, in 1822.
Both identified him as owner of the silversmithing firm.
The tureen was made by silversmiths in his employ.[71]

About the object The octagonal shape, the design of the ornamental
borders, and the feet of this tureen were directly
inspired by a nineteen-piece silver *surtout de table*
made in 1709 by silversmith Elie Pacot in Lille,

Silver; 256 oz.
Height 15 ¾ in (400 mm)
Length 17 ⅞ in (409 mm)
Width 14 ¾ in (374 mm)
96.4.171

PROVENANCE
This tureen was acquired
by Sir James Weir Hogg
(1790–1874) shortly after
his return to England from
India. It passed to his son,
Sir James Macnaghten

McGarel-Hogg, first baron
Magheramorne (1823–1924).
It was sold at Sotheby's,
London, April 26, 1985, lot
50. The Campbell Museum
purchased it in 1990 from
the firm of ADC Heritage,
New York, with funds
provided by W.B. Murphy.

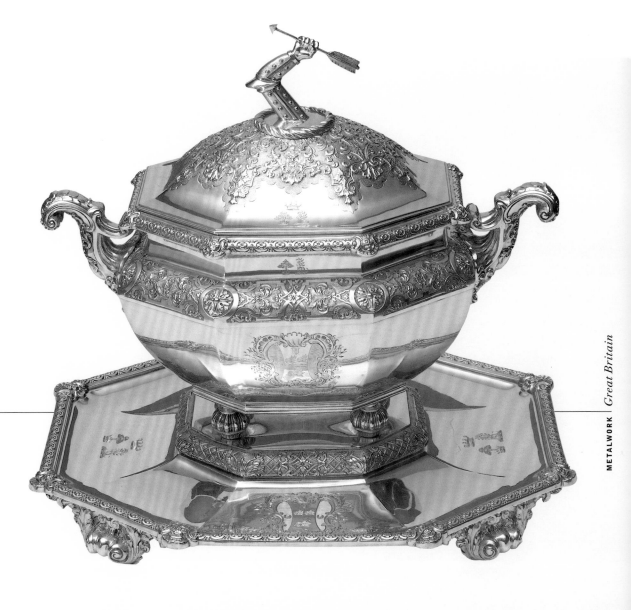

France. The *surtout*, an ornamental table service used to display dessert, was offered for sale through the London auction house of Christie, Manson and Woods in 1829, when the firm of R., J., & S. Garrard purchased it. Garrard resold various pieces of the group but not before recording the important features for use in designing new silver, such as this tureen.[72]

The coat of arms and motto *Dat gloria vires* (glory gives strength), belonging to Sir James Weir Hogg, are engraved twice each on the body and stand. The finial on the lid is the attendant crest. The multiple crests of his son, Sir James Macnaghten McGarel-Hogg, are engraved twice each on the lid, body, and stand.[73]

The lid, tureen, and stand are wrought, the latter two of several pieces soldered together. The principal ornamental borders are stamped; the finial, secondary borders, handles, and feet are cast and chased. The finial is bolted to the lid with an alignment pin; the remaining cast components are soldered in place. The tureen is bolted to the stand.

Multiple marks are stamped in various parts, identifying the retailer, date and place of fabrication, adherence to the English sterling standard of 92.5 percent pure silver, and payment of a tax to the Crown. The lid, body, and stand are each stamped with the number "1," indicating this tureen was originally one of a pair.

A Owner's coat of arms and crests

B Marks identifying the retailer, date, place of fabrication, adherence to the proper standard, and payment of a tax

27 Tureen

ENGELBART JOOSTEN THE HAGUE, HOLLAND, 1772

Maker, artist, craftsman

Engelbart Joosten lived his entire life in The Hague. Following his apprenticeship, he became a master silversmith in 1755 and was active at his craft until his death in 1789. He seems to have had numerous well-to-do patrons, as judged by the quantity of his surviving silver, which he made in both the mature rococo and neoclassic styles.

About the object

This vase-shape tureen and finial resemble ancient Roman cinerary urns, but with a strong French accent. During the third quarter of the eighteenth century, numerous Parisian silversmiths fabricated vase-shape tureens with scrolled feet and garlands and swags of laurel. Among the most successful was Robert-Joseph Auguste, who made a closely related tureen for the Hanoverian minister to the French court in 1771. That tureen probably provided the inspiration to Joosten for the design of this example and its mate.[74]

The coat of arms, engraved twice on the tureen and once on the stand, belong to Assueer Jan, baron Torck, and his wife.

The lid, liner, body, and stand are wrought. The cast finial is bolted to the lid through a cast and chased collar; cast and chased ornaments and a wrought bezel are soldered and riveted to the edge. Handles with movable pendant rings, legs, and ornamental features are cast, chased, and soldered and riveted in place on the tureen. Cast handles and a drawn molding are soldered to the lip of the removable liner. Cast and chased handles, border, and ornamental features are soldered and riveted to the stand.

Four marks are stamped on various parts; three of these identify the maker, date of fabrication, and town and country of origin; the last guarantees that the object is no less than the Dutch standard of 93.4 percent pure silver. A single groove is filed into the edge of the lid's bezel; a double groove is filed into the edge of the tureen and liner, indicating this lid has been switched with that of its mate, which is in the collection of the Rijksmusuem.[75]

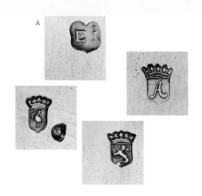

A *Marks identifying the maker, date, town and country of origin, and adherence to the proper standard*

B *Owner's coat of arms*

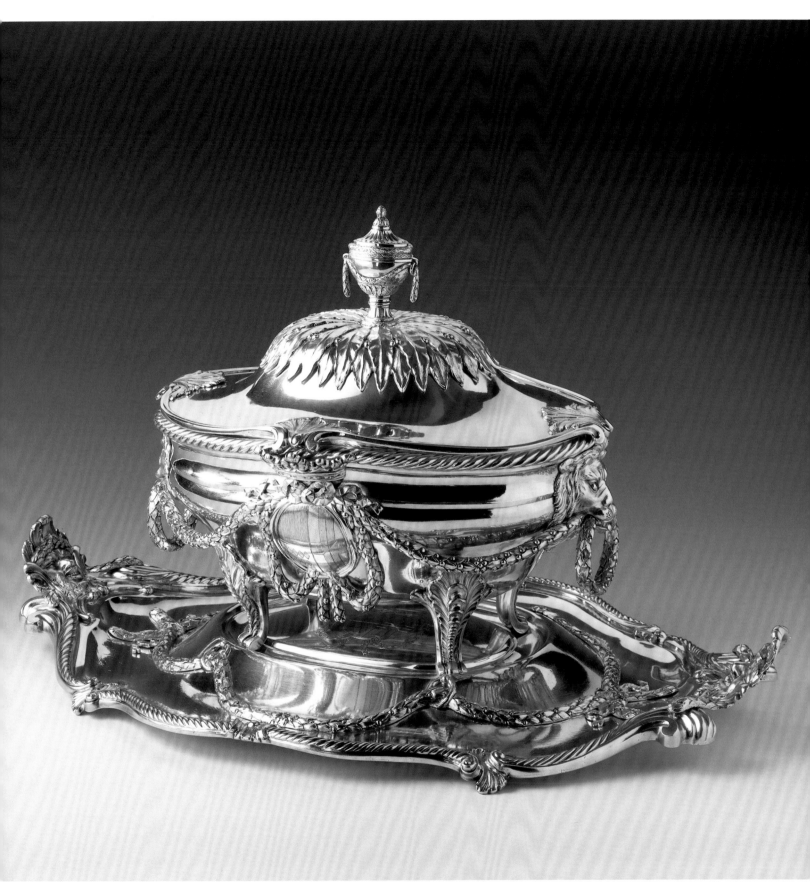

Silver; 301 oz
Height 12 ¾ in (324 mm)
Length 23 in (584 mm)
Width 14 ¾ in (374 mm)
96.4.256

PROVENANCE
This tureen was made for
Assueer Jan, baron Torck
(1733–93), and his wife,
Eusebia Jacoba de Rode van
Heeckeren (1739–93), who
bequeathed it to their second
son, Reinoud Jan Christiaan
Torck. Helena Susanna
Cornelia van Pallandt owned
it early in this century. Upon
her death, she willed it to her

husband, Walton White
Evans von Hemert, who sold
it to Dutch antiques dealer
H. Nijstad. The Campbell
Museum purchased it from
Nijstad in 1970.

LITERATURE
Gans and Duyvene de Wit-
Klinkhamer, *Dutch Silver*,
fig. 121.

*Selections from the Campbell
Museum Collection* 1972,
no. 16; 1976, no. 16; 1978,
no. 17; 1983, no. 113.

28 Tureen

GIOVANNI BATTISTA NOVALESE **TURIN, ITALY, 1786–93**

Maker, artist, craftsman

Giovanni Battista Novalese was admitted to the Goldsmiths' Company in Turin in 1783, but he is not listed as a working silversmith there until 1786. He is subsequently identified as a technical adviser, until 1799, and is last mentioned in city records in 1802.[76]

About the object

A pensive Heracles (Hercules in Latin), the most famous of all Greek heroes, sits atop the lid of this tureen. He appears to be resting after having completed the first two of the twelve labors assigned to him by the Greek king Eurystheus. Those labors were to slay the Nimean lion, which he did by choking and beating it with a club. He then skinned it and, as seen here, always wore the pelt. His second labor was to kill the Hydra of Lerna (a multiheaded water monster with a hound's body) by lopping off its heads. It lies dead behind the seated Heracles. The remaining ornamental features of this tureen are expected neoclassic components—sculpted lion-head monopods, foliate swags, and human masks—all against a background of compatible decoration, including bead-and-reel, wave-form, water-leaf, and Greek key borders.

The tureen, liner, and stand are floridly engraved with the initials "GV," perhaps identifying the original owner. They are also engraved with the conjoined initials "GM," which probably belonged to a late nineteenth-century owner.

The lid, tureen, and stand are wrought. A multipart cast and chased finial is bolted to the lid; the narrow ornamental border is riveted in place. It is accompanied by a chased border, and a wrought bezel is soldered to the rim. Cast and chased legs and swags are bolted to the tureen; an ornamental border is chased into the lip, and a second border is riveted near the bottom. Sheet metal handles with chased ornament are bolted to the tureen at the lower ends, with a

Silver; 222 oz
Height 15 ½ in (394 mm)
Diameter 18 ⅞ in (481 mm)
96.4.250

PROVENANCE
The Campbell Museum purchased this tureen in 1969 from Rome antiques dealer Nicola Bulgari.

LITERATURE
Buhler, "Silver Tureens," p. 909.

Selections from the Campbell Museum Collection 1969, no. 20; 1972, no. 22; 1976, no. 22; 1978, no. 24; 1983, no. 122.

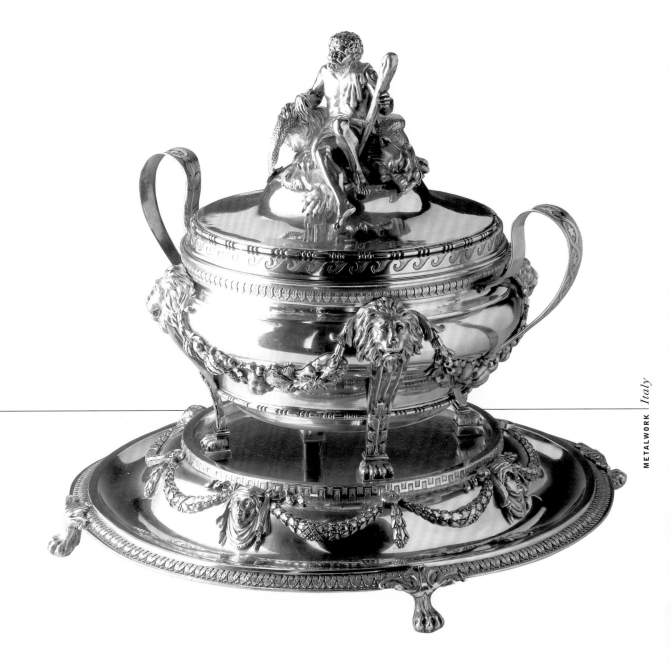

hinged joint at the top. The tureen is fitted with a removable wrought liner with gilt interior and two cast and chased handles soldered to the rim. Cast and chased masks and swags are bolted to the stand; the similarly fabricated feet are soldered in place. A reinforcing rim is soldered to the edge, accompanied by two chased ornamental borders.

Four different marks are stamped into various parts, identifying the maker and two assayers, Giuseppe Vernoni and Bartolomeo Bernardi.[77] The Roman numeral "V" is filed into the bezel of the lid and the lip of the liner, suggesting this tureen originally may have been part of a set.

Marks identifying the maker and assayers

29 Tureen

MAKER UNKNOWN **PROBABLY MEXICO CITY, MEXICO, 1733–78**

Maker, artist, craftsman

More than $10 million worth of silver and gold was extracted from Mexican mines in 1733, increasing to more than $21 million in 1791. These riches encouraged many Spanish silversmiths to relocate to Mexico; eighty-one were working in Mexico City in 1753. The guild of Mexican goldsmiths, following the lead of its more ancient counterpart in Spain, required marks on all silverwork; one mark would serve to identify the maker.[78] Because regulations changed periodically, however, and were enforced only sporadically, particularly with respect to the silversmith's personal mark, many of the marks on Mexican silver are difficult to identify. The maker of this tureen is unknown.

About the object

The squat, bulbous body of this tureen and low-domed lid are lobed, like a melon. All the appendages take their inspiration from natural motifs: scallop shells at the tops of the legs and a flowering bud with leafy collar as the finial. The shape of the tureen and ornamental details derive from Spanish prototypes, particularly examples made in Madrid during the mid eighteenth century.[79]

The block letter "B," shaded in crosshatching, referring to an owner, is engraved on the inside lip of the tureen and again on the outside of the lid's flange. The conjoined block letters "BD," shaded with diagonal lines, are engraved on the underside of the lid.

The lid and body are each wrought of one piece of metal. A drawn molding and bezel are soldered to the edge of the lid; a multipart cast finial with chased detail is bolted through the center. The four legs and two handles are cast with chased detailing. They are riveted and soldered to the body; a reinforcing flange is soldered to the outer edge of the lip.

Two short, vertical parallel lines, perhaps intended to indicate the number 2, are engraved inside the body at one end, suggesting that this tureen might have been one of a pair. Four marks are stamped inside the body and again on the underside of the lid. One identifies Mexico as the place of origin; another, Diego Gonzalez de la Cueva as the assayer of the metal; and a third, that a tax was paid on the object. The fourth mark indicates that the tureen was imported into Cádiz, Spain, probably in the eighteenth century.[80]

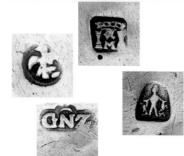

Marks identifying the assayer, place of origin, payment of a tax, and importation into Cádiz, Spain

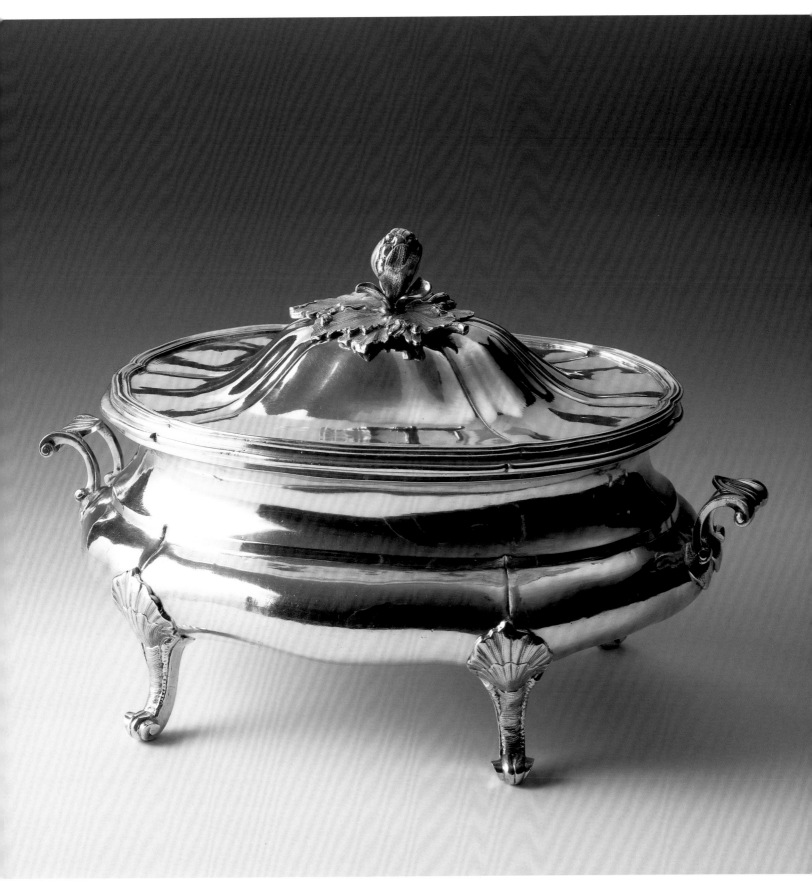

Silver; 116 oz
Height 9 5/16 in (237 mm)
Length 14 7/8 in (367 mm)
Width 8 5/8 in (220 mm)
96.4.231

PROVENANCE

This tureen was advertised
by Parisian antiques dealer
Jacques Kugel in 1967.[81]
It was purchased by the
Campbell Museum from New
York City silver dealer S. J.
Shrubsole in 1968.

LITERATURE

Buhler, "Silver Tureens,"
p. 908, fig. 10.

*Selections from the Campbell
Museum Collection* 1969,
no. 21; 1972, no. 24; 1976,
no. 24; 1978, no. 26; 1983,
no. 124.

30 Tureen

ZACHARIAS DEICHMANN ST. PETERSBURG, RUSSIA, 1766

Maker, artist, craftsman

St. Petersburg, founded by Peter the Great (1672–1725) in 1703 to strengthen Russia's ties with Europe, was an overwhelming success. The population grew to almost a quarter of a million inhabitants in fewer than one hundred years. The city was also the site of numerous industrial enterprises; the most important was shipbuilding. Because of its rapid growth and wealth, St. Petersburg attracted many Russian and European silversmiths. Zacharias Deichmann, born in Olinsky, Russia, was among them, although he and his fellow native silversmiths were outnumbered by their foreign counterparts by about 15 to 1.[82]

About the object

This tureen appears to be a loose interpretation (with two bows and no stern) of a mid to late seventeenth-century ten-gun ship—the sort that plied the North Atlantic when Peter the Great was studying European shipbuilding and marine architecture. The two-headed eagle with orb and scepter (insignia of the Romanov family) with the initial of Catherine the Great (Ekaterina II, czarina of Russia between 1762 and 1796) on its breast, adorns each side of this tureen, suggesting that it was commissioned for governmental purposes.

The coat of arms and motto *La liberté* (liberty) of George Ackers, Moreton Hall, Chester, England, and his wife, Harriott-Dell Hutton, are engraved on each end of the lid.[83] The accompanying crest is engraved on each of the four anchors that make up the handles.

The lid and tureen are each wrought of a single piece. A multipart cast and chased capstan is riveted to the lid. It is fitted with drawn and twisted wire ropes. Cast ornaments and a wrought bezel are soldered to the edge; chased details decorate the top surface. Cast

Parcel-gilt silver; 210 oz 10 dwt
Height 10¼ in (261 mm)
Length 18¾ in (476 mm)
Width 8½ in (216 mm)
96.4.209

PROVENANCE
Englishman George Ackers (1788–1836) and his wife, Harriott-Dell Hutton, whom he married in 1811, were the first known owners of this tureen. The Campbell Museum purchased it from Paris antiques dealer Jacques Kugel in 1966.

LITERATURE
Buhler, "Silver Tureens," p. 908.

Hodgson, "Soup … Soup," p. 7.

Selections from the Campbell Museum Collection 1969, no. 15; 1972, no. 15; 1976, no. 15; 1978, no. 16; 1983, no. 130.

Taylor, "Campbell Collection," p. 21.

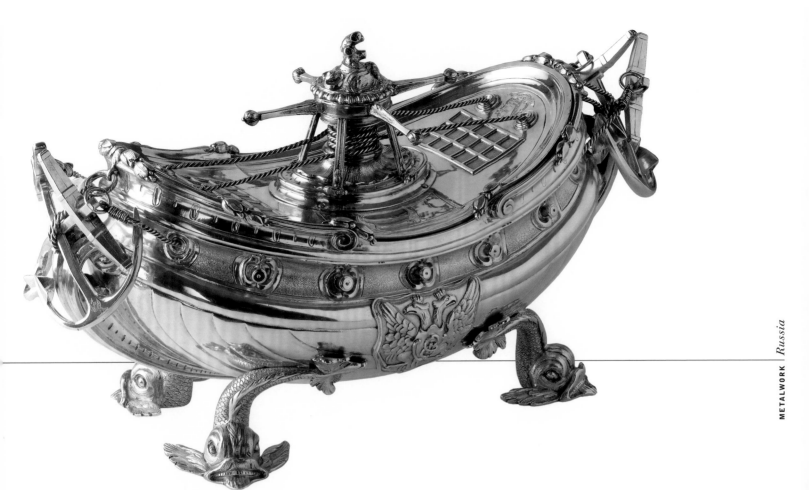

and chased feet, handles, cannon muzzles, and ornaments at the lip and on the sides are all soldered in place on the tureen, in conjunction with chased detailing.

Five marks are stamped into each component: four identify the maker, place of origin, date, standard of purity, and assayer, Ivan Frolov. The fifth mark appears to be a cluster of anchors and may be a Russian admiralty mark. The French mark of a swan is stamped into both parts of the tureen, indicating that it was imported into France after 1893. The weight in Russian units, 16 funts 16 zolotniki, is engraved on the underside of the tureen. "No. 10" is engraved on the tureen and lid, indicating that this tureen was part of a larger set.[84] The interior is gilded.

A *Owner's coat of arms and crest*

B *Catherine the Great's monogram*

C *Marks identifying the maker, assayer, date, adherence to the proper standard, and possibly an admiralty mark*

D *French import mark*

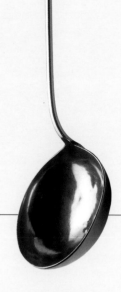

31 Ladle

BENJAMIN HURD BOSTON, MASSACHUSETTS, 1760–81

Maker, artist, craftsman

Benjamin Hurd was the tenth of fourteen children born to Jacob and Elizabeth Hurd. He was apprenticed to his father, a well-known and successful silversmith in Boston. His brother Nathaniel, older by ten years, also learned the craft from their father. Both brothers became proficient silversmiths, Nathaniel for almost forty years and Benjamin for about twenty years prior to his death in 1781.

Jacob and Nathaniel are represented by a large body of silverwork. Benjamin, however, has left relatively little silver bearing his name. Only about eighteen objects are presently recorded that bear one of his three known marks; most are flatware, but two baptismal basins, a teapot, and a cream jug have survived. His flatware, including teaspoons, tablespoons, and this ladle, are equally well fabricated and finished.[85]

About the object

Based on the style of this ladle and working dates of its maker, it may be the earliest American soup ladle presently known.[86] It is typical of most mid eighteenth-century American silver flatware; it has a modest expression of style. The round-end, upturned handle with midrib on the front was the standard design for silver tea- and tablespoons, the occasional fork, and large spoons made at that time. The juncture of handle and bowl is defined by a substantial stepped, semicircular drop. It is simpler than die-stamped foliate flourishes on some spoons of this date but is also more detailed than the standard, simple, rounded drop most frequently encountered.

The owner's initials, "I P," are engraved in shaded block letters separated by a stylized flower head on the handle back—typifying mid eighteenth-century practice.

This ladle consists of two pieces of wrought silver, the handle and bowl, that were soldered together after being fully hammered to shape. Hurd stamped his name on the underside of the bowl next to the center punch.

Silver; 5 oz 10 dwt
Length 15 in (381 mm)
Depth 2 ¾ in (70 mm)
Diameter 4 ¼ in (108 mm)
96.4.72

PROVENANCE
Philip H. Hammerslough, Hartford, Conn., owned this ladle at one time. The Campbell Museum purchased it from Boston silver and jewelry dealer Firestone and Parson in 1974.

LITERATURE
Hammerslough, *American Silver*, pp. 68, 69.

Maker's mark

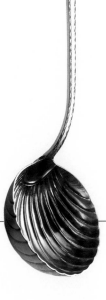

32 *Ladle*

PAUL REVERE BOSTON, MASSACHUSETTS, 1781–97

Maker, artist, craftsman

Paul Revere, son of a silversmith with the same name, apprenticed to his father in 1747. His father died in 1754, before Paul could complete his training. Although he was legally too young to inherit the business, he remained active there until he was twenty-one, when he assumed control. During the ensuing five decades, Revere and his employees produced hundreds of household, personal, ceremonial, and commemorative silver artifacts for well-to-do Bostonians. Revere's daybooks record that he fabricated twenty-five ladles between 1781 and 1797, calling them tureen ladles, soup ladles, and in one instance, a scalloped tureen ladle. For the most part, he made one in any given year, except for 1795, when he fashioned five, and 1796, when he made six.[87]

About the object

During the eighteenth century, English silversmiths fashioned various objects in the shape of a scallop shell—including fruit baskets, sugar boxes, salt dishes, and tea caddy spoons—just as their European counterparts had done since the early Renaissance. The bowl of this ladle follows that tradition and was most likely inspired by an imported English silver-plated ladle of similar form.[88] The owner's initials, "UR," are engraved on the handle. They do not relate to any customer's name in Revere's daybooks nor do they look like Revere's engraving. They belong to a subsequent nineteenth-century owner, possibly Uriah Rich (1826–1909) of Truro, Massachusetts.

This ladle consists of a wrought handle and a wrought bowl, which have been soldered together. The ornamental border that frames the handle is engraved; the lobes of the bowl are chased.

The maker stamped his identifying mark into the back of the handle.

Silver; 6 oz
Length 14 ¼ in (362 mm)
Depth 2 ⅝ in (66 mm)
Diameter 3 ⅞ in (99 mm)
96.4.56

PROVENANCE
The Reverend and Mrs. Andrew Hull of Elmira, N.Y., owned this ladle in the late nineteenth century. Following her husband's death in 1894, Mrs. Hull gave the ladle to Samuel G. H. Turner, who also lived in Elmira. After Turner's death, the ladle was offered as part of his estate at Sotheby's, New York, October 28, 1969, lot 121.

The Campbell Museum purchased it at that time.

LITERATURE
Selections from the Campbell Museum Collection 1972, no. 25; 1976, no. 25; 1978, no. 27; 1983, no. 145.

Maker's mark

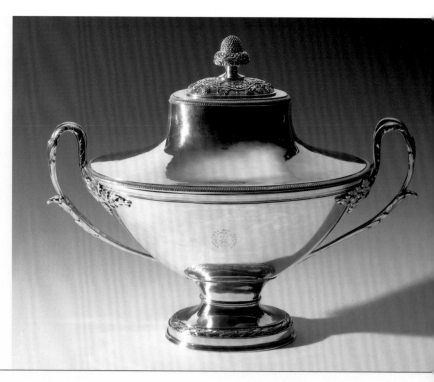

33 Tureen

HUGH WISHART NEW YORK, NEW YORK, 1793–1810

Maker, artist, craftsman

Wishart listed himself in the New York city directories between 1794 and 1824 as a working goldsmith and silversmith and intermittently between 1826 and 1837 with no profession. These findings suggest that he retired in the mid-1820s. Little is known about his professional or personal life. That he was an accomplished craftsman, we can be sure; there is a large body of surviving silver bearing his name. Wishart was proficient at making flatware—including spoons, forks, skewers, marrow scoops, ladles, and sugar tongs—and hollowware—including tea sets, beakers, porringers, pipkins, pitchers, cake baskets, pap boats, salvers, punch bowls, soup tureens, and silver-hilted swords.[89]

About the object

The shape of this tureen is indicative of the general enthusiasm for antique Greek pottery vases throughout Europe and the United States at the end of the eighteenth century. This particular interpretation is inspired by French silver and silver-plated prototypes, particularly in the design of the lid with its central plateau and proportionally small base. Immigrating French craftsmen could have brought the design

for such a tureen to New York. Alternately, merchants such as George Olive, who "imported...from Europe... jewellery, silver and plated goods," could have provided the specific inspiration for the maker of this tureen.[90]

The coat of arms and motto *Dant facta hanc coronam* (rewards come from deeds), belonging to a member of the Ball family, are engraved on the bowl.[91]

The lid, body, and pedestal are wrought. A bezel is soldered to the underside of the lid; the body and pedestal are soldered together. The cast and chased finial is bolted to the lid through a separate wrought and chased collar. The narrow ornamental borders are die rolled and soldered in place. The handles are cast, chased, and soldered in place; a chased border decorates the base of the pedestal, and a drawn molding is soldered to the lip.

The maker's mark is stamped into the edge of the pedestal. A single dot is punched into the bezel of the lid and again in the lip of the body, suggesting this tureen was one of a pair.[92]

A

B

A *Maker's mark*

B *Owner's coat of arms*

Silver; 112 oz 14 dwt
Height 13 ¼ in (336 mm)
Length 17 in (432 mm)
Width 9 ½ in (241 mm)
96.4.206

PROVENANCE
This tureen was consigned to Sotheby's, New York, October 21, 1965, lot 106, by a Mrs. Anna De Crasson of Florida. The Campbell Museum purchased it in 1966 from New York City silver dealer S. J. Shrubsole.

LITERATURE
Buhler, "Silver Tureens," p. 909, fig. 15.

Hodgson, "Soup ... Soup," p. 8.

Selections from the Campbell Museum Collection 1969, no. 22; 1972, no. 27; 1976, no. 27; 1978, no. 29; 1983, no. 147.

34 Ladle

JOSEPH AND TEUNIS D. DUBOIS NEW YORK, NEW YORK, 1795–97

Maker, artist, craftsman

The DuBois brothers were born in Freehold Township, Monmouth County, New Jersey, to the Reverend Benjamin and Femmentje DuBois. Both apprenticed in New York City; Joseph's master is unknown, and Teunis probably apprenticed to his older brother. They worked as partners for three years and then established separate businesses shortly before Joseph's death in 1798. In 1799 Teunis returned to Monmouth County, where he continued silversmithing until 1813, when he turned his attention to farming.[93]

A substantial portion of the DuBois brothers' business seems to have been wholesale to New York City silversmiths, jewelers, watchmakers, and fancy hardware merchants, including William G. Forbes, John Bailey, and Lemuel Wells. They also sold to retail customers. The bulk of their work appears to be flatware, principally tea-, table-, and salt spoons. They also made mustard spoons, sugar tongs, punch ladles, and occasionally slop bowls, cruet frames, and teapots.[94]

About the object

The long, slender, arched, and flaring handle is mated to a perfectly plain hemispherical bowl. The surfaces are largely unembellished, except for a trace of a midrib on the back of the handle tip, the pointed reinforcement at the juncture of handle and bowl, and the engraving on the handle front—all indicative of the federal style, fashionable from about 1790 to 1815.

The initials "AMP," in feathered script and within the bright-cut ellipse on the handle front, belong to the original owners. Though presently unknown, they were probably husband and wife New York City residents sharing a surname beginning with the letter *M*. The brothers stamped three marks on the back of the handle near the end. In addition to the rectangle containing their initials, there is a rectangle containing an eagle head—Joseph's personal mark—and another containing a sheaf of wheat—Teunis's personal mark. This ladle is entirely wrought from one piece of metal.

Silver; 8 oz
Length 15 ¼ in (387 mm)
Depth 2 ⅞ in (73 mm)
Diameter 3 ⅞ in (98 mm)
96.4.70

PROVENANCE
Leon Rosenbloom of Rockport, Mass., gave this ladle to the Campbell Museum in 1972.

Makers' marks

35 Tureen

WILLIAM FORBES, RETAILED BY BALL, TOMPKINS, AND BLACK
NEW YORK, NEW YORK, 1839–51

Maker, artist, craftsman

William Forbes apprenticed to his silversmith father, Collin V. G. Forbes. He subsequently became journeyman and then junior partner in his father's business before striking out on his own about 1839. He retired in 1864 and is thought to have died shortly thereafter. Forbes seems to have had a successful career as an independent silversmith. A substantial number and variety of forms bearing his mark have survived, including flat- and hollowware. Like a number of his competitors, he extended his opportunities by aligning himself with merchandisers for whom he made silverware on a wholesale basis.

Retailer

The firm of Ball, Tompkins, and Black was one in a continuum of partnerships that extended from 1832 until 1992 and supplied jewelry and stylish silverware to affluent fashion-conscious consumers. The firm advertised as a manufactory as well as wareroom, which indicates that it employed working jewelers and possibly silversmiths. The company also subcontracted work to competing firms and individuals whose prod-

A

B

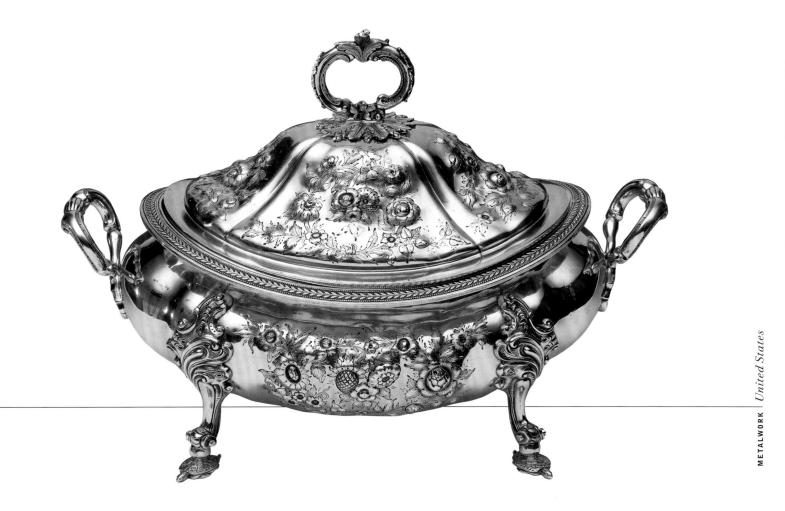

ucts were marketed under the name Ball, Tompkins, and Black.

About the object The tureen's shape generally follows English precedent of the second quarter of the nineteenth century, though with a distinct American accent as evidenced in the squat, broad stance and conservative reserves of generic floral and fruit forms in low relief. In contrast, the exuberant rococo scrollwork on the legs suggests they may be English-made imports. The legs have what appear to be identical counterparts on a number of silver soup tureens made in London during the mid eighteenth century.[95] A whimsical addition to the otherwise sophisticated rococo legs are the diminutive sea turtles, which were cast individually and chased and soldered in place. Their incorporation into the otherwise generic design possibly relates to the vessel's intended contents—turtle soup.

The letter "S" is engraved as shaded Gothic text in a reserve on one side of the body and in a similar reserve on the lid.

The elliptical body of this five-quart tureen and conforming lid are each wrought of one piece of metal. The handle, which is bolted to the lid and kept in place with an alignment pin, is cast with chased and engraved detail. The two loop handles and four legs soldered to the body are similarly formed. A die-rolled border encircles the lip of the body; panels of repoussé decorate the two long sides of the body and four reserves on the lid.

The number "2" is stamped incuse in the edge of the lid at one end and on the top of the lip in the die-rolled border, indicating that the tureen was one of a pair. The maker's and retailer's marks are stamped into the underside of the body in a manner that seems to have been used on many of the larger items retailed by Ball, Tompkins, and Black.[96]

A *Owner's surname initial*

B *Marks identifying the maker, retailer, and place of fabrication*

Silver; 98 oz 19 dwt
Height 11 ¼ in (286 mm)
Length 16 ½ in (419 mm)
Width 9 ½ in (241 mm)
96.4.190

PROVENANCE
The Campbell Museum purchased this tureen in 1974 from Boston silver dealer J. Herbert Gebelein. It was stated to have been made for a member of the Sturges

family, possibly Jonathan Sturges (1802–74), a New York City merchant in the mid nineteenth century.

LITERATURE
Selections from the Campbell Museum Collection 1978, no. 31; 1983, no. 149.

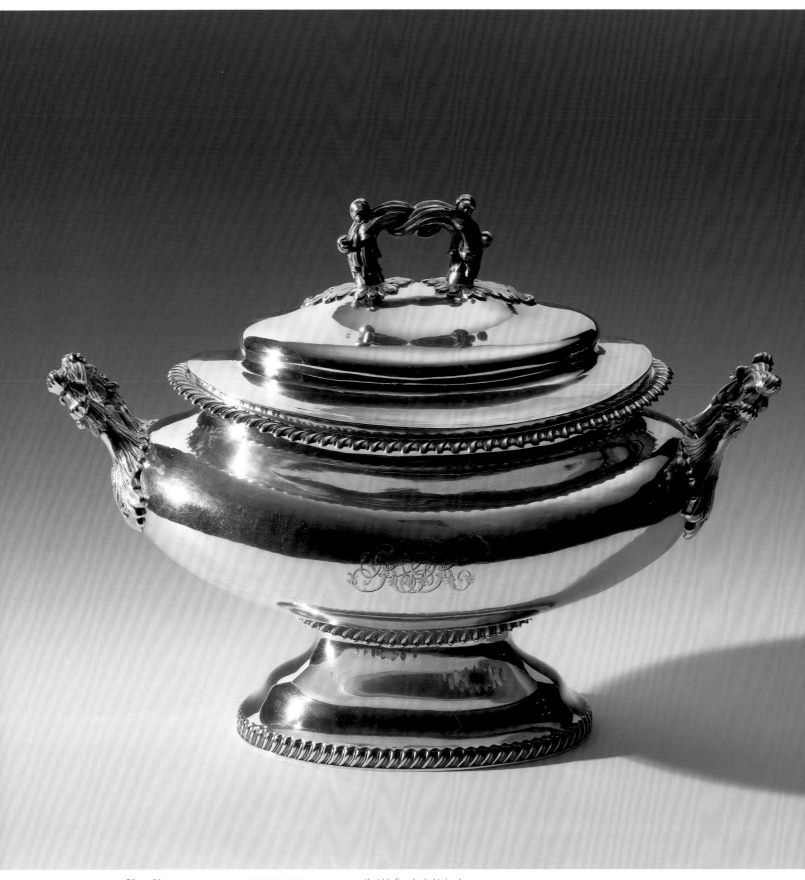

Silver; 58 oz
Height 10 ¾ in (273 mm)
Length 14 ⅝ in (372 mm)
Width 9 in (229 mm)
96.4.216

PROVENANCE
As evidenced by the
monogram, this tureen may
have been made for Reuben
G. Ring (b. ca. 1820), a mid
nineteenth-century Boston
milliner. The Campbell
Museum purchased it in 1970
from the New York firm of M.
Knoedler. The vendor stated
that his firm had obtained
it from a Mrs. Niven in
California.

LITERATURE
Selections from the Campbell
Museum Collection 1972,
no. 29; 1976, no. 29; 1978,
no. 32; 1983, no. 150.

36 *Tureen*

GEORGE B. JONES, TRUE M. BALL, AND NATHANIEL C. POOR BOSTON, MASSACHUSETTS, 1849

Retailer The partnership of Jones, Ball, and Poor was formed in 1846 and remained under that name until 1852. It was one in a series of partnerships that began in 1796 with John M. McFarlane and exists today as Shreve, Crump, and Low. The three partners were first located at 123 Washington Street but moved to 226 Washington Street in 1850. They advertised as jewelers with "a great variety of rich silver goods, and jewelry, recently manufactured under their immediate inspection."[97]

In the 1840s, there were thirteen silversmithing firms working in Boston, but most seem to have specialized in flatware. Consequently, Jones, Ball, and Poor had few individuals it could commission to fabricate silver hollowware to retail under its name. The most likely candidate was Obadiah Rich, who was a proficient silversmith located only a few doors away at 69 Washington Street.[98]

About the object The handles on this tureen are segments of intertwined ribbed vines that form loops. The design appears to derive directly from the handles on a silver vase made by Obadiah Rich and Samuel L. Ward in 1835 for presentation to Daniel Webster by the citizens of Boston.[99]

The initials "RGR" are engraved in florid interlocking script on one side of the body.

The lid, body, and pedestal are each wrought individually. A bezel is soldered to the underside of the lid; the body and pedestal are soldered together. The three handles are cast, chased, and soldered in place. The leafy ornaments on the lid are chased; the three borders of gadrooning are die rolled and soldered in place.

Three marks are stamped into the underside, identifying the retailers, place of sale, and adherence to the American coin standard, which is 90 percent silver. The date "1849" is engraved inside the footrim.

Marks identifying the retailers, place of fabrication, and adherence to the proper standard

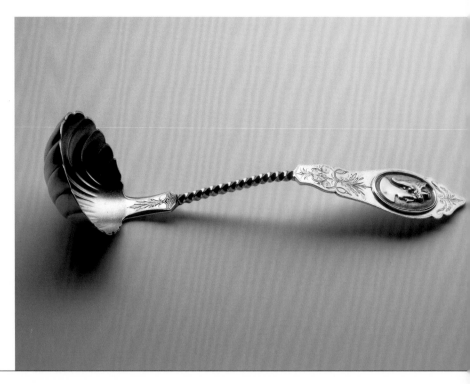

37 *Ladle*

DUHME AND COMPANY CINCINNATI, OHIO, CIRCA 1863

Maker, artist, craftsman

In 1834 Herman Duhme (1819–88) and his family arrived in Springfield, Ohio, from Osnabruck, Germany. In 1840 he struck out on his own, settling in Cincinnati, where he worked in a dry goods store for one year and in a jewelry store for another. In 1842 Duhme opened his own store, which grew into "one of the greatest jewelry emporiums in the West." The firm advertised that "all silverwares made by Duhme & Co…are guaranteed 925/1000 Fine…hand-made, hand-engraved and hand-burnished."[100] They also boasted that they were among the few major silverware manufacturers in the United States that continued to use traditional methods, which they did until 1910, when the business closed.

About the object

The style of this ladle is called the "medallion" pattern. This example depicts a profile of the Roman god Mercury, one of numerous variants used on American silver and silver-plate flatware, hollowware, and jewelry during the 1860s and again in the 1880s.[101] Most examples depict Roman or Greek gods and goddesses adapted from early nineteenth-century English design books, notably Rudolph Ackermann's *Selections of Ornaments in Forty Pages for the Use of Sculptors, Painters, Carvers, Modellers &c.* and Frederick Knight's *Knight's Gems*. Variants were also made showing contemporary profiles of women and, as might be expected, George Washington.

This ladle is wrought from one piece of metal. The medallion was die stamped and soldered in place on the handle; the interior of the bowl was acid etched to produce a matted surface and was then gilded.

The manufacturer's identifying mark is stamped into the back of the handle.

Parcel-gilt silver; 8 oz
Length 11¾ in (98 mm)
Depth 3¼ in (82 mm)
Diameter 3½ in (89 mm)
96.4.68

PROVENANCE
Leon Rosenbloom of
Rockport, Mass., gave
this ladle to the Campbell
Museum in 1972.

Maker's mark

PORCELAIN

Vienna Porcelain Factory

Claudius Innocentius Du Paquier began making porcelain in Vienna about 1719. He was assisted by Samuel Stölzel, a kiln master who had defected from the Meissen porcelain factory to the Vienna porcelain factory. In 1720 Stölzel returned to Meissen, taking talented artist Johann Gregor Höroldt with him as a peace offering. Following their departure, Du Paquier continued to make porcelain, but he experienced severe financial problems. He received grants from the Viennese authorities and was sustained by orders from royal and noble customers.

Du Paquier's early productions included a large quantity of useful porcelains including soup tureens, bowls, wine coolers, and tea- and coffeeware. Factory painters used soft pastel colors and were often inspired by the designs on imported oriental porcelains; other pieces were sold white and were decorated by *hausmaler*, or independent artists. Despite every effort, Du Paquier was unable to achieve commercial success. Deeply in debt and holding a large stock of unsold porcelain, he decided to sell his business in 1744. Empress Maria Theresa authorized its purchase by the State, and Du Paquier remained as manager of the factory until his death in 1751.

When Maria Theresa acquired the Vienna porcelain factory, it underwent a great deal of reorganization. A new source of raw materials had been discovered, and, with State investment, there was a revival of fortunes. By the middle of the eighteenth century, the Vienna factory was prospering and had achieved a reputation for rich and splendid work, including figures and groups as well as useful wares.

With the death of Maria Theresa in 1780, the royal family ceased to take a personal interest in the factory. Although it continued to function through the efforts of committed management, business declined. The company tried to revive earlier successful styles and to imitate contemporary competitors; however, after 1830 economic and artistic success eluded them, and the factory closed in 1864.

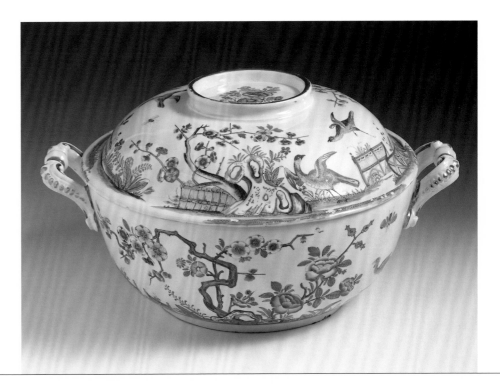

38 *Tureen*

VIENNA PORCELAIN FACTORY **VIENNA, AUSTRIA, 1725–30**
(CLAUDE DU PAQUIER PERIOD)

About the object The low, circular shape of the tureen is based on a Chinese rice-bowl form. It has a vertical collar that acts as a handle for the lid and forms a footring if the lid is inverted and used as a dish. European-style scroll handles are applied to each side of the bowl.

The enamel-painted decoration is inspired by oriental patterns.[102] The bowl has a garden design on each side with prunus and rock patterns enlivened with insects and birds. On one side a diminutive rooster struts beneath the tree. The lid has a complementary design that includes large birds in a garden of prunus trees and banded hedges. A small, oriental flower spray is painted within the collar on the lid, and a larger spray with a small insect is painted on the center of the interior of the base. The edges of the tureen and the enameled design are enhanced with gilding.

This shape of tureen is a practical form that must have been a successful product for Du Paquier. Other examples have survived and are recorded with decoration of similar, but not identical, patterns.[103]

Hard-paste porcelain with
enamel-painted decoration
and gilding
Height 7 3/4 in (197 mm)
Diameter 14 5/8 in (372 mm)
96.4.162

PROVENANCE
This tureen was purchased
by the Campbell Museum
in 1985 from Paris antiques
dealer Jacques Kugel, with
funds provided by John T.
Dorrance Jr.

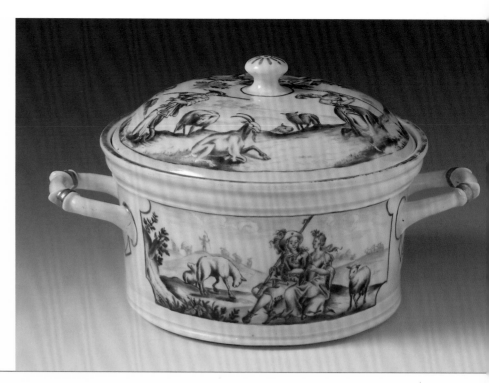

39 *Soup bowl*

VIENNA PORCELAIN FACTORY **VIENNA, AUSTRIA, 1730–35**
(CLAUDE DU PAQUIER PERIOD)

About the object

The small, circular bowl is straight sided with handles applied on either side on the horizontal axis. The lightly domed lid has a button finial. The form of the base and the ridged footring suggest that the bowl was designed with an accompanying stand.

The decoration is enameled in sepia, or shades of brown, monochrome. It is painted within panels on each side of the bowl and as a continuous band around the lid. The scenes depict pastoral subjects. The lively narrative character of the painting suggests that it may represent a story, possibly the seduction of a pilgrim by a shepherdess. The pilgrim is seen on the bowl sitting with the shepherdess. He wears his cockle-shell hat ornament and carries his pilgrim staff. On the lid he is disheveled, as the shepherdess leaves the scene wearing his hat and carrying his staff.

Typical of early Vienna porcelain, the sepia enamel-painting is a style of decoration known as *schwarzlot*. Painted decoration of this kind was undertaken by both factory artists and by *hausmaler*, or independent decorators. Similar decoration can be found on other Du Paquier pieces. Tentative attributions suggest that if a factory artist is responsible, it might be Joseph Philipp Danhöffer, who worked at the Vienna factory from about 1726 to 1737.[104] The covered bowl is painted with gilt bands at the rims and with gilt highlights at the handles and finial.

Hard-paste porcelain with
enamel-painted decoration
and gilding
Height 4½ in (114 mm)
Diameter 6¼ in (158 mm)
96.4.82

PROVENANCE
This bowl was sold at
Christie's, Geneva, April
26, 1972, lot 88. It was
purchased by the Antique
Porcelain Company,
New York, on behalf of
the Campbell Museum.

LITERATURE
*Selections from the Campbell
Museum Collection* 1978,
no. 59; 1983, no. 2.

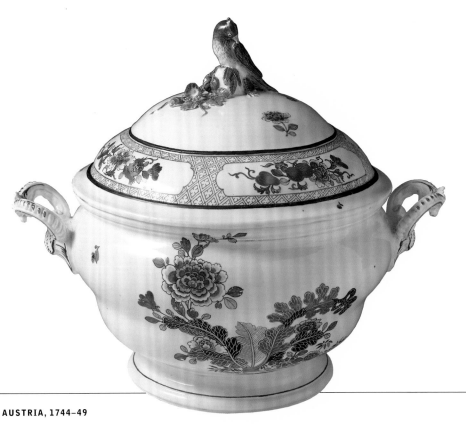

40 Tureen

**VIENNA PORCELAIN FACTORY VIENNA, AUSTRIA, 1744–49
(STATE-OWNED PERIOD)**

About the object The tureen is a conventional, ogee oval-based form. The bowl stands on a deep foot and has ornate, molded scrolling handles. A bird finial sits on the fruiting and flowering vine of a morning glory. The enamel-painted decoration is inspired by a Chinese design. A large spray of pink chrysanthemums among blue, red, and green foliage decorates each side of the bowl. On the lid is a wide diaper border with horizontal flowering sprays in reserve panels. There are small scattered flower sprays, some covering imperfections in the body. The finial is painted in naturalistic colors. Decorative edging and banding is in puce enamel,

and foliage stems are detailed in gilding. This more formal kind of oriental decoration is typical of the state-owned period's *famille rose* style. It replaced the freer, Japanese *Imari*, banded hedge, birds and rocks pattern of the Du Paquier period.[105]

An impressed mark of a shield (*Bindenschild*) is on the base of the tureen together with an incised "C" and "6" or "9."

Hard-paste porcelain with underglaze-blue and enamel-painted decoration and gilding
Height 10¾ in (273 mm)
Length 13½ in (342 mm)
Width 10 in (252 mm)
96.4.101

PROVENANCE
The tureen was sold at Christie's, London, May 30, 1963. It was then in a private collection. The Campbell Museum purchased it in 1970 from C. Bednarczyk, Vienna.

LITERATURE
Mrazek and Neuwirth, *Wiener Porzellan*, pp. 102–3, pl. 188.

Selections from the Campbell Museum Collection 1972, no. 56; 1976, no. 56; 1978, no. 60; 1983, no. 3.

EXHIBITED
250 Jahre Wiener Porzellan, Österreichisches Museum, Vienna, 1970–71.[106]

Jingdezhen, China

The fine, white porcelains of China have dominated Western taste since they were first brought to Europe as exotic souvenirs of intrepid travelers and explorers. The miraculous translucency, the strong blue-and-white patterns, and the jewel-like enamel colors became the standard by which all other pottery was judged. When Europeans aspired to make porcelain, they aspired to make it like the Chinese did.

The earliest known white porcelains date from A.D. 575 and were made at the Gongxian kiln site in Henan, China.[107] By the period of the Five Dynasties (A.D. 907–60), porcelainmaking had become more widely practiced in China, and Jingdezhen was a major center of production. The city was close to essential raw materials and fuel supplies, and the nearby river offered easy access to trading routes. Imperial kilns at Jingdezhen produced porcelains of the highest standard, exclusively for the emperor's use. Other kilns made wares for local consumption and for export.

The Portuguese were the first Europeans to establish regular trade with China. In 1511 they secured a base on Malacca, where they met with Chinese junks, or ships, and traded in silk and porcelain. In 1557 the Portuguese were permitted to settle on Macao, which became their new headquarters. Exports began with blue-and-white porcelains made for the Persian market, but gradually Western forms and patterns were introduced. Eventually Portugal lost its dominant position within the trade, but Chinese porcelains remained fashionable and continued to be imported.[108] The Dutch East India Company was formed in 1602 specifically to pursue the markets in China. In 1606 the company founded the city of Batavia, on the island of Java, as their trading headquarters. By the end of the seventeenth century, the English became the new dominant force in the China trade, when they began trading directly with the Chinese mainland.

The Chinese emperor wished to pursue the lucrative export markets but was reluctant to allow the *Fan Kwae*, or "foreign devils," general access to the country. In 1720 he gave a group of Chinese merchants license to transact business with visiting ships. He also established a procedure that controlled access to the chosen trading city of Guangzhou (Canton).

On approaching China, ships would anchor off the Macao peninsula and await permission to continue up the Pearl River. They would then sail to Boca Tigris, where credentials were presented at the fortress. (This location is recorded in the decoration of No. 42.) From this point, ships sailed to Whompoa, where they lay at anchor. The captains and supra cargoes (private traders) were then ferried by their Chinese merchants to the small strip of land on the banks of the Pearl River, outside the city of Guangzhou, which was set aside for foreign trading stations.

By 1775 England, Holland, France, Denmark, Sweden, Austria, and Spain had established trading headquarters in Guangzhou (Canton)—compounds comprising residencies, commercial offices, and warehouses. Europeans called the compounds factories; the Chinese knew them as hongs and confined the foreigners to these areas during their stay at Guangzhou. Only licensed Chinese merchants were permitted to negotiate trade deals with visiting captains and supra cargoes.

The potters of Jingdezhen made porcelains in plain white or with underglaze-blue painted patterns. These were shipped to Guangzhou (Canton), where overglaze colored decoration could be added in specialists' workshops. A European trader could fill most of his porcelain requirements from general stock available through his merchant. However, the trader might also commission special shapes and patterns when new porcelain objects were required to set fashionable tables in Europe and America. Chinese workers were given wooden prototype shapes to copy; drawings, prints, and engravings supplemented the design sources. The trade flourished, and in the eighteenth century, millions of pieces of porcelain were shipped to the West.

Porcelain was a precious material when the export trade began. By the second half of the seventeenth century, however, tea and silk had become more valuable commodities. Nevertheless, Chinese porcelain remained popular even when European factories began to make their own. The exoticism of the Orient was part of the fashionable rococo movement that dominated Europe during the first half of the eighteenth century. In the second half of the eighteenth century, when there was a reaction against rococo excess, the qualities of "the antique" became guiding tenets of architects and designers. In England, antique taste was represented by a strict adherence to classical order, and ornament was inspired by archaeological discoveries. In ceramics it was difficult to restrict tableware to classical forms, which were inappropriate for the social entertainments and eating habits of the day. But decoration was designed to conform. The swags of flowers on the tureen made for the Duke of Gloucester owe more to classical taste than oriental botany (see No. 44).

Throughout the rococo period, the secrets of making porcelain spread throughout Europe. Domestic industries could now supply the market quickly when new fashions were introduced. Ceramic technology advanced to provide sophisticated equipment, new and vibrant colors, and exquisite gilding. As the taste for Chinese porcelain declined in Europe in the late eighteenth century, the newly emerging nation in America established its own China trade. In 1784 the *Empress of China* set sail from New York for the first direct contact with China, and the porcelain trade that was no longer necessary to Europe became a staple in the American market well into the nineteenth century.[109]

41 Soup plate

JINGDEZHEN, CHINA, 1745–50

About the object　This soup plate (one of a pair) is decorated with an enamel-painted design depicting the "Judgment of Paris." The pink and gold painted border is a design of volutes and shells in the fashionable rococo style. The scene illustrates the mythological story of Paris, whom the gods charged with the task of judging the rival claims of Hera, Aphrodite, and Athena, for the title of "the fairest" of them all. The prize was the golden apple of Discord. Paris is shown sitting to the left of the group, offering the golden apple to Aphrodite. In return she assisted him in carrying off Helen of Troy. Hera and Athena sought vengeance, and eventually Paris was killed at the taking of Troy. A dalmatian-like dog sits at the feet of Paris, and cupid lies on the ground at the feet of the sisters.

An engraving of this scene is likely to have been supplied to the Chinese artists for copying. This early version shows the figures in classical drapes; later editions usually depict the figures fully dressed in contemporary costume. Mythological subjects were widely used as themes for decorating Chinese porcelain from about 1735 to 1760 and were produced alongside religious scenes and subjects from literary and artistic sources. They are usually found on tea and coffee services and on bowls and plates. The "Judgment of Paris" is one of the most commonly found patterns.[110] The Dutch market was particularly fond of decorative plates of this kind, which were used, like inexpensive paintings, to decorate the home.

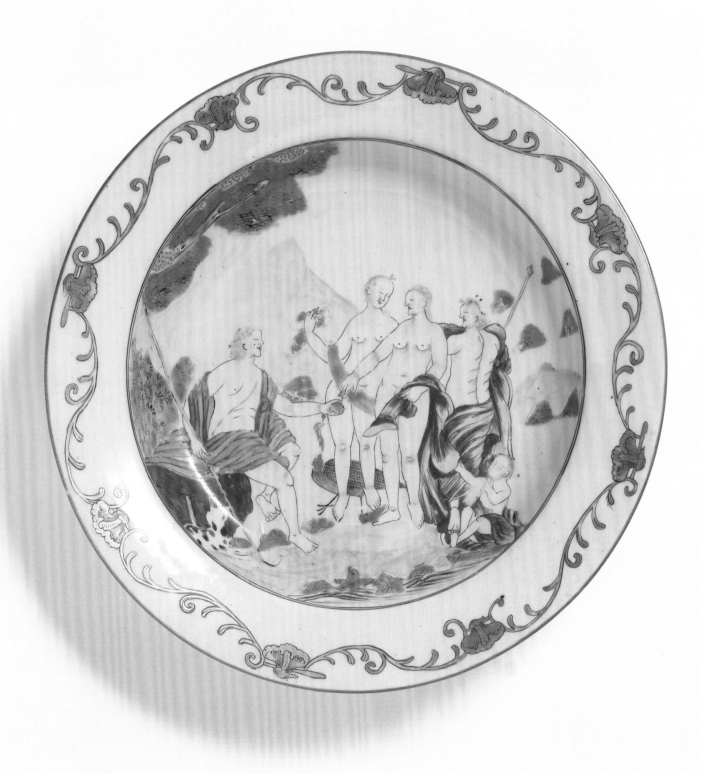

Hard-paste porcelain with
enamel-painted decoration
and gilding
Diameter 9 in (228 mm)
96.4.17.1

PROVENANCE
The Campbell Museum
purchased the soup plates
in 1966 from Cromer
Antique Gallery, Cromer,
Norfolk, Eng.

LITERATURE
*Selections from the Campbell
Museum Collection* 1972,
no. 86; 1976, no. 86; 1978,
no. 96; 1983, no. 11.

Transfer print of a Canton landscape, 1820–40, by William Gallimore, a designer and engraver who did considerable work for Wedgwood and other Staffordshire potters who used the prints to decorate earthenware. (Downs Collection, Winterthur Library.)

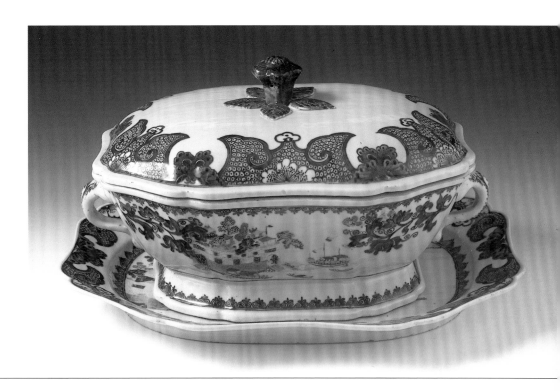

42 *Tureen*

JINGDEZHEN, CHINA, 1750–70

About the object This tureen of low rectangular form with faceted sides stands on a high foot and has simple loop handles and a flower finial. Tureens of this shape may occasionally be seen in European ceramics, particularly in British tin-glazed earthenware (see No. 118).

The underglaze-blue painted decoration forms a wide border, with butterflies separating panels of conventional, stylized flowers on a "fish-roe" patterned ground. Narrower bands of cloud scrolls border the rim and foot of the tureen and the cavetto of the stand. The body of the tureen is painted with horizontal scrolling-leaf sprays. Elements of these borders and the style of painting are echoed in English pottery (see No. 118).

The overglaze enamel-painted decoration is a Chinese river scene depicting Bogue Fortress, or Boca Tigris. This fort, at the narrow entrance to the Pearl River approaching the trading port of Guangzhou, or Canton, was known to the Chinese as the "tiger's mouth." The source of this view is not known. It is likely that it was based on a painting, drawing, or print produced for the Western market either by Chinese or visiting European artists. Painted pictures of the Pearl River became popular export items in the eighteenth century and were produced on a large scale after the rebuilding of the factories at Guangzhou following a disastrous fire in 1748. It is reasonable to suppose that this form of decoration would have the most significance for someone who recognized the scene; it was most likely a special commission for someone engaged in the China trade.

Hard-paste porcelain with enamel-painted decoration

Tureen:
Height 8 in (203 mm)
Length 15 in (380 mm)
Width 10 in (255 mm)

Stand:
Length 16 ¼ in (413 mm)
Width 13 in (330 mm)
96.4.96

PROVENANCE
Purchased by the Campbell Museum in 1974 from Matthew and Elisabeth Sharpe of Conshohocken, Pa.

43 *Tureen*

JINGDEZHEN, CHINA, 1760–70

About the object This tureen is modeled in the form of a seated Buddha. The lid joins the body at a line just below the breasts. The open garment of the Buddha appears to be decorated with underglaze color; details of his face are in overglaze enamel color. The figure is perhaps that of Budai Heshang, the "Laughing Buddha," who is always depicted as a corpulent seated figure with bare chest and stomach. He usually carries a cord of beads and a sack containing his worldly goods.[111] This Buddha has a sack in his left hand, but no beads are visible.

The Buddha may be considered a strange subject for a soup tureen. Certainly the interior contours suggest that serving and cleaning were not easy processes. But the eighteenth-century rococo fashion was full of excess and novelty.[112] The fantasy and exoticism of the Orient were a major element in design; perhaps this piece is a major expression of chinoiserie tableware.

Hard-paste porcelain with
underglaze and overglaze
painted decoration
Height 14 in (355 mm)
Length 13½ in (342 mm)
96.4.97

PROVENANCE
The tureen was purchased
from J. Rochelle Thomas in
1972 and given to the
Campbell Museum by Elinor
Dorrance Ingersoll.

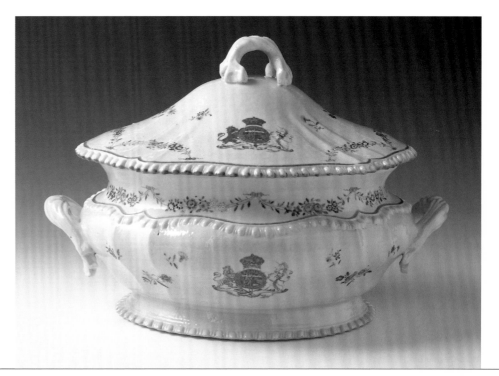

44 Tureen

JINGDEZHEN, CHINA, CIRCA 1770

About the object This tureen is of oval, bombé form standing on a deep foot. It is molded with pairs of vertical ribs and with gadrooning to the foot, neck, and rim of the lid. The handles on the lid and tureen are formed as twisted branches. The shape is based on popular, contemporary silver designs.

The overglaze enamel decoration is in the English taste. Random flower sprays and simple floral swags are painted in shades of pink, yellow, blue, and green; the swags are suspended from gilt bows. Extremely detailed coats of arms are placed centrally on the lid and body and are finely painted in enamel colors and gilding. David Sanctuary Howard, the leading scholar on Chinese armorial porcelain, has stated that "the arms are those of William Henry, 1st Duke of Gloucester and Edinburgh. William Henry was born in 1742, the

third son of Frederick Lewis, Prince of Wales, son of King George II. His eldest brother ascended the throne in 1760 as George III, and in 1764 he was created Earl of Connaught and Duke of Gloucester and Edinburgh.... He married ... in September 1766.... He died in 1805, when he was succeeded by his only son, William Frederick as second duke, but at his death in 1834, without heirs, the honors became extinct."[113]

Arms of William Henry,
1st Duke of Gloucester
and Edinburgh

Hard-paste porcelain with enamel-painted decoration and gilding
Height 10 ½ in (267 mm)
Length 16 in (407 mm)
Width 12 in (308 mm)
96.4.255

PROVENANCE
The tureen stayed with the service at Gloucester House and was sold with the Duke of Cambridge's effects in 1904. It was in the collection of Frederick Arthur Crisp, who privately published a catalogue of his own collection entitled

Armorial China in 1907. The tureen was not listed but was part of the Crisp sale at Puttick & Simpson, London, in 1923. It was purchased by the Campbell Museum in 1969 from Elinor Gordon, Villanova, Pa.

LITERATURE
Selections from the Campbell Museum Collection 1969, no. 53; 1972, no. 91; 1976, no. 91; 1978, no. 101; 1983, no. 18.

45 *Tureen*

JINGDEZHEN, CHINA, CIRCA 1770

About the object This tureen is molded in the form of the head of a water buffalo.[114] The naturalistic modeling includes transverse ridges on the horns, which are typical of the animal. The lid is formed by the upper half of the head; the bowl is formed by the lower half of the head, with extensions formed by the tongue and lower jaw. The open mouth and pierced nostrils would permit the escape of steam from hot soup, creating a dramatic sight as the wild beast appeared to breathe at the table. The tureen stands on a conventional oval underdish.

The head is decorated with overglaze enamels in natural colors with a narrow band of pink and gold scrolling foliage at the foot. The stand is painted with a central design depicting the buffalo head seen from above; there are four pink and gilt floral sprays in the well; a spearhead border edges the cavetto; and the rim has a pink and gilt scrolling-leaf border.

Porcelain tureens in the form of animal heads were made in China for the Western market and were popular in the 1760s. Other models include boars' heads and geese, which were ordered by the Dutch East India Company in Guangzhou in 1763.[115] Large soup tureens in naturalistic forms such as animals and vegetables were a fashionable expression of rococo taste in eighteenth-century Europe, and many were also made in local pottery and porcelain. A number of European ceramic boars' heads are recorded (see Nos. 80, 94), but there appears to be no Western equivalent to the Chinese water buffalo.

Tureen stand depicting the head of a water buffalo

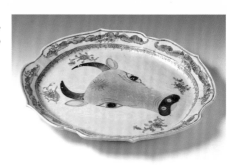

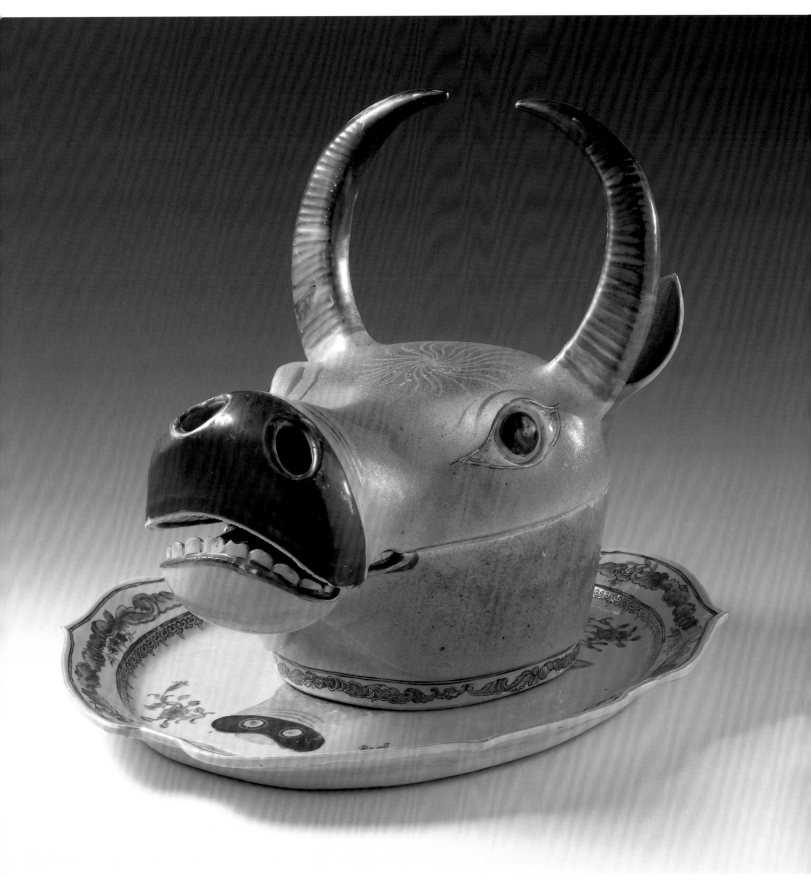

Hard-paste porcelain with
enamel-painted decoration

Tureen:
Height 15 ¼ in (387 mm)
Length 15 ¼ in (387 mm)
Width 10 in (252 mm)

Stand:
Length 19 ½ in (495 mm)
Width 17 ¼ in (438 mm)
96.4.234

PROVENANCE
The tureen was purchased
by the Campbell Museum
in 1966 from Louis Lyons,
New York.

LITERATURE
Gordon and Gordon, *Oriental
Lowestoft*, pl. 16.

*Selections from the Campbell
Museum Collection* 1969,
no. 52; 1972, no. 87; 1976,
no. 87; 1978, no. 97; 1983,
no. 12.

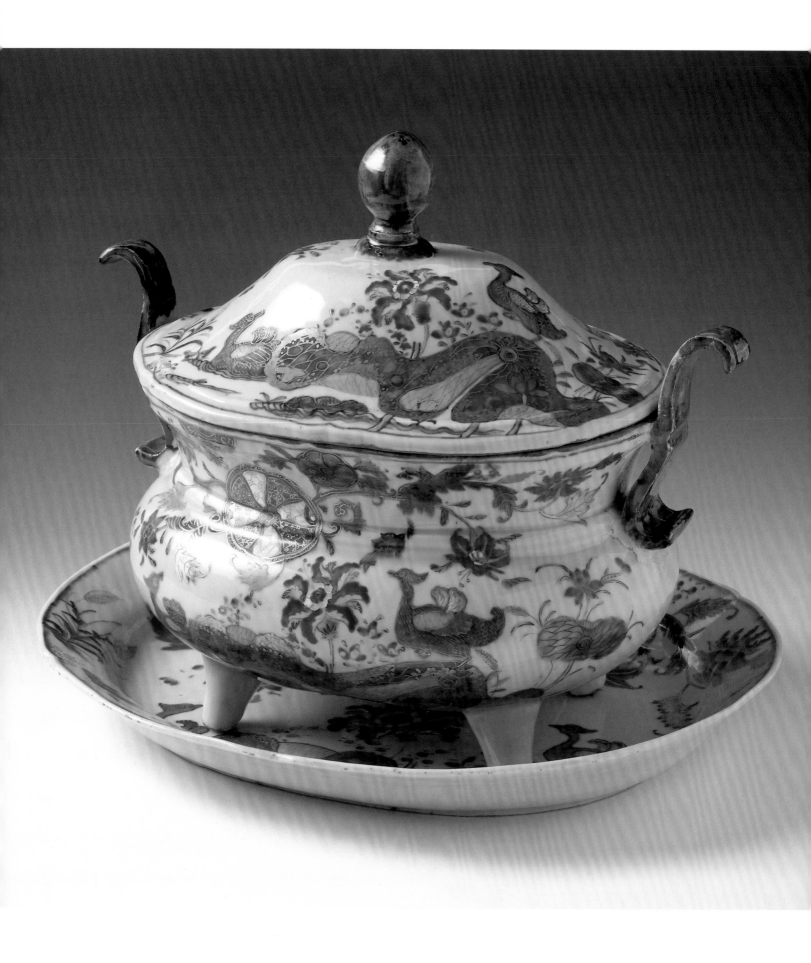

46 Tureen

JINGDEZHEN, CHINA, 1770–80

About the object This tureen resembles an original Chinese form more closely than others in the collection. The oval body swells beneath a deep collar and supports a simple lid with ball finial. The vertical handles and high feet recall the form of Chinese bronzes made in the traditional manner as incense burners or ritual food vessels.

The decoration is painted in underglaze-blue and overglaze enamels and gilt. The design is considered to be a variant of the "tobacco leaf" or "pseudo tobacco leaf" pattern. This name, commonly used for a whole range of bright foliage patterns, persists, even though scholars have pointed out that the pattern is not of tobacco leaves and that the plants are likely to be derived from European or Indian textiles—which in turn are inspired by the hibiscus and passion flower.[116]

This particular pattern is an early version in which the flowering elements float above a watery landscape; a mandarin duck sits on the river, and another walks on the bank. A later variant on this design was an allover pattern of leaves and flowers in a strong bright palette made for the American market in the nineteenth century.

Hard-paste porcelain with enamel-painted decoration

Tureen:
Height 12 in (308 mm)
Length 14 in (355 mm)
Width 9 ½ in (240 mm)

Stand:
Length 16 in (410 mm)
Width 11 in (278 mm)
96.4.251

PROVENANCE
This tureen was recorded in a private collection in Portugal prior to 1970, when the Campbell Museum purchased it from Fred B. Nadler, Bay Head, N.J.

LITERATURE
Selections from the Campbell Museum Collection 1972, no. 85; 1976, no. 85; 1978, no. 95; 1983, no. 10.

47 *Tureen*

JINGDEZHEN, CHINA, 1775–85

About the object This tureen is of oval, slightly bombé shape modeled with vertical lobes. The lid has a large finial of vegetable and leaf forms. The body stands on heavily modeled, scrolling-foliage feet. The upright scroll handles curve around bearded mask heads. A molded border of laurel leaves edges the oval, quatrefoil stand and rim of the tureen.

Tureens of this model are considered rare, but a number do exist and have been the focus of scholarly attention. It is generally believed that the form evolved from European silver and ceramic prototypes. The silver tureen from the Berkeley Castle service, made by Jacques Roëttiers in 1737, certainly indicates that inspiration was drawn from this source. In discussions about the origins of the shape, this tureen is usually described in relation to silver tureens made by Nicolas Roëttiers, son of Jacques, and of a later date.[117] The earlier tureen and stand from the Berkeley Castle service have a form, stand, feet, and finial that are similar to the Chinese porcelain example, but the handles are different. The porcelain examples seem to be versions of scroll-and-mask handles used at the Meissen factory about 1740.

The decoration of this tureen is painted in enamel colors with a coat of arms on each side of the tureen and on the stand. The naturalistic foliage at the feet and finial is in striking contrast to the more formal border in shades of puce and pink. This color palette was first used on porcelain in the early 1720s in combination with complex patterns and is generally known as *famille rose*. From the 1740s, designs became progressively simpler; border designs were narrower and were embellished with single flower heads or floral swags. The mask handles are painted and gilded in the European manner.

The most significant aspect of this decoration is the coat of arms with five stars in cross formation on a field azure above azure waves on a silver field. The motto NOMEN HONOR QUE MEIS translates as "Ours is the Name and Honor." The arms have been identified as those of the Sobral family of Portugal. In a letter to the Campbell Museum, it was suggested that the tureen was from one of six sets ordered by Anselmo José da Cruz Sobral.[118] Anselmo was one of three

Arms of the Sobral family

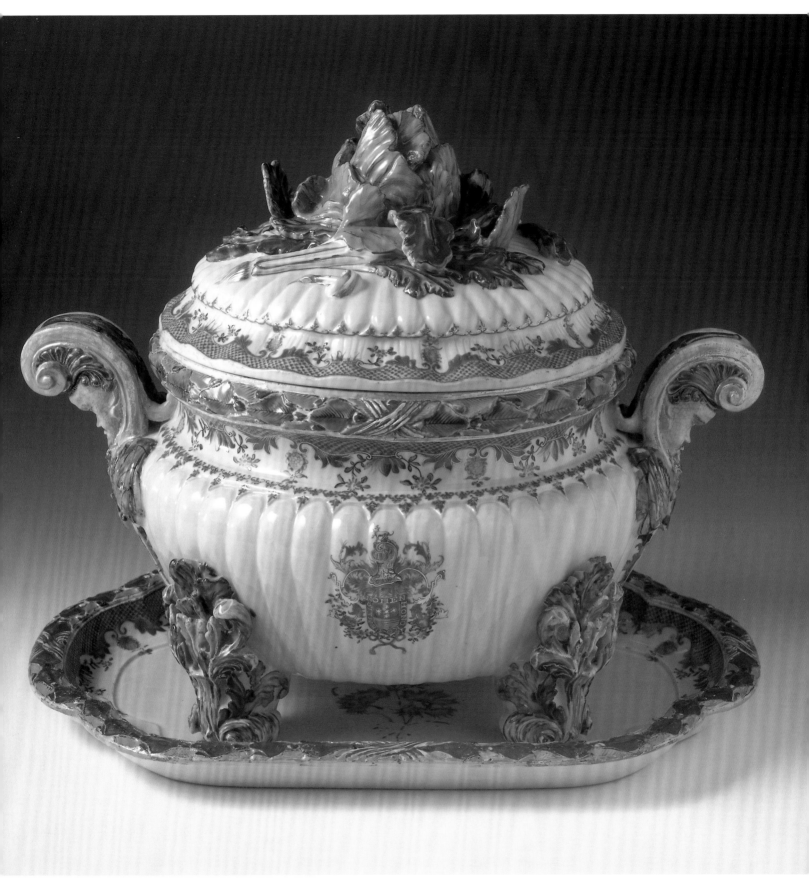

Hard-paste porcelain with
enamel-painted decoration
and gilding

Tureen:
Height 12 ½ in (315 mm)
Diameter 12 in (305 mm)

Stand:
Length 16 in (407 mm)
Width 12 in (305 mm)
96.4.196

PROVENANCE
The tureen was advertised
by J. Rochelle Thomas, New
York, in *The Connoisseur*
(December 1969) and was
presented to the Campbell
Museum by Elinor Dorrance
Ingersoll in 1969.

LITERATURE
*Selections from the Campbell
Museum Collection* 1972,
no. 88; 1976, no. 88; 1978,
no. 98; 1983, no. 13.

brothers who all rose to prominence during the rule of Prime Minister Sebastião de Carvalho e Melo, who held office in the period 1755–77. Anselmo was appointed to various offices including: Gentleman of the Royal Household, Knight of the Military Order of Christ, Member of the Treasury Council, and Administrator of the Tobacco Monopoly. Of the other brothers, José Francisco da Cruz Alagoa was Chief Treasurer of Portugal; at his death in 1768 Joaquim Inácio da Cruz returned from business ventures in Brazil and assumed a number of important positions in government and in the royal household of King José I. It was Joaquim who, for his outstanding services, was made *fidalgo* (meaning enobled) in 1773. He received the lordship of the town of Sobral, with the obligation to use the surname Sobral. Joaquim died in 1781 without children. Anselmo was one of his heirs, and he inherited the Sobral title.

We know something of Joaquim Inácio da Cruz from studies undertaken in Portugal.[119] He was responsible for ordering at least seven different services from China decorated with the Sobral arms, which were issued in 1773. The tureen in this collection may have been his from an additional service or may date to after 1783, when Anselmo inherited the title and arms.

48 *Soup plate*

JINGDEZHEN, CHINA, CIRCA 1799

About the object This simple, circular soup plate is painted in overglaze-blue enamel and gilt, with a central design of a classical urn-shape vase within concentric bands of scrolling leaves and dentil pattern. The whole design is based on shapes and motifs that typify the classical taste popular in America in the late eighteenth and early nineteenth centuries.

The plate is from a service made for the Dale family of Philadelphia and ordered by Capt. Richard Dale on his last voyage to China, in 1799. Dale began his career as a cabin boy, saw action in the Revolutionary War, was a captain in the China trade, and retired as one of the first commodores of the United States Navy.[120]

At age twelve, Dale, from Portsmouth, Virginia, signed up as a cabin boy bound for Liverpool under the captainship of one of his uncles. By 1775 he had risen to first mate. In the Revolutionary War he served as a lieutenant on a light cruiser and was captured and escaped a number of times during engagements with the British navy. He served with distinction as first lieutenant to John Paul Jones on the *Bonhomme Richard.*

By the 1780s Dale had begun his China trade ventures. He is recorded in 1787–88 in a Chinese glass painting entitled *Captain George Harrison of the* Alliance *and His Friends in Canton.* "First mate Richard Dale" is identified by his name in his hat band.[121] Dale remained lucratively employed in the merchant service until 1794, when George Washington appointed him one of the six captains of the new navy. By 1795 Dale had obtained leave from the navy to return to the China trade, and he sailed for Guangzhou in command of the *Ganges.* Three years later, his ship was purchased by the government when war with France threatened. Dale remained captain and made the first cruise undertaken by a vessel of the new navy. In dispute with naval authorities, he returned to China. His journey to Guangzhou in 1799 is likely to have been his last.

On settlement of the naval dispute in his favor, Dale once again served in the United States Navy. He was appointed commodore and saw action before he retired in 1802 with a comfortable fortune. He settled permanently in Philadelphia. His two sons both entered the navy: Richard was killed in action in 1815, and John M. died in service.

Hard-paste porcelain with enamel-painted decoration
Diameter 9 7/8 in (250 mm)
96.4.23.1

PROVENANCE
According to family tradition, the service descended through the marriage of Commodore Dale's daughter Sarah to Thomas McKean Petit; by their daughter Sally, Mrs. John Wilson, to her daughter Alice, Mrs. Robert E. Pent; and eventually to Richard Dale Pent, whose sister Alice sold it some time before 1950.[122] Two soup plates from this service were purchased by the Campbell Museum in 1974 from Matthew and Elisabeth Sharpe of Conshohocken, Pa.

49 *Set of spoons*

ROYAL COPENHAGEN PORCELAIN MANUFACTORY **COPENHAGEN, DENMARK, 1780–90**

Maker, artist, craftsman

In 1775 Franz Henrich Müller founded a porcelain factory in Copenhagen, Denmark. His artistic input came from a master modeler, Anton Carl Luplau, hired from the factory at Fürstenberg, Germany. German porcelain was the inspiration for many European factories, and Copenhagen was no exception. However, the large number of indigenous workers gave the products a distinctly Danish character.

In 1779 King Christian VII bought shares in the company and gave it the name Royal Copenhagen Porcelain Manufactory, which still exists today. The firm concentrated on providing inexpensive tableware for the general market; underglaze-blue painting was used for such pieces. However, at that time the factory also employed several skilled artists from Berlin who undertook enamel-painted decoration for luxury goods, which they produced on a smaller scale. During the nineteenth century the factory experienced a number of setbacks and a decline in its artistic importance and influence. In 1884 the Royal Copenhagen Porcelain Manufactory underwent a rebirth; the factory occupied new premises, employed new management, and received an infusion of artistic talent. This renaissance has ensured its continued success.

About the objects

The form of the spoons follows that of contemporary silver tablespoons. Each is painted with a similar pattern on the obverse and reverse: a bouquet of flowers in naturalistic colors on each side of the bowl and small florets at the end of the handle and at the top and bottom of the stem. The spoons are edged in gilt, and a molded cartouche on the handle is framed with gilt scrolls.

Spoons were made in porcelain by a number of eighteenth-century manufactories, but as they are particularly vulnerable at the thin, narrow part of the stem, they rarely survive. Single spoons and pairs of spoons are recorded, and examples may be seen in this collection. However, sets of twelve surviving intact are an exceptionally rare occurrence.

The factory mark of three wavy blue lines appears on the reverse.

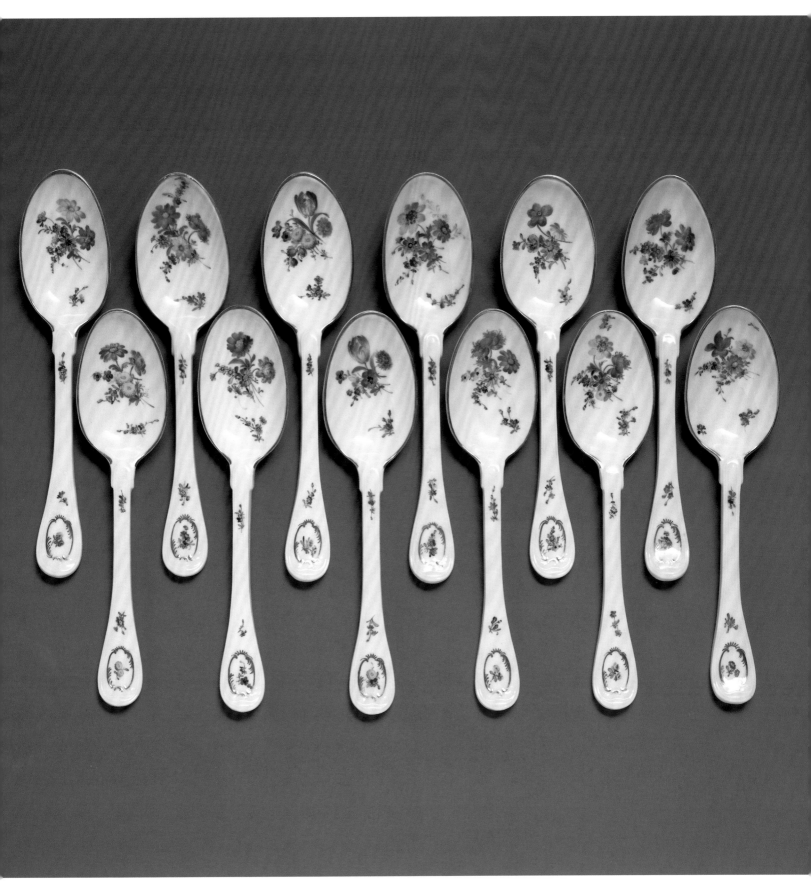

Hard-paste porcelain with
enamel-painted decoration
and gilding
Length 8 ¼ in (210 mm)
96.4.271.1–.12

PROVENANCE
The spoons were purchased
by the Campbell Museum
in 1975 from the Antique
Porcelain Company, New York.

LITERATURE
*Selections from the Campbell
Museum Collection* 1978,
no. 126; 1983, no. 22.

Vincennes/ Sèvres Porcelain Factory

The French porcelain industry evolved from a technology that did not, at first, rely on Chinese-style hard-paste porcelain; instead, they produced soft-pastes. The earliest of these probably was made in Rouen, where a patent was issued to Louis Poterat in 1673. He worked alone and in secrecy; if he produced porcelain, the output was small and ceased at his death in 1696. The first really successful factory was established at St. Cloud sometime between 1690 and 1693 and operated under letters patent (rights-of-production documents) from Louis XIV. The St. Cloud factory flourished well into the eighteenth century, closing in 1766 because of financial problems.

Sometime in the early 1730s, possibly in the late 1720s, soft-paste porcelain was perfected at Chantilly and later at Villeroy, the latter being continued at Mennecy and eventually Bourg-la-Reine. However, it was the Chantilly factory that had the greatest influence on what was to be the premier factory of France and, eventually, of late eighteenth-century Europe: Vincennes/Sèvres.

The first attempts at porcelainmaking at the château of Vincennes took place between November 1739 and February 1741. Claude-Humbert Gérin and brothers Robert and Gilles Dubois, who previously had worked at Chantilly, developed a porcelain that might have been inspired by Chantilly but differed from it. Jean-Henri Louis Orry de Fulvy, a former director of the French East India Company, assumed control of the factory, which was successful. On the death of Orry de Fulvy in 1751, Louis XV began to take an interest. He first acquired twenty-five percent of the company and in 1759 took over complete responsibility. In the summer of 1756 the factory had moved from Vincennes to new buildings at Sèvres, built on property belonging to Madame de Pompadour on the outskirts of Paris. With Louis XV's ownership came privileges and financial support, and the Sèvres factory flourished.

Factory products were often marked with the royal cipher, and from 1753 a series of letters was used to denote the year of production: "A" to "Z" appeared sequentially between 1753 and 1777; "AA" to "UU" connoted 1778 to 1798, with "I" and "J" both being used for 1786. In the early nineteenth century, other symbols were used to indicate the year. Artists responsible for making and decorating the porcelain also had symbols to identify their work; often these were letters either incised into the paste or painted in an inconspicuous place. Artists almost never signed their names in full, and it is not always possible to identify who made a particular piece.

In 1769 the Sèvres factory developed a hard-paste porcelain, which was simpler to produce and more stable during firing. The factory also developed new colors and working practices so that the artistic and technical qualities of the material matched the skills of the workforce. Sèvres was eminently equipped to produce luxury goods in the ornate French rococo taste, and the porcelain became the most desirable in Europe.

Because Louis XV had purchased the factory in 1759, Sèvres remained the property of the French Crown and ultimately of the French government. The firm survived the French Revolution and subsequently concentrated on hard-paste porcelain production. It abandoned soft-paste when the extremely gifted administrator Alexander Brongniart gained control and made the factory into a more commercial enterprise. The Sèvres factory gained recognition for the quality of its entries in many nineteenth-century exhibitions. The company is still known for the excellence of its productions.

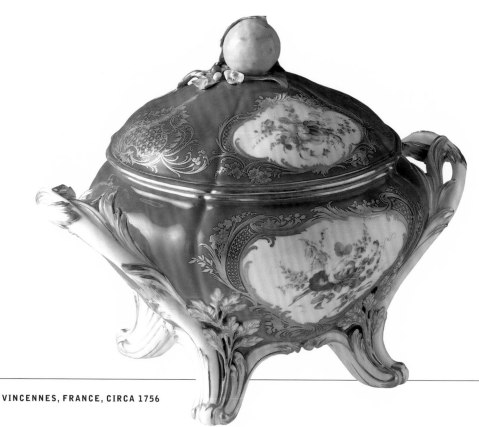

50 Tureen

VINCENNES PORCELAIN FACTORY VINCENNES, FRANCE, CIRCA 1756

Maker, artist, craftsman

The shape of this tureen is from a design by Jean-Claude Chambellan Duplessis. Duplessis was a talented goldsmith, sculptor, and designer who worked in Turin, Italy, before arriving in Paris about 1740 to work as a goldsmith and gilt-bronze founder. He was employed at Vincennes and Sèvres from about 1748 to 1774, designing shapes and working on bronze and ormolu mounts for porcelain. Duplessis's work is well recorded in the archives of the Manufacture Nationale de Sèvres.

The incised initials "JJ," or "gg," are recorded and represent the workman who formed the tureen; he has not yet been identified. Painter François-Joseph Aloncle used a script letter "N" similar to that found on this piece. He is known to have worked in the period 1758–81, after the Vincennes factory moved to Sèvres, where he specialized in animal and landscape painting. Although some suggest that the work of Aloncle cannot be identified before the Sèvres records, he may have been a painter of flowers and fruit during the Vincennes period. Therefore, this piece may be his work.[123]

About the object

The tureen is of bulbous form, molded with vertical indentations that divide the lid and bowl into four lobes. The bowl is supported by scrolling foliage that forms the feet and twists up to create the handles. Applied sprays of oak leaves curve up the body from the foliate feet. The finial is in the form of a lemon within flowers and leaves. The shape of this tureen is listed in the factory records as *pot-à-oille "du roi."* Some examples are known to have had silver liners so that hot soup could be placed into them at the table, ready for serving.[124] The shape was first produced for a service for Louis XV, commissioned in 1751 and delivered between 1753 and 1755. The form was popular, however, and continued to be produced until the 1790s.

The decoration of this tureen includes enamel-painted floral bouquets within gilt-framed cartouches reserved on a green ground. Chased gold floral sprays are painted around the cartouches and under the handles. The use of a ground color was a feature of Vincennes and Sèvres porcelain. Green was created using a copper base and was first produced on a large scale in 1756. It is said that the first complete service in green was that given by Louis XV in 1758 to the Danish King Frederick V.[125]

The underside is marked with a faint blue royal cipher, a script "N" in blue enamel, and the incised marks "JJ" or "gg."

Soft-paste porcelain with enamel-painted decoration and gilding
Height 9 in (226 mm)
Diameter 9 in (226 mm)
96.4.245

PROVENANCE
The tureen was formerly in the collection of Gilbert Lévy. It was illustrated on the cover of the catalogue of his sale at Hôtel Drouot, Paris, November 23, 1967. The Campbell Museum purchased the tureen in 1967 from the Lévy sale.

LITERATURE
Selections from the Campbell Museum Collection 1969, no. 40; 1972, no. 68; 1976, no. 68; 1978, no. 74; 1983, no. 66.

A *Painted mark*
B *Incised mark*

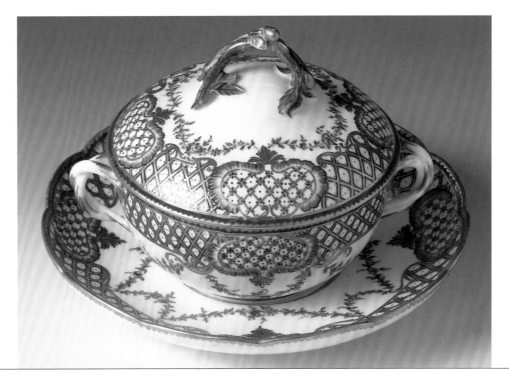

51 Bowl

SÈVRES PORCELAIN FACTORY SÈVRES, FRANCE, 1760–70

Maker, artist, craftsman

The incised mark "DU" on the base of the bowl represents the name of the workman who shaped this piece of porcelain. The letters possibly stand for Gilbert-François Duponchelle, who worked at Sèvres from about 1754 to 1768. Duponchelle's son, François-Philippe, also may have used this mark between 1757 and 1787.[126] "DU" appears on a range of soft-paste porcelain useful wares and is recorded on covered bowls in the 1760s.

About the object

This form of covered bowl was recorded at Sèvres as an *écuelle ronde tournée.* The bowl has handles in the form of entwined scrolls, and the lid has a handle in the form of a leafy branch. Sèvres made this shape in four sizes. One model was smaller than this one, and two were larger. This shape first appeared in 1752 and continued in production throughout the eighteenth century. The circular, twelve-lobed stand that accompanies this bowl is listed as a *plateau rond* by the Sèvres factory. The earliest known examples date from 1753; the shape was still in production

in 1790.[127] The enamel-painted decoration is of a trellis border with panels of diaper in pink, blue, and green enriched with heavy gilding. Swags of flowers painted in naturalistic colors are suspended from the trellis borders.

Covered bowls were a popular product of the Sèvres factory. They came in several different sizes and shapes. Not intended to be part of a dinner set, they were sold as individual service pieces and were meant for use in the bedroom or boudoir to serve bouillon or broth to sustain ladies and gentlemen during the long period of dressing. The stands, or plateaux, supported the bowl and held bread that was eaten with the soup.

The royal cipher mark is in gold on the base of the bowl and in blue on the base of the stand; an incised mark "DU" is on the base of the bowl.

Royal cipher mark

Soft-paste porcelain with enamel-painted decoration and gilding

Bowl:
Height 5 in (125 mm)
Length 6 ½ in (165 mm)

Stand:
Diameter 8 in (202 mm)
96.4.28

PROVENANCE
The Campbell Museum purchased this piece in 1968 from Nicolier, Paris.

LITERATURE
Selections from the Campbell Museum Collection 1969, no. 39; 1972, no. 67; 1976, no. 67.

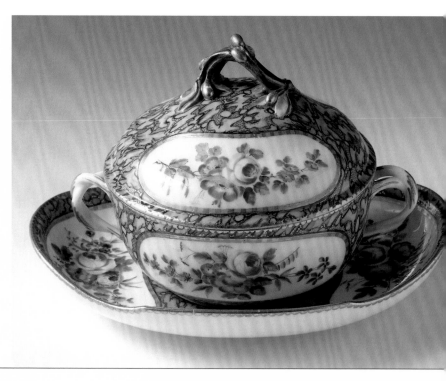

52 Bowl

SÈVRES PORCELAIN FACTORY SÈVRES, FRANCE, 1761

Maker, artist, craftsman

The artist's mark of three dots is noted in the Sèvres factory records as that of painter Jean-Baptiste Tandart, who began work at the Vincennes factory in 1754 and continued at Sèvres until about 1800. He died in 1816. He was especially skilled in the painting of flowers in sprays, wreaths, and garlands. His work is recorded on vases, teawares, services, other useful wares, and plaques for use on furniture.[128]

About the object

Round bowls, or *écuelles rondes tournées,* are first recorded at Sèvres in 1752; their popularity persisted until the end of the century. The bowl has two entwined-scroll handles; the handle on the lid is in the form of a laurel branch. Sèvres produced covered bowls in this shape in four sizes, of which there are one smaller and two larger versions.

The stand, or *plateau ovale d'écuelle,* is shaped with rounded ends and straight sides. This example is the smallest of the four sizes produced and was not introduced until 1761, the year in which this soup bowl
was made.

The bowl, lid, and stand are all decorated with a *rose marbré,* or rose-pink marbled ground, which

involved several processes to create the complex pink, blue, red, and gold *caillouté,* or pebble-pattern marbling. The gilt-framed, reserve panels are painted in enamel colors with floral bouquets by Tandart. Each bouquet has a solid center of large blooms with long sprays trailing on either side and infill of foliage and flower heads. The *rose marbré* ground is known on at least one other covered bowl and stand of this form, but that example has reserve panels painted with fruit and flowers.[129]

The royal cipher mark is painted on the base of the bowl in overglaze blue. The Sèvres factory used an alphabetical system of marks to signify the year of manufacture; the cipher on this bowl encloses the date letter "I" for 1761. Beneath the cipher is the artist's mark of three dots; the letters "DU" are incised on the base of the bowl and "dh" is incised in script on the stand. The incised marks relate to the worker responsible for forming the object—"DU" is thought to be a member of the Duponchelle family (see No. 51); the script "dh" is recorded on other pieces but has not been attributed to any one worker.

Royal cipher mark enclosing the date letter; artist's mark below

Soft-paste porcelain with enamel-painted decoration and gilding

Bowl:
Height 4 ⅛ in (105 mm)
Length (handle to handle)
6 in (153 mm)
Diameter 5 ⅛ in (130 mm)

Stand:
Length 7 ⅛ in (181mm)
96.4.265

PROVENANCE
The Campbell Museum purchased this piece in 1968 from Winifred Williams, Eastbourne, Sussex, and London, Eng.

LITERATURE
Selections from the Campbell Museum Collection 1969, no. 42; 1972, no. 70; 1976, no. 70; 1978, no. 76; 1983, no. 78.

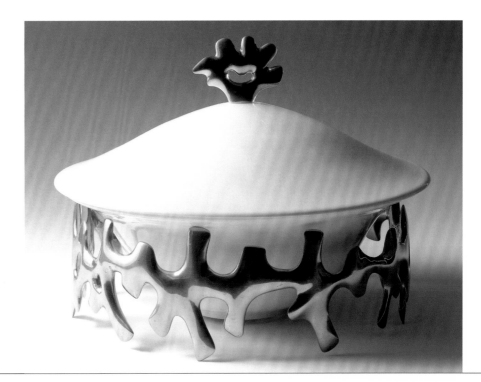

53 Tureen

SÈVRES PORCELAIN FACTORY SÈVRES, FRANCE, DESIGNED 1970

Maker, artist, craftsman

This tureen was designed by Étienne Hajdu, a Romanian who introduced new forms and new decorations to Sèvres in the 1970s. Hajdu managed to design porcelains of the finest quality with little reference to the traditional repertoire. His work speaks eloquently of modern design, in which the starkness of form and extraordinary quality of materials and finish create an object that is both useful and beautiful.

About the object

The tureen and lid are of deceptively simple shape. Plain, white porcelain in such an undecorated expanse has to be flawless; imperfections cannot be hidden under a painted leaf or printed border design. Chinese forms may have inspired the shape of the bowl and lid, but the exaggerated width owes everything to Hajdu's sense of style. The tureen is suspended on a nickled steel stand; its contorted, abstract form is in direct contrast to the smooth, rounded bowl and cover. The silver sheen surprisingly complements the grey-white porcelain body, and the exuberant finial displays the artist's confidence in his use of materials.

The tureen was designed as part of a service for French president Georges Pompidou.[130] The Sèvres factory contracted to make no more than twenty examples. Four were made: two for President Pompidou, one for the artist, and one for the Campbell Museum.

Marks on the base include the standard blue royal cipher and brown printed factory mark together with "17 Hajdu 70" painted in blue and "JH 10 70 AA" incised near the footring.

Hard-paste porcelain with nickeled steel stand and finial
Height 12 in (305 mm)
Diameter 15 ¾ in (401 mm)
96.4.46

PROVENANCE
The Campbell Museum purchased this tureen in 1972 from the Sèvres porcelain factory.

A *Printed factory mark*

B *Royal cipher mark*

C *Artist's mark*

PRÉSIDENCE DES ÉTATS-UNIS D'AMÉRIQUE

— ·⟩◉⟨· —

	Potage tortue verte.
HORS D'ŒUVRE.	Petites croustades à la Reine.
POISSON.	Filets de basse rayée, au gratin.
RELEVÉS.	Langues de veau à la Béchamel.
	Dinde sauvage à la Régence.
ENTRÉES.	Côtelettes de mouton à la Soubise.
	Boudins de perdreaux à la Richelieu.
	Suprême de volaille aux truffes.
	Pain de gibier à la Belle-Vue.
	Sorbets à l'Américaine.
RÒTS.	Canvass-Back-Ducks.
	Faisans bardés, au jus.
ENTREMETS.	Petits pois et asperges.
	Charlotte russe.
	Macédoine de fruits.
	Abricots à la Condé.

~~~~~~~~~

*Diner de 25 couverts, servi au président Grant, à Washington,
par M. Adolphe Hardy (maison Gauthier).*

# 54 *Plate*

**HAVILAND & COMPANY    LIMOGES, FRANCE, 1873**

*Maker, artist, craftsman*

In contrast to the central position occupied by Sèvres in late eighteenth-century Europe, Limoges experienced its greatest success after 1850. The first factory was established in the 1780s and specialized in making blanks for the Sèvres factory. Independent industrial expansion and commercial success did not arrive until the middle of the nineteenth century. David Haviland, a New York dealer and ceramic importer, was a catalyst in the rise of the Limoges factories. Haviland first visited France in 1840 and settled in Limoges in 1842. He exported French porcelain to Haviland Brothers for distribution across America. He then set up his own porcelain decorating firm and was successful by 1855.

Unfortunately, the Civil War created some financial difficulties for the New York–based office, and the American company declared bankruptcy. Haviland then concentrated his efforts in France and established Haviland & Co. with his sons, Charles and Théodore. Charles took the leading role in the business in 1865. The Haviland company began making their own porcelain and continued to deal with other Limoges factories on behalf of American clients. The Havilands were able to supply blanks from their own factory or from

Hard-paste porcelain with printed and enamel-painted decoration and gilding
Diameter 9 ½ in (240 mm)
96.4.16

PROVENANCE
It is believed that the soup plate was made to Grant's order in 1873. Congress authorized sales of outdated White House furnishings; thus, pieces came into public ownership. This plate was auctioned at Sotheby Parke Bernet, New York, November 17, 1972, and was purchased by the Campbell Museum.

LITERATURE
*Selections from the Campbell Museum Collection* 1978, no. 79; 1983, no. 82.

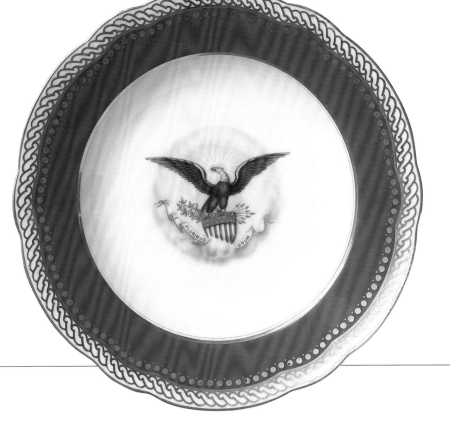

nearby porcelainmakers and continue their specialist decorating business. They introduced new techniques into the factory, and through the last decades of the nineteenth century, they produced fine tableware and ornamental pieces, which were popular in the American market. The family continued in porcelainmaking, and as time passed they established new partnerships and new companies. In 1972 the last of the Havilands retired, but the company continues working with both traditional and new designs, always producing porcelains of the finest quality.

*About the object*

This simple, circular soup plate is molded with a twelve-lobed rim. The decoration comprises an American eagle mounted on a national shield, which is above the motto *E Pluribus Unum.* The design is printed in outline and overpainted with enamel color. The border is a purple ground with gilt decoration.

President and Mrs. Abraham Lincoln first ordered a service of this pattern with the "solferino pink" or "royal purple" border in 1861 from Messrs. E. V. Haughwout & Co. of New York. Haughwout had designed this pattern and exhibited examples in the

New York Crystal Palace Exhibition of 1853. It is traditionally believed that the Haughwout firm ordered blank porcelain shapes from Haviland in Limoges for decoration on their own premises in New York. Following the assassination of President Lincoln in 1865, President Andrew Johnson assumed office. The White House china was not in good condition and was insufficient for Johnson's needs; he therefore ordered a large number of additional pieces. Haughwout supplied these in 1866. Johnson was succeeded in office by Ulysses S. Grant. President and Mrs. Grant ordered State services in other china patterns and in 1873 supplemented the Lincoln service with additional pieces they ordered from the retailer J. W. Boteler and Brothers of Washington, D.C., who used marked blanks from Haviland. It was some years later when the last presidential order was given for china in this pattern. In 1884 President Chester A. Arthur added thirty dishes to the service, again through Boteler.

A mark printed in red on the reverse reads "FABRIQUÉ PAR HAVILAND & CO. POUR J. W BOTELER & BRO WASHINGTON."

*Printed mark on reverse*

# *Meissen Porcelain Factory*

The acquisition of Chinese porcelain was a consuming passion for many royal and noble families of Europe in the late seventeenth century. The desire to secure an unlimited personal supply of this precious material inspired some to pursue the secrets of its manufacture.

The first successful Chinese-style porcelain made in Europe was developed under the patronage of Augustus the Strong (1670–1733), elector of Saxony and king of Poland. As a consequence of Augustus's obsession with porcelain, intensive experimentation was conducted to discover the ingredients and techniques of production. Ehrenfried Walther von Tschirnhaus (1651–1708) and Johann Friedrich Böttger (1682–1719) worked together in Dresden, and there they discovered the secrets of making fine, dense, high-fired, red stoneware. Shortly after Tschirnhaus's death in 1708, the first hard-paste porcelains were produced, and Augustus established a small factory nearby at Meissen.

Böttger was involved in porcelain and stoneware production at Meissen until his death in 1719. In 1720 Johann Gregor Höroldt (1696–1775) joined the staff as a painter, and his talents were such that he eventually became art director. His painterly influence is particularly dominant in the 1720–35 period. In 1731 the extremely gifted modeler Johann Joachim Kändler (1706–75) was appointed to create life-size animal figures to decorate the new Japanese Palace planned by Augustus. The palace and the collection were an eclectic mix of oriental and oriental-style works. The porcelains included pieces from Augustus's factory at Meissen, where Japanese-inspired designs were fashionable from about 1727 to 1740. In 1733 Augustus the Strong died and was succeeded by his son, Augustus III (1696–1763). The management of

the Meissen factory was of less interest to the new king, and Heinrich Count von Brühl (1700–1763) became its director. Under Brühl's direction, Kändler's work was brought to prominence. His talents as a sculptor found outlet in the creation of exquisite small porcelain figures and the design of elaborate table services.

Despite the proliferation of porcelain companies in the first half of the eighteenth century, Meissen continued to be the most dominant factory in Europe until the 1760s. From the earliest days, other countries offered sanctuary to any workers willing to escape from Meissen with the secrets of porcelainmaking. Eventually, rival establishments were set up in Germany, Austria, France, and Italy. At the time other European factories were becoming proficient, the town of Meissen was subjected to invasion and occupation by the Prussians. Frederick the Great (1712–86) occupied Dresden in 1744 during the Second Silesian War. During the Seven Years' War (1756–63), production slowed, and the factory was occupied and looted.

The combination of circumstances in which the interruption of production and development occurred with the rise of other European porcelain factories inevitably led to Meissen's decline. Although porcelainmaking has continued to the present day, by the end of the eighteenth century the finest period of Meissen was over.

MEISSEN ARTISTS AND CRAFTSMEN

*Johann Gregor Höroldt*  Höroldt was a skilled porcelain artist and ceramic chemist who worked at Meissen from 1720 to 1765. He developed a full range of enamel colors for use in the factory, and he supervised other painters. Inspired by prints and engravings acquired by Meissen in 1720 (including Dutch landscape prints and a number of chinoiserie engravings by Peter Schenk the Younger), Höroldt created a lively, colorful interpretation of China and the Chinese people. Working from some of these prints,

Höroldt made preparatory drawings for painting on porcelain. One hundred and thirty-two sheets of Höroldt's sketches, thought to date between 1720 and 1730, were collected and preserved by a Georg Wilhelm Schulz in the early twentieth century; they are referred to as the Schulz Codex. Scenes from the Schulz Codex appear in various combinations on porcelain from the 1720s until about 1740.

*Christian Friedrich Herold*   After training in Berlin as a painter in enamels and raised gold work, Herold moved to Meissen, where he was employed at the factory from 1725 until shortly before his death in 1779. He was an extremely talented painter who specialized in harbor scenes and landscapes.

*Johann Gottfried Klinger*   Klinger was employed as a flower painter at Meissen from 1726 to 1746, but his name is more often associated with shadowed insects. He later worked at the Vienna porcelain factory. A single signed piece of his work for Meissen is recorded.

*Johann Gottlieb Kirchner*   Kirchner was hired as a sculptor at Meissen in 1727. He had worked primarily with stone monumental pieces, and for a time he found it difficult to master models in clay and wood on a smaller scale. Personal problems as well as his inability to realize the expectations of his employers led to termination at Meissen in 1728. He then left the district to resume his occupation as a sculptor. Meissen, however, had no more luck with his successor and in 1730 rehired Kirchner, as master sculptor. He is recorded as having designed thirty handles,

finials, feet, and various relief ornaments. Nevertheless, his second term of office was also problematic. In 1731 a young and talented modeler Johann Joachim Kändler, joined Meissen, and in 1733 Kirchner finally left the factory.

*Johann Joachim Kändler*   A talented sculptor and modeler, Johann Joachim Kändler was hired by Meissen in 1731—principally to model life-size porcelain animals for Augustus the Strong's Japanese Palace. However, when Augustus died in 1733, he was succeeded by his son, who had little enthusiasm for the project. Kändler therefore had to find a new outlet for his talents. He was appointed *Modellmeister* at Meissen and concentrated on designing table services and small figures. His work was encouraged in the 1730s and 1740s by the influential minister and court favorite Count Heinrich von Brühl, who became director of Meissen. Kändler remained at the Meissen factory until his death in 1775.

*Johann Friedrich Eberlein*   Eberlein was employed at the Meissen factory from 1735 to 1749; he worked as Kändler's assistant. They were responsible for producing a wide range of useful and ornamental shapes, including tableware with relief and molded surface patterns.

*Hausmaler*   The literal translation of *hausmaler* is housepainter. With reference to porcelain, however, it refers to a ceramic artist who works independently. Some artists may have a workroom within their residences; others may have separate studios or workshops. Most *hausmaler* bought porcelain in the glazed white state and added enamel and gilt decoration; occasionally, pieces they acquired from Meissen already had simple decoration, such as underglaze-blue painting.

# 55 Tureen

MEISSEN PORCELAIN FACTORY    MEISSEN, GERMANY, 1730–35

*Maker, artist, craftsman*

The design of this tureen shape, particularly the handles, is attributed to Johann Gottlieb Kirchner. The decoration is in a style usually attributed to Christian Friedrich Herold although it is also associated with Johann Georg Heintze, who worked at Meissen from about 1720 to 1749. The consummate skill of the many Meissen painters makes it difficult to identify the work of individual hands.

*About the object*

This tureen is a standard oval shape, popular at Meissen in the 1730s. The finial is an elaborate though conventional form; the handles on the body are of female masks surmounted by plumed headdresses. The handles on the stand are intricate scrolls applied on the vertical axis. A later development of this form can be seen in Nos. 57 and 59.

The body of the tureen and the top of the lid have a complex pattern of burnished gold. A narrow border around the lid is painted in gold with a trellis-and-scroll design. The trellis is overlaid by a wash of iridescent pink luster known as "Böttger luster"—named after Johann Friedrich Böttger, the Meissen factory administrator who developed the hard-paste porcelain body and introduced this decoration.

Within the overall gold ground are eighteen reserve panels with enamel-painted coastal and harbor views. The bowl and lid have large quatrefoil panels on each side painted in enamel colors with detailed scenes of travelers waiting at the waterside. One scene depicts a camel carrying a large pack. The narrow trellis-and-scroll border has oval reserve panels, also painted in enamel colors with shipping and harbor subjects. Around the finial and between the large panels on the lid are smaller circular and quatrefoil vignettes, enamel painted in purple *camaïeu*. The handles of the tureen are enamel painted with red and yellow plumes.

The stand has a gold resist border with oval reserve panels painted in enamel colors. The central area of the stand is bordered by a trellis-and-scroll design in gold, with Böttger luster framing enamel-painted scattered flower sprays. The flowers are inspired by a style of decoration on oriental porcelains known at Meissen as *Indianische Blumen*.

The crossed swords mark is painted in underglaze blue on the base of the tureen and stand. There is an incised mark inside the footring of the stand and on the base of the tureen.

A  *Crossed-swords mark on base*

B  *Incised mark*

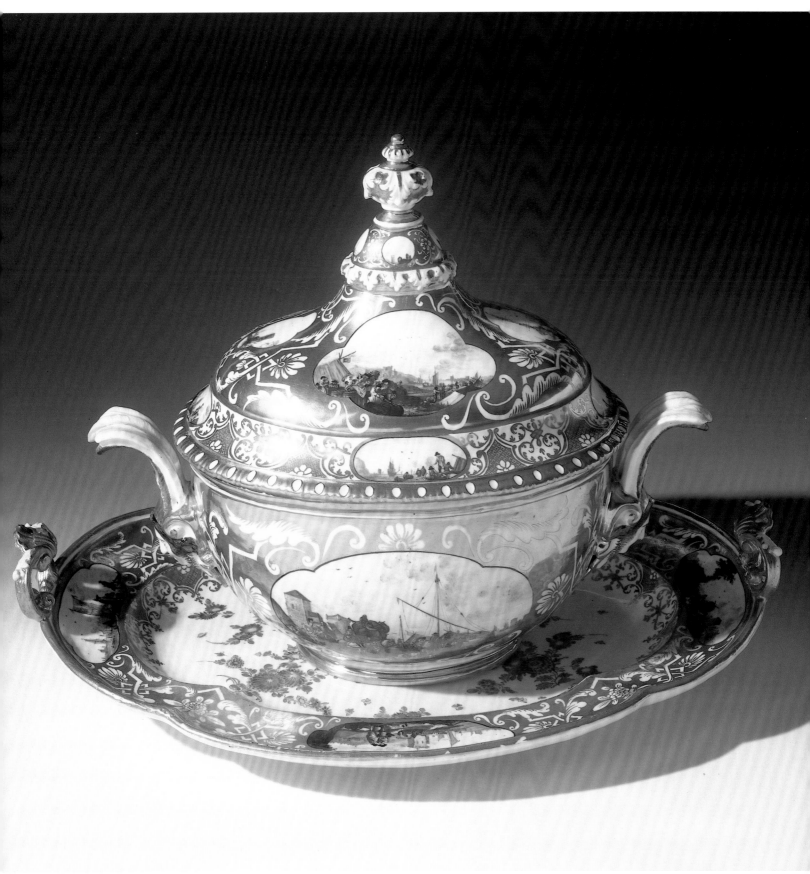

Hard-paste porcelain with
enamel-painted decoration,
gilding, and luster

Tureen:
Height 11 in (280 mm)
Length 13 in (332 mm)
Width 7 in (180 mm)

Stand:
Length 16 in (406 mm)
Width 11 ¾ in (299 mm)
96.4.5

PROVENANCE
Formerly in the collection
of Dr. F. Mannheimer, this
tureen was sold at Frederick
Muller & Cie in Amsterdam,
October 15, 1952, lot 276.
By 1965 it was the property
of the Antique Porcelain
Company, New York, from
whom the Campbell Museum
purchased it in 1969.

LITERATURE
DeYoung Museum,
*Continental Table
Porcelains*, no. 59.

*Selections from the Campbell
Museum Collection* 1969,
no. 27; 1972, no. 41; 1976,
no. 41; 1978, no. 40; 1983,
no. 88.

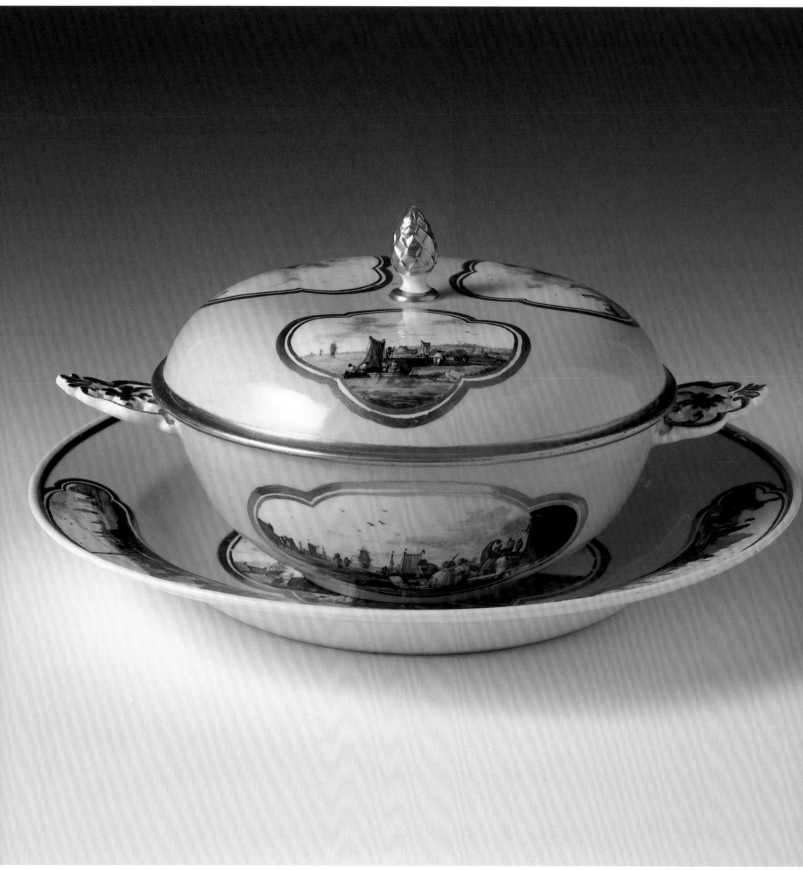

Hard-paste porcelain with
enamel-painted decoration
and gilding

Bowl:
Height 4 ¼ in (108 mm)
Length 8 ⅝ in (217 mm)
Width 6 in (154 mm)

Stand:
Diameter 9 ⅜ in (238 mm)
96.4.261

PROVENANCE
This covered soup bowl was
described as "The Property
of a Nobleman" when
it was sold at Sotheby's,
London, November 26, 1968,
lot 115. It was purchased
from the sale on behalf of
the Campbell Museum.

LITERATURE
*Selections from the Campbell
Museum Collection* 1969,
no. 25; 1972, no. 40; 1976,
no. 40; 1978, no. 39; 1983,
no. 87.

# 56 *Bowl*

**MEISSEN PORCELAIN FACTORY     MEISSEN, GERMANY, CIRCA 1735**

*Maker, artist,*
*craftsman*

The enamel-painted decoration is in the style of
Christian Friedrich Herold.

*About the object*

The simple, circular bowl has flat, molded handles
and a tall artichoke-molded finial on the lid. The form
is derived from metal originals such as the silver-gilt
example in No. 1. The bowl and lid are decorated with
a yellow ground, first produced at Meissen about 1725.
There are quatrefoil reserve panels on the front
and reverse of the bowl, three similar panels on the
lid, and one in the center of the stand. The rim of the
stand has three long oval reserves. The handles and
the reserves are all edged with gilding.

The enamel-painted decoration in the reserves
depicts harbor scenes. Each vignette illustrates a dif-
ferent subject with a combination of European and
Oriental traders, bales of merchandise, and river and
delta views. The underside of the stand is painted
with three flowering branches in the oriental style
known at Meissen as *Indianische Blumen.*

The crossed swords mark is painted in underglaze
blue on the base of the bowl and stand. An indistinct
numeral is impressed on the footring of the stand.

*Crossed-swords mark*
*on base*

# 57 Tureen

**MEISSEN PORCELAIN FACTORY    MEISSEN, GERMANY, CIRCA 1738**

*Maker, artist, craftsman*

The tureen was designed under the direction of Johann Joachim Kändler and Johann Friedrich Eberlein. The decoration is in the style of Johann Gregor Höroldt.

*About the object*

This tureen is of a standard oval plan, based on a design attributed to J. G. Kirchner and produced by Meissen in the early 1730s (see No. 55). The design of this later model is attributed to Kändler and Eberlein in 1737–38. It is larger than the earlier model, and the vulnerable handles on the stand are no longer part of the design.

The decoration of the tureen and stand is a complex series of patterns using enamel-painted decoration, gilding, and Böttger luster.[131] The design includes borders and cartouches in *Laub-und-Bandelwerk*, a formal leaf-and-strapwork ornament of late German baroque taste, painted in gold with washes of pearl Böttger luster. There are large cartouches on each side of the tureen and lid. The lid also has borders at the rim and at the base of the finial. The stand has a large central cartouche with a border at the rim.

The main enamel-painted panels depict fantastic Chinese-style scenes painted in the manner of Johann Gregor Höroldt. The scene on the stand may be found in the Schulz Codex drawings, folio nos. 41 and 42; it is derived from a print by Peter Schenk the Younger. The scenes on the tureen and lid depict Chinese figures sitting at tables in gardens. The illustration on the lid derives partly from a print by Augsburg engraver Martin Engelbrecht.[132] The borders contain long quatrefoil reserves with European harbor scenes enamel painted in purple *camaïeu*. The combination of European and Chinese subjects is unusual.

The crossed swords mark is painted in underglaze blue on the base of the stand; "25" is impressed on the base of the tureen.

B

A *Crossed-swords mark on base of stand*

B *Impressed mark on base of tureen*

A

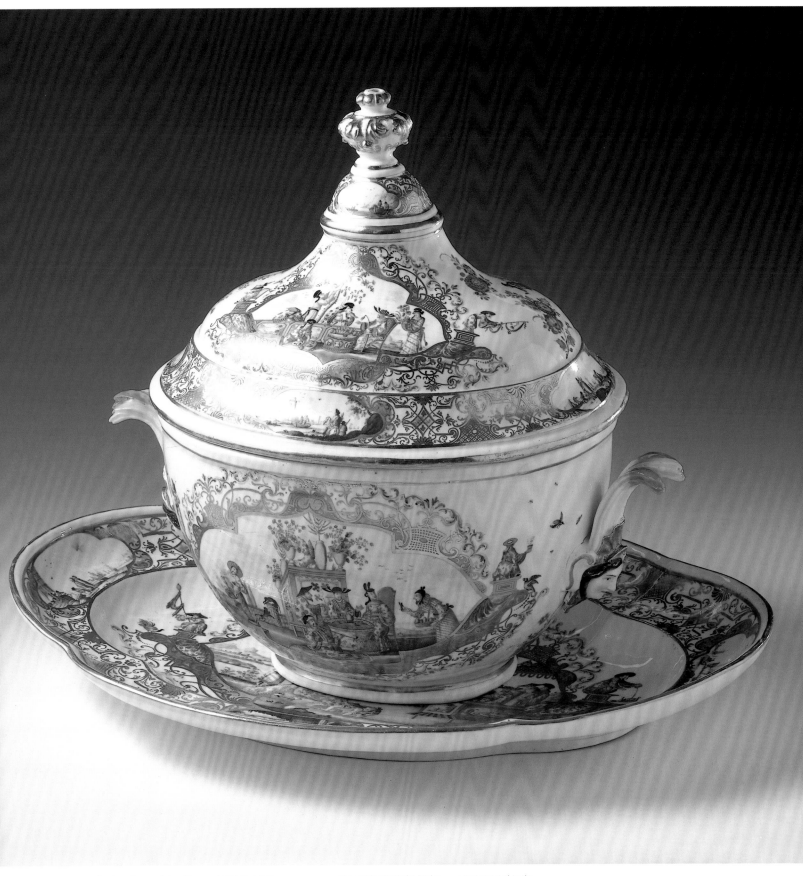

Hard-paste porcelain with enamel-painted decoration, gilding, and luster

Tureen:
Height 13 in (330 mm)
Length 14 in (358 mm)
Width 8 ½ in (216 mm)

Stand:
Length 17 ½ in (444 mm)
Width 13 in (330 mm)
96.4.164

PROVENANCE
This tureen first came to notice in 1958, when it was lot 142 in a sale of "Important Continental Porcelain" held at Sotheby's in London. In 1972 it formed part of the collection of Fritz Katz sold at Sotheby Parke Bernet in New York. By 1979, as part of "The Christner Collection of Important Continental and English Ceramics," it was sold at Christie's, New York, as the property of Mrs. John W. Christner, of Dallas, Tex. In December 1979 it was presented to the Campbell Museum by John T. Dorrance Jr.

LITERATURE
*Selections from the Campbell Museum Collection* 1983, no. 84.

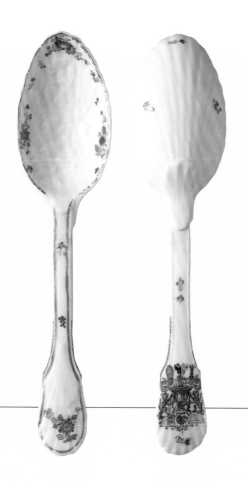

## 58 *Spoon*

**MEISSEN PORCELAIN FACTORY**  **MEISSEN, GERMANY, 1737–41**

*Maker, artist,*
*craftsman*

This spoon is from one of the most famous services designed by Johann Joachim Kändler with the assistance of Johann Friedrich Eberlein.

*About the object*

The spoon was part of the Swan Service, so called because of the dominant theme of swans incorporated into the design of each piece. The service was commissioned by Heinrich Count von Brühl to commemorate his marriage to Gräfin Maria Anna Franziska von Kolowrat-Krakowska in 1737. The service was enormous, with estimates of its original size ranging from 2,200 to 2,400 pieces. The bowl of this spoon is modeled with three swans amid reeds on rippling water.

The shallowly molded details are within an enamel-painted border and floral sprays. The reverse of the bowl is molded with flutes radiating from a scallop shell, and the handle is painted with the arms of the Brühl family, all with tiny floral sprays painted in a random manner. The spoon is edged with a gilt band, and the Brühl arms are detailed in gold.

Hard-paste porcelain with
enamel-painted decoration
and gilding
Length 7 ¼ in (184 mm)
96.4.257

PROVENANCE
The service remained in the
Brühl family until just after
the Second World War, when
pieces began to appear on
the market. This spoon was
presented to the Campbell
Museum in 1969 by John T.
Dorrance Jr.

LITERATURE
*Selections from the Campbell*
*Museum Collection* 1969,
no. 29; 1972, no. 46; 1976,
no. 46; 1978, no. 46; 1983,
no. 95.

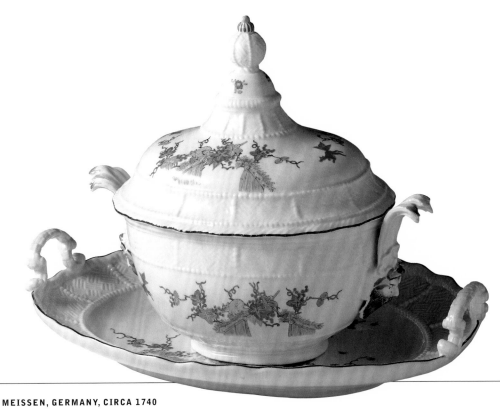

# 59 Tureen

**MEISSEN PORCELAIN FACTORY       MEISSEN, GERMANY, CIRCA 1740**

*Maker, artist, craftsman*

Johann Joachim Kändler designed the first basket-weave border for Meissen tablewares about 1732, revising and modifying the pattern in the 1740s. In 1735 Count Alexander Joseph von Sulkowsky ordered a table service with the first basket-weave, or *ordinair-ozier,* border. The service, decorated with the arms of Sulkowsky and his wife, Maria Franziska Freiin von Stein zu Jettingen, is so well known that the name *Sulkowsky* is often used to describe the border molding.

*About the object*

This deep, oval tureen has handles in the form of bearded, male, mask heads with foliate headdresses. The stand has scroll handles applied on the vertical axis. The borders are molded in relief with a basket-weave pattern. This shape was probably the earliest used for soup tureens modeled at Meissen and dates from about 1732.

   The mask-head handles of the tureen are painted in naturalistic enamel colors with green and yellow laurel wreaths and green and yellow-tipped plumes. The enamel-painted decoration on the body and stand derives from a Japanese prototype made in Arita, with characteristic colors and motifs known as *Kakiemon.* The pattern seen on this tureen has been given many names by collectors but is currently identified as the "red and yellow squirrel" pattern.[133] Japanese porcelains were particularly popular in Europe during the early eighteenth century. Augustus the Strong of Saxony and Poland was an enthusiastic collector of oriental porcelain, including *Imari* and *Kakiemon* wares from Arita, Japan. His Japanese Palace in Dresden was created for the display of his collections, which included European and oriental porcelains. *Kakiemon*-inspired decoration was popular at Meissen from the late 1720s throughout the 1730s.

   The crossed swords mark is painted in underglaze blue on the base of the tureen and stand; "27" is impressed on the base of the stand.

Hard-paste porcelain with enamel-painted decoration

Tureen:
Height 10 ¾ in (273 mm)
Length 13 in (330 mm)
Width 7 in (176 mm)

Stand:
Length 15 ⅞ in (403 mm)
Width 11 ½ in (280 mm)
96.4.92

PROVENANCE
The Campbell Museum purchased the tureen in 1970 from the Juerg Stuker Gallery, Bern, Switz.

LITERATURE
*Selections from the Campbell Museum Collection* 1972, no. 44; 1976, no. 44; 1978, no. 43; 1983, no. 91.

*Crossed-swords mark on base*

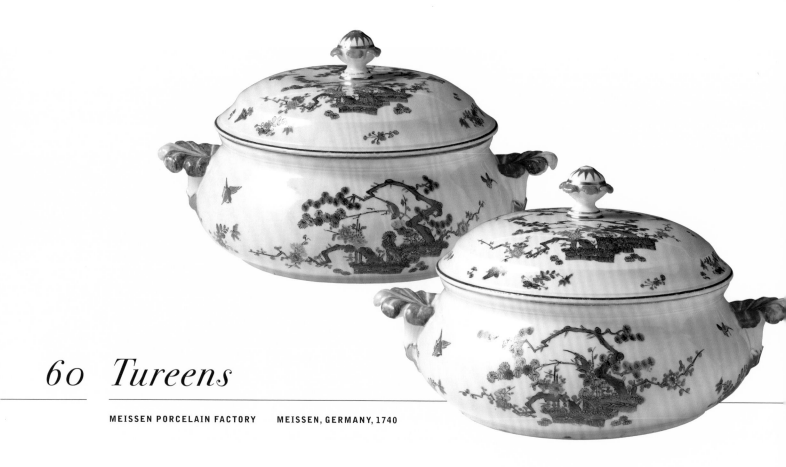

# 60 Tureens

**MEISSEN PORCELAIN FACTORY    MEISSEN, GERMANY, 1740**

*About the objects*    The tureens are of a low, circular form; the lid has a simple stylized, floral finial, and the body has handles in the form of spreading plumes. The enamel-painted decoration derives from Japanese porcelain painted in the *Kakiemon* style and palette.[154] The pattern depicts a small bird perched amid branches of pine, prunus, and bamboo, which form the *shochikubai,* or "three friends of winter"—known as the "three friends" pattern. The plumes of the handles are painted in strident shades of yellow, puce, and iron-red, in contrast to the restricted use of color in *Kakiemon* decoration. The base of the handles, the finial on the lid, and the edge of lid are decorated with gilding. Although *Kakiemon*-style designs were particularly popular, the "three friends" pattern is less common. Porcelain factories including Chantilly and St. Cloud, in France, and Chelsea and Bow, in England, also produced pieces with variations of this design.

The crossed swords mark is painted in underglaze blue; the number "20" is impressed on the base of the tureen.

Hard-paste porcelain with
enamel-painted decoration
and gilding
Height 8 in (203 mm)
Length 13 ½ in (343 mm)
Width 11 in (278 mm)
96.4.274.1, .2

PROVENANCE
The tureens were given to
the Campbell Museum
in 1978 by Mr. and Mrs.
Edward M. Pflueger.

LITERATURE
*Selections from the Campbell
Museum Collection* 1983,
no. 85.

A    *Crossed-swords mark
on base*

B    *Impressed mark on
base*

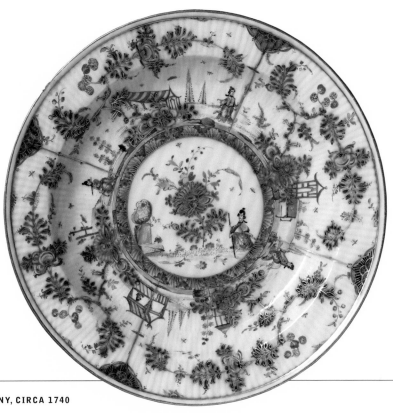

# 61 *Plate*

**MEISSEN PORCELAIN FACTORY    MEISSEN, GERMANY, CIRCA 1740**

*Maker, artist, craftsman*

This soup plate is in a style traditionally said to be that of F. J. Ferner and his workshop. Little is known of Ferner, and the earliest author to discuss his work illustrates pieces with distinctly European subjects rather than the Chinese-style scenes now also attributed to him. Ferner may have been trained in the workshop of Franz Ferdinand Meyer of Pressnitz; their work may bear similar characteristics.[135] Ferner's workshop appears to have been in operation from about 1740 to 1750 and specialized in applying enamel painting to Meissen underglaze-blue, factory-decorated wares.

*About the object*

This circular soup plate is molded with a plain, circular central panel; a design of closely fluted ribs radiates outward. The blue decoration is painted under the glaze, and the simple floral design is a standard factory pattern known as *Strohblumenmuster,* or "strawflower" pattern. Chinese-style figures and landscapes have been added in overglaze enamel colors and gold by an independent decorator, creating a unique design.

The tradition of independent enamel decorators was established in the mid seventeenth century in Germany. Such decorators operated out of small workshops and painted in enamel colors or gold onto glass, metal, and ceramic surfaces. They used whatever supplies of Chinese—and from the 1720s and 1730s, Meissen and Vienna—porcelains that were available. The Meissen factory tried to discourage the practice, but supplies were available throughout most of the eighteenth century. The *hausmaler,* or independent decorators, were responsible for a wide variety of decorative styles, from exquisite gilding of glazed white pieces to the enlivening of simple, underglaze-blue, factory-produced designs.

The crossed swords mark is painted in underglaze blue.

Hard-paste porcelain with underglaze-blue painted decoration; enamel-painted decoration and gilding added at a later date
Diameter 8 7/8 in (225 mm)
96.4.85

PROVENANCE
The Campbell Museum purchased the soup plate in 1970 from Herbert Asenbaum, Vienna.

LITERATURE
*Selections from the Campbell Museum Collection* 1972, no. 43; 1973, no. 43; 1978, no. 42.

*Crossed-swords mark on reverse*

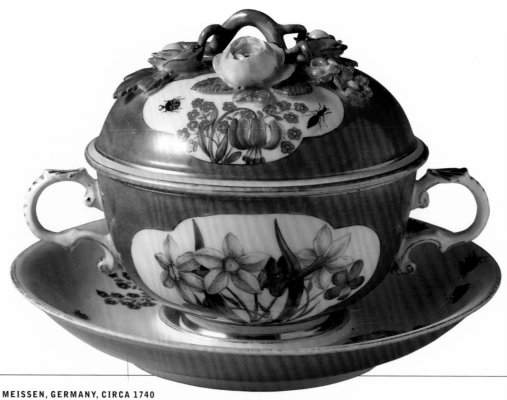

# 62 Bowl

**MEISSEN PORCELAIN FACTORY    MEISSEN, GERMANY, CIRCA 1740**

*Maker, artist, craftsman*

The decoration of this piece is attributed to Johann Gottfried Klinger.[136]

*About the object*

The small, circular bowl and stand are of simple form with complex scroll handles on the body and a freely modeled twig handle on the lid terminating in a colorful spray of flowers. The tureen and lid are decorated with a purple ground color with quatrefoil reserve panels. The stand has a purple ground on the underside. The edges of the panels, rims, and handles are all banded with gilding. The reserve panels and face of the stand are painted in enamel colors with floral sprays and insects (a style of painting known as *Holzschnittblumen*) or with flowers from woodcut prints. Such decoration portrays an increasing interest in a more naturalistic style of botanical illustration rather than the stylized oriental flowers popular in the 1730s. *Holzschnittblumen* are occasionally depicted with shadows, but on this piece only the insects exhibit this characteristic.

The crossed swords mark is painted in underglaze blue on the bases of the stand and bowl; "6" is impressed on the footring of the stand; "10" is impressed at the footring of the bowl.

A  *Crossed-swords mark painted on base*

B  *Impressed numeral "6" on footring of stand*

Hard-paste porcelain with enamel-painted decoration and gilding

Bowl:
Height 4 ¾ in (110 mm)
Length 6 ½ in (166 mm)
Width 4 ¼ in (106 mm)

Stand:
Diameter 6 ⅞ in (175 mm)
96.4.83

PROVENANCE
The covered soup bowl was purchased by the Campbell Museum in 1969 from Dr. George Segal of M. Segal, Basel, Switz.

LITERATURE
*Selections from the Campbell Museum Collection* 1969, no. 28; 1972, no. 45; 1976, no. 45; 1978, no. 44; 1983, no. 92.

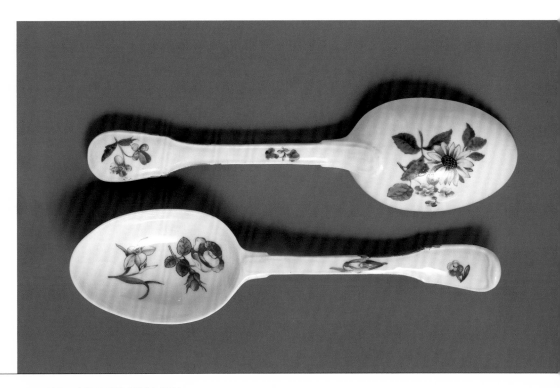

# 63 Spoons

**MEISSEN PORCELAIN FACTORY**     **MEISSEN, GERMANY, CIRCA 1740**

*Maker, artist, craftsman*

The flower decoration on these spoons is in a style usually attributed to Johann Gottfried Klinger.[137]

*About the objects*

These table spoons are unusual ceramic survivors. Spoons were made in large numbers in many ceramic bodies during the eighteenth century, but they were extremely vulnerable and usually broke at the stem. The form is based on metal shapes popular at that time.[138]

The enamel-painted decoration comprises floral sprays with one tiny winged insect in one of the spoon bowls. The floral painting style known as *Holzschnittblumen,* derived from the floral designs from woodcuts found in contemporary botanical texts. Some of the flower sprays have linear brushwork resembling the engravings that they copied.

Hard-paste porcelain with
enamel-painted decoration
Length 7 ¾ in (197 mm)
96.4.272.1, .2

PROVENANCE
The Campbell Museum
purchased these spoons in
1975 from the Antique
Porcelain Company, New
York.

LITERATURE
*Selections from the Campbell
Museum Collection* 1978,
no. 45; 1983, no. 94.

Where given

Occasion.

*Vice President - Mrs Sherman*

Date *Tues March 30*
*Dinner*

| Guests Present. | Menu. |
|---|---|
| *Ke 8%* | |
| *Vice President - Mrs Sherman* | *Caviar on Toast* |
| *Japanese Ambassador - Baron Takahira* | *Mushroom Soup* |
| *Pafs - Mr Jusserand* | *Brook trout - tartares* |
| *Argentine Minister - Mad Portela* | *Lamb - vegetables* |
| *Senator - Mrs Scott* | *Moussed Faie gras* |
| *Admiral - Mrs Emory* | *Pheasants - Salad* |
| *Sec of Navy - Mrs Meyer* | *Berry Ice Cream* |
| *Senator - Mrs Burrows* | |
| *Senator Smith - Mrs Small* | |
| *Mr Jordan Cumming   Miss Lear* | |
| *Rep - Mrs Weeks* | |
| *Mrs Heald - Miss Tuckerman* | |
| *Benny         Mrs Say* | |
| *General Emp - Mrs Leiter* | Wines. |

Unable to attend.

*Mrs Jordan Cumming*
*French Ambassador*

Particulars of Table Decorations. *Brustifel baskets with pink binneraria*
*- deutzia.*
*Very different - unusual.*

# 64 *Bowl*

## MEISSEN PORCELAIN FACTORY        MEISSEN, GERMANY, 1740–45

*About the object*

This covered bowl is of spherical shape, and it stands in a deep saucerlike stand. All the top surfaces are encrusted with handmade and applied flowers in a style known as *Schneeballen,* or snowball. The handles are modeled in the form of twisted vines and terminate in sprays of leaves and grapes. There are also sprays of grapes and vines on the lid and on the stand. A portrait bust of Athena, the Greek goddess of war, rises from the flowers as a finial.

The snowball effect is created by rows of individual flower heads, painted in enamel colors with a yellow center and radiating veins of red. The interior of the bowl is completely gilded. Beneath the stand are three flower sprays separated by insects painted and chased in gold. The fruiting vine meandering through the snowball and forming the handles is enameled in green with bunches of grapes in purple and burgundy.

On each side of the lid and in the center of the stand is a large armorial cartouche painted in full color. The arms are those of Alexis Madeleine Rosalie de

A

B

A  *Detail of painted battle scene*

B  *Crossed-swords mark painted on base*

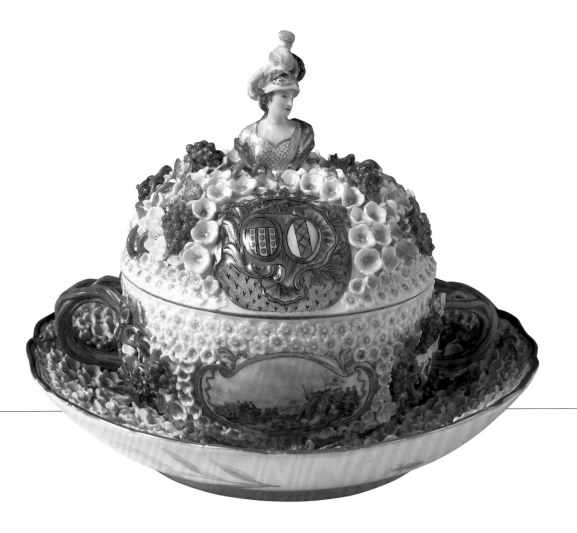

Châtillon of Champagne and his second wife, Anne Gabrielle Le Veneur de Tillières of Normandy and Brittany. The Comte de Châtillon was a military man, entering the army as a colonel in 1703 at the age of thirteen and rising to the position of Maestre de Camp Général de la Cavalerie in 1735. In the following year he became the governor of Monseigneur le Dauphin, the son and heir of Louis XIV, king of France and Navarre. In the same year he took his seat in the French parliament and was elevated to the title of Duché Prairie de Châtillon. He died in 1754. His second wife also came from a military family. Her father was brigadier of the king's armies. They were married in 1725; she lived until 1781.[139]

On each side of the bowl is an asymmetrical cartouche enclosing enamel-painted scenes of military engagements. The battles traditionally are believed to depict the War of Austrian Succession and to derive from contemporary engravings by Georg Philipp Rugendas. The coats of arms relate to military families who were involved in French conflicts in the early eighteenth century, but they are not recorded as participants in the War of Austrian Succession, which took place in the period 1740–48. However, the bowl was made at that time, and the current military exploits may have been thought an appropriate decoration.

The crossed swords mark is painted in underglaze blue on the bases of the bowl and stand; the impressed mark "9" (or "6") is at the footring of the bowl.

Hard-paste porcelain with
enamel-painted decoration
and gilding

Bowl:
Height 7 in (178 mm)
Diameter 8 in (202 mm)

Stand:
Diameter 9 ⅛ in (232 mm)
96.4.197

PROVENANCE
The Campbell Museum
purchased this piece in 1970
from M. Segal, Basel, Switz.

LITERATURE
*Selections from the Campbell
Museum Collection* 1972,
no. 49; 1976, no. 49; 1978,
no. 51; 1983, no. 99.

# 65 Tureen

MEISSEN PORCELAIN FACTORY    MEISSEN, GERMANY, 1744–45

*Maker, artist,*
*craftsman*

The low-relief molding on this tureen is attributed to Johann Friedrich Eberlein, who designed a number of molded border patterns for table services in collaboration with Johann Joachim Kändler.

*About the object*

The globular-shape tureen and lid are molded into eight vertical segments. These are modeled in low relief with sprays of flowers alternating with plain panels. The circular stand is also formed in eight lobed segments with alternating plain and floral molded sprays. The center of the stand has a circlet of molded flowers. The finial is in the shape of a lemon, half-peeled and surrounded by nuts and cloves and supported on conventional scrolls. The relief molding is known as the "Gotzkowsky" pattern, named for Johann Ernst Gotzkowsky, who first ordered a service in this style in 1743–44. Gotzkowsky was a financier in Berlin; in the 1760s, he owned his own porcelain manufactory.

*Deutsche Blumen,* or German flowers, are painted in enamel colors on two panels of the lid, bowl, and stand. These portray popular European flowers of the eighteenth century, in contrast to the stylized *Indianische Blumen* inspired by oriental porcelain imports. Additional enamel-painted and gilt decoration includes panels with the imperial Russian double eagle blazoned with the figure of St. George and the Cross of the Order of St. Andrew, the first called of the apostles. The cross also bears the inscription "SAPR," for *Sanctus Andreas Patronus Russiæ,* St. Andrew Patron Saint of Russia.

The service was commissioned by Augustus III of Saxony as a gift to Empress Elizabeth I of Russia. The service, comprising in excess of 570 pieces, is listed in the factory records of 1744.[140] This piece still bears the inventory mark of the Hermitage, the imperial household at St. Petersburg.

The crossed swords mark is in underglaze blue on the base of the tureen and on the stand. There is a red enamel worker's mark beneath the stand; "20" is impressed on the tureen, and "21" is on the stand. The Russian inventory mark is beneath the lid and stand in red paint.

A

B

C

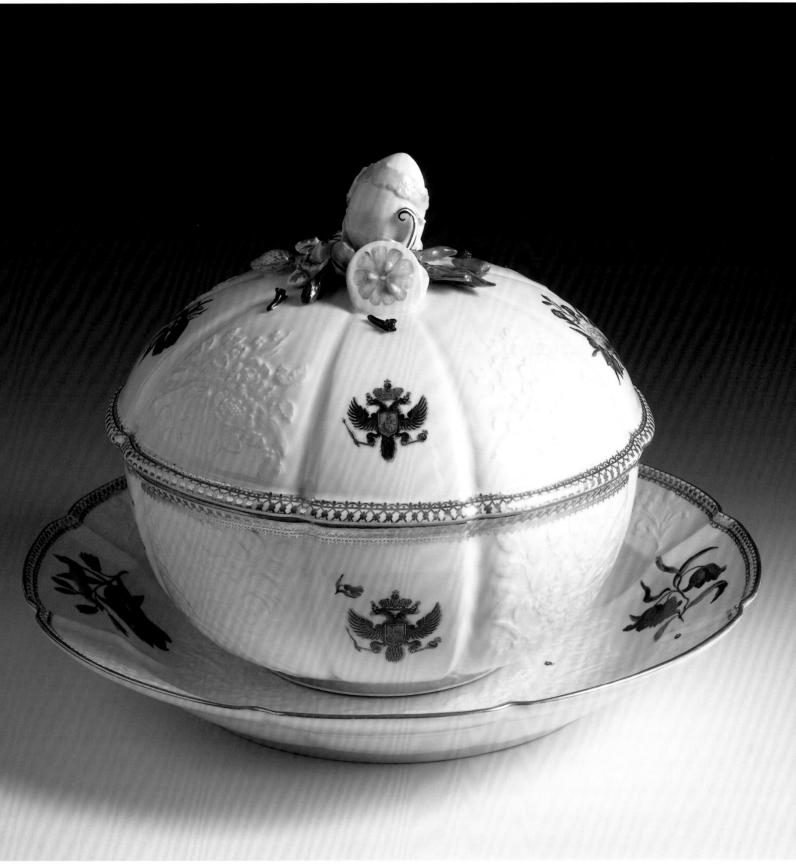

A  *Crossed-swords mark on base*

B  *Imperial Russian eagle emblazoned with St. George*

C  *Cross of St. Andrew*

Hard-paste porcelain with enamel-painted decoration and gilding

Tureen:
Height 9 ¾ in (248 mm)
Diameter 10 ⅛ in (257 mm)

Stand:
Diameter 14 ½ in (368 mm)
96.4.106

PROVENANCE
The tureen is from the collection of Catalina von Pannwitz, Castle Hartekamp, Holland. It was purchased in 1976 from Rosenberg & Stiebel, New York, by Mrs. Elinor Dorrance Ingersoll as a gift for the Campbell Museum.

LITERATURE
*Selections from the Campbell Museum Collection* 1978, no. 48; 1983, no. 96.

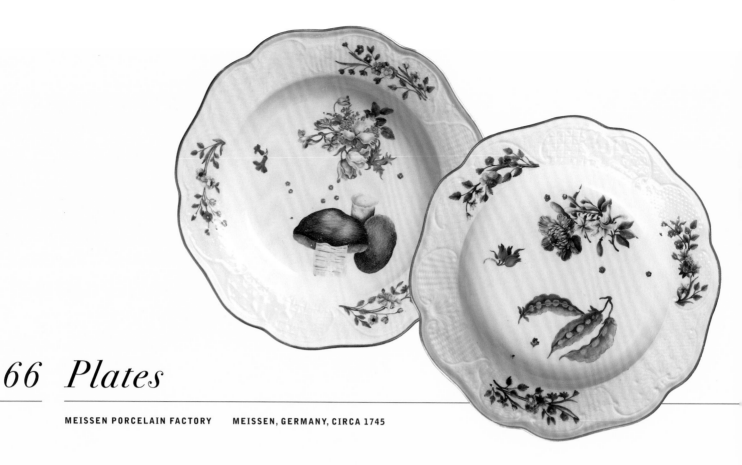

# 66 *Plates*

**MEISSEN PORCELAIN FACTORY    MEISSEN, GERMANY, CIRCA 1745**

*Maker, artist, craftsman*

The modeling of the relief border pattern is attributed to Johann Friedrich Eberlein.

*About the objects*

The soup plates are circular with a lobed rim. The border pattern is modeled in low relief with six panels of decoration, including an anthemion leaf on a basket-weave ground, a shell on a star-diaper ground, and an acanthus leaf on a closely trellised ground. These alternate with similar scrolled panels on which sprays of flowers are molded and painted in enamel colors. The center has designs of flowers and vegetables—pea pods on one plate (.1) and mushrooms on the other (.2). *Deutsche Blumen,* or German flowers, are scattered in a random fashion. The smallest flower heads often cover slight imperfections in the body. The plates are edged with gold.

The molded design is known as *Brühlsche-Allerlei,* meaning Bruhl's mixed pattern, referring to the diversity of molding. The design was first created in 1742 for a service ordered by Count Heinrich von Brühl, administrator of the Meissen factory from 1733 to 1763. Dessert plates in this service have pierced borders.[141]

The crossed swords mark in underglaze blue and impressed mark "21" are on the reverse of plate .1. The crossed swords mark above two dots in underglaze blue and impressed mark "20" are on the reverse of plate .2.

Hard-paste porcelain with enamel-painted decoration and gilding
Diameter 9¾ in (247 mm)
96.4.81.1, .2

PROVENANCE
These plates were purchased from the Antique Porcelain Company, New York, in 1975, by the Campbell Museum with funds provided by Elinor Dorrance Ingersoll.

LITERATURE
*Selections from the Campbell Museum Collection* 1978, no. 49; 1983, no. 97.

A

B

A *Crossed-swords mark on base of .1*

B *Crossed-swords mark on base of .2*

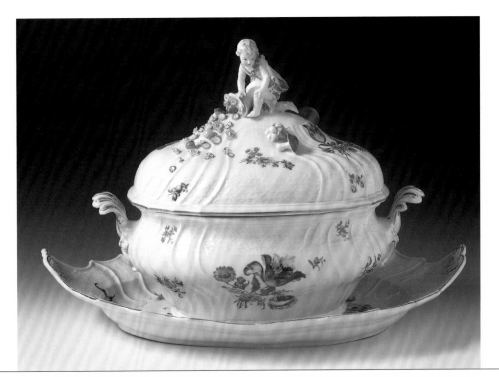

# 67 *Tureen*

**MEISSEN PORCELAIN FACTORY     MEISSEN, GERMANY, CIRCA 1750**

*Maker, artist, craftsman*

The basic form of this tureen was standardized by Johann Joachim Kändler about 1740.

*About the object*

This is perhaps one of the more frequently found tureen shapes from Meissen. The relief molding was developed from a border pattern known as *Alt-Brandenstein,* named after Count Brandenstein, master of the royal household who ordered the first service in this pattern in 1738. The original relief design had groups of ribs radiating in the border. In 1744 the *Neu-Brandenstein* pattern was introduced; the straight, radial ribs were replaced by sensuous, curving ribs more in tune with rococo taste. The finials on this style of tureen can vary from conventional foliate forms to more sculptural devices. This tureen has an ambitious finial in the form of a boy kneeling aside an overturned cornucopia from which fruit, vegetables, and flowers tumble out over the cover.

The tureen and stand are painted in enamel colors with large and small sprays of flowers in a naturalistic style that became popular on German porcelain in the 1740s. These *Natürliche Blumen* were not directly derived from botanical illustrations but were part of the porcelain painters' conventional floral vocabulary. The edges of the tureen, cover, and stand are banded with gilding.

The crossed swords mark is painted in underglaze blue (now faint) on the base of the tureen and stand; "54" and "4" are impressed on the stand.

Hard-paste porcelain with enamel-painted decoration and gilding

Tureen:
Height 12 ¼ in (311 mm)
Length 15 in (382 mm)
Width 8 ½ in (210 mm)

Stand:
Length 19 in (483 mm)
Width 11 ¾ in (299 mm)
96.4.223

PROVENANCE
The tureen was purchased by the Campbell Museum in 1966 from Winifred Williams, Eastbourne, Sussex, and London, Eng.

LITERATURE
*Selections from the Campbell Museum Collection* 1969, no. 31; 1972, no. 50; 1976, no. 50; 1978, no. 52; 1983, no. 100.

A Crossed-swords mark on base

B Impressed numerals "54" and "4" on base of stand

A

B

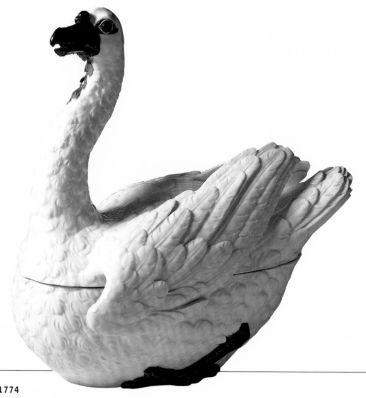

# 68 *Tureen*

**MEISSEN PORCELAIN FACTORY**   **MEISSEN, GERMANY, AFTER 1774 (POSSIBLY NINETEENTH CENTURY)**

*Maker, artist, craftsman*   Johann Joachim Kändler modeled this tureen.

*About the object*   The tureen is modeled in the form of a male swan. The lower body forms the bowl of the tureen; the upper body, tail, neck, and head form the lid. The wings are partially open and trail down over the join. The bird's partially open bill reveals a saw-edge to the upper and lower mandibles; his tongue is visible, and a trail of pond weed hangs out of the mouth down to the neck.

The white porcelain represents the main body of the bird. The surface is deeply molded and probably detailed by hand to represent the full plumage. Enamel color is reserved for the green weed, black bill, red tongue, and black and red eyes.

This model appears to be one of a pair of swans recorded in Kändler's *taxa*, or journal, which notes work completed or in progress. The journal men-

tions that a pair of swan tureens was designed and modeled by December 1773. Kändler also notes that the tureens were of delicate size and formed with a vivacious or alert appearance. The tail was not spread, but the wings were slightly raised upward from the body as part of the lid. Two swan models were made— one a reflection of the other to form a true pair and make an appropriate appearance at the dining table.[142]

There are traces of a crossed swords mark in underglaze blue on the base.

A   *Impressed mark*

B   *Incised mark*

Hard-paste porcelain with enamel-painted details
Height 15 in (380 mm)
Length 14 ½ in (370 mm)
96.4.228

PROVENANCE
The tureen was formerly in the collection of James Donahue of Long Island. It was sold by his executors

at Parke-Bernet Galleries, New York, November 2, 1967, lot 225. The tureen was purchased from the sale on behalf of the Campbell Museum.

LITERATURE
*Selections from the Campbell Museum Collection* 1969, no. 30; 1972, no. 48; 1976, no. 48; 1978, no. 50; 1983, no. 98.

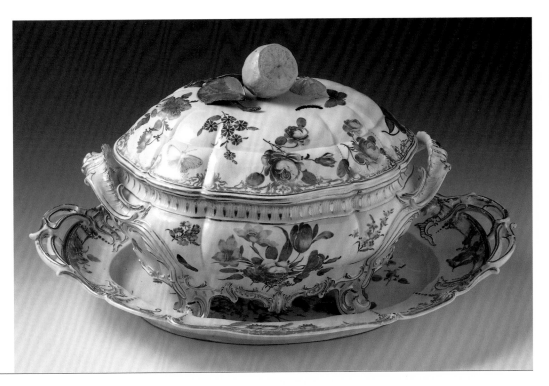

# 69 *Tureen*

**NYMPHENBURG PORCELAIN FACTORY     NEAR MUNICH, GERMANY, 1760–65**

*Maker, artist, craftsman*

The Nymphenburg factory was established at Neudeck in 1747 by Crown Prince Maximilian III Joseph, elector of Bavaria. Early experiments became successful after 1754, when the experienced porcelainmaker Joseph Jacob Ringler arrived from the Hannong factory at Strasbourg. After Ringler left Neudeck, the porcelainmaking business was moved to the grounds of the Nymphenburg Palace. Under the elector's patronage, it flourished. During the second half of the eighteenth century, it employed skillful craftsmen and produced some of the finest porcelains in Europe.

Among the many artists at Nymphenburg was Joseph Zächenberger, who worked as a flower painter from 1760 to 1770. His work is characterized by large bouquets, scattered flower sprays, and insects. The strong colors are rendered particularly effective by a play of shadow and light, which gives great depth.

Maximilian III Joseph died on December 30, 1777. He was succeeded by his cousin, Carl Theodor, elector of the Palatinate, who by that time owned the Frankenthal porcelain factory. The Nymphenburg factory continued but declined under the new elector's preference for Frankenthal. The factory experienced many difficulties and eventually became Bavarian state property. Since 1862 it has been leased to a private company and, as the State Porcelain Manufactory, continues to produce fine porcelain for retail and supplies Dresden decorators with blanks.

*About the object*

The tureen is an oval shape molded into panels. It is supported on scrolling-leaf feet that join the body in a pattern of relief-molded S- and C-shape scrolls; it has scrolling-leaf handles. The finial resembles a cut lemon. The large oval stand has an indented rim and open-scroll handles. This tureen and stand represent porcelain of the highest quality in the fashionable rococo taste and were part of a service designed by Franz Anton Bustelli.

The tureen is from a service made for the electoral court in Munich. It has been suggested that Zächenberger was responsible for the enamel-painted decoration.[143] The pattern includes large bouquets of flowers, scattered flower sprays, and insects. The palette has strong, clear colors; the flora and fauna are depicted naturalistically. A complex gilded border edges the lid and stand, and an unusual combination of blue enamel and gilt lines the rims and scroll moldings. The foot of the tureen has an impressed Bavarian shield and incised "z." The base of the stand has an impressed Bavarian shield and an incised "43."

Hard-paste porcelain with enamel-painted decoration and gilding

Tureen:
Height 9 ¼ in (235 mm)
Length 13 ½ in (343 mm)
Width 8 ½ in (210 mm)

Stand:
Length 18 ¼ in (463mm)
Width 12 ¼ in (312 mm)
96.4.214

PROVENANCE
The Campbell Museum purchased this tureen in 1972 from Winifred Williams, Eastbourne, Sussex, and London, Eng.

LITERATURE
*Selections from the Campbell Museum Collection* 1978, no. 57; 1983, no. 106.

*Impressed mark of Bavarian shield and incised numeral "43"*

# 70 *Tureen*

## CARL THEODOR PORCELAIN FACTORY
## FRANKENTHAL, GERMANY, 1770

*Maker, artist,
craftsman*

Paul-Antoine Hannong (1700–1760) began experimenting with porcelain manufacture in Strasbourg, France, and enjoyed a degree of success after 1752, with the help of Joseph Jacob Ringler, a traveling arcanist. When Louis XV gave monopoly rights to Vincennes for the production of porcelain in France, Hannong decided to leave the country. In 1755 he relocated to Frankenthal, Germany, where he opened a factory that specialized in the production of figures. Vases and table services were also made—often inspired by the products of the Meissen factory. A number of fine modelers were employed at Frankenthal. Johann Wilhelm Lanz moved from Strasbourg with Hannong and was joined by Johann Friedrich Lück in 1757. Both Lanz and Lück are remembered more for their contribution to porcelain figure modeling than for their tableware designs.

In 1762 financial problems forced the Hannong family to sell the factory, and it was acquired by Carl Theodor, elector of the Palatinate. Lanz left the factory

WINTERTHUR,
NEAR MONTCHANIN, DELAWARE.

FRIDAY  April 23 '09    DINNER

Grape Fruit

Clear Soup

Planked Shad

Broiled Chicken

~~String Beans~~
Peas.

Ham and Pineapple Salad

Vanilla Ice and Guavas.

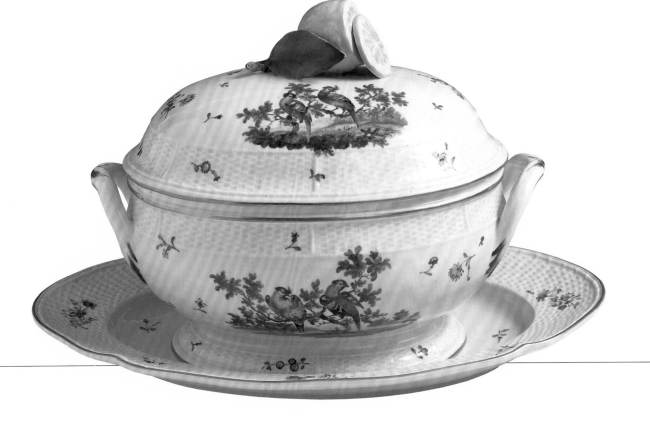

about this time, and Lück became master modeler. Lück returned to Meissen in 1763 and was replaced by his older brother, Karl Gottlieb Lück. The Frankenthal factory experienced some years of success before Germany became engaged in war with France in 1794–96, during the French Revolutionary Wars (1792–1802). The factory finally closed in 1799, when the stock was disposed of by auction. The molds were distributed and a number went to the Nymphenburg porcelain factory.

*About the object*
The simple oval tureen and stand are modeled with a broad border pattern in relief. The design is a basket weave based on Meissen's *alt-ozier* pattern. The cut-lemon finial on the lid was perhaps inspired by similar finials from Nymphenburg.

The basic form of this tureen was one of the early shapes produced by the factory and originated between 1759 and 1762, when both Lanz and Lück were employed as modelers. It continued in production after Carl Theodor acquired the factory. The enamel-painted pattern has a central design of exotic pheasants in branches with scattered floral sprigs painted on the *ozier,* or basket-weave, border. The high quality of Frankenthal porcelain can be seen in this tureen, but the enamel painting, although competent, seems to lack the liveliness seen in similar work from other contemporary European factories (see No. 83).

There is a mark painted in underglaze blue, comprising a crown above a "CT" monogram and "7," together with an impressed "i" and incised script "L" on the base of both the stand and tureen. An "i" is impressed inside the lid.

Hard-paste porcelain with enamel-painted decoration and gilding

Tureen:
Height 8 ¾ in (222 mm)
Length 12 in (308 mm)
Width 8 in (202 mm)

Stand:
Length 15 in (381 mm)
Width 10 ½ in (268 mm)
96.4.78

PROVENANCE
The tureen and stand were donated to the Campbell Museum in 1970 by A. P. Rochelle Thomas, New York.

LITERATURE
*Selections from the Campbell Museum Collection* 1972, no. 54; 1976, no. 54; 1978, no. 56; 1983, no. 108.

*Crown and monogram mark*

# 71 Tureen

ROYAL PORCELAIN MANUFACTORY    BERLIN, GERMANY, 1823–25

*Maker, artist,*
*craftsman*

King Frederick II of Prussia was eager to secure his own porcelain manufactory. In 1751 he granted a monopoly of production to Wilhelm Caspar Wegely. Frederick II, also known as Frederick the Great, marched on Saxony in 1756, marking the beginning of the Seven Years' War. His troops occupied Dresden and confiscated all the porcelain stocks held at Meissen. Wegely closed his factory in 1757, realizing that he no longer could expect a monopoly of supplying porcelain to the king. Frederick was intent on establishing his own porcelain company to rival Meissen, and he found a financial partner in Johann Ernst Gotzkowsky, a self-made wealthy entrepreneur, merchant, banker, and art dealer. While the war was still in progress, buildings were acquired in Berlin, and skilled staff were recruited. Some of the leading artists were encouraged to leave Meissen for Berlin. The Gotzkowsky experiment did not survive, and in 1763 Frederick assumed sole control of the porcelain works, which became known as Königlichen

Porzellan-Manufaktur (KPM, the Royal Porcelain Manufactory).

To ensure success, Frederick ordered a search for new sources of raw materials. The factory was enlarged, and the number of workers was increased. The king was the major client, but other European royal and noble families also commissioned table services and decorative wares. When Frederick the Great died in 1786, he was succeeded by Friedrich Wilhelm II, who handed the running of the Berlin factory to a State commission. The installation of new equipment and the formal Royal Academy training of factory artists brought about technical and artistic advances. The early nineteenth century was a challenging period, and Berlin was invaded and occupied by French forces. After the defeat of Napoleon in 1815, the Berlin factory recovered and experienced one of

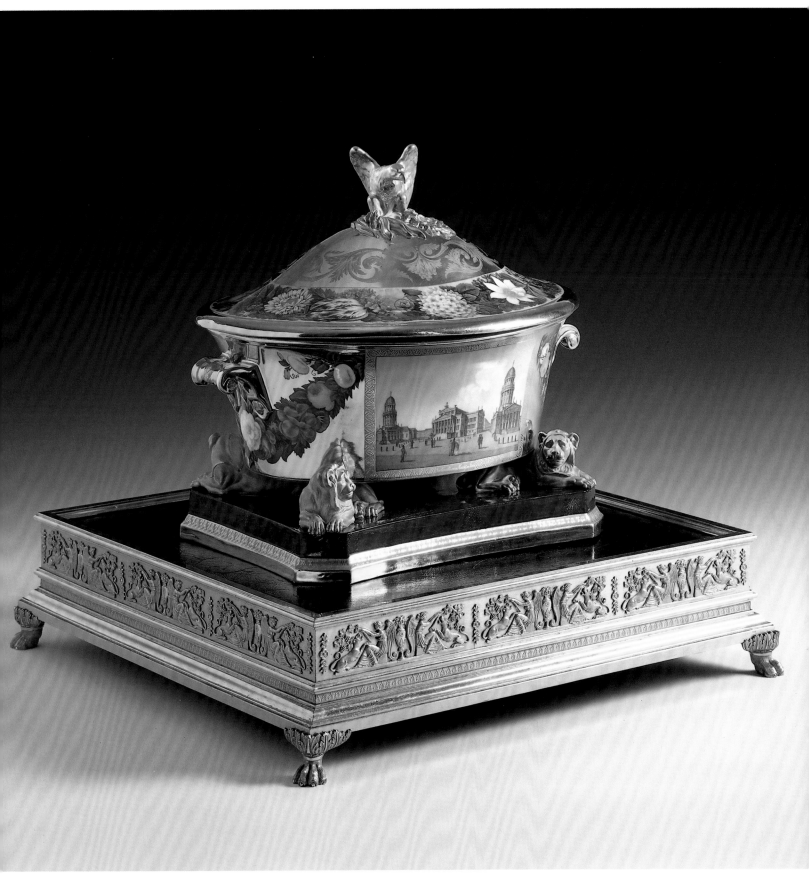

Hard-paste porcelain with
enamel-painted decoration
and gilding

Tureen:
Height 11 ⅝ in (287 mm)
on stand: 14 ¾ in (375 mm)
on stand and base: 20 in
(510 mm)
Length 16 ½ in (420 mm)

Stand:
Length 14 ½ in (368 mm)

Base:
Length 21 ½ in (538 mm)
96.4.8

its most successful periods. Porcelain was wrought into vases and table services, often of monumental scale. The painted decoration was of the highest quality, with subjects ranging from the patriotic to the topographical. Throughout the nineteenth century the Berlin factory contributed to international exhibitions, earning great acclaim. The Royal Porcelain Manufactory continues that tradition to the present day.

*About the object*    The large square base that supports the tureen and stand is made of ormolu, with lion's-paw feet and panels of Egyptian-style figures in relief. The porcelain stand is rectangular with a recumbent lion at each corner to support the tureen. The top surface is enameled a rich blue and speckled with gold to represent lapis lazuli. The supporting lions and the foot are gilt.

The tureen is of large oval form with scrolled handles and a finial in the form of a Prussian eagle with a circlet of laurel in one talon and a branch in the other.

The meticulous attention to detail and the range and quality of decoration make this part of one of the finest table services produced by the Berlin factory. The burnished gold ground on the lid has chased designs of scrolling acanthus leaves above a band of flowers painted in naturalistic colors. The body of the tureen has swags of flowers behind the handles on a gold ground and chased-gilt frames around hand-painted topographical views of Berlin. The scenes are titled *Die Bibliothek in Berlin* and *Der Gens'dames Markt in Berlin,* depicting the National Library and Gendarme Square.

The view of Gendarme Square was a popular subject for Berlin porcelains. The buildings behind the market square were the French Protestant church (north side), built for the Huguenots; the Royal Theater (center), which was rebuilt after a fire in 1817; and the German new church (south side). Some views show one or two of these buildings. This example shows all three. The Berlin factory had a collection of drawings and prints created by its own artists that served as patterns for the decoration.[144]

A

A  *Scepter mark*

B  *Detail of painted scene*
    *(opposite, above)*

The tureen is from a large banquet service made for the wedding of Princess Louisa of Prussia to Prince Friedrich of the Netherlands, which took place in 1825. The service included at least three tureens of this size; soup plates; dinner plates; dessert dishes; serving dishes; ice cream cups and table centerpieces in the form of urns; tazzas; and rosewater bottles. There were more than 450 pieces in all. The larger pieces, including the tureens and eight ice pails, were decorated with hand-painted topographical views of Berlin. All the pieces had decoration of burnished gold and floral garlands.

The tureen, stand, and base combine to form a magnificent example of the Empire style, which dominated European decorative arts in the first half of the nineteenth century. The style is characterized by the opulent use of classical and Egyptian ornament with increasing quantities of gold detail.

The mark of a scepter is painted on the base in underglaze blue.

PROVENANCE
The service remained in the possession of the royal family of the Netherlands until sometime in the twentieth century. It was sold at Sotheby's, London, May 23, 1967, lot 68, from the estate of the late Fürstin Marie zu Weid, princess of the Netherlands. Part of the service was returned to Germany and is in the Neue Pavilion, Schloss Charlottenburg, Berlin. One tureen was purchased by the Campbell Museum.

LITERATURE
*Selections from the Campbell Museum Collection* 1972, no. 59; 1976, no. 59; 1978, no. 63; 1983, no. 110.

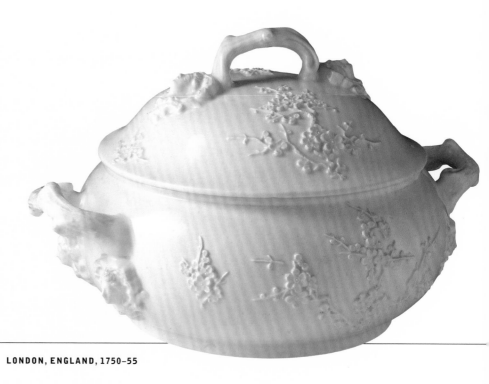

## 72 Tureen

**BOW PORCELAIN WORKS    LONDON, ENGLAND, 1750–55**

*Maker, artist, craftsman*

The New Canton porcelain manufactory was established in the East End of London about 1747. The factory was built in Stratford Road, Stratford-le-Bow, Essex. Consequently, it is usually known as the Bow porcelain works. The name *New Canton* proclaimed the partners' intention to manufacture porcelain to compete with Chinese imports. To that end, the factory began production by concentrating on tableware for general use. The decoration of these wares is predominantly in the oriental style.

The chief partners of the Bow enterprise were Edward Heylin, a clothier from Bristol, and Thomas Frye, an Irish artist and mezzotint engraver. In 1744 Heylin and Frye took out a patent for a recipe to make porcelain; in 1749 a further patent was issued to Frye alone. The Bow factory did not use the standard Chinese ingredients of china clay and china stone; therefore, like all mid eighteenth-century English porcelain, Bow products are classified as soft-paste. A number of different recipes appear to have been used at the factory. It is believed that in the early years they experimented with fine white clay from the mountains of North Carolina. By 1750 they had developed a standard, glassy, white porcelain recipe that

included a proportion of bone ash. Bow may lay claim to beginning the trend that resulted in the development of bone china, England's standard porcelain body since about 1800.

Newspaper advertisements of the 1750s suggest that Bow porcelain could be bought directly from the factory, from the warehouse in Cornhill, and through two public auctions. Few details are given in the notices, and unfortunately no sale catalogue survives. Although Bow claimed to attract the "Nobility and Gentry," advertisements note "also a large Assortment of the most useful China in Lots, for the Use of Gentlemen's Kitchens, Private Families and Taverns, &c."

Public auctions were held by the proprietors of the Bow manufactory in the spring of 1758. The first was of a collection brought from the manufactory; the second was the entire stock of the West End warehouse that they gave up at the time. By the 1760s the Bow porcelain manufactory was in decline. Their wares became unfashionable, and production probably ended in 1775. In the following year the company was sold to William Duesbury, who moved the stock and plant to his porcelain factory in Derby.[145]

Soft-paste porcelain
Height 8 ½ in (215 mm)
Length 14 ½ in (370 mm)
Width 11 ½ in (292 mm)
96.4.90

PROVENANCE
It is possible that this tureen is the one sold by Christie's, London, March 1965, and listed as the property of a gentleman. The Campbell Museum purchased it in 1971 from William Height Lautz, Antique Porcelains, New York.

Food arrangement, dated July 1, 1747, from the dinner book of Robert Jocelyn, first viscount Jocelyn and Lord Chancellor of Ireland, who kept detailed diagrams from October 30, 1740, to November 5, 1751. (Downs Collection, Winterthur Library.)

*First Course*

Crawfish Soops remou

Haunch of Venison Roast

Chickins Boild w.th Rice & Steud Turneps

Turkey Doabe w.th Steud lettuce

Lambs Ears Ragou.t

Badger Flambe w.th Colleflower

Blanket Collops

Pattey of Lobstars

Beef allea Doabe

Setout Turkey Pye remou Broild markt vale

Boild Rabbitts & onions

A Small Pig Ro.u

Fillis of Fowls

Fricease of Frogs

Duks all: a: Dolfin

Steud Soulls w.th Sorrel

Pudding in Turbant

Pidgons Bagelled w.th Sorrel & poch Eggs

Soop Loraine

Fricandoes of Lamb

remou 10.th Cline of Beef

*About the object*   This tureen is made of a fine white porcelain with applied sprigs of prunus or plum blossoms. The handles on the lid and on either side of the body are molded to resemble twigs or branches, usually referred to as crabstock. These handles terminate with molded and applied face masks that depict a woman, possibly the goddess Flora, who represents spring. Handle terminals similar to this are known to have been used at Chelsea, where they were inspired by Meissen originals. In the 1730s, Meissen modeler J. J. Kändler designed a basket that had face-mask handle terminals representing the four seasons. Chelsea chose to replicate the four different faces, but Bow economized with the use of only one classical female face.[146]

White porcelains with prunus sprigs were inspired by Chinese porcelain, known as *blanc de chine*, made at Dehua in Fujian province and shipped to Europe in vast quantities in the seventeenth and eighteenth centuries. These wares were copied in Europe; the French factory of St. Cloud is particularly renowned for white porcelains in this style. Most of the prunus-decorated white porcelains made at Bow were left white; but some had additional enamel-painted details.

LITERATURE
*Selections from the Campbell Museum Collection* 1972, no. 73; 1976, no. 72; 1978, no. 82; 1983, no. 30.

# Worcester Porcelain Factory

In 1751 a group of businessmen joined forces to establish a porcelain manufactory on the banks of the river Severn in the cathedral city of Worcester. Dr. John Wall and William Davis conducted the initial experiments in porcelainmaking, but they were unsuccessful.

Farther down the river at the port city of Bristol, an excellent soft-paste formula had been developed with soap rock as one of the major ingredients. In 1752 the partnership in Worcester bought the Bristol business lock, stock, and barrel. They acquired the porcelain recipe, and the molds were moved to Worcester, where they continued to be used for some years. Many early products were small tablewares, often decorated with delicately molded panels surrounding small scenes painted in underglaze blue. The porcelain was exceptionally good for making teawares, for unlike many of its rivals, the body could withstand the thermal shock of hot liquids without cracking or shattering. A large tureen and stand in the Campbell Collection of Soup Tureens at Winterthur is an exception to the normal range of products. Its size is unusual, but the painted decoration is typical of the 1752–58 period (see No. 73).

Scale-blue patterns were an invention of the Worcester porcelain factory and were introduced about 1760. There are technical problems associated with the application of an even, underglaze blue. To alleviate these problems Worcester developed a special technique. They outlined the reserve panels on the once-fired, biscuit porcelain body. The surrounding ground was created using a wash of a diluted cobalt-blue slip, which was then overpainted with a scale design in a more concentrated blue. When the blue decoration dried, the piece was glazed and fired again. After glazing, they painted the enameled decoration in the reserve panels. This might require several subsequent firings at successively lower temperatures before the final flourishes were added in gold. Gilding not only enriched the decoration but tidied up the edges of the reserve panels where the underglaze blue often had a hazy outline because the color "bled" into the glaze.

From the 1760s, European styles and taste influenced the factory; enamel-painted floral designs, gilding, and colored grounds were introduced. In particular, Worcester's blue-scale ground was a great success. Despite the domination of French and German designs, many patterns still originated in the Orient. Tablewares in the Japanese and Chinese taste were very popular and were sold in great numbers. Tureens were not a major part of the factory's output. However, a five-day sale held at the London auction rooms of James Christie's in December 1769 included "two oval tureens, covers and dishes, quadroon edges enameled in flowers and gilt" and "a fine table service of sixteen oblong dishes, in five sizes, a tureen, cover and dish, five dozen of table plates, and eleven soup ditto of the rich mazarine blue and gold enameled in flowers."

Although the factory suffered some reversals in the 1770s and 1780s, new owners kept production going. It became the Worcester Royal Porcelain Company in 1862. The factory is still creating modern and traditional tableware. It has the distinction of being the only English porcelain concern to survive in continuous production from the mid eighteenth century to the present day.

A  *Detail of painting inside the bowl (No. 73)*

B  *Painter's mark (No. 73)*

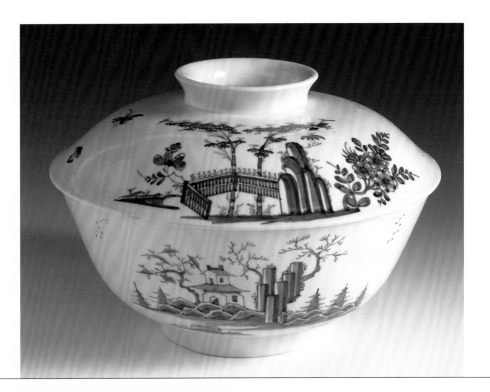

# *73 Bowl*

**WORCESTER PORCELAIN FACTORY     WORCESTER, ENGLAND, CIRCA 1754**

*About the object*   The wheel-thrown bowl and lid are handpainted in underglaze blue. The design on the exterior is known as the "plantation" pattern and depicts a Chinese-style scene with house and fenced garden with rocks and bamboo. Painted inside the bowl is a less commonly seen pattern known to collectors as the "lake dwellings" pattern; it comprises a water scene with a house and willow tree on an island and two pagoda islands in the background.[147]

Huge quantities of English porcelain were produced during the eighteenth century to compete with Chinese exports that flooded Europe. The simplicity of this Worcester bowl does not immediately appear to conform to the prevailing rococo taste for excessive, florid ornamentation; however, it does represent the rococo interest in chinoiserie. The rice-bowl shape

reflects its Chinese inspiration. Perhaps the severity of the form was unpopular, for no other examples are known to exist.

The "plantation" pattern is common on Worcester porcelain from about 1754, but this example is more carefully painted than usual. Eventually the pattern became a standard decoration and, from about 1760, was translated into a transfer print for application, also in underglaze blue. By 1770 the "plantation" pattern was replaced by the even more popular "fence" pattern.[148]

A painter's mark appears in underglaze blue.

Soft-paste porcelain with underglaze-blue painted decoration
Height 6 ¼ in (159 mm)
Diameter 8 ⅝ in (222 mm)
96.4.161

PROVENANCE
In 1954 this object was in the collection of Worcester blue-and-white porcelain that was acquired "during the past forty years" by Mr. and Mrs. J. W. Jenkins.[149] In April 1970 the important collection of Worcester blue-and-white porcelain was sold at Sotheby's, as the property of the late Mrs. M. B. Jenkins. In the August–September 1970 edition of *The Antique Collector*, the bowl was advertised by Tilley & Co. Antiques, London; the Campbell Museum purchased it in September 1970.

LITERATURE
Branyan, French, and Sandon, *Worcester Blue and White Porcelain*, p. 169.

*Selections from the Campbell Museum Collection* 1972, no. 79; 1976, no. 79; 1978, no. 89; 1983, no. 45.

Watney, *English Blue and White Porcelain*, pl. 24c.
Wills, "Worcester Blue and White," fig. 7.

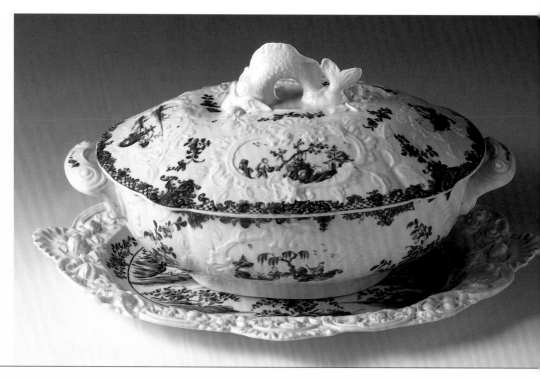

## 74 Tureen

**WORCESTER PORCELAIN FACTORY    WORCESTER, ENGLAND, CIRCA 1755**

*About the object*
The tureen is a large oval-base shape with conventional handles and a finial in the form of a dolphin. The surface is heavily modeled with foliate cartouches and is extensively painted in underglaze blue. Sprays of flowers are painted between each cartouche; within each cartouche is an oriental-style garden or river scene. The interior is painted with a larger river scene. Three other tureens of this model are recorded; each is decorated with different, but related, painted patterns, and the combined patterns are referred to by collectors as the Tureen Panel Group. A similar tureen with differently modeled cartouches and underglaze-blue printed scenes is also recorded.[150]

The stand has a heavily molded rim with floral scrolls, or *rocaille,* and floral garlands with a bird, lizard, and fish entwined. A complex oriental-style scene known to collectors as the "Chinese Garden" is painted in underglaze blue in the center. The design depicts an Oriental woman attended by two men in a garden; a servant stands behind them with a fan.

It is generally accepted that tureens and stands of these forms were intended to be sold together. However, none have survived united. These two pieces were "married," or perhaps "remarried," some 215 years after they were produced, shortly before the Campbell Museum acquired them.

A painter's marks in underglaze blue appears on the base of the tureen and stand.

*Painter's mark*

Soft-paste porcelain with underglaze-blue painted decoration

Tureen:
Height 8 ¼ in (209 mm)
Length 16 in (408 mm)
Width 9 ½ in (240 mm)

Stand:
Length 18 ¼ in (464 mm)
Width 13 ⅜ in (340 mm)
96.4.98

PROVENANCE
The stand was sold at Sotheby's, London, October 7, 1969, lot 139. The sale was entitled "The Caldwell Collection Catalogue of English Blue and White Porcelain, the property of the late Captain Derek Cooper, R. N." Tilley & Co., London, purchased it.

The tureen belonged to Robert Drane and was lot 1 of his famous collection sold in 1922 at the London galleries of Albert Amor.[151]

The purchaser is not recorded, but some 40 years later the tureen was illustrated in Franklin A. Barrett, *Worcester Porcelain and Lund's Bristol,* where it was credited to Mr. and Mrs. F. A. Barrett's collection.

The tureen and stand appear to have been united between 1969 and 1972, when the Campbell Museum purchased the 2 pieces as a set from Winifred Williams, Eastbourne, Sussex, and London, Eng.

LITERATURE
Barrett, *Worcester Porcelain,* pl. 43a (tureen).

Branyan, French, and Sandon, *Worcester Blue and White Porcelain,* p. 49 (stand).

*Selections from the Campbell Museum Collection* 1978, no. 88; 1983, no. 44.

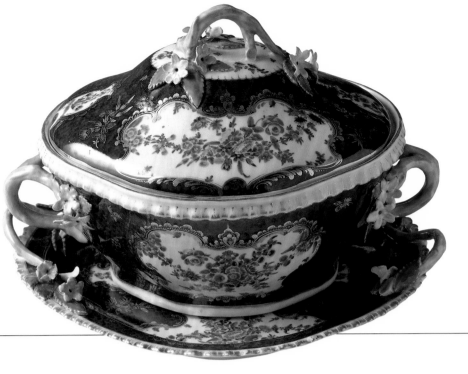

# 75 *Tureen*

**WORCESTER PORCELAIN FACTORY**
**WORCESTER, ENGLAND, CIRCA 1770**

*About the object*  The tureen is of an oval, slightly quatrefoil plan with a gadrooned edge—a design based on popular silver models of the period. It is the most commonly seen of all the eighteenth-century Worcester tureens and probably relates to shapes described as "quadrooned" in factory records.[152]

Both the tureen and stand are painted with floral sprays and bouquets of the highest quality within panels reserved against scale-blue ground. The panels conform to the prevailing rococo taste and are asymmetrical in outline, the larger reserves alternating with small vase-shape compartments. The twig, or crabstock, handles are in bright green and terminate in sprays of pink flowers.[153] The reserve panels are outlined and highlighted with gilt foliate sprays, and the scale-blue ground has scattered floral sprays painted in gold.

A fret mark is painted in underglaze blue on the base of the tureen and stand.

*Painted fret mark*

Soft-paste porcelain decorated with underglaze-blue enamel painting, and gilding

Tureen:
Height 7 ½ in (190 mm)
Length 11 ¼ in (287 mm)
Width 8 ½ in (217 mm )

Stand:
Length 11 ⅝ in (295 mm)
Width 9 ½ in (241mm)
96.4.208

PROVENANCE
The Campbell Museum purchased the tureen in 1967 from J. Rochelle Thomas, New York, when it was listed as being "from the collection of the Earl of Dudley, England."[154]

LITERATURE
*Selections from the Campbell Museum Collection* 1969, no. 51; 1972, no. 83; 1976, no. 83; 1978, no. 92; 1983, no. 49.

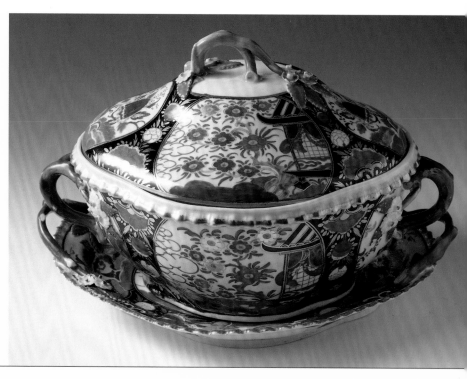

# 76 Tureen

**WORCESTER PORCELAIN FACTORY**     **WORCESTER, ENGLAND, CIRCA 1770**

*About the object*

The tureen is of an oval, slightly quatrefoil plan with a gadrooned edge, modeled after popular silver designs of the period. Tureens described in the Worcester records as "quadrooned" probably refer to this shape, which was one of the most popular produced by the Worcester factory.

The enamel-painted decoration derives from Japanese *Imari* porcelains with garden scenes. The Worcester pattern is known as the "pavilion" and comprises a freely drawn garden landscape with a pavilion to one side. The predominant colors are deep blue, iron-red, and gold. The main decorative panels are reserved against a ground of dark under glaze blue that in turn has small reserves of stylized flowers in red. The whole is enlivened with gilding. The underside of the stand is painted with bands of underglaze blue around the footrim and with under-

glaze-blue stems and iron-red flowers in the manner of oriental porcelain dishes. The twig, or crabstock, handles are painted in orange-red and yellow and terminate in yellow and pink floral sprays. The design of this kind of detail has been linked with the factory modeler John Toulouse.[155]

The decoration of this tureen and stand reflects the European interest in Japanese porcelains, which were available in great quantities in the West until the export trade ceased in the 1740s. Much of the porcelain was shipped through the port of Imari, and this town gave its name to a general decorative style. Typically the term *Imari* refers to a palette of underglaze blue, overglaze red, and gilding.[156]

Soft-paste porcelain decorated with underglaze-blue enamel painting and gilding

Tureen:
Height 7 3/8 in (190 mm)
Length 11 1/4 in (287 mm)
Width 8 1/2 in (217 mm)

Stand:
Length 11 1/2 in (292 mm)
Width 9 1/2 in (241mm)
96.4.79

PROVENANCE
The Campbell Museum purchased the tureen in 1970 from Winifred Williams, Eastbourne Sussex, and London, Eng.

LITERATURE
*Selections from the Campbell Museum Collection* 1972, no. 82; 1976, no. 82; 1978, no. 92; 1983, no. 48.

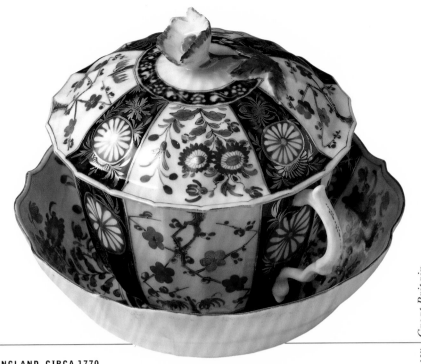

# 77 *Bowl*

**WORCESTER PORCELAIN FACTORY**     **WORCESTER, ENGLAND, CIRCA 1770**

*About the object*    This soup, or broth, bowl is an unusual piece. Although two-handle bowls of this type are not uncommon, large single-handle ones are not widely recorded.[157] The bowl and lid are molded into a faceted form, and the stand is scalloped to match. The decoration comprises panels of underglaze blue with reserves of stylized chrysanthemums or mons alternating with panels of enamel-painted flowering prunus branches and chrysanthemum plants. Designs of this kind—in colors of red, blue, and gold—are inspired by Japanese porcelains, and they are often called "Japan" patterns in the Worcester factory records.

Patterns in these rich colors were popular from about 1765 and continued to be produced into the nineteenth century. It is suggested that the basic paneled design of this pattern was known as "Queen's" pattern and that a version with additional gilding was known as "Rich Queen's" or "Best Queen."[158] The Worcester factory introduced this variation about 1765, and it was still available in 1815.

A fret mark is painted in underglaze blue on the base of the bowl and stand.

Soft-paste porcelain decorated with underglaze-blue enamel painting and gilding

Bowl:
Height 4 ⅝ in (119 mm)
Diameter 5 in (128 mm)

Stand:
Diameter 5 ⅞ in (138 mm)
96.4.188

PROVENANCE
The Campbell Museum purchased this piece in 1970 from Winifred Williams, Eastbourne, Sussex, and London, Eng.

LITERATURE
*Selections from the Campbell Museum Collection* 1972, no. 81; 1976, no. 81; 1978, no. 91; 1983, no. 47.

*Painted fret mark*

# 78 Plate

WORCESTER PORCELAIN FACTORY     WORCESTER, ENGLAND, CIRCA 1775

*About the object*

This soup plate is of circular form with a lobed rim. The twelve-lobe shape was developed from more ornate Meissen plates and was introduced at Worcester in the late 1750s. It was then adapted for standard production during the 1760s and 1770s.

The enamel-painted and gilded pattern is in the Chinese style and is known from the Chamberlain factory pattern books as "dragon in compartments." Members of the Robert Chamberlain family, who had been working at Worcester, left the factory about 1786 to begin an independent decorating business. By 1791 they were also making porcelain. Chamberlain and Company continued in family hands until 1840, when the firm combined with the Worcester factory.

Collectors call this design "Bengal tyger" and "Akylin." The complex pattern has a narrow-cell diaper band at the rim, with reserve panels containing a stylized flower head. A diamond-shape panel that dominates the center of the plate is quartered into smaller panels, each decorated with a different design: two fabulous beasts alternate with floral arrangements. The whole is painted in strong colors with red, blue, green, pink, and yellow and is highlighted with gilding.

The pattern was first used at Worcester from about 1765–68 on teawares and from about 1770 on dessertwares. It became very popular in the 1780s, and early nineteenth-century versions are known on rival Worcester and Staffordshire manufacturers' porcelains. The Worcester factory has reissued the pattern in the twentieth century.

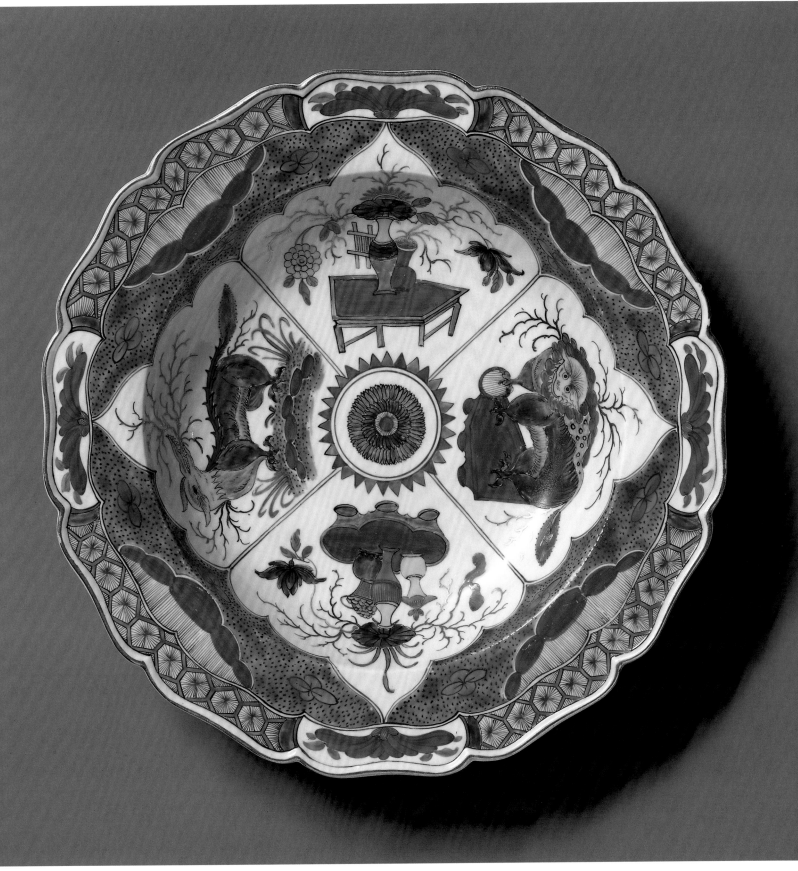

Soft-paste porcelain with
overglaze enamel-painted
decoration
Diameter 9 5/8 in (244 mm)
96.4.158.2

PROVENANCE
The Campbell Museum
purchased the plate and its
pair in 1970 from Charles
Woollett & Son, London.

LITERATURE
*Selections from the Campbell
Museum Collection* 1972,
no. 80; 1976, no. 80; 1978,
no. 90; 1983, no. 46.

# Chelsea Porcelain Factory

One of the first (and certainly the most ambitious) eighteenth-century English porcelain factories was established in the fashionable suburban village of Chelsea. It was situated on the banks of the River Thames at a convenient distance from the city of London, where a wealthy clientele was eager to purchase fine porcelains.

There was considerable experimentation in England to find successful recipes for the production of porcelain. The formulas at the Chelsea factory changed a number of times as experiments were made with different ingredients. Although they never achieved the hard-paste porcelain made in China and in Europe, their soft-paste possessed a delicate, silky quality that found a ready market.

By 1745 Nicholas Sprimont, a Huguenot silversmith from Liège in Belgium, was manager of the Chelsea porcelain works and was publicizing his wares for sale from the factory premises. The *Daily Advertiser* of March 5, 1745, reported, "We hear that the China made at Chelsea is arriv'd to such Perfection, as to equal if not surpass the finest old Japan ... and that the same is in so high Esteem of the Nobility, and the Demand so great, that a sufficient Quantity can hardly be made to answer the Call for it."

Of all the early English porcelain factories, Chelsea was the only one to begin by directly targeting the luxury market. Productions included a wide range of ornamental figures and vases and expensively decorated tableware. With the support of Sir Everard Fawkener, a wealthy and noble patron, Chelsea porcelains were introduced to fashionable society and were purchased by the royal family and members of the aristocracy.

The consistent high quality of the porcelain was the responsibility of Sprimont, who was at first manager and later proprietor of the factory. His artistic influences and fashionable taste had strong foundations in his training and accomplishments as a silversmith. His work as a designer and maker of silver and porcelain is best expressed in his large sculptural works that epitomized the rococo fashions prevalent in Europe in the middle of the eighteenth century. Scrolls and curves, flora and fauna, foliage and flourishes all compete in a swirl of ornamentation creating vases, tureens, and services for the extravagant table.

It is possible that Sprimont's porcelains were commissioned and sold directly from the Chelsea factory, but documentary evidence suggests that annual public auctions were a major means of disposing of stock. Tureens did not form a large part of the production at the Chelsea factory. When they do appear in the sale catalogues, they are usually highlighted as major individual items sold singly rather than in lots with other items. In the catalogues of the 1755 and 1756 sales, there is a large animal tureen listed almost every day. The "boar's head" and "rabbit" models are greatly outnumbered in 1755 by eleven lots of "hen-and-chicken" tureens. By 1756 the numbers are fairly even with three or four of each being sold. In addition to the examples represented in the Campbell collection there are other animal models, including life-size swans, male and female ducks, two fighting-cocks, and a very popular double-pigeon tureen. Other tureens are described in the sale lists by their form or decoration such as "round" or "scallop'd edges with purple flowers." These conventional shapes are often followed in the listing by soup plates, usually in sets of twelve, but sometimes in eights and, rarely, in sixes.

By 1759 a new, more sophisticated French rococo style had been introduced into Chelsea designs. Through the 1760s there were fewer exotic animal-form tureens. Instead, there was a new emphasis on vibrant ground colors and exquisite paintings of flowers and birds. Unfortunately no catalogue survives from the 1760 sale. From the five-day sale of 1761, only the first four days of the catalogue survive, and no soup tureens of any kind appear to be listed. No sale was advertised in 1762, and advertisements for sales in 1763 and 1764 indicate a decline in business, as Sprimont became too ill to manage.

In 1769 Sprimont sold existing finished porcelain to Thomas Morgan, a china dealer in Picadilly, and the factory and equipment were purchased by James Cox. In 1770 Cox sold the business to William Duesbury, owner of the Derby porcelain manufactory. Duesbury continued to operate the Chelsea works until 1784, when the molds, models, and equipment were moved to Derby. Sales are recorded throughout this period. The last sale of Chelsea, which included "ALL THE FINISHED AND UNFINISHED STOCK OF THE *CHELSEA PORCELAIN* MANUFACTORY," took place in December 1783. The sale included five hen-and-chicken tureens in white (glazed but not decorated) and a boar's head in biscuit (fired but unglazed). Perhaps these remaining tureens were imperfect and therefore not worth expensive enamel decoration. Alternatively they may have been produced at the end of the 1750s, becoming unfashionable and, therefore, unsaleable before they were decorated.

# 79 Tureen

CHELSEA PORCELAIN FACTORY    LONDON, ENGLAND, CIRCA 1754

*Maker, artist, craftsman*

The decoration on this Chelsea porcelain tureen is attributed to Jefferys Hamett O'Neale. O'Neale was an Irish artist who was employed at various times by porcelainmakers, most notably the Chelsea and Worcester factories. His work is known from a number of signed pieces, especially two Chelsea dishes painted with classical scenes and several Worcester vases, including a garniture painted with animals. Although there are no recorded fable scenes signed by O'Neale, this class of decoration is usually ascribed to his hand. Close observation suggests that there were at least two fable painters at work on Chelsea porcelain; one is associated with the early period of production and one with the 1753–58 period, when wares were marked with a red anchor.[159]

*About the object*

Although the outline of this oval tureen is fairly simple, the surface is molded with a complex design of scrolling foliage. Nicholas Sprimont, the artistic driving force behind the Chelsea porcelain factory, was a trained silversmith; this piece particularly reflects the sculptural qualities normally associated with the finest, most fashionable silver examples.[160]

The molded surface ornament has diaper panels, stylized acanthus, and scrolling foliage. The small asymmetrical reserve panel behind each leafy handle serves to frame painted floral sprays. Larger panels on the two sides of the tureen are highlighted in puce enamel and enclose painted scenes of animals. On one side, a pack of hounds brings down a stag. On the other side, there is a landscape with a group of animals standing in the foreground, including a boar, stag, bull, and sheep. The painted decoration is usually associated with *Aesop's Fables;* however, the subjects seem to be inspired by background scenes in published illustrated fables rather than by the fables themselves. The lid has a decorative finial of a young huntsman kneeling by his hound, enamel painted in conventional colors. The tureen is traditionally thought to be part of a large service made for Warren Hastings.[161]

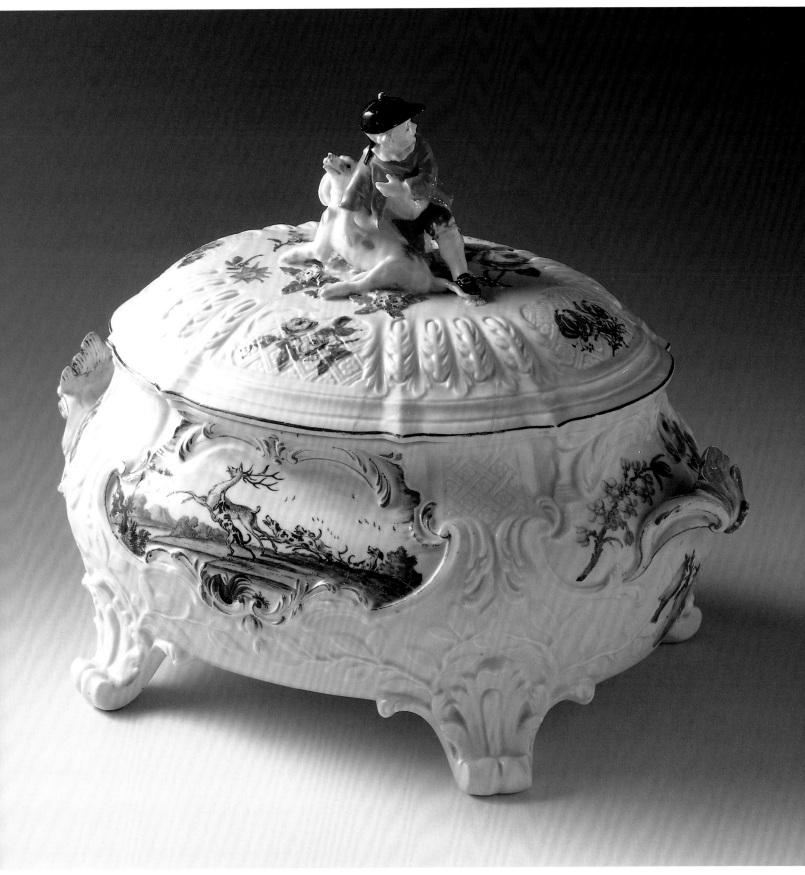

Soft-paste porcelain with
enamel-painted decoration
and gilding
Height 10 in (344 mm)
Length 12 ½ in (317 mm)
Width 9 in (230 mm)
96.4.93

PROVENANCE
In 1928 this tureen came
into the possession of Myron
A. Wick Jr., who presented
it to the Campbell Museum in
1974.

# 80 Tureen

**CHELSEA PORCELAIN FACTORY     LONDON, ENGLAND, CIRCA 1755**

*About the object*     The Chelsea porcelain manufactory auction catalogue for March 18, 1755, lists "a very curious TUREEN in the form of a BOAR'S HEAD, and a beautiful dish to ditto *with proper ornaments.*" The tureen would have been similar to the one illustrated here, which is graphically modeled to represent the severed head of a boar. The white porcelain body is thickly potted, and the glaze is made more opaque by the addition of tin oxide. Enamel-painted decoration realistically portrays the animal's fur and the trickles of blood coming from the eyes, nostrils, mouth, and ears. Appropriate hunting accoutrements are modeled around the rim of the stand, or underdish: a quiver of arrows, a curved hunting knife with an otter-head handle, and a branch of oak. The border of the dish is modeled to resemble quilting and is enamel painted in rose-pink with gold stitching; the center is painted with scattered flower sprays.

The German factory of Meissen was renowned for its creation of large porcelain centerpieces for the dining table; however, it produced few tureen forms. It is possible that the boar's head was a design originating at Chelsea. The use of animal forms and bizarre decorative styles is typical of the fashionable rococo craftsmen and artists of mid eighteenth-century England. Perhaps this particular model was inspired by the practice of parading a real boar's head into a banqueting hall to celebrate a victorious hunt.[162]

The tureen is marked with an anchor painted in red on the inside of the base.

*Red anchor mark*

Soft-paste porcelain with enamel-painted decoration and gilding

Tureen:
Height 9 ¾ in (247 mm)
Length 14 ¼ in (362 mm)

Stand:
Length 22 in (559 mm)
Width 14 ½ in (370 mm)
96.4.1

PROVENANCE
This tureen is often described as having belonged to Queen Charlotte, wife of King George III. However, in the Christie's catalogue for May 24, 1819, describing her property for sale we find "A TURENNE OF FINE OLD CHELSEA CHINA shaped as A BOAR'S HEAD, and a capital dish of the same, finely painted with a stag hunt,

flowers and insects." It was purchased by Lord Wemyss. If the capital dish is intended to be the accompanying stand, or underdish, the design is different from that in the Campbell collection, and the Campbell tureen is not that formerly in the possession of Queen Charlotte.

The tureen was possibly owned by the earl of Lonsdale and sold from his collection by Christie, Manson and Wood, March 5, 1879, lot 166: "ANOTHER [tureen] formed as a boar's head—on stand, painted with flowers." This important tureen has a long history of ownership. In May 1930 it was part of an exhibition at Messrs. Law, Foulsham, and Cole's

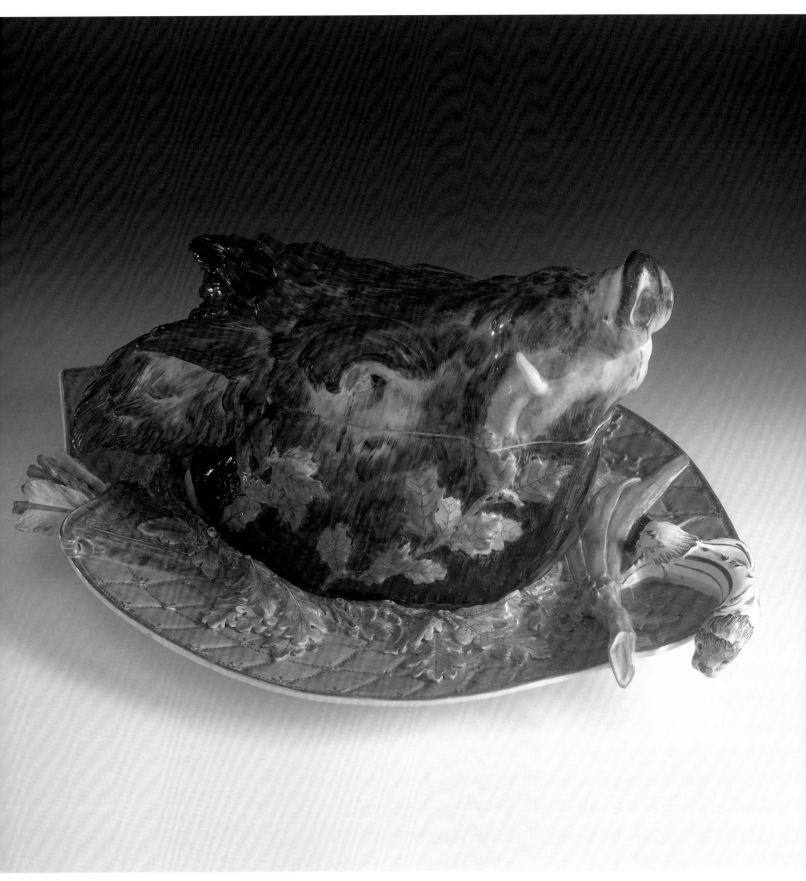

(7 South Molton Street, Bond Street, London) and was illustrated in *The Connoisseur*. Subsequently it was in the possession of Hugh Godley and was lot 35 in the sale of his collection at Sotheby's, London, May 6, 1937. The tureen was purchased by James McGregor Stewart from Jas. A. Lewis & Son, Inc., New York, December 27, 1949. Almost twenty-five years later the tureen came into the hands of Sotheby's again, when, on November 13, 1973, it formed lot 124 in a sale "formerly the property of the Late Mr. & Mrs. James McGregor Stewart of Halifax, Nova Scotia." It was purchased at the sale by the Antique Porcelain Company, New York. In March 1974 it was sold to John T. Dorrance Jr., who presented it to the Campbell Museum.

EXHIBITED
*Art Treasures*, an exhibition organized by the British Antiques Dealers Association at Christie's, London, 1932, exhibit no. 736.

LITERATURE
Gardner, "Animals in Porcelain," pl. 7.

Gardner, "Chelsea Porcelain Rareties," pp. 126–29, fig. 5. Grundy, "Antique Art Treasures," pp. 324–36.

Mackenna, *Chelsea Porcelain: Red Anchor*, pl. 41, figs. 83, 84.

*Selections from the Campbell Museum Collection* 1976, no. 73; 1978, no. 80; 1983, no. 31.

*The Connoisseur* (May 1930): 330.

# 81 Tureens

**CHELSEA PORCELAIN FACTORY    LONDON, ENGLAND, CIRCA 1755**

*About the objects*

On March 11, 1755, the Chelsea porcelain auction catalogue offered "a fine TUREEN in the shape of a RABBIT *as big as life*, in a fine oval dish." The two tureens in the Campbell collection conform to that description, although they no longer have oval dishes or stands. The body of the rabbit forms the main bowl of the tureen, and the ears form a finial to lift the lid from its back. The animals appear particularly docile; this may be the softening effect of the thick, opaque, white glaze that covers the porcelain body, concealing the molded details. The fur coats are represented by painted patches of a manganese purple-brown in which the brush strokes convey the texture of the hair. The rabbits are lying among leaves painted in shades of green and turquoise with puce-color veining. A small spray of leaves is molded on one side of the body, and a larger leaf is on the other. Each rabbit is nibbling on a leaf that holds a small snail. A companion snail may be seen on the larger supporting leaf.

Chelsea porcelain of the early 1750s is fairly thick and heavy, covered with a lead glaze that is whitened by the addition of tin oxide. This combination was particularly suitable for the depiction of these plump, gentle rabbits. The major problem with English soft-paste porcelain of this kind is its instability during the high temperatures of the biscuit-firing process. The consequent movement and warping of the porcelain is noticeable in these models. The tureen lids were cut from the back of the rabbit when the clay was dried but not fired; each is slightly different. The bodies and the lids shrank and deformed so that the fit was never perfect; each tureen is unique. To keep the related lids and bases together they were painted with a number. A rabbit with lid and base marked "No 1" was purchased by Lady Charlotte Schrieber in the 1870s for £4.10s. and is now in the collection of the Victoria and Albert Museum, London. The rabbit marked "No 25," the highest recorded number, was sold in New York in 1957 in the Mrs. John E. Rovensky sale at Parke-Bernet Galleries and is now at the George R. Gardner Museum of Ceramic Art, Toronto.

A

B

A  *Red anchor mark on .3*
B  *Red anchor mark on .2*

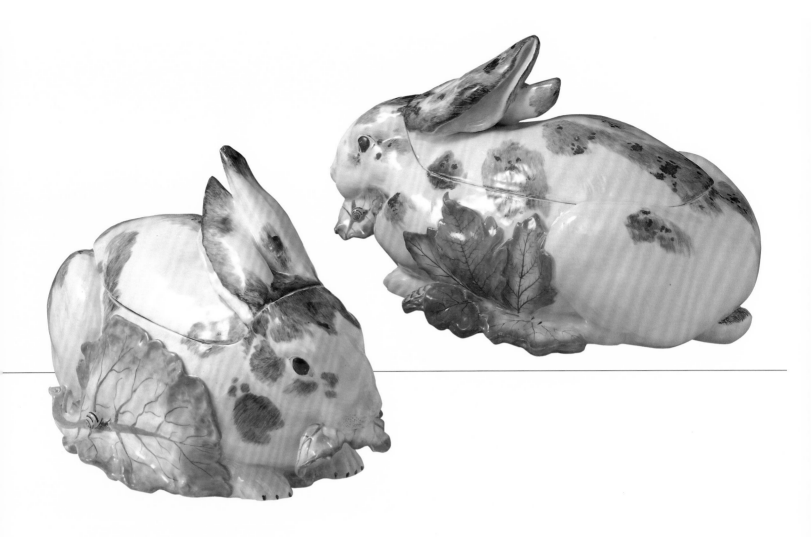

Every contemporary notice indicates that the rabbit should sit on a stand or dish, usually described as oval. The vocabulary of the rococo style included the juxtaposition of contrasting elements, and the dish may not have been a close match to the tureen. As no surviving rabbits are known to have their dishes, it seems likely that they became separated at some time in their life and were used or sold as individual Chelsea pieces.

Figures of rabbits and hares were popular ceramic ornaments, but tureens in the form of life-size rabbits appear to be peculiar to the Chelsea factory. There is no reason to believe that these two are a pair, as they

face the same direction. A true pair would usually face each other. Furthermore, there is no documentary evidence that rabbits of this size were sold as pairs, although smaller examples for desserts may have been.

One of the rabbits ( .2) is marked with "No 7" and an anchor painted in red on the underside of the lid and "No 7" painted in red on the inside of the tureen. The other rabbit (.3) is marked with "No 4" and an anchor painted in red on the underside of the lid and "No 4" painted in red on the inside of the tureen.

Soft-paste porcelain with enamel-painted decoration

(.2) Height 8 ⅜ in (212 mm)
Length 14 ½ in (368 mm)
Width 9 in (228 mm)

(.3) Height 8 ½ in (218 mm)
Length 14 in (355 mm)
Width 8 ½ in (226 mm)
96.4.2, .3

PROVENANCE
The tureens were purchased by the Campbell Museum in March 1966 from the Antique Porcelain Company, New York.

LITERATURE
*Selections from the Campbell Museum Collection* 1969, no. 47; 1972, no. 75; 1976, no. 75; 1978, no. 83; 1983, no. 34.

# 82 Tureen

CHELSEA PORCELAIN FACTORY     LONDON, ENGLAND, CIRCA 1755

*About the object*

The hen-and-chickens tureen was one of Chelsea's most popular models and was described by the factory in their auction catalogue of March 10, 1755, as "a most beautiful tureen in the shape of a HEN AND CHICKENS, *big as life*, in a curious dish adorn'd with sun flowers." The hen in the Campbell collection is enamel painted in a soft downy yellow with manganese-purple brushwork to indicate feathers. She is depicted resting with her brood of chicks peeking out from beneath her feathers. One particularly brave youngster stands on her back and acts as a useful finial to lift the lid of the tureen. This is one of the few Chelsea porcelain tureens that may have been inspired by a Meissen original. The famous German factory first produced a model of a hen-and-chickens tureen in 1732 and a teapot of the same subject in 1734. The tureen was also copied by earthenware potters in Staffordshire and was produced in life-size and smaller versions.[163] The model has continued in popularity, and today small nesting hens are made to hold eggs.

Contemporary references usually describe the hen-and-chickens tureen as sitting in a dish modeled with sunflowers. The Chelsea factory also sold sunflower dishes separately. As not all surviving tureens have their stands, presumably some of the hens and their sunflowers were separated.

A red anchor mark is painted in enamel on the inside of the lid.

*Red anchor mark*

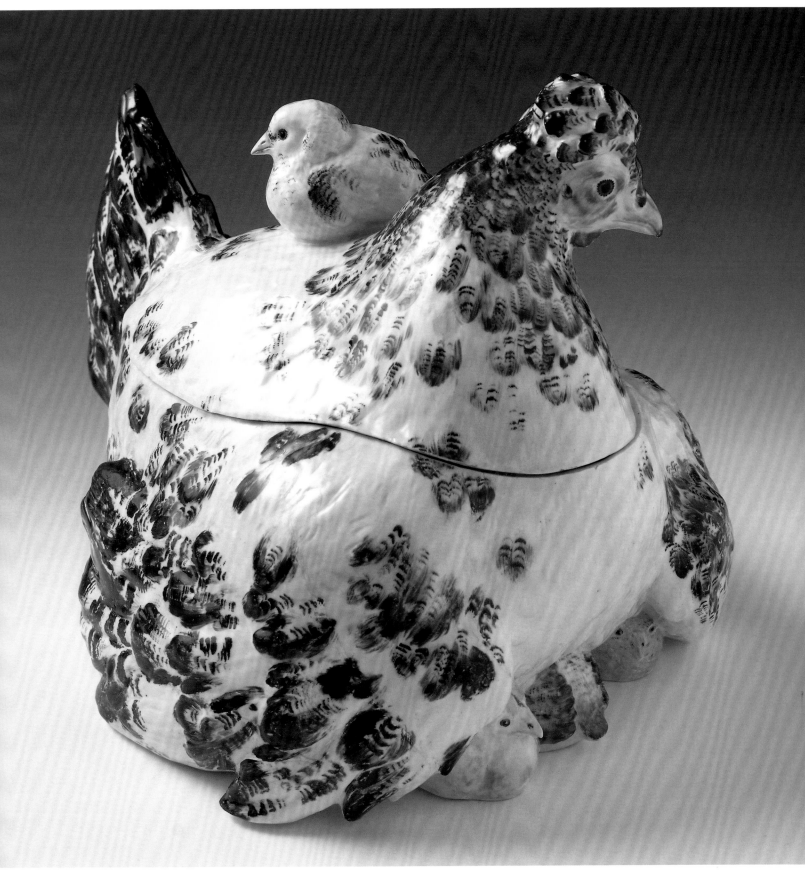

Soft-paste porcelain with
enamel-painted decoration
Height 9 7/8 in (251 mm)
Length 13 1/2 in (342 mm)
Width 10 in (252 mm)
96.4.222

PROVENANCE
The tureen was purchased
by the Campbell Museum
in March 1966 from the
Antique Porcelain Company,
New York.

LITERATURE
*Selections from the Campbell
Museum Collection* 1969,
no. 46; 1972, no. 74; 1976,
no. 74; 1978, no. 84; 1983,
no. 35.

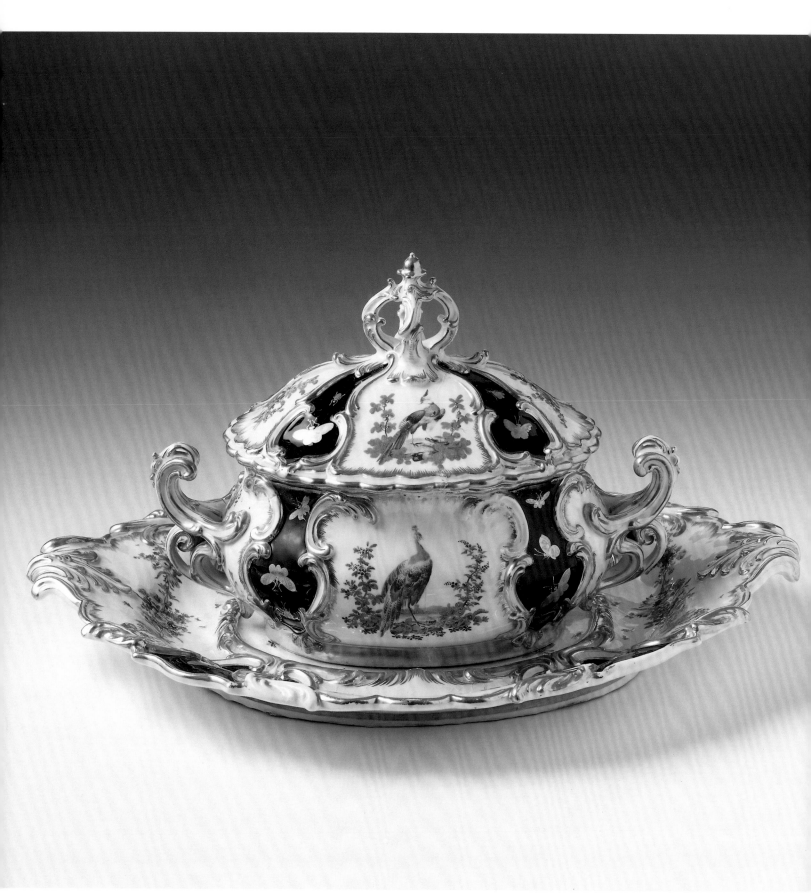

Soft-paste porcelain with underglaze-blue and enamel-painted decoration with gilding

Tureen:
Height 10 in (255 mm)
Length 13 in (330 mm)
Width 7 ½ in (190 mm)

Stand:
Length 19 ½ in (495 mm)
Width 14 ½ in (370 mm)

Soup plates:
Diameter 9 in (229 mm)
96.4.107.1, .2, .3

PROVENANCE
The tureen and soup plates are part of a service commissioned by King George III and Queen Charlotte as a gift to Her Majesty's brother, Duke Adolphus Frederick of Mecklenburg-Strelitz, Ger. It was supplied in 1763 at a cost of £1,150 and is considered one of the finest rococo table services made in England. Until the 1920s the service remained in the possession of the dukes of Mecklenburg-Strelitz. The service was exhibited by

Albert Amor in London in 1925. Some pieces may have been sold before the remaining service, comprising 132 pieces, was purchased by Sir (later Lord) Joseph Duveen for his personal collection in the United States. Between 1944 and 1947 the service was owned by James Oakes. In 1947 Oakes presented it to Her

Majesty Queen Elizabeth, the Queen Mother; the service is now in the Buckingham Palace collection.[164]

The pieces in the Campbell collection probably were among those sold by Amor before Duveen acquired the remainder of the service. They were purchased by the Campbell Museum in 1966 from the Antique Porcelain Company, New York.

154

# *83 Tureen*

**CHELSEA PORCELAIN FACTORY**    **LONDON, ENGLAND, 1762–63**

*About the objects*

The tureen and soup plates (below) come from an extensive and elaborate rococo porcelain service. The tureen is of oval form with complex, two-tier scrolling handles; the lid has an open, crownlike finial. The stand to the tureen has a large well and a deep rim with extended, curled finger-holds to facilitate handling. The soup plates are of simple circular form with scalloped edges.

By 1760 the lead glaze on Chelsea porcelain ceased to contain tin oxide; it became clear and brilliant. The clarity meant that colors applied to the biscuit porcelain would not be clouded by the white opacity that results from the addition of tin. This technical development enabled the factory to produce decoration with vibrant colored grounds in the French taste, as exemplified by the products of the royal manufactory at Sèvres.

This service is decorated with underglaze-blue panels that are described in contemporary records as "mazarine blue," a term that defines the depth and luminosity of this particular shade. The alternating panels are painted in enamel colors with floral sprays and exotic birds, the center of the stand having a finely executed group of birds including a peacock trailing his spreading tail. Gilding on Chelsea porcelain of the 1760s is of the finest quality. Here it enriches and emphasizes the asymmetrical scrolling foliage that divides the design into panels. The panels with underglaze-mazarine-blue grounds are embellished with insects thickly painted in gold; chased detail adds texture and pattern to their wings. The outward-curving profile of the rim of these panels distinguishes this service from all others made by the Chelsea factory.

The mark of a gold anchor is painted on the base of tureen, stand, and soup plates.

LITERATURE
*Selections from the Campbell Museum Collection* 1969, cover and no. 48; 1972, cover and no. 76; 1976, cover and no. 76; 1978, no. 86; 1983, no. 37.

*Gold anchor mark*

# 84 Tureen

**WILLIAM LITTLER**     **LONGTON HALL, STAFFORDSHIRE, ENGLAND, OR WEST PANS, SCOTLAND, 1755–75**

*Maker, artist,*
*craftsman*

William Littler was a practical potter in Staffordshire. He and his partner, Aaron Wedgwood, are credited with the development of a beautiful blue decorative finish on white salt-glazed stoneware. His technical abilities convinced some London businessmen to set up a venture at Longton Hall in Staffordshire for porcelain production. Littler offered his technical expertise, and the London partners brought financial skills and commercial connections. The porcelain factory at Longton Hall lasted for nine years, from 1751 to 1760. Some wonderful objects were made, but many imperfect pieces survive, suggesting that production of the glassy soft-paste porcelain was unpredictable and quality was difficult to maintain.

Like many of its rivals, Longton Hall offered wares for sale through London auctions. The *Public Advertiser* gave notice of a sale in April 1757 offering "a New and curious Porcelain or China of the *Longton Hall* Manufactory, which has the Approbation of the best Judges, and recommended by several of the Nobility to this public Method of Sale. Consisting of Tureens, Covers and Dishes."[165] Longton Hall is not noted for large porcelain pieces such as soup tureens, and the advertisement may have referred to dessert- rather than dinnerwares. Nevertheless, exceptions were made, and the tureen in the Campbell collection was considered a Longton example until recently.

The challenge of making large quantities of consistently good porcelains eventually defeated Littler, and his partners called a halt to production. "Upwards of ninety thousand Pieces of the greatest variety" were advertised for sale in the 1760 closing auction. Many may have been imperfect or undecorated. Littler, however, did not give up his ambitions to make porcelain. He moved to Scotland, where he found an opportunity to continue his operations. By 1764 he was the proprietor of a small factory established at West Pans, near Musselburgh, to the east of Edinburgh. Newspaper advertisements suggest that the factory produced porcelains in styles that were similar to those made at Longton Hall; "mazarine blue" wares are particularly mentioned.[166]

Littler enjoyed brief success at West Pans. He was unable to make fine porcelain and continued to experience problems with producing a consistently good body. By 1777 he was in financial difficulty and returned to Staffordshire.

In 1990 the site of the pottery at West Pans was excavated, and extensive remains of discarded porce-

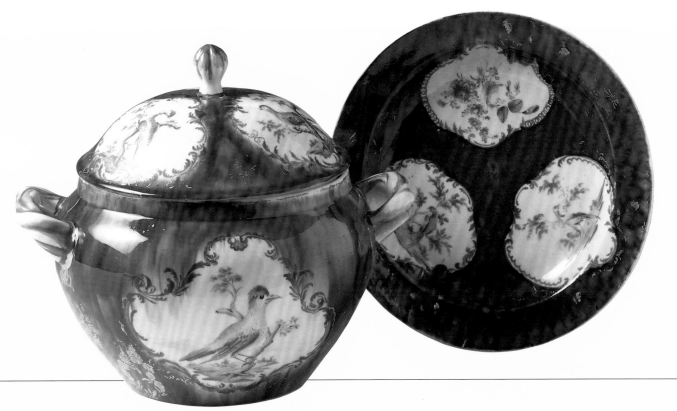

lain wasters and kiln furniture were found. This evidence is still being analyzed. Interim reports suggest that although there was an overlap of some patterns and shapes, Longton Hall and West Pans also had their own distinctive range of products.[167]

*About the objects*   The tureen and soup plate are of simple globular and circular shapes. The tureen is reminiscent of the shape of mid eighteenth-century Continental broth pots known as a *pot-à-oille.* The handles are formed from entwined strips of clay in the style known as "twisted rope."[168]

The decoration of the tureen reflects the eighteenth-century rococo taste. Flowers and birds are painted within asymmetrical panels outlined with red enamel scrolling foliage. The larger panels contain paintings of exotic birds.[169] The painted panels are reserved against a deep blue ground that bears the traces of an extensive and finely painted floral decoration in gold.

Littler's name is intimately associated with the introduction of a cobalt blue ground color to the Staffordshire ceramic industry. By 1749 he and his partner were able to supply salt-glazed stoneware with a blue ground. Although Wedgwood has some share in this development, history had always credited the

discovery to Littler, and the color is usually called "Littler's blue." One of the most difficult problems in decorating porcelain is achieving an even ground color—well illustrated here. The solution adopted by the Worcester porcelain company was to develop blue-scale grounds.[170] Littler followed the more common practice of applying a complex painted pattern of gilding over the blue ground. The technology of gilding was not widely understood in mid to late eighteenth-century English ceramic industry, and the gold seems to lift from the surface very easily. The traces of gold that remain on this tureen and soup plate can only hint at their former richness.

There are many problems associated with attributing these pieces definitively to Staffordshire or to Scotland. Excavations reveal a close affinity between porcelains from both sites. Excavated fragments from West Pans have molded details that match an extant plate with enamel-painted decoration in a style similar to that seen on the soup plate. However, a fragment of twisted-rope handle similar to that on the tureen was found on the Longton Hall site together with the only excavated examples of underglaze-blue decoration.[171]

Soft-paste porcelain with underglaze-blue, overglaze enamel painting and gilding

Tureen:
Height 8 ½ in (215 mm)
Diameter 8 ½ in (215 mm)

Soup plate:
Diameter 9 in (220 mm)
96.4.218

PROVENANCE
The tureen and stand were the "property of a lady" when they were offered for sale by Sotheby's, London, March 26, 1957, lot 148. The Campbell Museum purchased them in 1966 from the Antique Porcelain Company, New York.

LITERATURE
*Selections from the Campbell Museum Collection* 1969, no. 49; 1972, no. 77; 1976, no. 77; 1978, no. 85; 1983, no. 41.

# 85 Tureen

*Maker, artist, craftsman*

This piece is traditionally attributed to the Derby porcelain factory. Andrew Planché, who arrived in the city of Derby in 1748, is believed to be the founder of the factory. He was a Huguenot jeweler, and it is thought that he may have had some experience with European porcelain.[172] In 1756 Planché took additional partners, including William Duesbury, a London china painter who had been involved in the Staffordshire porcelain venture at Longton Hall. Planché left, and the Derby factory began to concentrate on the production of figures and ornamental shapes. The Derby soft-paste porcelain body was not stable enough to use for service of hot liquids, so the factory concentrated on the production of high quality, skillfully decorated, dessertwares.

In 1770 William Duesbury and Company bought the Chelsea porcelain factory; they then acquired the Bow and Vauxhall works. Duesbury continued production of Chelsea figures at Derby and made a range of small toilette wares and decorative vases at Chelsea until 1784, when the London factory closed.[173] After

Duesbury's death in 1786, the Derby factory continued under the direction of his son, William Duesbury II, who maintained the high standards of production. He introduced new shapes, and the firm adapted patterns to the neoclassical taste of the late eighteenth century.

When Duesbury II died in 1797, the factory began a long, slow decline. They continued to produce some fine decoration but introduced a range of cheaper wares to compete with the inexpensive bone china of Staffordshire. Although a new concentration on figure production in the 1830s revived the factory's reputation, the competition from other English ceramic factories was overwhelming. The Derby works closed in 1848.

## About the object

This large tureen is of relatively plain, oval shape with ornate handles in the form of scrolling foliage. The enamel-painted decoration has elements from a pattern first devised in the 1740s for a Chinese porcelain service commissioned by English merchants in Canton for Commodore George Anson. The pattern combines images of the breadfruit and palm trees found in

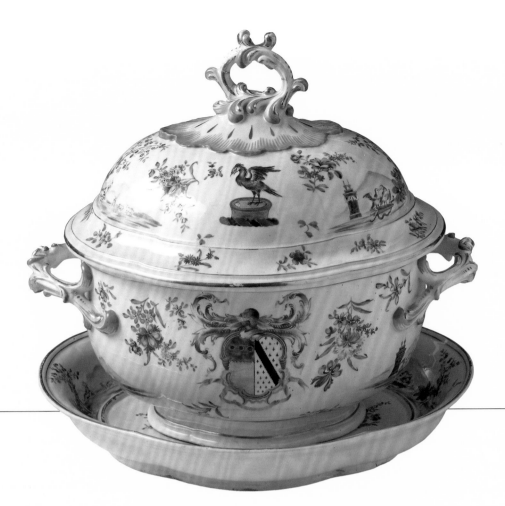

engravings made for the illustrated travel book *Anson's Voyages,* with an altar of love, a quiver of arrows, and billing doves.[174] The pattern occurs in Chinese export and Worcester porcelain with variations on these themes and is known as the "Valentine" pattern.

This tureen also has extensive floral decoration and a central coat of arms of Latham impaling Kelsall. The original service was probably made to commemorate the marriage of Capt. Richard Latham R. N. and Jane Kelsall. Both the bride and groom had connections with the China trade, but no further personal details are known.

In 1758 Richard Latham was a senior merchant at Fort St. George in Madras, on the southern edge of the Bay of Bengal. Thomas Kelsall was a member of the Council of Bengal in 1755. The British had established outposts in India to facilitate trade with the East,

including China. It is believed that Captain Latham and Jane Kelsall were connected to these prominent English families serving in India.[175]

At least three Chinese porcelain services are recorded with the arms of Latham impaling Kelsall. Tureens of this form are not traditionally associated with the Derby factory in this period. The Worcester porcelain company is known to have used a version of the "Valentine" pattern from about 1756 to 1760 on tea services and small ornamental pieces such as sweetmeat baskets; no dinnerwares are recorded. The tureen is not a standard Derby model. As a number of Chinese services using these motifs were completed in the 1740s, there is reason to suppose that this Derby piece is either a replacement for a damaged Chinese original or an addition to a Chinese service.

Soft-paste porcelain with enamel-painted decoration and gilding

Tureen:
Height 11 1/2 in (292 mm)
Length 13 1/2 in (344 mm)
Width 9 3/4 in (248 mm)

Stand:
Length 13 in (280 mm)
Width 11 in (286 mm)
96.4.221

PROVENANCE
The Campbell Museum purchased the tureen in 1966 from Winifred Williams, Eastbourne, Sussex, and London, Eng.

LITERATURE
*Selections from the Campbell Museum Collection* 1969, no. 50; 1972, no. 78; 1976, no. 78; 1978, no. 87; 1983, no. 42.

# 86 Bowl

**COOKWORTHY AND CHAMPION'S FACTORY     BRISTOL, ENGLAND, CIRCA 1775**

*Maker, artist, craftsman*

William Cookworthy was the first person to patent the production of hard-paste porcelain in England. The patent was awarded in 1768, and in that year he assembled a group of partners and established a factory in Plymouth. In 1770 the business moved to Bristol, where Richard Champion, one of the partners, began to play a more active role.

Cookworthy sold his patent to Champion in 1773 and left England for the colonies of North America. Champion continued production, finally selling the patent to a consortium of Staffordshire businessmen who founded Hollins, Warburton & Company, at Shelton New Hall in 1781. The products of Champion's Bristol factory are distinctive. They made a range of tea- and tablewares as well as figures and biscuit porcelain plaques. Their tablewares are neatly potted and elegantly decorated in the neoclassical taste. The factory artists excelled at painting delicate swags of flowers and simple banding with gilt embellishments.

*About the object*

The small bowl has two ear-shape handles that are based on a form commonly found on teacups from the Bristol factory. The finial is modeled as a flower bud.

A simple decoration circles the bowl, lid, and stand. The adjacent enameled bands of light and dark orange are entwined with gilding; the edges of the cup, lid, and stand have a gold dentil border.

Small soup bowls made at Bristol are not commonly seen.[176] They were intended for use by individuals in their private apartments and were not produced in large services. The fashion for them may have spread from France, where such items were made in great numbers at the Sèvres factory. The French name for the shape is *écuelle*, a name used generally to describe any small covered soup bowl.

A blue "X" and gold "3." appear on the base of the bowl and stand.

A

B

A   *"X" mark on base*

B   *Numeral "3" mark on base*

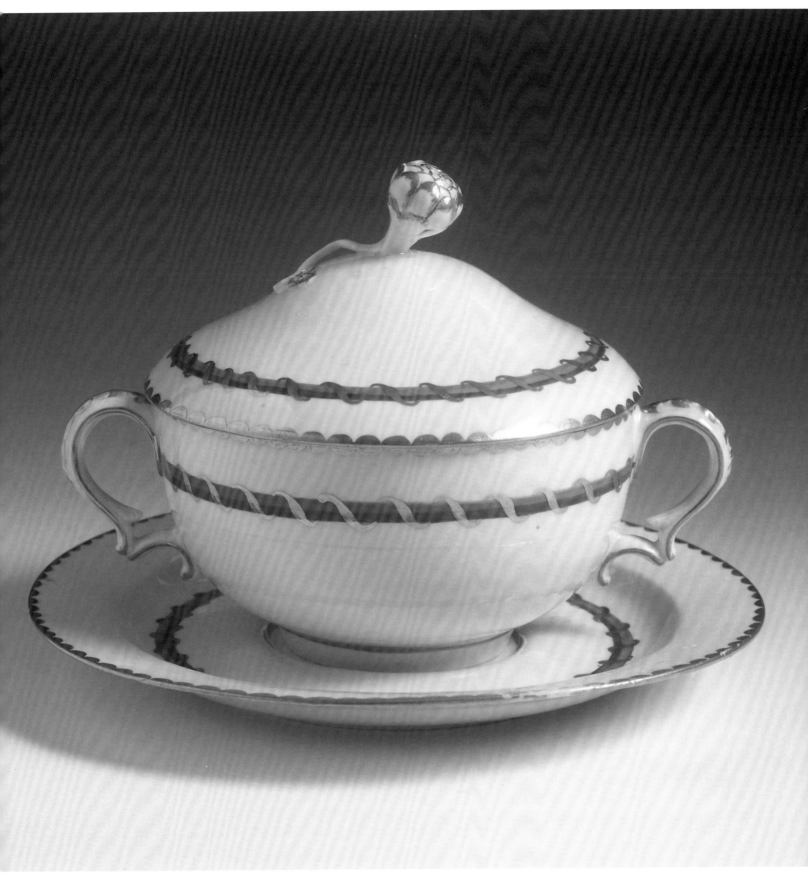

Hard-paste porcelain with
enamel-painted decoration
and gilding

Bowl:
Height 4 ¼ in (108 mm)
Diameter 5 ¾ in (146 mm)

Stand:
Diameter 6 ⅜ in (162 mm)
96.4.74

PROVENANCE
The Campbell Museum
purchased this piece in
1970 from Winifred
Williams, Eastbourne,
Sussex, and London, Eng.

LITERATURE
*Selections from the Campbell
Museum Collection* 1972,
no. 84; 1976, no. 84; 1978,
no. 94; 1983, no. 50.

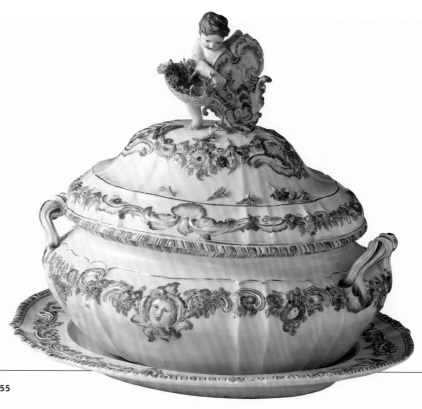

# 87 Tureen

**GINORI FACTORY   DOCCIA, ITALY, 1750–55**

*Maker, artist, craftsman*

The Marchese Carlo Ginori established his factory at Doccia, near Florence, in 1737. A former Du Paquier employee, Giorgio delle Torri, assisted him, and he took advice from the Vezzi factory in Venice. In its early years, the factory had problems obtaining a reliable supply of raw materials. As if to compensate for the lack of sophistication in the porcelain body, Doccia porcelains concentrated on sculptural qualities. In 1757 Ginori died and was succeeded by his son, Lorenzo. The factory continued and made experiments to improve the porcelain. In 1770 they introduced a new glaze containing tin oxide, which made it whiter and opaque. The factory continued as a family business until 1896, when it was incorporated with the Società Ceramica Richard of Milan, and the name changed to Richard-Ginori.

*About the object*

The tureen is of oval bombé form with scrolling foliate handles. The tureen, lid, and stand are extensively molded with panels of ribs, gadrooned rims, and bands of embossed decoration. The latter comprise rococo motifs such as shells, asymmetrical scrolling foliage, and flowers. There is a central face mask on each side of the body. The lid has an elaborate finial modeled as a putto supporting a shield decorated with a coat of arms. He carries a basket of flowers from which blossoms are scattered across the lid of the tureen.

The use of strong enamel colors and gilding on the molded details emphasizes the sculptural quality of this tureen. The coat of arms, clearly painted in appropriate colors, are those of the Marchese Francesco and Marchesa Laura Marana. Marchesa Laura was a friend of Carlo Ginori's. Extant correspondence suggests that she ordered at least two porcelain services from him. She requested that the first be decorated with a stencil pattern in underglaze blue. This tureen is probably from the second service, which she requested be polychrome decorated.[177]

Hard-paste porcelain with enamel-painted decoration and gilding

Tureen:
Height 11 ¾ in (298 mm)
Length 12 ⅞ in (327 mm)

Stand:
Diameter 14 ¾ in (375 mm)
96.4.102

PROVENANCE
The service ordered by the Marchese and Marchesa Marana was dispersed some time ago. In 1963 this tureen was recorded as the possession of Prince Paolo of Greece, formerly in the Demidoff collection.

It then became the property of Princess Olga of Greece and was sold at Sotheby's, London, July 5, 1966, lot 16, when the Campbell Museum acquired it.

LITERATURE
Lisci, *Porcellana di Doccia*, pl. 33.

*Selections from the Campbell Museum Collection* 1969, no. 34; 1972, no. 61; 1976, no. 61; 1978, no. 66; 1983, no. 119.

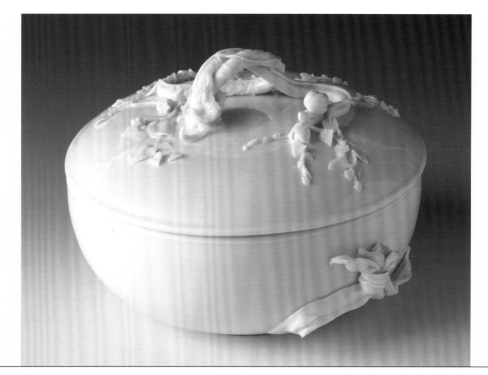

# 88 *Bowl*

**CAPODIMONTE FACTORY      NAPLES, ITALY, 1750–55**

*Maker, artist, craftsman*

King Charles III of Spain, when he was king of Naples, aspired to have his own porcelain factory. He began experiments in 1743 on the grounds of the royal palace at Capodimonte, outside Naples. He used a formula that did not rely on kaolin and petuntse, which were the major ingredients of Chinese-style porcelain. The resultant soft-paste porcelain was used to produce a range of small figures and distinctively molded and painted tableware. In 1759, when Charles succeeded to the Spanish throne, he moved the factory from Capodimonte to Buen Retiro, near Madrid.

References to the Capodimonte factory record the employment of many porcelain workers and artists. Giuseppe Gricci is listed in the archives and was a "Genoese thrower who had worked at Turin before going south." He is also noted for his modeling of "figurines and floral sprays for the lids of sugar bowls and [he] made boxes in the Meissen style." It is possible that this covered bowl is the work of Gricci, to whom almost all of the factory's sculptural work has been assigned.[178]

*About the object*

This is a simple yet elegant piece of porcelain in which the designer has taken the opportunity to create orna-mentation without the use of color. The handles applied to the body and lid are modeled in the prevailing rococo taste, displaying an interest in natural forms and sinuous curving lines. The handle on the lid is formed to resemble twisted branches entwined with ivy. A snail clings to the smallest branch. The handles on the bowl appear to have been modeled as bows of ribbon.

White porcelain exported from Fujian, China, was available in Europe at this time. The range of wares included figures, teaware, vases, boxes, and bowls. Plain white porcelains requiring one or two firings are potentially less expensive to produce than hand-painted and gilt examples. Colored decoration needs not only the hand of skillful painters but also many firings before it is complete. European factories were eager to supply consumers with white porcelain. Inspired by Fujian wares, many factories produced ornamental wares and tablewares for the popular market.[179]

The mark of a fleur-de-lis is painted in underglaze blue on the base.

Soft-paste porcelain
Height 4 ½ in (114 mm)
Diameter 6 ⅜ in (163 mm)
96.4.33

PROVENANCE
The Campbell Museum purchased this piece in 1968 from M. Sestieri, Rome.

LITERATURE
*Selections from the Campbell Museum Collection* 1969, no. 33; 1972, no. 60; 1976, no. 60; 1978, no. 64; 1983, no. 117.

*Fleur-de-lis mark*

# 89 Plate

**COZZI FACTORY**     **VENICE, ITALY, 1770–90**

*Maker, artist, craftsman* — Geminiano Cozzi was one of the most prominent porcelainmakers in Venice. He began experimenting with porcelain in 1762 and was successful enough to receive a State privilege in 1765. The factory was a commercial success throughout the last decades of the eighteenth century. They made a few figure models, busts, and cane handles but primarily concentrated on tableware, including pieces commissioned by the State. Production continued during the French invasion of 1793 and the subsequent Austrian occupation, but the financial consequences forced the factory to close in 1812.

*About the object* — The plate is of a circular form with an indented rim. The decoration comprises a narrow border and asymmetrical bouquets and flower sprays painted in underglaze-blue and overglaze-red enamel, all enlivened with gilding. This simple design represents the oriental-style patterns that found favor in the 1780s at the Cozzi factory, where the *Imari* palette was particularly popular. The narrow border is also found on an ornate soup tureen molded in the rococo style, but the central pattern is much more complex.[180]

The mark of an anchor suspended from a ring is painted in red enamel.

Hard-paste porcelain with underglaze-blue and enamel-painted decoration and gilding
Diameter 9 ½ in (241 mm)
96.4.20

PROVENANCE
The Campbell Museum purchased this soup plate in 1968 from Lukacs-Donath Antiques, Rome.

LITERATURE
*Selections from the Campbell Museum Collection* 1969, no. 36; 1972, no. 63; 1976, no. 63; 1978, no. 68; 1983, no. 123.

*Anchor mark*

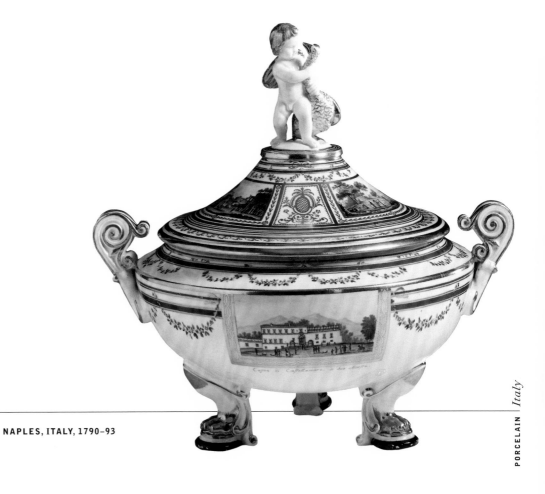

# *90* Tureen

**NAPLES PORCELAIN FACTORY     NAPLES, ITALY, 1790–93**

*Maker, artist, craftsman*

In 1771, more than ten years after the Capodimonte factory closed, Ferdinand IV, king of Naples and Two Sicilies, resolved to revive his father's porcelain-making venture. In 1773 he established a new factory on the grounds of the royal palace and began soft-paste porcelain production. The main products were, again, figures and tableware. The factory received commissions from the royal family and produced pieces to be given as diplomatic gifts. The business was sold in 1806, and the factory was moved to the foot of Capodimonte Hill, where production declined. Eventually the premises became a hospital.

The royal factory employed a number of experienced artists and modelers. In 1781 they appointed Filippo Tagliolini to be chief modeler. He was a sculptor who had formerly worked in the Vienna porcelain factory. It was shortly after this date that they produced a series of large, sculptural table services; Tagliolini must have been ultimately responsible for the work. The firm made services for King Charles III of Spain, King George III of England, and the duchess of Palma. This tureen was from a service made for King Ferdinand IV of Naples.

*About the object*

The design of the tureen is based on a classical urn shape, with the body supported by paw feet. The lid is topped by a small "antique" sculptural finial modeled as a small boy with a goose. This is a well-known subject and gave the name *Servizio dell'Occa,* or Goose Service, to the complete set of tableware.

The service was made between 1790 and 1793 and reflects the late eighteenth-century interest in classical taste. The decoration combines simple borders with floral swags painted in enamel colors with meticulously painted topographical views and extensive gilding. On each side of the body and lid are large gilt bordered panels painted with views of Naples. Depicted on one side of the body is the *Palazzo di Prepano di Sua Maestà. Casino di Castellamare di Sua Maestà* is on the other side. The lid has smaller panels painted with untitled scenes depicting figures in landscapes and picturesque ruins. The paintings on the complete service document Naples before the French occupation in 1799.

The mark of a cross is incised beneath the base and inside the lid.

Soft-paste porcelain with enamel-painted decoration and gilding
Height 12 ¾ in (323 mm)
Length 13 ½ in (343 mm)
Width 11 in (278 mm)
96.4.95

PROVENANCE
The tureen was formerly in the collection of Lady Berwick, Attingham Park, Shropshire, Eng. It was auctioned by Christie's, London, June 3, 1974, and purchased on behalf of the Campbell Museum.

LITERATURE
*Selections from the Campbell Museum Collection* 1978, no. 65; 1983, no. 118.

*Incised mark*

# 91 *Plate*

**FRANCIS GARDNER FACTORY    MOSCOW, RUSSIA, 1777–80**

*Maker, artist, craftsman*

Francis Gardner was a British resident of Moscow who operated a financial business in foreign exchange. He researched the possibilities of making porcelain in Russia and in 1766 received a royal privilege for the rights to establish a factory. He purchased a wooded estate at Verbilki, outside Moscow, where he built his factory. Gardner hired skilled workers from the German porcelain industry to assist him technically and purchased serfs to perform unskilled tasks. By 1769 porcelain production was under way.

The exceptional quality of Gardner's porcelain was widely praised, and his work came to the attention of Empress Catherine II (Catherine the Great). She commissioned him to make services for use in the Winter Palace in St. Petersburg and gave him access to services previously supplied to the Russian court by Meissen and Berlin.[181] The factory continued to make tableware in addition to producing figures in the style of those created at Meissen. In the nineteenth century a new periodical, *The Magic Lantern*, inspired the production of a popular series of figures portraying native Russian people.

The company continued to flourish and in 1847 added tin-glazed earthenware (faience) to its line. Financial difficulties began for the Gardners in 1861, when all Russian serfs were freed. Many of those trained at his factory left to work for other porcelain manufacturers. Although they revived the more popular series of figure models, the Gardner family's prosperity declined. In 1892 they sold the factory to Matvei Siderovich Kuznetsov, owner of the largest combine of porcelain factories in Russia.

*About the object*

The soup plate (one of a pair) is molded in the "royal" shape. It is painted in enamel colors and gilding and decorated with symbols of the Imperial Order of St. Andrew. The star of the order is in the center of the plate. Around the rim is the chain of the order with a badge at one side. The edge is gilded.

*Factory mark*

This soup plate was part of a service ordered by Catherine the Great in 1777—one of four services she commissioned decorated with the ribbons, badges, and stars of the more important of the imperial orders for use at their annual saint's day feasts at the Winter Palace. The Order of St. Andrew, first called of the apostles, was the highest of the Russian imperial orders and was established by Peter the Great in 1698. It was reserved for members of the imperial family, the highest Russian officials, and ambassadors. Each year on November 5, the feast of St. Andrew was celebrated with a High Mass followed by dinner at the Winter Palace, by imperial invitation only. [182]

A cursive "G" in blue and an incised worker's mark appear on the reverse of the soup plate.

Hard-paste porcelain with enamel-painted decoration and gilding
Diameter 9⅝ in (249 mm)
96.4.244.1

PROVENANCE
The service from which this soup plate comes was in use at the Winter Palace until the time of Nicholas I (1825–55). He sent all the original pieces to the Hermitage and commissioned copies from the Imperial Porcelain Factory in St. Petersburg. The old pieces remained at the Hermitage until the 1920s, when many were sold by the Soviets.[183] This soup plate and its pair were purchased by the Campbell Museum in 1975 from the Antique Porcelain Company, New York, with funds provided by Elinor Dorrance Ingersoll.

LITERATURE
*Selections from the Campbell Museum Collection* 1978, no. 70; 1983, no. 131.

# 92 *Plate*

**IMPERIAL PORCELAIN FACTORY    ST. PETERSBURG, RUSSIA, CIRCA 1840**

*Maker, artist, craftsman*

The Imperial Porcelain Factory was founded in 1744 at the order of Empress Elizabeth II. A former Meissen worker, C. K. Hunger, was unable to produce a successful formula, and the task was handed over to a Russian chemist, Dmitri Ivanovich Vinogradov, who located suitable native clays to create a good hard-paste porcelain.

Manufacture began in earnest when Elizabeth's daughter-in-law, Catherine II, ascended the throne in 1762. Porcelains were first made in the style of fashionable French and German wares, but as classical styles replaced rococo tastes, the factory developed its own shapes and designs. In the early decades of the nineteenth century, the Imperial Porcelain Factory began to make copies of the old imperial services. They also began to design new banqueting services for use in imperial palaces both old and new, creating services for the czar's Cottage Palace, the Peterhof Palace, the czarina's Island Pavilion at Peterhof, and for the imperial yachts.

Czar Alexander III brought new life to the Imperial Factory in the late nineteenth century with special orders for his court, including ormolu-mounted vases and painted table services. The Russian Revolution marked the end of the Imperial Porcelain Factory. In 1917 it was designated the State Porcelain Factory and continues as such today.

*About the object*

The soup plate is circular with an indented rim. It has complex enamel-painted and gilt border designs. The conventional strapwork pattern on the rim includes four circular reserve medallions, each decorated with the state seal. The seal shows a double-headed eagle with widespread wings. He has a scepter in his right claw and a laurel wreath in his left. On the breast is a shield with an image of St. George against a red background. The center of the plate has a gilt astral medallion.

The factory mark of Nicholas I is painted in overglaze blue.

Hard-paste porcelain with enamel-painted decoration and gilding
Diameter 9 ⅝ in (244 mm)
96.4.212.2

PROVENANCE
The soup plate was part of a service auctioned at Christie's, London, March 21, 1967: "Magnificent Imperial Russian Banqueting Services Used at the Coronations of the Tsars." The soup plate was among items purchased by the Antique Porcelain Company, New York, and subsequently purchased by the Campbell Museum.

LITERATURE
*Selections from the Campbell Museum Collection* 1969, no. 45; 1972, no. 66; 1976, no. 66; 1978, no. 73; 1983, no. 132.

*Factory mark*

# *EARTHENWARE AND STONEWARE*

Illustration from *Catchpenny Prints* (New York: Dover Publications, 1970).

Recipe for "Soop meagre" from Hannah Glasse, *The Art of Cookery Made Plain and Easy* (1760). (Winterthur Library.)

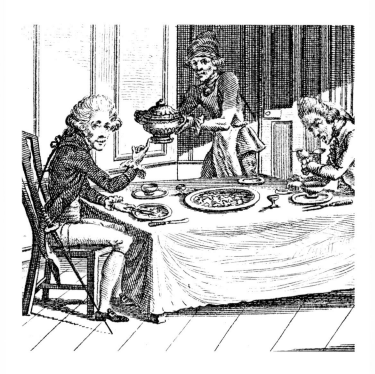

BELGIUM

## *Soop meagre.*

TAKE half a pound of butter, put it into a deep stew-pan, shake it about, and let it stand till it has done making a noise, then have ready six middling onions peeled and cut small, throw them in, and shake them about. Take a bunch of sellery clean washed and picked, cut it in pieces half as long as your finger, a large handful of spinach clean washed and picked, a good lettuce clean washed, if you have it, and cut small, a little bundle of parsley chopped fine ; shake all this well together in the pan for a quarter of an hour, then shake in a little flour, stir all together, and pour into the stew-pan two quarts of boiling water ; take a handful of dry hard crust, throw in a tea spoonful of beaten pepper, three blades of mace beat fine, stir all together and let it boil softly half an hour

Tin-glazed earthenware (faience)

Tureen:
Height 10 3/8 in (265 mm)
Length 12 in (305 mm)
Width 10 in (252 mm)

Stand:
Length 15 3/4 in (400 mm)
Width 8 in (202 mm)
96.4.195

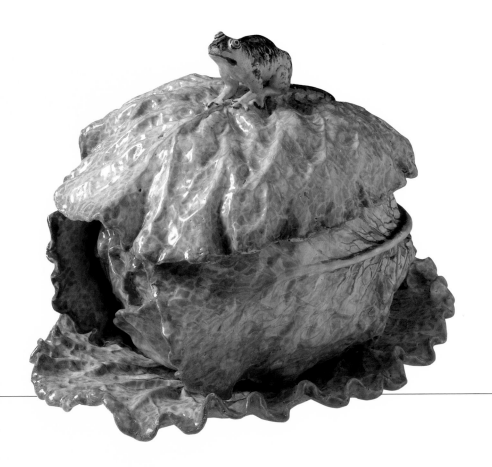

# 93 *Tureen*

**PHILIPPE MOMBAERS FACTORY
BRUSSELS, BELGIUM, CIRCA 1755**

*Maker, artist, craftsman*

The first important tin-glazed earthenware, or faience, factory established in Brussels was founded in 1705 by Corneille Mombaers and Thierry Witsenburg. The factory had its greatest success under the direction of Corneille's son, Philippe Mombaers, who had previously worked in French and Dutch faience potteries. Philippe began in 1724, and by the middle of the century the factory was able to offer an amazing range of goods. One of the most prestigious lines was tureens, which they made in an unrivaled variety of forms from fish and fruit to animals and vegetables.

*About the object*

This tureen is molded in the shape of a cabbage. A single leaf forms the lid, and a larger leaf acts as the stand. The cabbage is heavily modeled, the leaves having prominent central stems and a complex net-

work of veins leading the curled edges. The naturalistically modeled finial is in the form of a startled frog. The coloring is characteristic of the Mombaers factory. The tin glaze appears to be marbled in white, pink, and green. The quality of the colors, particularly the bluish green of the leaf edges, is thought to be peculiar to this factory.[184] The frog is painted in shades of yellow and brown with a deep red mouth.

PROVENANCE
A similar, possibly the same, tureen was formerly the property of Sir Oliver Welby of Grantham, Eng. It was sold with his collection at Sotheby's, London, February 24, 1956, lot 36. A cabbage tureen, possibly that formerly owned by Sir Oliver, appeared in the sale of "Important

French and Soft-Paste Porcelains and Faience ... The Unique Collection of Margaret Glover of New York," at Parke-Bernet Galleries, New York, March 22 and 23, 1957, lot 296. James Donahue of Old Brookville, Long Island, N.Y., acquired the tureen, and it was sold with his collection of English and Continental pottery and porcelain at

Sotheby Parke Bernet, New York, November 2, 1967, lot 131, when it was purchased on behalf of the Campbell Museum.

LITERATURE
*Selections from the Campbell Museum Collection* 1969, no. 67; 1972, no. 121; 1976, no. 121; 1978, no. 129; 1983, no. 8.

# 94 Tureen

**ATTRIBUTED TO TÄNNICH OR BUCHWALD FACTORY**
**KIEL, HOLSTEIN, DENMARK (NOW GERMANY), CIRCA 1770**

*Maker, artist, craftsman*

From about 1758, attempts were made to establish a tin-glazed earthenware (faience) manufactory at Kiel in Holstein, Denmark. The first commercial success came in 1763, when itinerant pottery artist Johann Samuel Friedrich Tännich arrived from Strasbourg. Tännich directed a factory founded under the patronage of the duke of Holstein. The factory was sold in 1766, and within three years Tännich was replaced with Johann Buchwald, who remained as director until about 1771–72. During the Tännich and Buchwald periods, the factory made a range of decorated ornamental and useful wares including punch bowls, plates, wall fountains, vases, flowerpots, and tureens. Buchwald was a talented modeler, and the factory employed skilled artists who painted decoration of flowers, landscapes, chinoiserie, and genre subjects. Following Buchwald's departure, there was a decline in the standard of production; the factory

finally closed in 1788. The city of Kiel passed into the possession of Germany in 1866 and is no longer part of Denmark.

*About the object*

The tureen is modeled in the form of a boar's head. The accompanying oval stand has a rim molded in relief as a wreath of oak leaves and acorns. The lid of the tureen is formed from the upper part of the head. Problems associated with creating large molded pieces of this kind include the instability of the ceramic body at high temperatures during the firing process. This example suffers from warping; the unfortunate beast has an unintentional lopsided grin.

The painted decoration of the tureen and stand is, unusually, monochromatic. Shades of manganese-purple define the physical details of the boar's mouth, eyes, and nostrils and convey the texture of the animal's fur. The oak wreath on the rim of the stand is painted in similar tones, picking out the veins of the oak leaves and details of the acorns. The wreath

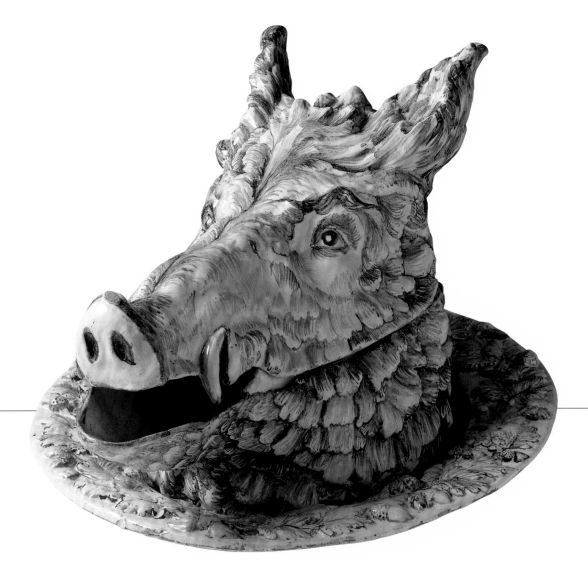

frames a sketchy rendering of a Chinese-style garden scene with a figure in the foreground carrying a parasol.

Tureens of this kind may have been designed to serve as the centerpiece of ceremonial and celebratory dinners to replace the severed head of a hunted boar. This example would have been an extremely fashionable object combining the rococo vogue for animal forms with a fascination for the Orient.

A mark on the base of the stand, with very large incised script, is obscured by glaze.

Tin-glazed earthenware (faience) with enamel-painted decoration

Tureen:
Height 11 ⅝ in (295 mm)
Length 18 in (460 mm)
Width 10 ½ in (266 mm)

Stand:
Length 19 ½ in (496 mm)
Width 17 in (431mm)
96.4.242

PROVENANCE
The tureen was formerly the property of Sir Oliver Welby of Grantham, Eng., and was sold with his collection at Sotheby's, London, February 24, 1956, lot 36. The Campbell Museum purchased it in 1966 from the Antique Porcelain Company, New York.

LITERATURE
*Daily Telegraph* (London), September 1, 1973, p. 9.

*Selections from the Campbell Museum Collection* 1976, no. 119; 1978, no. 127; 1983, no. 20.

# 95 Tureen

**JEAN-BAPTISTE GUILLIBAUD    ROUEN, FRANCE, CIRCA 1730**

*Maker, artist, craftsman*

Tin-glazed earthenware (faience) production began in Rouen in 1644. By 1720 eight separate factories were in business, including the pottery of Jean-Baptiste Guillibaud. Guillibaud's work is identified from attributions of signed pieces and related wares, including a service made about 1728 for Charles-François-Frédéric de Montmorency, duke of Luxembourg. Guillibaud used a distinctive range of patterns including trellis work, oriental-style flowers, strong colors, and colored grounds. The work is often heavy and quite thickly potted.

By the 1780s approximately eighteen faience factories were operating in Rouen. However, the popularity for English-style creamware began to dominate the middle-class market, and by the first decade of the nineteenth century only four faience factories remained in business.

*About the object*

The tureen is a simple circular shape with a scalloped rim, which is repeated in the modeling of the stand. Decoration is in the strong colors that are typical of Rouen faience. The deep borders comprise panels of trellis in green and red with panels of stylized flower heads in red, green, yellow, and blue. A narrow band of yellow-and-black gadrooned pattern edges each piece.

Guillibaud frequently used elements of this design to create a decorative scheme; the pattern is characteristic of his production. The circlets of flowers on the lid and stand are painted in bright colors and are applied very thickly, creating a textured surface. The design is based on motifs found in Chinese *famille rose* porcelains that were popular imports into Europe in the eighteenth century. In this early period, technical problems associated with the creation of pinks and purply reds forced faience manufacturers to use a palette of colors that differed from that of the Chinese. A true copy of the rose color was not possible.

The mark "G.3" is painted in blue script on the tureen base and is on the base of the stand.

*Factory mark*

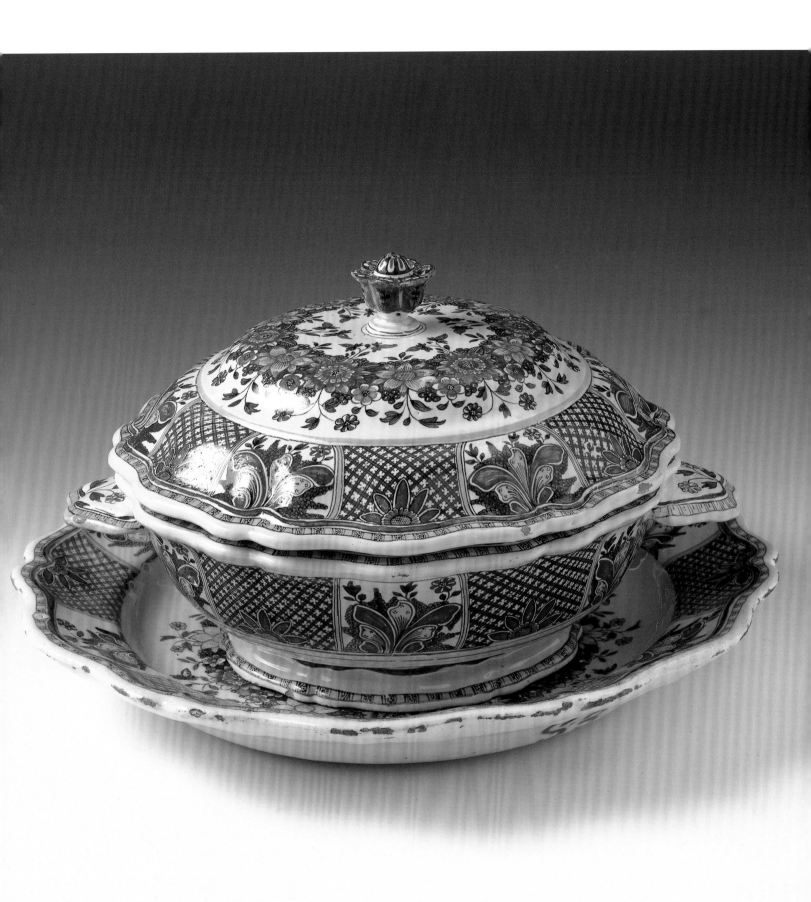

Tin-glazed earthenware
(faience)
Height 7 ½ in (190 mm)
Length 13 in (330 mm)
Width 11 ¼ in (286 mm)

Stand:
Diameter 14 ⅞ in (378 mm)
96.4.108

PROVENANCE
The Campbell Museum
purchased this tureen in
1966 from Nicolier, Paris.

LITERATURE
*Selections from the Campbell
Museum Collection* 1969,
no. 55; 1972, no. 93; 1978,
no. 93.

# Strasbourg Factory

Strasbourg, situated in eastern France, is close to the German border; factory production was perhaps influenced by German porcelains and fashions more than any other French faience factory. The Strasbourg pottery was established in 1721 by Charles-François Hannong; three years later he built a second workshop in nearby Haguenau. The Hannong family operated the two factories until about 1781. Paul-Antoine Hannong, Charles's son, was the most dynamic member of the family, occupying the position of factory director in Strasbourg from 1739 to 1760. Rococo fashions influenced the shapes he produced. He introduced enamel-painted decoration and gilding, and he employed artists who had worked at the porcelain factories of Höchst and Meissen.

Among the porcelain workers who arrived in Strasbourg was Joseph Jacob Ringler, who knew the secrets of hard-paste porcelain manufacture. Paul Hannong was inspired to try to make his own porcelain; however, because of the royal monopoly held by the Sèvres factory, no other hard-paste porcelain manufactories were allowed to operate in France. Hannong thus moved his porcelain production to Frankenthal, Germany, where he opened a factory (see No. 70). Paul Hannong still owned the Strasbourg works and asked his son Pierre-Antoine to oversee daily management there. When the elder Hannong died in 1760, Pierre-Antoine inherited the Strasbourg pottery, and his brother Joseph Adam inherited Frankenthal. Pierre-Antoine was not a gifted manager, and within two years the business had to be rescued by the monies from the sale of the Frankenthal porcelain factory. Joseph Hannong then took control from his brother, and Strasbourg experienced another period of commercial success. The factory continued to produce a fine range of tableware. Forms were perhaps less exuberant, but they maintained the high standards of decoration.

Like his father, Joseph was also fascinated by porcelain. He undertook a few experiments but incurred some financial setbacks. In the face of the monopoly at Sèvres, Joseph was imprisoned and declared bankrupt in 1781. The era of the Hannongs at Strasbourg had ended, but their influence continued as their work inspired many other European faience manufacturers.

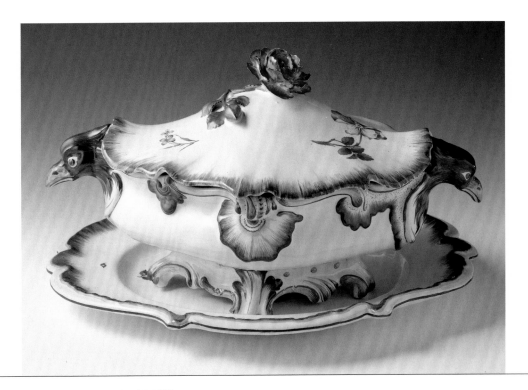

# 96 Tureen

**PAUL-ANTOINE HANNONG    STRASBOURG, FRANCE, CIRCA 1755**

*About the object*    This tureen is of oval bombé shape with a high, scrolling, foliate foot. It stands on a large oval platter modeled with an indented rim. The bowl of the tureen has handles in the form of eagles' heads and is molded around the rim with asymmetrical scrolls, shells, and leaves. The undulating lid is topped by a finial modeled as a full-blown rose rising from a stem with leaf and rosebud.

The enamel-painted decoration emphasizes the molded details with shades of red, yellow, green, purple, and blue. The eagle-head handles are painted in naturalistic colors. On the lid, the rose finial and small flower spray are enameled in deep pink and green.

The stand is painted with a bouquet of roses tied with a blue bow; the roses appear to have been painted from nature. Tiny, scattered rosebuds are applied, some covering surface imperfections. The juxtaposition of incongruous elements and the use of shell and scrolling ornamentation place this tureen in the center of rococo fashion. It is one of the most commonly seen tureen shapes from Strasbourg and is represented in many major museum collections.[185]

Tin-glazed earthenware
(faience) with enamel-
painted decoration

Tureen:
Height 8 ⅛ in (204 mm)
Length 15 in (381 mm)
Width 8 ½ in (216 mm)

Stand:
Length 15 ½ in (383 mm)
Width 13 ¼ in (336 mm)
96.4.211

PROVENANCE
This tureen was one of
a pair in the René Fribourg
collection sold by Sotheby's,
London, October 15, 1963,
lot 378. The Antique
Porcelain Company, New
York, purchased the pair

and sold this tureen to the
Campbell Museum in 1966.

LITERATURE
*Selections from the Campbell
Museum Collection* 1969,
no. 58; 1972, no. 97; 1976,
no. 97; 1978, no. 106; 1983,
no. 64.

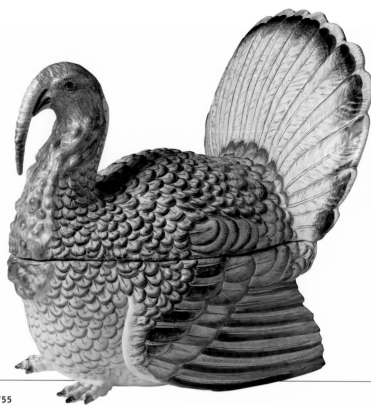

# 97 *Tureen*

**PAUL-ANTOINE HANNONG**    **STRASBOURG, FRANCE, CIRCA 1755**

*About the object*    This tureen is modeled in the shape of a life-size turkey, with feathers, head, and wattle molded in relief. The head, upper half of the body, and fanned tail form the lid. The bowl is formed by the lower body; the half-open wings touch the ground at the tips and, with the feet, give stability.

The decoration is hand painted in enamel colors. Manganese-purple-brown is used to detail the feathers; additional brush stokes in ochre-brown define the feather shafts and barbs. The head is blue with a fierce red and black eye. The wattle is painted bluish-pink to simulate wrinkled skin.

Turkey tureens of a different model with more detailed painting are also recorded as the work of Hannong.[186] Large soup tureens in naturalistic forms such as animals and vegetables were a fashionable expression of rococo taste in eighteenth-century Europe. They were first made by German factories, particularly the Höchst factory, from where the fashion spread to Strasbourg and then to the whole of France.

Tin-glazed earthenware (faience) with enamel-painted decoration
Height 15 ¾ in (385 mm)
Length 16 ½ in (420 mm)
Width 10 in (254 mm)
96.4.269

PROVENANCE
This tureen was formerly the property of His Highness, the Prince de Ligne. It was sold from his collection at Sotheby's, June 25, 1968, when it was purchased by the Antique Porcelain Company, New York. The tureen was then purchased by the Campbell Museum with funds provided by John T. Dorrance Jr.

LITERATURE
*Selections from the Campbell Museum Collection* 1983, cover and no. 65.

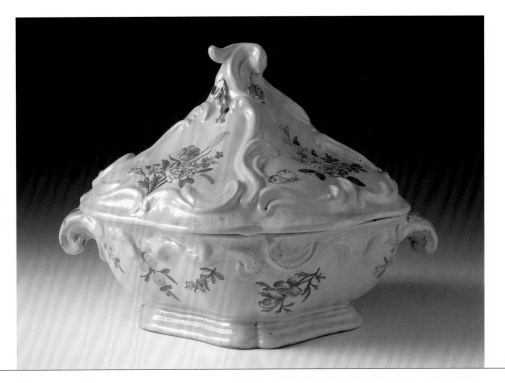

# 98 Tureen

**VEUVE PERRIN    MARSEILLES, FRANCE, CIRCA 1760**

*Maker, artist, craftsman*

One of the most proficient potters of Marseilles was Pierette Caudelot, the widow of Claude Perrin, whose faience works she inherited in 1748. As a woman of exceptional business ability and artistic taste, her endeavors ensured that the factory was successful. She engaged capable partners and produced a range of decorated tableware. Her work included services molded in bold rococo forms, some decorated with vibrant yellow grounds and others with white or slightly tinted grounds. Enamel-painted decoration included natural flower sprays, patterns based on Chinese originals, and chinoiseries. From 1748 until her death in 1793, she was known as Veuve (widow) Perrin. She created an outstanding factory that her son inherited and kept in operation into the early years of the nineteenth century.

*About the object*

The tureen is of curving form with a tall lid and scrolling handles and finial. It is modeled at the rim with asymmetrical S- and C-shape scroll borders. The lid is divided into four panels bordered with scrolls. The ground color is a strong yellow overpainted with enamel colors; the shallow bowl of the tureen is painted with small floral sprays. The deeper lid has larger bouquets of flowers and insects including a butterfly and caterpillar. Small molded and enamel-painted flowers hang from the finial.

The tureen is typical of the work of Veuve Perrin. Her strong rococo forms with bold decoration were popular through the middle years of the eighteenth century. The Perrin factory style of painting involved light brushwork, with colors often mixed with white, creating strong pastel tones.

Tin-glazed earthenware (faience) with enamel-painted decoration
Height 8 ¾ in (222 mm)
Length 12 ⅛ in (310 mm)
Width 6 ¼ in (159 mm)
96.4.75

PROVENANCE
The tureen belonged to Henry Reynaud, whose collection of Marseilles faience was sold by Christie's, Geneva, May 9, 1982. This tureen, lot 4, was purchased by Lovice Ullein-Reviczky of Zurich on behalf of John T. Dorrance Jr., who presented it to the Campbell Museum.

LITERATURE
*Selections from the Campbell Museum Collection* 1983, no. 70.

# *Jacques Chapelle Factory*

Although there had been a faience factory at Sceaux since 1735, it only came to prominence with the arrival of Jacques Chapelle in 1748. Along with many other potters of his day, Chapelle aspired to make porcelain, but the royal monopoly lay with Vincennes and then Sèvres. He did make porcelain but was prohibited from continuing production. Instead, he began to refine his faience and established himself as a rival with high-quality wares available at his Paris shop.

Chapelle became the sole owner of the Sceaux factory in 1759. When he retired in 1763, he leased the factory for nine years to two men who continued the tradition of fine painting and maintained a close relationship with porcelain productions. The work attracted skilled painters and modelers, and the tureens produced in the 1760s were a characteristic part of their product range, which included dishes, vases, and table services.

In 1771 Chapelle sold the business, and the Sceaux factory continued under the direction of various owners. Like many other faience factories, Sceaux suffered from the effects of the French Revolution, and it abandoned the production of fine work. Although the factory survived into the nineteenth century making popular faience and domestic wares, it never again achieved the status it had in the eighteenth century.

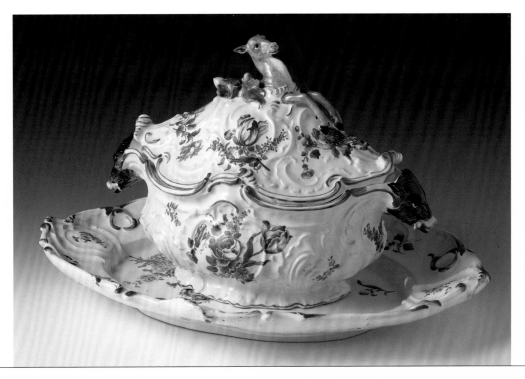

# 99 Tureen

**JACQUES CHAPELLE FACTORY    SCEAUX, FRANCE, CIRCA 1760**

*About the object*    This tureen is of oval bombé shape. The surface is heavily molded in relief with panels framed by scrolling foliage and shells. The bowl of the tureen has an asymmetrical rim formed by S- and C-shape scrolls that curve into handles molded in the shape of boars' heads. The lid, also heavily molded, is topped by a finial modeled with the head and forelegs of a deer and a spray of oak leaves and acorns. The boars'-head handles and leaping deer on the lid suggest an interest in animals of the chase.

The decoration is finely painted in enamel colors with bouquets of naturalistic flowers, including roses, tulips, and narcissi. The bouquets are centered on the plain panels but freely meander over the molded frames. Naturalistic colors are also used in painting the animal heads. The tureen, lid, and stand are edged in puce enamel. The fine quality of the painted decoration reflects the influence of French porcelain and illustrates Chapelle's attempts to rival the Sèvres porcelain monopoly.

Rococo fashions demanded exuberance, fantasy, and asymmetry. All these features can be seen in this tureen, which was produced when the Sceaux factory was approaching an unrivaled degree of perfection among French faienciers.

A fleur-de-lis mark is painted in puce on the base of the tureen and stand.

Tin-glazed earthenware (faience) with enamel-painted decoration

Tureen:
Height 9 ½ in (240 mm)
Length 13 ¾ in (348 mm)
Width 6 ½ in (165 mm)

Stand:
Length 18 ¼ in (465 mm)
Width 12 ¼ in (310 mm)
96.4.273

PROVENANCE
This tureen was purchased by the Campbell Museum in 1970 from B. W. Berry, Konst & Antikhandel, Göteborg, Swed.

LITERATURE
*Selections from the Campbell Museum Collection* 1972, no. 96; 1976, no. 96; 1978, no. 105; 1983, no. 68.

*Fleur-de-lis mark*

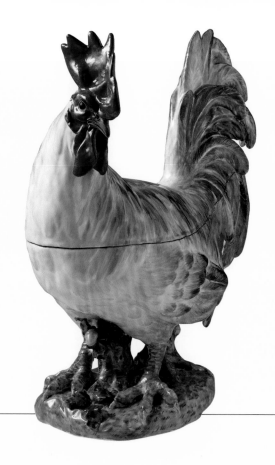

# 100 Tureen

**JACQUES CHAPELLE FACTORY    SCEAUX, FRANCE, CIRCA 1760**

*About the object*

This tureen is modeled in the form of a strutting rooster. He stands with his comb raised and his tail displayed. The lower body forms the bowl of the tureen; it is supported by the feet of the bird and by two strategically placed tree stumps. The upper body, head, and tail form the lid. The only safe access is to raise the lid by grasping the head and tail.

The enamel-painted decoration is applied to create a naturalistic bird. The head with comb and wattle is in deep red. The eye is a fierce black and red. To portray the feathers, the artist has used the texture of brushstrokes in brown with pink and blue highlights. The rooster's legs and feet are painted in appropriate colors, and he stands on a base painted in imitation of green grass with trees stumps and leaves.

Large soup tureens modeled as life-size animals were produced by many European faience potteries in the middle of the eighteenth century. This example was probably inspired by an earlier model produced by Strasbourg factory artist Jean-Guillame Lanz.

A fleur-de-lis mark is painted in manganese on the interior of the lid.

Tin-glazed earthenware (faience) with enamel-painted decoration
Height 17 ¼ in (437 mm)
Length 15 ¾ in (400 mm)
96.4.219

PROVENANCE
This tureen was formerly the property of James Donahue of Long Island, N.Y. It was sold with his collection of English and Continental pottery and porcelain at Parke-Bernet Galleries, New York, November 2, 1967, lot 123. It was purchased from the sale by the Campbell Museum.

LITERATURE
*Selections from the Campbell Museum Collection* 1969, no. 57; 1972, no. 95; 1976, no. 95; 1978, no. 104; 1983, no. 69.

*Fleur-de-lis mark*

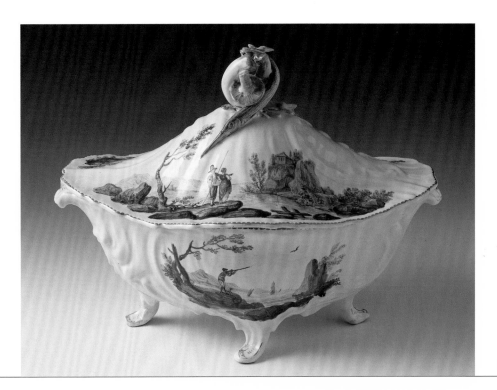

# 101 Tureen

**JOSEPH-GASPARD ROBERT     MARSEILLES, FRANCE, 1760–70**

*Maker, artist, craftsman*

Many potteries were established in Marseilles in the eighteenth century. The numbers increased as they exploited the rich local clay deposits. One of the successful factories was that of Joseph-Gaspard Robert, who began making faience in 1750 in partnership with his stepfather. Four years later he built a second workshop, and production expanded. In 1759 Robert applied for, and eventually received, royal permission to make porcelain. He made a good case that the Sèvres factory could not fulfill domestic demand and that exports of pottery and porcelain would be an economic stimulus for the country. Although he may have been experimenting with ingredients and formulas, it seems unlikely that he was producing any commercial quantities until about 1770. His interest in porcelain is reflected in his faience with the production of a smoothly potted body and finely detailed painted decoration.

*About the object*

The tureen is heavily modeled with an asymmetrical design of vigorously scrolling leaves. The leaves sweep up into handles at either end and extend down to form four, insubstantial curving feet. The finial is modeled in the form of a mushroom and a twist of three fish amid shells and seaweed.

The enamel-painted decoration is in the style usually attributed to Robert's factory. His aspirations as a porcelainmaker are reflected in the quality and subject matter of his painted decoration. The lid and bowl each have two panels of waterside views. The subjects demonstrate an interest in scenes of local life: three of the panels have people fishing; the fourth panel is painted with a huntsman shooting at a bird. A gilt dentil pattern edges the tureen and lid, and traces of gold decoration remain on the handles and feet. The delicately painted landscapes are unusual for tin-glazed earthenware, which is usually characterized by broader brushwork often depicting floral subjects.

A large incised script mark on the tureen base is partially obscured by glaze but includes the numeral "32."

Tin-glazed earthenware (faience) with enamel-painted decoration and gilding
Height 10 ¼ in (260 mm)
Length 14 in (356 mm)
Width 8 ½ in (216 mm)
96.4.215

PROVENANCE
This tureen was purchased by the Campbell Museum in 1970 from Nicolier, Paris.

LITERATURE
*Selections from the Campbell Museum Collection* 1972, no. 100; 1976, no. 100; 1978, no. 109; 1983, no. 72.

*Incised mark*

# Moulin Factory

César Moulin founded a factory about 1720 in Castellet in the Vaucluse region of France. After his father's death, César Moulin II continued the business, and it descended in the family into the second half of the nineteenth century. Two brothers of César II, Charles-François and Jacques-Barthelemy, worked with their father until 1770, when they moved to the nearby town of Apt to establish their own factory. Both factories made pottery in imitation of English wares. In 1776 marbled ware was introduced into the range of products made at Apt.

Brown, cream, and sometimes blue clay are combined to produce the pottery. It is carefully mixed by hand until it resembles the semiprecious stone agate. The wares are then formed in molds to preserve the marbled appearance. If agates are thrown, the striations of color sweep around horizontally and upward diagonally, following the movements of the potter's hands. Similar agatewares were made at the family's Casellet factory as well as at other French potteries. Although many of these potteries may have had some success with their "English wares," most surviving pieces are attributed to Apt.

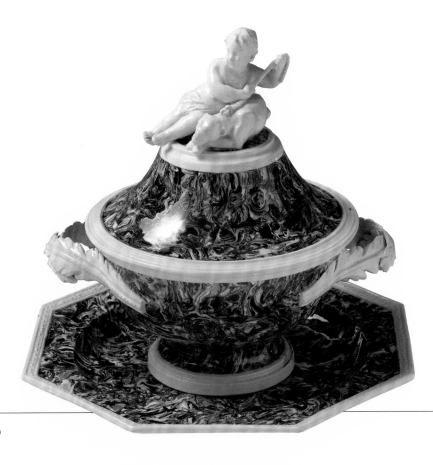

# *102 Bowl*

**MOULIN FACTORY       APT, FRANCE, CIRCA 1780**

*About the object*     This covered soup bowl is of conventional form—
based on a classical urn shape. The flattened top of
the lid supports a finial depicting a small figure of
a reclining boy with a recumbent dog on a leash. The
bowl is of hemispherical form on a stepped foot with
handles on either side in the form of curving, overlap-
ping leaves. The stand is hexagonal and reflects
contemporary fashions in dinner plates. Edgings and
details are in white clay.

   The urn shape, the restrained profile, and the style
of the finial reflect an interest in "the antique," which
inspired the neoclassical fashions of the second half of
the eighteenth century.

Wares of this type were made in Staffordshire,
England, in the eighteenth century and formed part
of a large export market to Europe and the colonies.
Staffordshire agatewares were widely imitated, but
the most successful pieces were made at Apt.

Agate earthenware

Bowl:
Height 8 in (203 mm)
Diameter 6 in (153 mm)

Stand:
Diameter 9 in (289 mm)
96.4.88

PROVENANCE
The Campbell Museum
purchased this covered bowl
in 1972 from Nicolier, Paris.

LITERATURE
*Selections from the Campbell
Museum Collection* 1983,
no. 76.

### French Shape Broth Bowl with Round Stand

| Height | over Top | Height of Cover | Height of Stand | over Top of Stand |
|---|---|---|---|---|
| 3½ | 6 | 1¾ | 1¾ | 7¼ |

### New Shape Broth Bowl & Stand

| | Height | within Top | Height of Cover | over verg of Cover | Height of Stand | over Top of Stand |
|---|---|---|---|---|---|---|
| Large | 4⅛ | 6³/₁₆ | 1¹³/₁₆ | 6 | 1⅝ | 8 |
| Middle | 3¹¹/₁₆ | 5⅜ | 1⅝ | 5¼ | 1½ | 7³/₁₆ |
| Small | 3⁵/₁₆ | 4⅝ | 1¾ | 4½ | 1⅜ | 6⁵/₁₆ |
| Quart | 4⅝ | 6¹³/₁₆ | 2 | 6⅝ | 1¾ | 8¾ |

### Old Shape Broth Bowl & Stand

| | Height | over Top | Height of Cover | over verg of Cover | Height of Stand | over Top of Stand |
|---|---|---|---|---|---|---|
| Large | 3⅝ | 6⅞ | 1⅜ | | 2 | 8 |
| Middle | 3¼ | 6 | 1³/₁₆ | | 1¾ | 7¼ |
| Small | 3⅜ | 5 | 1¹/₁₆ | | 1½ | 6¾ |

Three styles of broth bowls illustrated in Josiah Spode's patternbook, *Shape Book* (1820–21). (Downs Collection, Winterthur Library.)

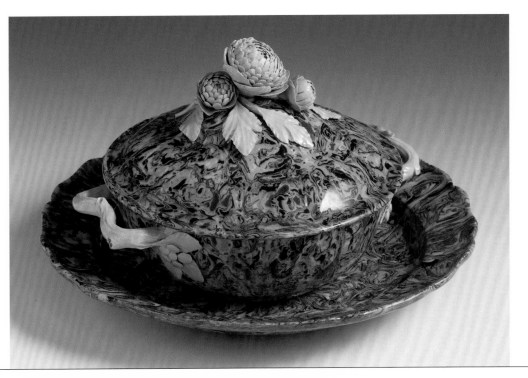

# 103 *Bowl*

**MOULIN FACTORY**     **APT, FRANCE, CIRCA 1780**

*About the object*     The bowl and lid are of simple circular shape. The stand has an indented rim. The body is made from brown, cream, and blue clays combined to produce pottery resembling the semiprecious stone agate. The handles of the bowl and finial on the lid are made in contrasting white clay. The handles are applied on the horizontal axis and take the shape of twisted branches with leaf and flower terminals. The finial is formed as a spray of four blossoms rising from leaves; the flowers are a complex assemblage of overlapping petals.

Agate earthenware

Bowl:
Height 5 ⅛ in (130 mm)
Diameter 6 ¼ in (158 mm)

Stand:
Diameter 9 ¾ in (247 mm)
96.4.84

PROVENANCE
The Campbell Museum purchased this covered bowl in 1970 from Nicolier, Paris.

# 104 Tureen

**MOSBACH FACTORY**   **BADEN, GERMANY, CIRCA 1775**

*Maker, artist, craftsman*

The factory at Mosbach was begun in 1770 and had the patronage of Carl Theodor, elector of the Palatinate, who owned the Frankenthal porcelain factory. In 1774 an itinerant but gifted ceramic artist named Johann Samuel Friedrich Tännich became director. Tännich had previously spent time at Strasbourg, Kiel, and Frankenthal and agreed to purchase the Mosbach factory. After five years he had not raised the necessary funds, and the pottery was bought by a consortium headed by Johann Georg Friedrich List, from the nearby Durlach faience works.[187] List left in 1787, and the Mosbach pottery continued as Roemer and Company until 1828 under the direction of Heinrich Stadler. It finally closed in 1836.

Products of the Mosbach factory have been identified from some marked and inscribed specimens. The range of goods includes table services for tea and dinner, vases, mugs, baskets, and tureens. Flower painting is perhaps the most dominant decoration with patterns of large bouquets or neoclassical-style swags; some of the finest examples were produced in the Tännich period. Under List's influence, European-style landscape painting was introduced, but in the nineteenth century simple, inexpensive banding and stylized flowers are most commonly seen.

*About the object*

This tureen is a deep oval shape molded as a basket of fruit. The lid is modeled to resemble overlapping leaves that occasionally part to reveal the fruity contents. Handles and feet are shaped like twigs with leaf and flower-bud terminals. The finial is modeled as a mound of fruit and legumes surmounted by a small bird.

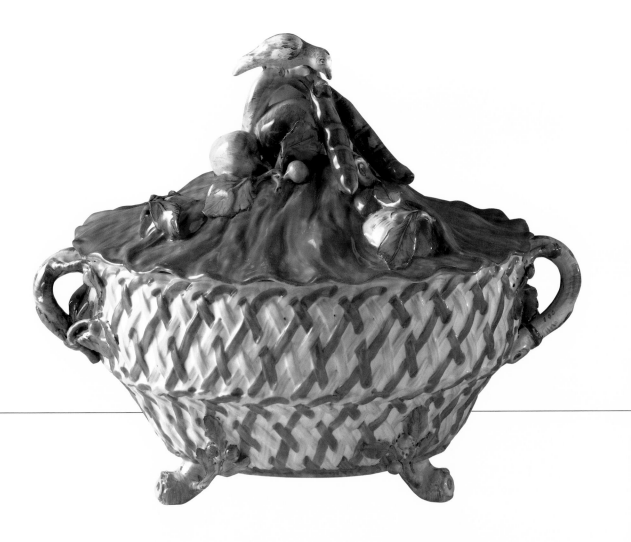

Enamel-painted decoration highlights the basket, emphasizing the interwoven trellis of green and yellow. The fruit, twig, and foliage details are all painted in naturalistic shades of green, brown, yellow, purple, and blue. The bird is painted in pink, yellow, and brown. The artist has used the brush strokes to simulate plumage.

Naturalistic models were a fashionable expression of rococo taste in eighteenth-century Europe; however, the theme of fruit is unusual. Most tureens reflect an interest in flowers, vegetables, and animals. Mosbach did produce some small covered bowls with bird finials, and they also made tureens in the shape of pigeons. This example is closer to the extensive range of baskets that they produced in the 1770–80 period.

Tin-glazed earthenware (faience) with enamel-painted decoration
Height 10 ½ in (267 mm)
Length 13 ½ in (342 mm)
Width 8 ¼ in (206 mm)
96.4.80

PROVENANCE
The tureen was sold at Christie's, London, June 17, 1968, lot 58, in a sale of "important Continental porcelain and faience." It was listed as "the property of THE LATE SARAH ROUBANIS inherited from the Collection of the late MADAME CONSUELO VANDERBILT BALSAN." Winifred Williams of Eastbourne, Sussex, and London, Eng., purchased the tureen and sold it to the Campbell Museum in 1970.

LITERATURE
*Selections from the Campbell Museum Collection* 1972, no. 107; 1976, no. 107; 1978, no. 114; 1983, no. 109.

# 105 Tureen

**PROBABLY STAFFORDSHIRE, ENGLAND, CIRCA 1760**

*Maker, artist, craftsman*

White salt-glazed stoneware usually cannot be attributed to a particular manufacturer. The pieces are seldom marked, and documentary and excavated evidence is rarely definitive. Salt-glazed stoneware was made in a great many pottery centers in England and Scotland. However, the overwhelmingly large number of factories based in Staffordshire suggests that, statistically at least, the majority of pieces came from that district.

*About the object*

The tureen is press molded in the form of a melon standing on a large leaf. The handles on the tureen and lid are hand modeled to resemble the stems and leaves of the vine; scattered molded flowers add texture and dimension. Salt-glazed stoneware is particularly suited to this kind of surface relief decoration. The fine body reproduces molded details very well, and the thin, tight-fitting glaze keeps the pattern sharply defined.

Melon tureens are not commonly found in salt-glazed stoneware but appear more frequently in various sizes of creamware dinner-, dessert-, and teawares. The details of form and molding vary from factory to factory, and some manufacturers illustrate examples in contemporary shape books. Most surviving examples are undecorated, but creamware melons decorated with colored glazes are recorded.[188]

Fruit and foliage were part of the repertoire of rococo decoration. The novelty of purchasing pieces in the shape of an exotic fruit, such as a melon, would have been appealing to the fashionable consumer who was looking for novelty and high style.

Design for a tureen from James and Charles Whitehead Manufacturers in Staffordshire. Illustrated in James Whitehead, *Designs for Sundry Articles of Earthenware...* (Birmingham, Eng.: Thomas Pearson, 1798), pl. 76. (Winterthur Library.)

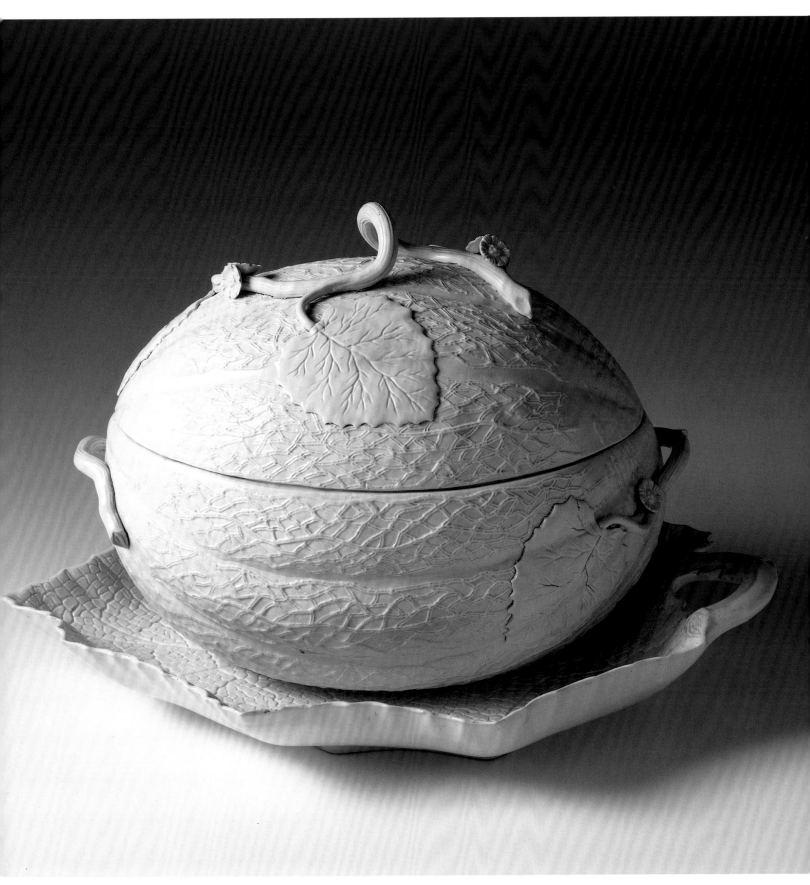

Salt-glazed stoneware

Tureen:
Height 8 ½ in (216 mm)
Length 11 ½ in (290 mm)
Width 8 in (202 mm)

Stand:
Length 15 in (380mm)
Width 11 in (277 mm)
96.4.226

PROVENANCE
The Campbell Museum
purchased this piece in
1966 from Carleton L.
Safford, Granville, Mass.

LITERATURE
*Selections from the Campbell
Museum Collection* 1969,
no. 77; 1972, no. 135; 1976,
no. 135; 1978, no. 141; 1983,
no. 39.

# 106 Tureen

*Maker, artist, craftsman*

It is difficult to identify the maker of white salt-glazed stoneware. However, parts of a soup tureen, including a lid and a stand, with shapes and designs similar to those of this example, were discovered during an excavation of a pottery site in Hanley, Staffordshire, England. Archaeologists are still studying the site, currently known as HEB 9, which is near the pottery occupied by Humphrey Palmer. It is hoped that when research is complete we may have a more conclusive attribution for this piece.

*About the object*

The tureen, lid, and stand are press molded. The tureen is a six-sided bombé form embossed with a design of fruiting currants with applied shell-molded handles. The handle of the lid is modeled in the form of a twisted rope or branch. Bands of conventional scrolling decorate the foot and rim. The stand has a scalloped edge and is embossed with floral sprays.

Although the patterns of the tureen and stand differ, excavated evidence suggests that they would have been used together.

The style of this tureen reflects rococo motifs and devices including a fascination with the natural world and an incongruous juxtaposition of ornamentation. Large, white salt-glazed soup tureens are recorded, but they appear more frequently in the popular seed, basket, barleycorn, and diaper designs. When George Washington ordered salt-glazed stoneware in 1757 and 1758, it is likely that it was the diaper pattern that was supplied. Washington's 1758 order included six "White stone" soup tureens at a cost of fifteen shillings.[189] The design of this tureen is not recorded in any other extant ceramic example.

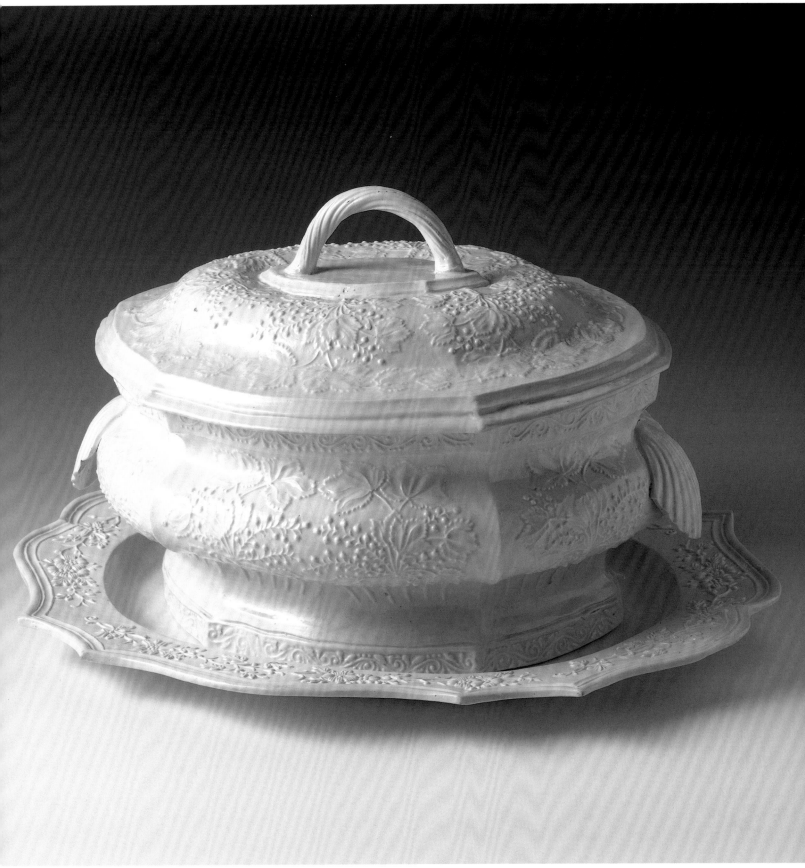

Salt-glazed stoneware

Tureen:
Height 8 ¼ in (210 mm)
Length 13 in (330 mm)
Width 10 in (252 mm)

Stand:
Length 15 ½ in (395 mm)
Width 12 ½ in (305 mm)
96.4.91

PROVENANCE
The Campbell Museum
purchased the tureen in
1970 from John M.
Graham II, Williamsburg, Va.

LITERATURE
*Selections from the Campbell
Museum Collection* 1972,
no. 136; 1976, no. 136; 1978,
no. 142; 1983, no. 40.

# *107 Plate*

**PROBABLY STAFFORDSHIRE, ENGLAND, CIRCA 1770**

*Maker, artist, craftsman*

The design of this soup plate has no distinguishing features that allow the identification of the manufacturer. It is a standard shape used by many English potters producing salt-glazed stoneware, plain creamware, and tortoiseshell-decorated creamware.

*About the object*

The soup plate is press molded in the "royal shape" with a gadrooned edge. The cream-colored earthenware is decorated with underglaze oxide sponging in the manner known as tortoiseshell. The brown color is derived from manganese, the blue is from cobalt, the yellow is from iron, and the green is from copper. The design of stripes is unusual, as color is more often applied in a random manner.

Ornamental objects made of natural materials such as minerals, semiprecious stones, and tortoiseshell were fashionable expressions of rococo taste. To imitate these products, English potters used their skills to make ceramic pieces with faux finishes. Pottery with tortoiseshell decoration was popular and relatively inexpensive; tablewares for tea, dinner, and dessert were produced, but there is little evidence to suggest that they were sold from the factory in complete services. It seems more likely that pottery dealers formed sets for the retail market.

Creamware of this type was widely used in England and was exported in large quantities to continental Europe. Documentary and excavated evidence suggests that it was also readily available in colonial America, where it graced the tables of private homes and public inns.[190]

Creamware with tortoiseshell decoration
Diameter 9¼ in (235 mm)
96.4.157

PROVENANCE
The Campbell Museum purchased the soup plate in 1970 from F. A. Allbrook, London.

LITERATURE
*Selections from the Campbell Museum Collection* 1972, no. 137; 1976, no. 137; 1978, no. 143.

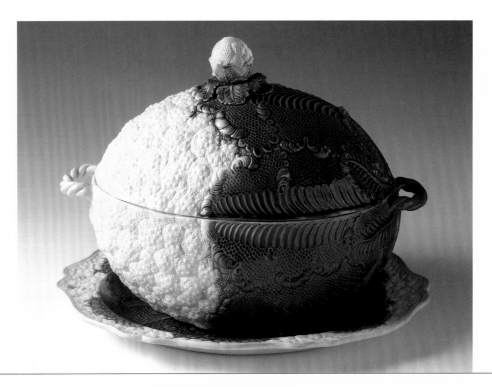

# *108 Tureen*

**POSSIBLY WILLIAM GREATBATCH FACTORY    LOWER LANE, STAFFORDSHIRE, ENGLAND, 1765–70**

*Maker, artist, craftsman*

William Greatbatch was in business in Lower Lane, Staffordshire, from 1762 to 1782. He was a skilled modeler and is known to have supplied a number of master molds and some finished wares to Josiah Wedgwood's Burslem factory. The business ended because of a debt that led to Greatbatch's bankruptcy. Following the closure of his business, he worked at the Wedgwood factory, where Wedgwood had promised him lifelong employment. Greatbatch died in 1813.

The site of his factory has been discovered and excavated. The recovered ceramic evidence suggests that he made a complete range of earthenware and stoneware. The molded wares included fruit and vegetable forms. While one might assume that one cauliflower looks very much like another, the detailed modeling of leaves and florets differs from factory to factory. The cauliflower molding of this tureen seems identical to that on tureen fragments found on Greatbatch's pottery site.[191]

*About the object*

This tureen is molded in the form of a large cauliflower. The handles are fashioned to resemble twisted rope, and the finial is a small cauliflower. The stand is also molded with leaves and cauliflower. The cream-colored earthenware body is decorated with copper-green glaze over the foliage molding and a transparent creamy lead glaze over the cauliflower.

The use of natural forms in decorative and useful tableware is a strong feature of eighteenth-century rococo fashion. Many tureens in the Campbell collection are designed in the shape of animals and plants; others have fauna and flora details. Staffordshire potters created a range of creamware fruit and vegetables; melon, pineapple, and other fruit forms were particularly popular. These shapes are usually associated with teaware. This example appears to be the only cauliflower tureen recorded.

Colored glazes, especially copper-green, are often associated with the factory of Josiah Wedgwood. Wedgwood kept notes of his experiments to improve pottery production in the 1750s and 1760s, and he perfected a green glaze in 1759. He was one of many Staffordshire potters to make plain green-glazed pottery as well as fruit and vegetable wares.

Creamware decorated with clear and colored glazes

Tureen:
Height 9 5/8 in (280 mm)
Length 13 1/8 in (330 mm)
Width 8 1/2 in (210 mm)

Stand:
Length 13 1/2 in (343 mm)
Width 10 1/2 in (268 mm)
96.4.246

PROVENANCE
This tureen is first recorded in a Sotheby's sale of "various properties" in London, March 1, 1966, when it was purchased by eminent London dealer F. A. Allbrook. The Campbell Museum purchased the tureen from J. Rochelle Thomas, New York, in 1967.

LITERATURE
*Selections from the Campbell Museum Collection* 1969, no. 78; 1972, no. 138; 1976, no. 138; 1978, no. 144; 1983, no. 43.

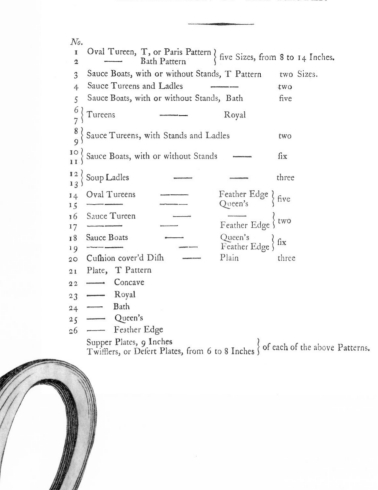

## EXPLANATION OF THE PLATES.

*No.*

| | | | | |
|---|---|---|---|---|
| 1 | Oval Tureen, T, or Paris Pattern | | } five Sizes, from 8 to 14 Inches. |
| 2 | —— Bath Pattern | | |
| 3 | Sauce Boats, with or without Stands, T Pattern | | two Sizes. |
| 4 | Sauce Tureens and Ladles | —— | two |
| 5 | Sauce Boats, with or without Stands, Bath | | five |
| 6 } 7 } | Tureens | —— | Royal |
| 8 } 9 } | Sauce Tureens, with Stands and Ladles | | two |
| 10 } 11 } | Sauce Boats, with or without Stands | —— | fix |
| 12 } 13 } | Soup Ladles | —— | —— | three |
| 14 | Oval Tureens | —— | Feather Edge } five |
| 15 | ———— | —— | Queen's } |
| 16 | Sauce Tureen | —— | } two |
| 17 | ——— | —— | Feather Edge } |
| 18 | Sauce Boats | —— | Queen's } fix |
| 19 | ——— | —— | Feather Edge } |
| 20 | Cuſhion cover'd Diſh | —— | Plain | three |
| 21 | Plate, T Pattern | | |
| 22 | —— Concave | | |
| 23 | —— Royal | | |
| 24 | —— Bath | | |
| 25 | —— Queen's | | |
| 26 | —— Feather Edge | | |

Supper Plates, 9 Inches
Twifflers, or Defert Plates, from 6 to 8 Inches } of each of the above Patterns.

Tureen design and page
from James and Charles
Whitehead Manufacturers
patternbook, *Designs
for Sundry Articles of
Earthenware…*
(Birmingham, Eng.:
Thomas Pearson, 1798),
pl. 1. (Winterthur Library.)

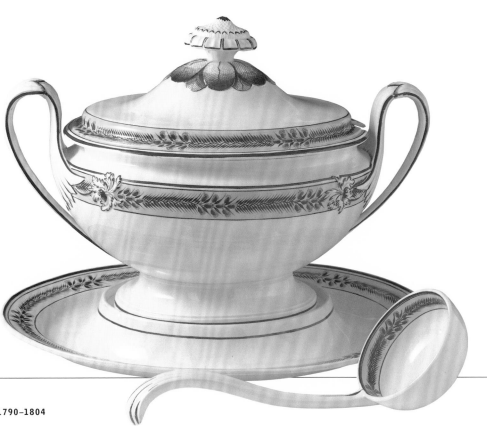

# 109 *Tureen*

**ELIJAH MAYER**
**HANLEY, STAFFORDSHIRE, ENGLAND, 1790–1804**

*Maker, artist, craftsman*

Elijah Mayer began business as a merchant in Holland. By 1784 he is listed in Staffordshire trade directories as an enameler in the town of Hanley. Sometime around 1790 he became a manufacturer of pottery, trading first as Elijah Mayer and later as Elijah Mayer & Son. Mayer died in 1813, but the factory continued in operation until about 1834. The products of the Mayer factory include high-style creamware, jasper, black basalt, and caneware. In the early years of the nineteenth century, trade directories list Mayer as a porcelain manufacturer. Throughout its working period, the Elijah Mayer factory was concerned with the most fashionable ceramics and made tableware for the discriminating customer.

*About the objects*

This molded tureen is of oval form. The applied handles have complex upper terminals of a large, flat, spreading leaf with small, molded, foliate sprays. A molded open flower rises from a circlet of leaves forming the finial. The matching ladle sits neatly inside the tureen, the handle curving up and out through a notch cut into the lid for that purpose. The shape seems

identical to shape number 1 illustrated in Wedgwood's catalogue for Queen's Ware, which was introduced sometime between 1790 and 1795.[192] Manufacturers often copied popular forms from one another, and there is no way to determine where this design was conceived. However, the superior reputation of the Wedgwood factory and its products usually leads to the conclusion that they were perhaps the originators.

By the end of the eighteenth century, fashions were dominated by the classical taste. The Mayer tureen reflects this with its simple form and restrained decoration. The border pattern is a band of yellow ground overpainted with stylized foliage, berries, and seed heads in black enamel. The edges of the tureen are banded in black, and the finial is also detailed in black enamel. The decoration is similar to Wedgwood patterns 257 and 259.[193]

The impressed mark "E.MAYER" appears on the inside of the foot of the tureen.

Creamware with enamel-painted decoration

Tureen:
Height 11 in (280 mm)
Length 16 in (407 mm)
Width 10 in (252 mm)

Stand:
Length 16 7/8 in (428 mm)
Width 12 1/2 in (317 mm)

Ladle:
Length 11 1/2 in (293 mm)
96.4.99

PROVENANCE
The Campbell Museum purchased this tureen in 1974 from The Art Exchange, New York.

*Impressed factory mark*

Transfer print of various genre scenes, 1820–40, by William Gallimore, a designer and engraver who created such images for Staffordshire potters who used them to decorate earthenware. (Downs Collection, Winterthur Library.)

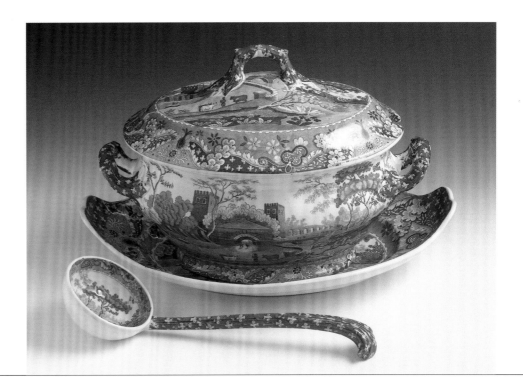

# 110 Tureen

**SPODE FACTORY    STOKE-UPON-TRENT, STAFFORDSHIRE, ENGLAND, 1814–18**

*Maker, artist, craftsman*

As a young man, Josiah Spode trained at the pottery factory of Thomas Whieldon, where he worked from 1749 to 1754. He entered a number of potterymaking partnerships before beginning work on his own around 1774. The Spodes were an enterprising family. Josiah Spode Sr. developed underglaze-blue printed pottery, and his son, also Josiah, was responsible for the successful marketing of bone china, which became the standard English porcelain by 1800. Their earthenware and porcelain productions were of the highest quality—regularly attracting orders from the royal family. Several generations of the company were honored with a royal warrant. Josiah Spode II died in 1827 and was succeeded briefly by his son, who died in 1829.

The Spode family was involved in wholesale and retail trade in London. They had two very able partners, William Taylor Copeland and Thomas Garrett, who took control of the factory in 1833 and operated it until Garrett's retirement in 1847. Since then the Spode works has always had a member of the Copeland family involved in its activities. The factory is still in production and continues to make fine bone china and underglaze-blue printed earthenware.

*About the objects*

The tureen was press molded and decorated with an underglaze-blue transfer-printed pattern known as "Castle." The design is adapted from an aquatint entitled *The Gate of Sebastian at Caperna* from *Views of Rome and Its Vicinity,* published by J. Merigot, 28 Haymarket, and R. Edwards, 142 New Bond Street, London, in 1796–98. The pattern is thought to have been introduced about 1806. Although other potters used the same design, the Spode factory always printed their version in a special paler blue.

Landscape patterns of this kind were popular designs for transfer-printed pottery. Classical, topographical, romantic, or exotic scenes were produced in shades of pale to royal blue for the British and European markets. The North American consumers preferred a much darker blue as well as topographical scenes of their own country.

"SPODE" above "37" with blue "B" is impressed on the base of the tureen and inside the lid. "SPODE" above "9" with a blue "A" is impressed on the base of the stand. A blue "B" appears on the ladle.

Pearlware with underglaze-blue transfer-printed decoration

Tureen:
Height 8 ¾ in (222 mm)
Length 13 ½ in (342 mm)
Width 7 ¾ in (197 mm)

Stand:
Length 15 ⅝ in (398 mm)
Width 11 in (278 mm)

Ladle:
Length 12 ½ in (318 mm)
96.4.77

PROVENANCE
The tureen was formerly in the collection of A. Gresham Copeland. It was given to the Campbell Museum in 1971 by Spode Ltd., through the generosity of Robert Copeland, a director of the Spode Company.

LITERATURE
*Selections from the Campbell Museum Collection* 1972, no. 141.

*Impressed factory mark*

# 111 *Plate*

WEDGWOOD FACTORY     ETRURIA, STAFFORDSHIRE, ENGLAND, CIRCA 1823

*Maker, artist, craftsman*

The remarkable contributions made by Josiah Wedgwood to the development of the English ceramic industry have been the subject of many detailed monographs. He began business on his own in 1759. His first factories were in Burslem and were run in partnership with his cousin Thomas Wedgwood. They specialized in the production of useful pottery, including items made of creamware.

Josiah's famous Etruria factory was founded in 1769 to produce ornamental wares, particularly black basalt vases, for wealthy patrons who were decorating their country houses in the revived classical style. He gradually transferred production of useful wares from Burslem to Etruria in the early 1770s. When Wedgwood ran the factory in the eighteenth century, he expressed his reluctance to make what was then generally described as "badged" ware. The personalization of pottery with coats of arms or other particular devices meant that the factory could never sell excess or unwanted pieces to other customers. He overcame this hesitancy when he saw that orders from royal and noble families were excellent marketing tools.

Wedgwood died in 1795, but his factory continued in the hands of his descendants until 1961. By 1940 the Etruria site had become unmanageable, and between 1940 and 1949 the firm moved to the country village of Barlaston. Production still continues at Barlaston, where the Wedgwood Company continues to make tableware in traditional and modern shapes.

*About the object*

This soup plate (one of a pair) is of a simple circular form with a painted border pattern that typifies the late eighteenth- to early nineteenth-century interest in classical taste. The overglaze painted border is a design of blue scallop and gold spikes, pattern 334 in Wedgwood's first pattern book, which was compiled between 1810 and 1814.[194]

The center is painted in enamel colors and gold with the coat of arms of His Royal Highness, the duke

*Impressed factory mark*

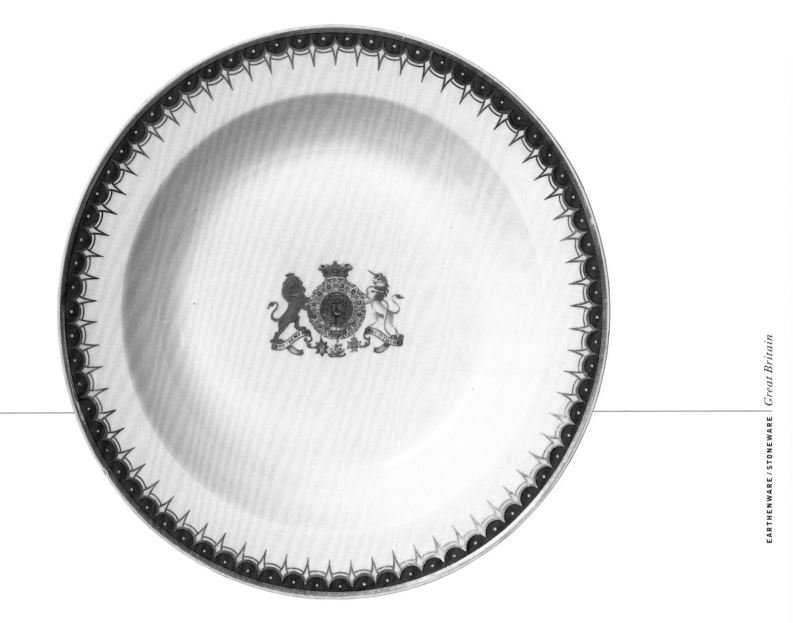

of Clarence, subsequently His Majesty King William IV, who reigned from 1830 to 1837. The original order is recorded in the factory archives. Between August 1821 and August 1823, the duke of Clarence ordered three different services from Wedgwood's London showrooms on York Street. On August 22, 1821, he ordered cream-colored earthenware decorated with "Blue Scallop gold Spike with arms in Centre" specifying "6 Cov^d Etruscan Soup Tureens." Two

years later an order for creamware of the same design included eight dozen flat-rim soup plates in two sizes. The coat of arms was illustrated on page 109 of the order book and is identical to that seen on this soup plate.[195]

The mark "WEDGWOOD" is impressed on the reverse above two curved dashes.

Creamware with enamel-painted decoration
Diameter 9 3/4 in (248 mm)
96.4.87.1

PROVENANCE
The Campbell Museum purchased the soup plate in 1970 from Louis Lyons, New York.

LITERATURE
*Selections from the Campbell Museum Collection* 1972, no. 140; 1976, no. 140; 1978, no. 146; 1983, no. 58.

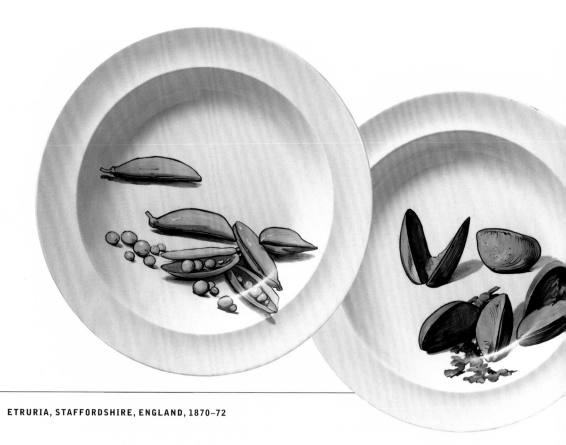

## 112 Plates

WEDGWOOD FACTORY    ETRURIA, STAFFORDSHIRE, ENGLAND, 1870–72

*Maker, artist, craftsman*

The Wedgwood Company, established in 1769, continues production today. In the nineteenth century, a number of other Staffordshire factories challenged their preeminent position in the industry. Although no longer considered the leader of fashion, Wedgwood continued to produce good quality wares that appealed to a traditional clientele. The company did make occasional forays into modern design, and they employed first-rate designers and artists. Artists Pierre Mallet and Léonce Goutard are unknown beyond the work they did on Wedgwood pottery for the retailers Messrs. Borgen and Company of London.

*About the objects*

These soup plates are a simple circular form of the kind that had been made by Wedgwood in the eigh-

teenth century. In 1870 the company revived the traditional creamware body for use in special commissions. The unusual hand-painted decoration of mussels and peas make this pair of soup plates an interesting combination of old and new.

From the middle of the nineteenth century, French ceramic artists had a major influence on English pottery and porcelain decoration. Several important factories employed French artists, and they served as art directors and heads of painting studios. Specialist retailers were also an integral part of the artistic development of the period, supplying designs to manufacturers and even supporting their own *ateliers* to provide appropriate decorations on plain pottery.[196]

In 1872 Borgen and Company of London commissioned from Wedgwood a range of dinnerware with

A Impressed factory mark
B Painted decorator's mark
C Impressed date code
D Impressed date code

202

decoration designed and painted by French artists
Pierre Mallet and Léonce Goutard. It is said that the
commission came from Mlle Norèle at Balmoral
Castle, writing on behalf of Her Royal Majesty Queen
Victoria.[197] Two similar services were requested
with painted decoration depicting different kinds
of food.

The marks "WEDGWOOD" and date letters "?AY"
(.1) and "MLA" (.2) are impressed on the plates. The
artists' signatures "Leonce & Mallet" are painted on.

Creamware with enamel-
painted decoration
Diameter (.1) 9 ⅝ in
(245 mm)
Diameter (.2) 9 ¾ in
(247 mm)
96.4.21.1, .2

PROVENANCE
The Campbell Museum
purchased these soup
plates in 1970 from David
Newbon, London.

LITERATURE
*Selections from the Campbell
Museum Collection* 1972,
no. 146; 1976, no. 146; 1978,
no. 150.

# 113 *Plate*

RALPH STEVENSON & WILLIAMS    COBRIDGE, STAFFORDSHIRE, ENGLAND, CIRCA 1825

*Maker, artist, craftsman*

Ralph Stevenson had various business partnerships for the making of pottery. He is recorded in Staffordshire trade directories from 1800 in the partnership Stevenson and Dale, but by 1815 he was in business alone. At the time of his bankruptcy in 1835, he was trading as Ralph Stevenson & Sons. Directories are not available for every year of the nineteenth century, and none exist between 1822–23 and 1828–29. It was during this interval that there was a brief partnership with Augustus Aldeborough Lloyd Williams. A partnership dissolution was announced in the *London Gazette* in 1826.

Stevenson came from a Staffordshire potting family; his step-father, uncle, brothers, and step-brothers were all manufacturers. Early rate records show that he owned and occupied his own factory, and in 1822 he also owned his own color works. The taxable value of his factory suggests that it was larger than the average pottery works. In his day Stevenson was known for his thriving export trade.[198]

*About the object*

The press-molded soup plate is of circular form with an indented rim. The underglaze-blue transfer-printed decoration reflects early nineteenth-century taste. The whole face of the plate is covered with the print, with a wide border descending into the plate to encircle the central scene. It was usual for border patterns to be used with a variety of centers creating a series of designs that formed a complete set. The acorn and oak leaf border on this piece was used extensively by Ralph Stevenson & Williams for their series of American topographical views. The central scene on this example is the Philadelphia Water Works. The view derived from a drawing by J. J. Barralet, which was then reproduced by Cornelius Tiebout in a stipple-and-line etching and published by H. Quig. The

Printed factory mark

204

print was entitled *View of the Water Works, Centre Square, Philadelphia.* The original date of publication is unknown, but Barralet and Tiebout were together in Philadelphia from about 1799 to about 1825.

English pottery manufacturers used many sources for their printed designs. Sometimes they commissioned special drawings, but more frequently commercially produced prints were obtained for use by the factory engraver. The Tiebout print of the Philadelphia Water Works was adapted to make an appropriate

composition for a circular plate. The small carriage that was central to the original was replaced by a Conestoga wagon placed on the extreme right.

A transfer-printed mark in underglaze blue with an incorrect title "PARK THEATRE NEW YORK" and the initials of the maker, "RSW," appear on the plate.

Earthenware with
underglaze-blue transfer-
printed decoration
Diameter 10 in (254 mm)
96.4.9

PROVENANCE
The Campbell Museum
purchased this piece in
1977 from William R.
and Teresa F. Kurau of
Jackson Heights, N.Y.

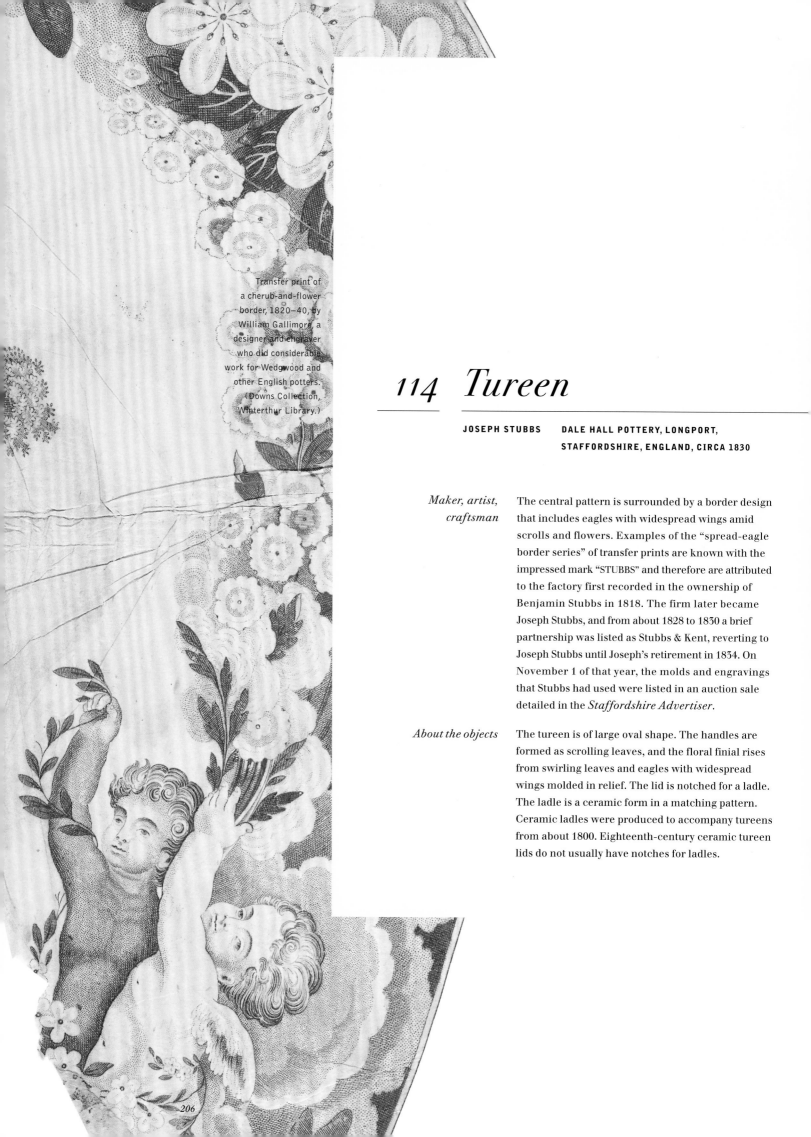

Transfer print of
a cherub-and-flower
border, 1820–40, by
William Gallimore, a
designer and engraver
who did considerable
work for Wedgwood and
other English potters.
(Downs Collection,
Winterthur Library.)

## 114 Tureen

JOSEPH STUBBS    DALE HALL POTTERY, LONGPORT,
STAFFORDSHIRE, ENGLAND, CIRCA 1830

*Maker, artist,*
*craftsman*

The central pattern is surrounded by a border design
that includes eagles with widespread wings amid
scrolls and flowers. Examples of the "spread-eagle
border series" of transfer prints are known with the
impressed mark "STUBBS" and therefore are attributed
to the factory first recorded in the ownership of
Benjamin Stubbs in 1818. The firm later became
Joseph Stubbs, and from about 1828 to 1830 a brief
partnership was listed as Stubbs & Kent, reverting to
Joseph Stubbs until Joseph's retirement in 1834. On
November 1 of that year, the molds and engravings
that Stubbs had used were listed in an auction sale
detailed in the *Staffordshire Advertiser*.

*About the objects*

The tureen is of large oval shape. The handles are
formed as scrolling leaves, and the floral finial rises
from swirling leaves and eagles with widespread
wings molded in relief. The lid is notched for a ladle.
The ladle is a ceramic form in a matching pattern.
Ceramic ladles were produced to accompany tureens
from about 1800. Eighteenth-century ceramic tureen
lids do not usually have notches for ladles.

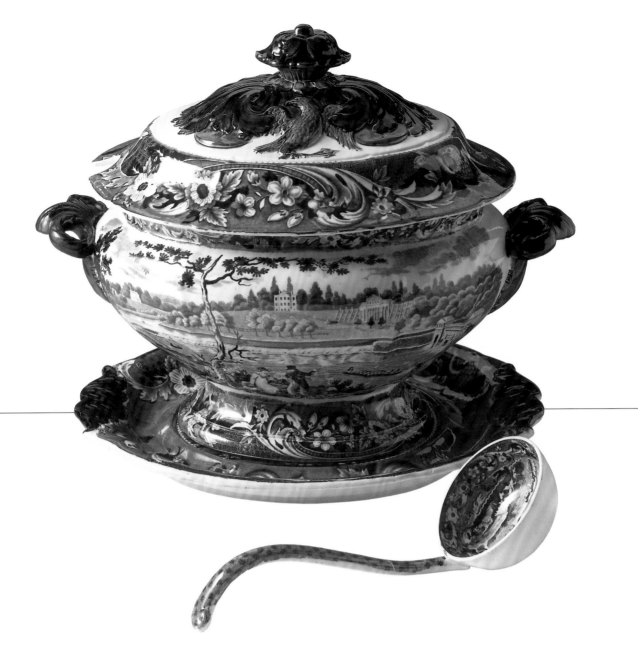

The central print on the tureen and stand is a view of Philadelphia. It is derived from an engraving entitled *View of the Dam and Water Works at Fair Mount, Philadelphia*, taken from a drawing by Thomas Birch, engraved by R. Campbell, and published by Edward Parker in 1824. The print shows a young couple sitting on the riverbank, a dam to the right, and three men rowing a boat. The water works lies across the river.

The spread-eagle border was used with a variety of American views. Many scenes were of New Jersey, New York, and Philadelphia; only one or two views of Boston are recorded. Transfer-printed wares of this deep color and with American views were destined for the American market. Many Staffordshire potters made their fortunes in overseas trade, and their wares are scarcely known in their own country.

The mark on the base of the stand is transfer printed in underglaze-blue with the name of the pattern, "Fair Mount near Philadelphia."

Pearlware with underglaze-blue transfer-printed decoration

Tureen:
Height 12 in (310 mm)
Length 17 in (432 mm)
Width 11 in (278 mm)

Stand:
Length 14 ½ in (368 mm)
Width 11 ¾ in (299 mm)
96.4.4

PROVENANCE
The Campbell Museum purchased this tureen in 1970 from John Bihler and Henry Coger, Ashley Falls, Mass.

LITERATURE
*Selections from the Campbell Museum Collection* 1972, no. 143.

*Printed factory mark*

Transfer print of Pompeii relics, 1820–40, by William Gallimore, a designer and engraver who created images for use in decorating earthenware. (Downs Collection, Winterthur Library.)

# 115 *Tureen*

**JAMES BEECH FACTORY**     **TUNSTALL, STAFFORDSHIRE, ENGLAND, 1846–47**

*Maker, artist, craftsman*

James Beech is first recorded as an earthenware potter in William White's *Staffordshire Directory* of 1834. He retired in 1848. His daughter married a fellow potter, Anthony Shaw, who appears to have continued his father-in-law's work at his own nearby factory. He even used printed patterns with Beech's initials included in a backstamp. The printed cartouches with "J._B." are sometimes found on pottery with the impressed mark of Anthony Shaw.

*About the object*

Both the press-molded tureen and stand have ornate profiles. The body of the tureen stands on four curling-leaf feet, and the handles have molded floral details. The lid has an oval ring handle molded as a floret supported by two leaves, and the stand has floral modeled finger grips.

The transfer-printed decoration is specifically designed for the American market. The pattern, "TEXIAN CAMPAIGNE," features scenes portraying battles from the Mexican War of 1846–48. The origin of the prints has not been identified, but major engagements represented here probably include the American victory at Palo Alto and the Charge of Captain May at the Battle of Reseca de la Palma on May 9, 1846. The border pattern includes trophies of war alternating with a female figure symbolic of America, printed in dark blue on the light blue ground.

The tureen reflects the nineteenth-century interest in historic revivals and is typical of the Victorian rococo-revival style. It is an adaptation or interpretation of an eighteenth-century fashion rather than a strict imitation.

The tureen is marked on the stand and base with an underglaze-blue printed device containing the pattern name "TEXIAN CAMPAIGNE" and the maker's initials "J._B."

Earthenware with underglaze-blue transfer-printed decoration

Tureen:
Height 10 in (254 mm)
Length 13 in (330 mm)
Width 8 1/2 in (210 mm)

Stand:
Length 14 3/8 in (365 mm)
Width 11 1/2 in (293 mm)
96.4.76

PROVENANCE
Purchased by the Campbell Museum in 1970 from John Bihler and Henry Coger, Ashley Falls, Mass.

LITERATURE
*Selections from the Campbell Museum Collection* 1972, no. 145.

*Printed factory mark*

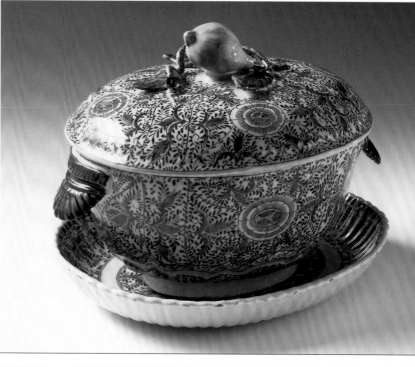

# 116 Tureen

**JUSTUS BROUWER FACTORY, DE PORSELEYNE BIJL**   **DELFT, HOLLAND, 1755–60**

*Maker, artist, craftsman*

The factory *De Porseleyne Bijl*, the Porcelain Axe, came to prominence in the 1740s and 1750s. At that time it was directed by father and son Justus and Hugo Brouwer. They began by producing delftware with decoration inspired by Chinese porcelain but moved into more decorative designs and shapes under Hugo's influence. Middle-class aspirations to own Chinese porcelain were the forces that determined production in the factory. The pottery continued until 1802, and output included tableware, vases, flower-pots, and figures.

*About the object*

This tureen is of oval shape, and the stand is molded with a deep rim of narrow flutes. The handles are modeled in the form of shells, and the finial is modeled as a fruit with buds and a flower head on an accompanying leafy tendril. The decoration is painted in cobalt blue with a design inspired by the Orient. The complex pattern includes stylized chrysanthemum heads within panels of elaborate leaves and tendrils. The handles are cobalt blue, and the finial is painted in shades of yellow, brown, blue, and green.

Tureens are not commonly found in Dutch delft, and this example is a rare survival.[199] The great faience and porcelain factories of Europe appear to have had little influence on the form or decoration of Dutch pieces. Rococo elements are occasionally found in the shape, but most of the painted patterns have their origins in Chinese porcelain.

The mark of a blue-painted device in the form of an axe appears on the base of the stand and the tureen.

*Painted mark*

Tin-glazed earthenware (delftware)

Tureen:
Height 9 7/8 in (243 mm)
Length 14 in (353 mm)
Width 9 1/4 in (234 mm)

Stand:
Length 13 1/2 in (342 mm)
Width 11 1/2 in (292 mm)
96.4.263

PROVENANCE
The Campbell Museum purchased this tureen in 1970 from Ginsburg and Levy, New York.

LITERATURE
*Selections from the Campbell Museum Collection* 1972, no. 123; 1976, no. 123; 1978, no. 132; 1983, no. 112.

Fabric-printed menu for
the 38th Anniversary
Dinner of the New
England Society,
December 22, 1857.
(Downs Collection,
Winterthur Library.)

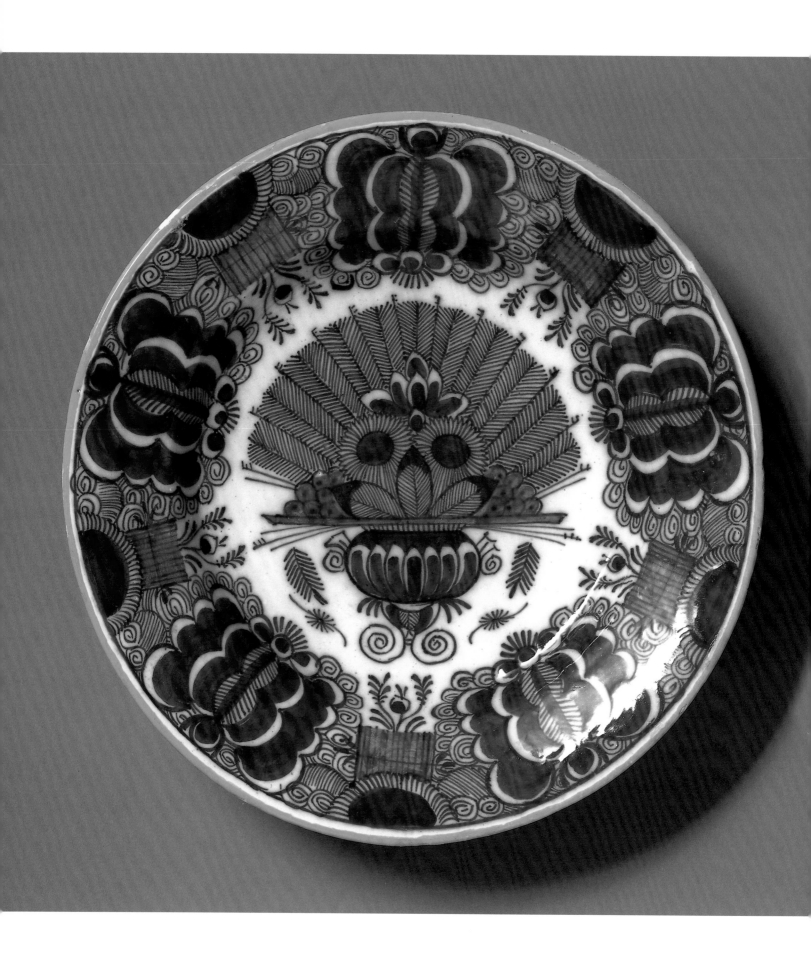

# 117 Plate

**LAMBERTUS SANDERUS FACTORY, DE PORSELEYNE KLAEUW     DELFT, HOLLAND, CIRCA 1765**

*Maker, artist, craftsman*

The factory *De Porseleyne Klaeuw*, the Porcelain Claw, was founded in 1662. It passed through several hands until 1763, when Lambertus Sanderus became the owner. Sanderus registered his factory mark, leaving little doubt as to his productions. He is particularly remembered for his plates with blue-painted decoration that formed part of the standard productions of the Delft industry. Sanderus continued in business until the 1790s. The company was sold and eventually closed in 1850.

*About the object*

The simple circular soup plate is typical of the kind of tin-glazed pottery made in Delft in the eighteenth century for middle-class consumers. The decoration is painted in blue with a broad band of stylized flower heads against cloud scrolls. The center has a vase of flowers set before a peacock-tail, or fan, motif. The edge is banded with yellow, perhaps in imitation of

the gilt trim occasionally found on Chinese porcelain. This design, sometimes called the "peacock" pattern is characteristic of Dutch delft produced in the second half of the eighteenth century.

The tin-glaze industry of Delft began to decline in the eighteenth century because of competition from rival factories in Europe and the rising production of alternative earthenware and stoneware in Staffordshire, England. By 1780 only fifteen faience factories remained in Delft. By 1808 there were seven, and by the middle of the eighteenth century, little of this major industry survived.

A mark of a blue-painted device in the shape of a claw appears with the numeral "4."

Tin-glazed earthenware
(delftware)
Diameter 9 1/8 in (231mm)
96.4.86

*Painted factory mark*

# 118 Tureen

**DELAMAIN FACTORY**     **DUBLIN, IRELAND, 1755–65**

**STAND: POSSIBLY LIVERPOOL, ENGLAND, 1755–65**

*Maker, artist, craftsman*

Tin-glazed earthenware was made in Dublin, Ireland, from about 1735. Capt. Henry Delamain purchased one of the established factories in 1753. He proposed to institute new and more efficient methods of manufacture and applied to the Irish House of Commons for financial support. In his petition he claimed to have acquired the knowledge of delftware production while serving with the military forces in Europe. He also declared his intention of producing such a quantity of good pottery that he would not only reduce the need for imported goods but also establish an export trade. He received a grant of £1,000 in 1753 and further grants in following years. Delamain expended a great deal of his own money on the venture, and the export market was necessary to recoup his investments. Unfortunately, sales abroad were interrupted by the Seven Years' War (1756–63), and his business declined. Delamain died in 1757, and the factory was continued by his wife, Mary, until her death in 1760. Responsibility for the pottery was then assumed by Henry's brother, William, and a partner, Samuel Wilkinson. Despite their efforts, the price of pottery fell so low that they were unable to sustain the business. They sold it in 1769, and it finally closed in 1771. The factory listed some of its available wares in a public notice issued in 1776, including "tureens, epergnes, boats, bowls, fruit and salad dishes." In addition a whole range of products has been attributed to Delamain including water cisterns, drug jars, spirit barrels, and standard tableware.[200]

### About the object

The tureen is press molded into a long octagonal shape. The handles are modeled as human heads with open mouths. The lid has a finial formed as fruit with a stalk and leaves. It is painted in blue with a design of a bowl of flowers, described as "penjing" or "landscape in a dish."[201]

A

B

A   *Painted numeral "6" on base of tureen*

B   *Painted numeral "4"*

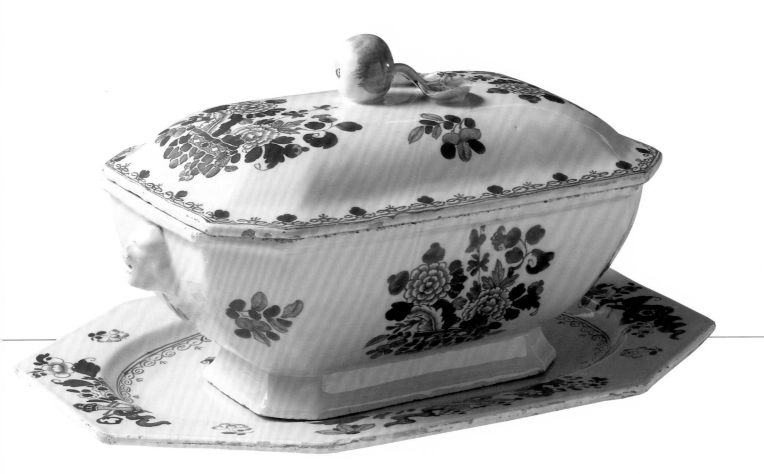

The stand is also octagonal but with an oval well. The center is painted with the same "penjing" design as the tureen. A border design includes scrolling flowers with articles associated with the Chinese scholar's writing table. Some of these objects form part of the "Eight Daoist Emblems" and "Eight Precious Things" used as decoration on Chinese porcelain.

The tureen and stand were acquired separately and brought together in 1969. They carry the same floral pattern that was used in both Dublin and Liverpool. Tureens of this molded shape are attributed to Delamain. An accompanying stand from Delamain would usually have had an octagonal well. Although the main pattern is the same, the narrow border around the well and around the edge of the lid are different. It is possible that the stand was made in Dublin or Liverpool.[202]

A "6" is painted in blue on the base of the tureen and inside the lid; "12" is painted in blue on the base of the stand.

Tin-glazed earthenware (delftware) with painted decoration

Tureen:
Height 8 in (203 mm)
Length 14 in (353 mm)
Width 8 in (203 mm)

Stand:
Length 16 ½ in (419 mm)
Width 11 ¾ in (299 mm)
96.4.249

PROVENANCE
The Campbell Museum purchased the tureen in 1968 from Rowland's Antiques, Bucks County, Pa. The stand was purchased in 1969 from Leon F. S. Stark Antiques, Philadelphia.

LITERATURE
*Selections from the Campbell Museum Collection* 1969, no. 75; 1972, no. 125; 1976, no. 125; 1978, no. 134; 1983, no. 115.

# 119 *Plate*

**BELVEDERE FACTORY     WARSAW, POLAND, 1776**

*Maker, artist, craftsman*

Few faience factories are recorded in Poland in the eighteenth century. Those that did exist were established by royal and noble men who wanted to enjoy the fashionable occupation of owning a pottery. The Belvedere factory at Warsaw was established in 1774 by Stanislaw Augustus Poniatowski, king of Poland; the director was Baron Franz Schütter. The best-known pieces from the factory are from the service represented by the soup plate in the Campbell collection at Winterthur. Beaker-shape vases were also said to have been made and decorated in the Chinese style. Schütter died in 1783, and faience production was then continued in Warsaw at the Wolff factory.

*About the object*

The soup plate is a simple circular shape with a neat footring. The face is painted in enamel colors and extensive gilding with a design inspired by Japanese *Imari* porcelains. The broad rim pattern has a blue ground with red chrysanthemums and gilt foliage alternating with three cloud-shape reserve panels with decoration of birds, butterflies, and peonies. The central device is a vase of flowers on a platform before a garden fence. Gilt inscriptions in Turkish on the vase and in four medallions in a surrounding band read "Obedience and Fidelity are due to Kings. From the King of the Lekhs at Warsaw to the Tsar of the race of Osman as a token of respect, this present is offered and sent."[203]

The underside of the soup plate is also decorated. Flowering branches are enamel painted in the oriental style, and the narrow trellis border has small reserves with moths, caterpillars, and fish. The soup plate is from a service said to have been commissioned by Stanislaw Augustus Poniatowski (King Stanislaw II) as a gift to Abdul Hamid I, Sultan of Turkey. The service was made in 1776 but not delivered until 1789. A large part of the service is now in the Topkapi Saray Museum, Istanbul, Turkey.

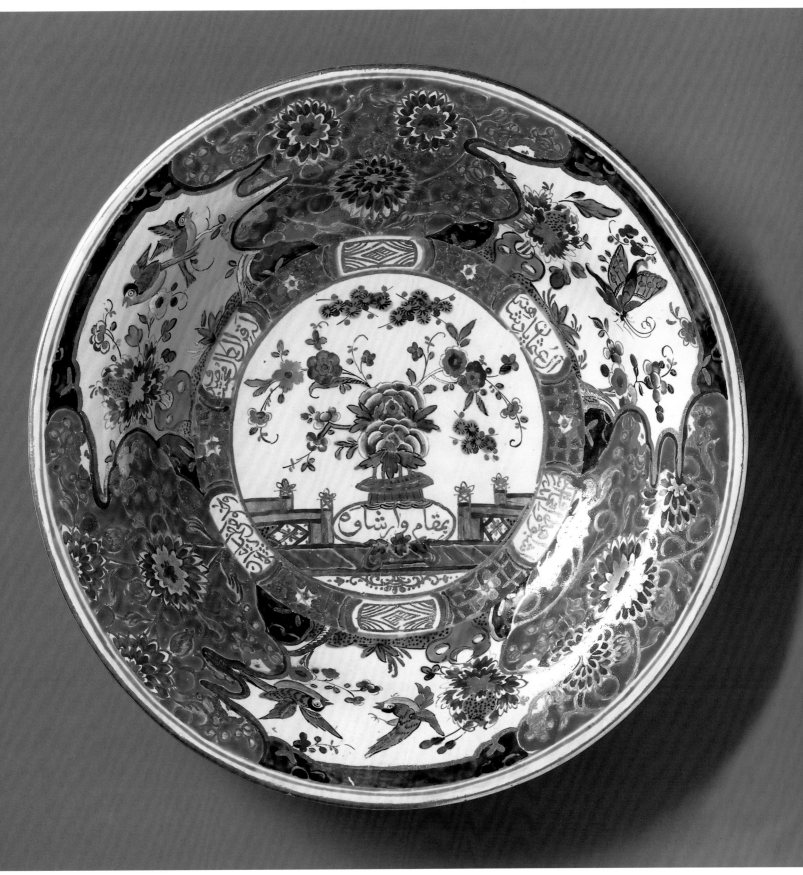

Tin-glazed earthenware
(faience) with enamel-
painted decoration and
gilding
Diameter 9 7/8 in (251 mm)
96.4.156

PROVENANCE
This piece was formerly
in the collections of Ole
Olsen and Count Stephen
Zamoyski. The Campbell
Museum purchased the
soup plate in 1969 from
the Antique Porcelain
Company, New York.

LITERATURE
*Selections from the Campbell
Museum Collection* 1969,
no. 65; 1972, no. 109; 1976,
no. 109; 1978, no. 116; 1983,
no. 126.

# 120 Tureen

**BILL STEWART**    **NEW YORK, NEW YORK, 1975**

*Maker, artist, craftsman*

This tureen was made by Bill Stewart of Hamlin, New York. Stewart began to work in clay as a graduate at Ohio University in the 1960s. He recalls that his earlier work "developed from a nostalgic preoccupation with childhood.... Its roots were the naïve, and reflected humor, joy, fantasy, curiosity and fear."[204] He received a grant from the National Endowment for the Arts to study circus history in America. He was also interested in mechanical toys and was influenced by his sons' imaginative play. He uses intense color, surface texture, and patterns in his ceramics, often stacking humans and animals into strange pyramids.

After a period of commercial success in the 1970s and 1980s, Stewart took time to review his work and returned to the studio to find new challenges. His pieces express an interest in tribal art, streamlined form, and large scale. He has completed a commission for a large sculpture for Greater Rochester International Airport and has exhibited in one-man and gallery shows in Manhattan.

*About the object*

The bowl of the soup tureen is a straight-sided oval shape. It is hand built with hand-modeled fantastic birds-head handles. The lid is also hand built and supports a tower of animals. The bottom creature is a crocodile carrying a buckled saddle cloth. A pig stands on his back. A teddy bear with a bird on his paw and a bird sitting in front of him are on top of the pig. The animals face the same direction. Facing in the opposite direction is a diminutive figure of a man sitting on the crocodile's tail eating an ice-cream cone. The whole piece is painted in brightly colored glazes and lusters and was made for a 1976 exhibition of contemporary soup tureens organized by the Campbell Museum. It is unlikely that this piece was ever intended to be used as a tureen.

In the nineteenth century, inexpensive pottery was widely available, and middle-class homes were often equipped with extensive table services that included soup tureens. During the twentieth century, homes, kitchens, work, and leisure changed beyond recognition. By the 1970s a new, more casual lifestyle was

*Artist's mark*

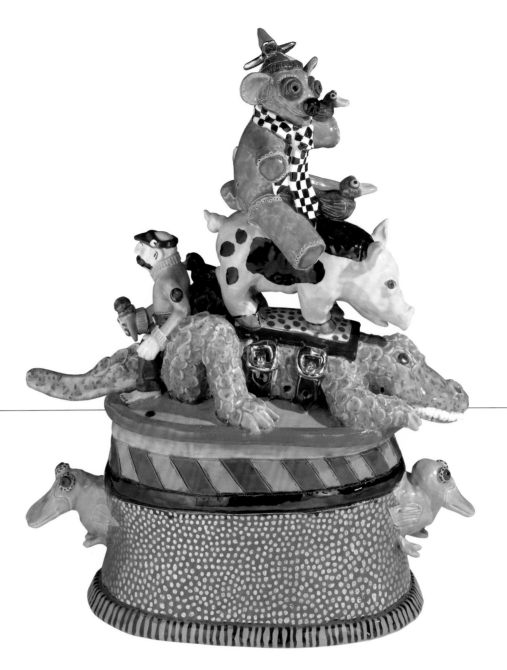

enjoyed by most people. Formal family meals were restricted to special events, and soup tureens ceased to be a major household necessity. However, in 1975 when the Campbell Museum challenged artists and craftspeople to make tureens for their exhibition, a new generation was introduced to the form. Some artists produced functional pieces, often inspired by the Japanese stoneware tradition. Others chose to

create sculptural forms, unwittingly paralleling some of the more extreme rococo shapes of the eighteenth century. It is widely accepted that tureens can perform a decorative as well as useful function in the modern home.

"Stewart 75" is painted on the base.

Earthenware with colored-glaze decoration and lusters
Height 20 in (508 mm)
Length 16 in (404 mm)
Width 7 ½ in (190 mm)
96.4.7

PROVENANCE
This piece was purchased by the Campbell Museum from the artist in 1976.

LITERATURE
*Selections from the Campbell Museum Collection* 1976, no. 41.

EXHIBITED
Museum of Contemporary Crafts of the American Crafts Council, New York, April–June 3, 1976. Cranbrook Academy of Art, Bloomfield Hills, Mich., October 24–December 5, 1976.

# 121 Tureen

**MAKER UNKNOWN**    **UNITED STATES, 1986**

*Maker, artist, craftsman*

The designer and maker are unknown.

*About the objects*

The tureen is slip cast and is assembled in four pieces to create the figure of a toad. The feet form a circular stand; the body of the toad is the bowl of the tureen; the top of the head is the lid. A pink ladle sitting inside the tureen curves out to form the tongue. There is no attempt to portray a naturalistic-looking toad, although the surface is textured to resemble a warty skin. Decoration in strong colors emphasizes the eyes and mouth in human rather than amphibian shades.

It is unlikely that this was ever intended to be used as a tureen. It conforms to a popular style of the 1980s in which humor, ingenuity, and strong colors were combined by ceramic artists to create amusing decorative pieces for the home. In many ways pieces of this kind relate to the large animal forms made in porcelain and faience during the eighteenth century in response to the rococo fashions of the day.

Earthenware with underglaze painted and slip decoration

Tureen:
Height 10 in (235 mm)
Length 15 ½ in (392 mm)
Width 10 ¾ in (273 mm)

Ladle:
Length 14 in (353 mm)
96.4.94

PROVENANCE
The tureen was given to the Campbell Museum in 1986 by Juice Bowls Products, Inc., Lakeland, Fla., a former subsidiary of the Campbell Company.

*APPENDIXES*

# Appendix A

## A scientific assessment of silver: XRF analysis

Energy dispersive X-ray fluorescence (XRF) is a tool that facilitates the nondestructive elemental analysis of materials used in the manufacturing of art objects. Pigments in watercolor or oil paintings, metal alloys, pottery, and glass can all be examined for elemental content by using XRF analysis. In some cases, depending upon the computer program, elemental data can be quantified. That is, not only the presence (qualitative analysis) but also the concentration (quantitative analysis) of elements can be determined.

For XRF analysis, an art object is placed in front of an X-ray tube, and an X-ray beam (two to six millimeters in diameter) is focused on the surface of the object. The beam causes the elements in the object to produce their own characteristic fluorescent X rays—an identifiable elemental fingerprint. These fluorescent X rays are electronically detected and displayed as a spectrum on a computer screen. Ideally, the surface of the object being analyzed should be flat and placed perpendicular to the X-ray beam. Surface irregularities, particularly with cast pieces, result in less than exemplary conditions and may affect results.

XRF analysis was developed in the 1960s as a qualitative analysis instrument for the chemical industry. In 1969 Victor Hanson, a recently retired DuPont Company engineer who was head of scientific research at Winterthur, adopted this process as a method of analyzing artifacts without having to take samples from the object—hence the term *nondestructive*. The original instrument used at Winterthur was a combination of electronic components from Kevex Corporation, Packard Instrument Company, and Hewlett Packard and employed radioactive elements rather than an X-ray tube, which is currently in use. XRF continues to be a primary tool at Winterthur and is now commonplace in many museums. The Detroit Institute of Art, the Cleveland Museum of Art, the Boston Museum of Fine Arts, the Freer Gallery of Art, and the Canadian Conservation Institute have incorporated XRF analysis as a significant part of understanding their collections.[1]

## METALS ANALYSES

The silver soup tureens and ladles in the Campbell collection were analyzed using a Kevex model #9020 X-ray fluorescence spectrometer—with a silver secondary target at 40kV and 1.7mA ratioed to the Winterthur silver standard 47.4 (silver 92.5%, copper 7.0%, gold 0.5%) and normalized using an in-house computer program. Four elements were analyzed quantitatively: silver (Ag), copper (Cu), gold (Au), and lead (Pb). Additional elements such as mercury, zinc, bismuth, nickel, and iron may be detected qualitatively but not reported quantitatively; however, general data for all objects analyzed are tabulated, with interpretive commentary.

Much of the hollowware in the Campbell collection is elaborate, including objects with pieces that have been soldered on or adhered to the body mechanically. To thoroughly evaluate an object's composition, many of these—including handles, legs, and decorative elements—were analyzed. Flatware is less elaborate and required only two points of analysis, the handle and the bowl. The resulting data may help to distinguish whether one silver batch or several different alloys were used to create an object. Analytical data may also offer clues as to how an object was fabricated. Cast silver contains slightly more silver than copper, making it a softer metal. Forged, drawn, or spun pieces will have a higher copper content, producing a tougher alloy.

## COMPARABLE DATA

XRF data from the Campbell collection were compared to a large database of British and American silver that has been gathered at Winterthur since 1970.[2] Previous analyses of well-authenticated American and British silver objects from the seventeenth through the twentieth centuries have established quite conclusively that silver alloys made prior to the mid nineteenth century usually contain trace amounts (<0.5%) of lead and gold; those made after this period are "clean" of such elements.

By the mid nineteenth century, electrolytic refining processes had been developed, permitting almost complete purification of silver ores and removing traces of gold and lead naturally found in association with silver. Thus, silver alloy objects with no trace amounts of gold and lead most probably date from the late nineteenth or early twentieth century.

Silver made in Britain invariably meets or exceeds the sterling standard, 92.5% silver. The balance is primarily copper. In contrast, American silver usually averages about 90% pure silver. British silversmiths were required by law to adhere to the sterling standard; their wares were assayed before they were sold. If objects did not meet the sterling standard, they could be destroyed. American silversmiths had no such legal constraints. In making silver objects, American colonial silversmiths usually combined silver from worn or outmoded items with silver coins of the period, which averaged about 90% pure.

## SURFACE DECORATION AND ITS EFFECTS

XRF is a surface analysis technique; therefore, the area chosen for analysis should represent the whole object. This assumption holds true for historic objects that have been handled and repeatedly polished during their two-hundred– to three-hundred–year lifetime. If, for example, objects are not well worn or if they have undergone more recent repairs or alterations, a higher than normal apparent silver content may be found. Apparent silver concentrations of 95% and above are often indicative of the residual effects of certain finishing processes, such as "pickling," which includes dipping an object in acid. Pickling dissolves copper in the surface layer, leaving a silver-rich surface (normally 95–96%) . Repeated polishing of such a piece would remove this layer, but a silver-rich area may still be identified in a recessed section. A tureen made by Robert Garrard Jr. (No. 24) illustrates this point. Its high overall apparent silver content (96–97.8%) relative to the sterling standard of 92.5% suggests fairly recent pickling or little use or polishing in its lifetime. A very high apparent silver content (98–99%) may also indicate that an object has been silver plated. One such example is a tureen made by John Edwards II (No. 12). The surfaces of the tureen

**1** Victor Hanson, "Quantitative Elemental Analysis of Art Objects by Energy-Dispersive X-ray Fluorescence Spectroscopy," *Applied Spectroscopy* 27 (1973): 309–34. XRF analyses can be found in Ian M. G. Quimby, *American Silver at Winterthur* (Winterthur, Del.: Henry Francis du Pont Winterthur Museum, 1995); Donald L. Fennimore, *Metalwork in Early America: Copper and Its Alloys from the Winterthur Collection* (Winterthur, Del.: Henry Francis du Pont Winterthur Museum, 1996); Philip M. Johnson, *Catalogue of American Silver: The Cleveland Museum of Art* (Cleveland: By the museum, 1994); Esen Atil et al., *Islamic Metalwork at the Freer Gallery of Art* (Washington, D.C.: Smithsonian Institution Press, 1985).

**2** Janice H. Carlson, "X-ray Fluorescence Analysis of Chinese Export Silver," in Janet Bridgland, ed., *Tenth Triennial Meeting: ICOM Committee for Conservation* (Paris: By the committee, 1993), pp. 3–8.

and cover have an apparent silver content of 98% or higher, indicating a relatively thick layer of pure silver, which could only result from plating. Due to the appropriate concentrations of gold and lead, however, it is believed that the underlying silver alloy can be dated pre–mid nineteenth century.

Surface decorations such as gilding will also affect quantitative results. XRF data for gilt silver will show an apparent high concentration of gold. A silver gilt tureen made by John Bridge (No. 25) has an apparent elevated gold level of up to 11%, reflecting the thin gold layer applied to the surface, not the actual silver alloy itself. If mercury is detected together with an elevated gold content, the use of a mercury amalgam gilding process is indicated. In this process, a thin layer of mercury/gold amalgam is applied to the surface of an object, which is then heated to drive off the mercury, leaving the gold adhered to the surface. Mercury was not detected in the Bridge tureen. However, this does not necessarily mean that a mercury amalgam was not used. Because the characteristic XRF spectral peaks for gold and mercury are in close proximity (difficult to resolve), the presence of a high concentration of gold may well obscure small peaks due to residual mercury.

Since its introduction into the museum world nearly thirty years ago, X-ray fluorescence analysis has proven to be a valuable tool for the study of metal alloy objects, especially silver. The data provides compositional information to evaluate an object, complementing the curator's eye and allowing for the complete description of an object.

KATE DUFFY AND JANICE CARLSON

*Appendix B*

*The composition of select silver objects in the Campbell Collection of Soup Tureens at Winterthur*

# 1

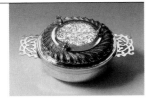

GEORG CASPAR MEIKL
VIENNA, AUSTRIA, 1706
96.4.147

| Écuelle | SILVER | COPPER | GOLD | LEAD | OTHER |
|---|---|---|---|---|---|
| handle | 73.99 | 3.86 | 21.97 | 0.18 | mercury |
| handle | 74.09 | 5.89 | 19.88 | 0.15 | mercury |
| side | 80.28 | 19.23 | 0.19 | 0.30 | zinc |
| side | 80.60 | 18.90 | 0.21 | 0.30 | zinc, trace mercury |
| side | 80.10 | 19.39 | 0.20 | 0.31 | zinc, trace mercury |
| bottom (center) | 90.19 | 9.38 | 0.25 | 0.18 | zinc, trace mercury |
| bottom (center) | 90.56 | 9.02 | 0.24 | 0.30 | zinc, trace mercury |
| bottom (center) | 90.15 | 9.43 | 0.25 | 0.19 | zinc |
| bottom | 80.08 | 19.41 | 0.20 | 0.18 | zinc, trace mercury |
| | | | | | |
| Lid | | | | | |
| foot | 92.77 | 3.80 | 3.37 | 0.07 | mercury |
| gadroon | 91.56 | 4.39 | 3.99 | 0.07 | mercury |
| center | 94.96 | 4.55 | 0.32 | 0.17 | mercury |

# 2 (.1)

JOHANN SEBASTIAN WÜRTH
VIENNA, AUSTRIA, 1781
96.4.230.1,.2

| Tureen (1 of 2) | SILVER | COPPER | GOLD | LEAD | OTHER |
|---|---|---|---|---|---|
| side | 95.06 | 4.74 | 0.10 | 0.10 | zinc |
| fluting | 94.66 | 5.14 | 0.12 | 0.08 | zinc |
| rosette | 93.66 | 6.08 | 0.12 | 0.14 | |
| handle (nose of lion) | 85.82 | 13.99 | 0.07 | 0.12 | zinc |
| handle (recessed area) | 97.14 | 2.71 | 0.11 | 0.04 | |
| ring | 94.89 | 4.80 | 0.18 | 0.13 | zinc |
| foot bracket | 97.64 | 2.23 | 0.10 | 0.03 | zinc |
| foot | 90.54 | 9.24 | 0.09 | 0.13 | trace zinc |
| | | | | | |
| Lid | | | | | |
| rim | 92.61 | 7.19 | 0.10 | 0.11 | trace zinc |
| gadroon | 90.11 | 9.70 | 0.09 | 0.10 | trace zinc |
| gadroon | 91.86 | 7.94 | 0.10 | 0.10 | trace zinc |
| turnip finial | 95.40 | 4.43 | 0.10 | 0.06 | trace zinc |

APPENDIX B  *Composition*

1 The side of the bowl contains about 80% apparent silver, falling below the Viennese standard of 81.25%. The bottom center, however, has an apparent silver content of 90%. Even though the silver content varies significantly from one area of the bowl to another, there is no visual evidence of repair or alteration. Mercury was identified throughout, suggesting that the gilt areas were created using the mercury-amalgam process.

2.1, The apparent silver content in
2.2 all areas of both tureens averages about 94%; the cast handles, finials, and feet contain about 95%. The apparent silver content of the nose of the lion handles on .1 is considerably lower than between its eyes, possibly due to polishing. This exemplifies the variability of silver content resulting from wear.

| Tureen (2 of 2) | SILVER | COPPER | GOLD | LEAD | OTHER |
|---|---|---|---|---|---|
| side | 94.70 | 4.71 | 0.13 | 0.46 | trace zinc |
| fluting | 92.92 | 6.30 | 0.12 | 0.65 | trace zinc |
| rosette | 91.64 | 7.54 | 0.18 | 0.65 | |
| handle (recessed area) | 96.90 | 2.68 | 0.06 | 0.36 | |
| ring | 94.15 | 4.89 | 0.18 | 0.78 | trace zinc |
| foot bracket | 95.40 | 4.18 | 0.12 | 0.29 | |
| foot | 92.92 | 6.20 | 0.22 | 0.66 | trace zinc |
| *Lid* | | | | | |
| rim | 93.27 | 6.12 | 0.10 | 0.51 | trace zinc |
| gadroon | 94.55 | 4.93 | 0.10 | 0.42 | trace zinc |
| gadroon | 95.41 | 4.12 | 0.10 | 0.37 | trace zinc |
| turnip finial | 94.29 | 5.18 | 0.13 | 0.40 | |

# 3

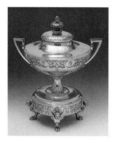

FRANZ HELLMAYER
VIENNA, AUSTRIA, 1800
96.4.187

| Tureen | SILVER | COPPER | GOLD | LEAD | OTHER |
|---|---|---|---|---|---|
| medallion | 92.21 | 7.53 | 0.18 | 0.08 | trace zinc |
| design | 94.51 | 5.23 | 0.19 | 0.08 | |
| side | 91.12 | 8.64 | 0.16 | 0.08 | trace zinc |
| handle | 92.98 | 6.76 | 0.15 | 0.10 | trace zinc |
| *Lid* | | | | | |
| rim | 93.26 | 6.51 | 0.16 | 0.06 | trace zinc |
| finial | 92.86 | 6.80 | 0.20 | 0.14 | trace zinc |
| *Stand* | | | | | |
| rim | 91.12 | 8.63 | 0.16 | 0.08 | trace zinc |
| design | 93.83 | 5.94 | 0.17 | 0.06 | trace zinc |
| support (wing) | 96.98 | 2.80 | 0.18 | 0.03 | |
| support (forehead) | 96.08 | 3.67 | 0.22 | 0.03 | trace zinc |
| support (foot) | 95.23 | 4.52 | 0.19 | 0.06 | trace zinc |

**3** All areas examined on this tureen far exceed the Viennese silver standard of 81.25% pure. The apparent silver content varies from part to part, however, suggesting the use of different alloys in different areas. The high apparent silver content of the cast winged monopods (95.2%–97%) is evidence of a surface enrichment. Zinc was identified in the majority of areas, suggesting the presence of silver solder.

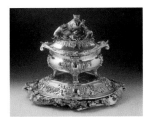

ANTON MICHELSEN
COPENHAGEN, DENMARK, 1866
96.4.6

| | SILVER | COPPER | GOLD | LEAD | OTHER |
|---|---|---|---|---|---|
| *Tureen* | | | | | |
| side | 95.21 | 4.56 | 0.16 | 0.08 | |
| side | 95.05 | 4.74 | 0.15 | 0.06 | |
| leaf | 92.72 | 7.16 | 0.03 | 0.08 | |
| handle-a | 92.78 | 7.04 | 0.09 | 0.09 | |
| handle-b | 91.86 | 7.99 | 0.07 | 0.08 | |
| crown | 92.54 | 7.12 | 0.26 | 0.08 | possibly gilt |
| medallion | 92.56 | 7.29 | 0.05 | 0.10 | |
| foot | 93.87 | 5.99 | 0.09 | 0.05 | |
| foot | 93.36 | 6.51 | 0.08 | 0.05 | |
| | | | | | |
| *Lid* | | | | | |
| side | 93.22 | 6.62 | 0.12 | 0.05 | |
| edge leaf (rim) | 93.07 | 6.86 | 0.04 | 0.04 | |
| small applied leaf | 95.82 | 4.07 | 0.07 | 0.04 | |
| large applied leaf | 96.92 | 2.70 | 0.32 | 0.07 | possibly gilt |
| dog (back)-a | 97.17 | 2.76 | 0.04 | 0.03 | |
| dog (back)-b | 96.80 | 3.14 | 0.03 | 0.02 | |
| bear (back) | 96.65 | 3.27 | 0.04 | 0.03 | |
| | | | | | |
| *Tray* | | | | | |
| club | 96.11 | 3.83 | 0.04 | 0.03 | |
| club (leaf) | 94.95 | 4.99 | 0.04 | 0.02 | |
| foot | 94.36 | 5.45 | 0.14 | 0.05 | |
| axe head | 94.64 | 5.27 | 0.04 | 0.05 | |
| mask | 94.23 | 5.56 | 0.18 | 0.04 | possibly gilt |
| medallion | 90.18 | 9.46 | 0.27 | 0.09 | possibly gilt |
| central element | 91.44 | 8.41 | 0.08 | 0.06 | |
| ribbon | 93.28 | 6.58 | 0.07 | 0.07 | |
| center | 94.21 | 5.62 | 0.13 | 0.04 | |
| side | 95.68 | 4.27 | 0.02 | 0.03 | |
| handle | 95.12 | 4.80 | 0.04 | 0.03 | |
| rim | 94.55 | 5.37 | 0.03 | 0.05 | |

APPENDIX B  *Composition*

**4** The apparent silver content of this tureen is consistently above 90%, with some of the cast components having 95% to 97% apparent silver. At least four of the examined areas have elevated gold levels but no mercury, which may indicate previous electroplated gilding.

## 6

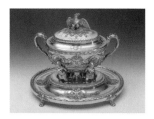

JACQUES-CHARLES MONGENOT
PARIS, FRANCE, 1783
96.4.170

| | SILVER | COPPER | GOLD | LEAD | OTHER |
|---|---|---|---|---|---|
| *Tureen* | | | | | |
| side | 95.08 | 4.77 | 0.10 | 0.05 | |
| side | 94.92 | 4.94 | 0.09 | 0.05 | |
| decoration | 96.03 | 3.83 | 0.11 | 0.03 | trace iron |
| support | 95.28 | 4.58 | 0.11 | 0.03 | |
| handle | 97.80 | 2.05 | 0.13 | 0.02 | trace zinc |
| *Lid* | | | | | |
| rim | 95.47 | 4.39 | 0.09 | 0.05 | |
| gadroon | 95.09 | 4.77 | 0.09 | 0.05 | |
| finial | 96.22 | 3.62 | 0.13 | 0.03 | |
| *Stand* | | | | | |
| rim | 95.01 | 4.86 | 0.12 | 0.01 | |
| foot | 95.60 | 4.23 | 0.14 | 0.03 | trace zinc and iron |

## 7

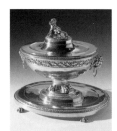

IGNACE-JOSEPH CRAISME
PARIS, FRANCE, 1787
96.4.227

| | SILVER | COPPER | GOLD | LEAD | OTHER |
|---|---|---|---|---|---|
| *Tureen* | | | | | |
| side | 95.21 | 4.63 | 0.08 | 0.08 | |
| decoration border | 96.26 | 3.46 | 0.11 | 0.17 | trace zinc |
| handle (snout) | 96.15 | 3.64 | 0.11 | 0.10 | zinc |
| handle (ring) | 94.60 | 5.13 | 0.13 | 0.15 | zinc |
| *Lid* | | | | | |
| side | 94.68 | 5.09 | 0.10 | 0.13 | trace zinc |
| finial (dog) | 95.60 | 4.20 | 0.09 | 0.11 | |
| finial (child) | 95.65 | 4.03 | 0.11 | 0.21 | trace zinc |
| *Stand* | | | | | |
| rim | 94.87 | 4.99 | 0.08 | 0.06 | trace zinc |
| foot | 94.64 | 3.52 | 0.13 | 1.71 | area of lead solder? |
| *Liner* | 94.52 | 5.24 | 0.11 | 0.13 | trace zinc |

**6** The apparent silver content of this tureen and lid hover around the Paris silver standard. Trace levels of zinc suggest the remains of silver solder.

**7** All parts of this tureen meet or slightly exceed the Paris standard of 94.45% silver. The liner has the lowest silver content with 94.52%, only 0.04% above the standard, providing some insight into how well silversmiths were able to control the content of their alloy. Gold and lead content are slightly higher than those of English objects of the same date. The lead content in the foot, quite high at 1.71%, is probably due to a solder repair.

# 8

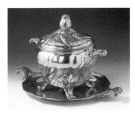

PAUL INGERMANN
DRESDEN, GERMANY, 1733–47
96.4.204

| | SILVER | COPPER | GOLD | LEAD | OTHER |
|---|---|---|---|---|---|
| *Tureen* | | | | | |
| side | 82.02 | 14.35 | 3.51 | 0.13 | zinc |
| side | 81.24 | 14.81 | 3.80 | 0.15 | zinc |
| handle | 81.50 | 9.34 | 9.03 | 0.13 | |
| foot | 84.19 | 7.54 | 8.19 | 0.09 | |
| | | | | | |
| *Lid* | | | | | |
| dome | 84.81 | 12.31 | 2.75 | 0.12 | zinc |
| finial | 84.20 | 11.84 | 3.78 | 0.18 | zinc |

# 9 (.1)

DAVID WILLAUME I
LONDON, ENGLAND, 1721–22
96.4.262.1, .2

| | SILVER | COPPER | GOLD | LEAD | OTHER |
|---|---|---|---|---|---|
| *Écuelle (1 of 2)* | | | | | |
| underside | 95.67 | 4.20 | 0.05 | 0.07 | trace mercury |
| side | 95.39 | 4.48 | 0.05 | 0.08 | trace mercury |
| handle (underside)-a | 95.99 | 3.86 | 0.09 | 0.06 | trace zinc |
| handle (underside)-b | 95.96 | 3.84 | 0.15 | 0.06 | |
| | | | | | |
| *Lid* | | | | | |
| finial | 95.09 | 4.78 | 0.06 | 0.06 | zinc |
| dome | 95.53 | 4.33 | 0.08 | 0.06 | trace mercury |

**8** The apparent silver content of the analyzed areas meets or exceeds the German standard of 13 lötiges (81.25%), although it should be noted that the readings are not wholly representative of the silver alloy due to the significant interference of surface gilding. Mercury was not identified in any examined area, suggesting the tureen was not gilded using the mercury amalgam process.

**9.1, 9.2** The English Britannia standard, in effect from 1696 to 1719, mandated 95.8% silver in household goods. These écuelles are very close to or exceed that standard. Despite the absence of quality marks on the lids, they are the same, except for one finial. Gold and lead content are consistent with an eighteenth-century date of fabrication. Traces of zinc may be due to residual silver solder.

| Écuelle (2 of 2) | SILVER | COPPER | GOLD | LEAD | OTHER |
|---|---|---|---|---|---|
| underside | 95.58 | 4.29 | 0.05 | 0.08 | |
| side | 95.55 | 4.31 | 0.06 | 0.08 | |
| handle (underside)-a | 96.35 | 3.53 | 0.08 | 0.04 | |
| handle (underside)-b | 96.07 | 3.79 | 0.08 | 0.06 | |
| | | | | | |
| *Lid* | | | | | |
| finial | 95.75 | 4.11 | 0.08 | 0.06 | mercury |
| dome | 96.08 | 3.77 | 0.09 | 0.05 | |

# 10

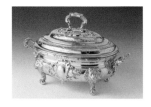

PAUL DE LAMERIE
LONDON, ENGLAND, 1738–39
96.4.270

| Tureen | SILVER | COPPER | GOLD | LEAD | OTHER |
|---|---|---|---|---|---|
| design | 93.00 | 6.79 | 0.10 | 0.11 | trace zinc and iron |
| side | 95.42 | 4.41 | 0.09 | 0.08 | trace zinc |
| side | 93.88 | 5.92 | 0.08 | 0.11 | trace zinc and iron |
| leg (snout) | 95.64 | 4.21 | 0.06 | 0.08 | trace zinc and iron |
| handle | 95.54 | 4.28 | 0.10 | 0.08 | |
| rim | 97.04 | 2.81 | 0.11 | 0.05 | |
| | | | | | |
| *Lid* | | | | | |
| dome | 94.66 | 5.19 | 0.07 | 0.08 | |
| finial | 95.22 | 4.65 | 0.08 | 0.05 | trace zinc and iron |

# 11

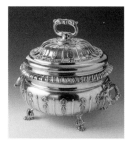

HENRY HEBERT
LONDON, ENGLAND, 1738–39
96.4.236

| Tureen | SILVER | COPPER | GOLD | LEAD | OTHER |
|---|---|---|---|---|---|
| side | 92.82 | 7.11 | 0.02 | 0.04 | |
| decoration | 92.80 | 7.06 | 0.05 | 0.09 | |
| handle | 94.87 | 5.04 | 0.04 | 0.05 | |
| rim | 92.74 | 7.10 | 0.09 | 0.08 | trace zinc and iron |
| foot | 93.40 | 6.47 | 0.07 | 0.06 | trace zinc |
| | | | | | |
| *Lid* | | | | | |
| rim | 92.64 | 7.28 | 0.02 | 0.05 | |
| dome | 93.33 | 6.59 | 0.03 | 0.06 | |
| handle | 94.10 | 5.79 | 0.05 | 0.06 | trace zinc and iron |

**10** All parts meet or exceed the sterling standard of 92.5% silver. The gold and lead content of all parts are similar throughout and consistent with the date of fabrication.

**11** The silver content of all analyzed parts meets or exceeds the British sterling standard of 92.5%. The cast handles and feet contain somewhat higher levels. Gold and lead content are somewhat lower than expected. Trace levels of zinc detected in the handles may result from the solder used to attach them to the body.

# 12

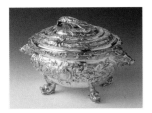

JOHN EDWARDS II
LONDON, ENGLAND, 1746–47
96.4.237

| *Tureen* | SILVER | COPPER | GOLD | LEAD | OTHER |
|---|---|---|---|---|---|
| handle (snout) | 99.53 | 0.22 | 0.04 | 0.21 | trace iron |
| side | 99.40 | 0.36 | 0.07 | 0.17 | |
| side | 99.37 | 0.40 | 0.06 | 0.17 | |
| foot (fish lip) | 99.47 | 0.28 | 0.06 | 0.19 | trace iron |
| *Lid* | | | | | |
| finial (lobster) | 99.06 | 0.73 | 0.06 | 0.14 | |
| top tier | 98.16 | 1.62 | 0.09 | 0.14 | |
| second tier | 98.83 | 0.96 | 0.07 | 0.14 | |
| rim | 99.36 | 0.43 | 0.06 | 0.16 | |
| edge design | 99.51 | 0.23 | 0.05 | 0.21 | trace iron |

*entire object probably
silver plated*

# 13

WILLIAM CRIPPS
LONDON, ENGLAND, 1752–53
96.4.233

| *Tureen* | SILVER | COPPER | GOLD | LEAD | OTHER |
|---|---|---|---|---|---|
| side | 94.02 | 5.80 | 0.13 | 0.05 | trace zinc |
| handle | 94.63 | 5.22 | 0.07 | 0.07 | zinc, trace iron |
| foot | 95.27 | 4.59 | 0.08 | 0.07 | zinc |
| *Lid* | | | | | |
| rim | 93.57 | 6.22 | 0.12 | 0.10 | zinc |
| dome | 92.90 | 6.88 | 0.12 | 0.10 | zinc |
| finial (flower) | 97.02 | 2.77 | 0.17 | 0.03 | |
| finial (leaf) | 97.50 | 2.36 | 0.12 | 0.02 | |

12  The apparent silver content of all parts of this tureen is 98% or higher—strong evidence that the object has been silver plated, since pure silver is too soft to withstand use in utilitarian objects. The underlying silver alloy is consistent with a mid eighteenth-century date, however, as indicated by appropriate concentrations of gold and lead.

13  All examined areas exceed the British sterling standard of 92.5%, with the tureen having a higher apparent silver content than the lid. The cast finial contains approximately 97% apparent silver, which could represent surface enrichment. The presence of zinc in many areas may be due to silver solder.

# 14

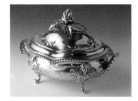

PETER ARCHAMBO JR. AND
PETER MEURE
LONDON, ENGLAND, 1754–55
96.4.267

### Tureen

|  | SILVER | COPPER | GOLD | LEAD | OTHER |
|---|---|---|---|---|---|
| tureen | 94.24 | 5.63 | 0.07 | 0.06 | trace zinc |
| tureen | 95.54 | 4.30 | 0.12 | 0.05 | zinc, trace iron |
| handle | 95.23 | 4.59 | 0.10 | 0.07 | trace zinc and iron |
| leg | 93.25 | 6.48 | 0.11 | 0.16 | trace zinc and iron |

### Lid

|  | SILVER | COPPER | GOLD | LEAD | OTHER |
|---|---|---|---|---|---|
| decoration | 94.93 | 4.89 | 0.12 | 0.07 | trace zinc and iron |
| dome | 94.87 | 4.80 | 0.28 | 0.05 | zinc |
| finial (leaf) | 96.25 | 3.59 | 0.10 | 0.06 |  |
| finial (flower) | 96.19 | 3.62 | 0.13 | 0.06 | trace zinc |
| rim | 93.90 | 5.75 | 0.29 | 0.09 | zinc |
| rim decoration | 93.32 | 6.51 | 0.09 | 0.08 | zinc, trace iron |

# 15

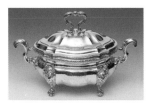

THOMAS GILPIN
LONDON, ENGLAND, 1755–56
96.4.192

### Tureen

|  | SILVER | COPPER | GOLD | LEAD | OTHER |
|---|---|---|---|---|---|
| handle-a | 96.78 | 3.03 | 0.08 | 0.11 | trace zinc and iron |
| handle-b | 96.24 | 3.53 | 0.11 | 0.12 | trace zinc and iron |
| side | 94.81 | 5.08 | 0.08 | 0.04 | zinc |
| side | 94.68 | 5.21 | 0.07 | 0.04 | trace zinc |
| foot (lion nose)-a | 93.99 | 5.83 | 0.11 | 0.07 | trace zinc and iron |
| foot (lion nose)-b | 94.05 | 5.78 | 0.10 | 0.08 | trace zinc and iron |

### Lid

|  | SILVER | COPPER | GOLD | LEAD | OTHER |
|---|---|---|---|---|---|
| finial | 97.96 | 1.92 | 0.07 | 0.04 | zinc |
| dome | 98.83 | 1.10 | 0.05 | 0.02 |  |
| edge | 98.64 | 1.28 | 0.06 | 0.03 | zinc |

### Liner

|  | SILVER | COPPER | GOLD | LEAD | OTHER |
|---|---|---|---|---|---|
| side | 94.56 | 5.37 | 0.04 | 0.03 |  |
| side | 94.89 | 5.05 | 0.03 | 0.03 |  |
| handle | 96.82 | 3.12 | 0.03 | 0.03 | trace iron |

**14** Silver content of this tureen is consistent with the British sterling standard. In general, gold and lead are consistent with a mid eighteenth-century attribution. The elevated apparent gold content of the dome and rim of the lid suggests that these parts may once have been gilt. No evidence of mercury was found. Zinc was identified, suggesting the presence of silver solder.

**15** The apparent silver content of many of the parts exceeds the British sterling standard by a significant amount. The liner and cast handles are particularly high, and the dome and edge of the lid have an apparent average silver content of nearly 99%, indicating probable electroplating. The gold and lead content of all parts are consistent with an eighteenth-century date.

# 16

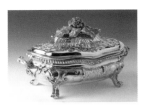

|  | SILVER | COPPER | GOLD | LEAD | OTHER |
|---|---|---|---|---|---|
| *Tureen* |  |  |  |  |  |
| decoration | 94.53 | 5.21 | 0.11 | 0.14 | zinc |
| side | 93.12 | 6.66 | 0.09 | 0.12 |  |
| handle | 95.59 | 4.20 | 0.12 | 0.09 |  |
| leg | 95.73 | 4.09 | 0.13 | 0.05 | trace bismuth |
| *Lid* |  |  |  |  |  |
| dome | 93.10 | 6.67 | 0.11 | 0.11 | trace zinc |
| decoration | 94.19 | 5.61 | 0.11 | 0.09 | trace zinc |
| finial (leaf) | 95.14 | 4.64 | 0.13 | 0.09 |  |
| finial (top) | 95.15 | 4.65 | 0.11 | 0.09 | trace iron and bismuth |

*liner could not safely be
removed for analysis*

# 17

|  | SILVER | COPPER | GOLD | LEAD | OTHER |
|---|---|---|---|---|---|
| *Ladle* |  |  |  |  |  |
| handle decoration | 94.92 | 4.92 | 0.11 | 0.05 | trace iron |
| handle | 92.02 | 7.76 | 0.15 | 0.07 | trace zinc, iron, and bismuth |
| bowl edge | 94.84 | 4.99 | 0.12 | 0.05 | trace iron |

# 18

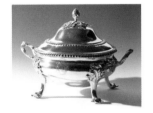

|  | SILVER | COPPER | GOLD | LEAD | OTHER |
|---|---|---|---|---|---|
| *Tureen* |  |  |  |  |  |
| side | 93.82 | 6.06 | 0.09 | 0.03 |  |
| side | 93.69 | 6.20 | 0.09 | 0.03 |  |
| leg | 93.91 | 5.85 | 0.14 | 0.10 | trace zinc |
| handle | 93.40 | 6.35 | 0.13 | 0.12 | zinc |
| *Lid* |  |  |  |  |  |
| dome | 95.07 | 4.77 | 0.11 | 0.05 | trace zinc |
| finial | 96.15 | 3.59 | 0.19 | 0.07 | zinc and iron |

**16** The side of the bowl and dome of the lid have the lowest silver content, about 93.1%. The cast parts all appear to have a higher silver content. Gold and lead content are relatively consistent from part to part and are typical of the eighteenth century. The source of bismuth is unknown.

**17** The silver content of the handle is 92.02%, which may explain why it does not carry the sterling standard mark. The edge of the bowl and decoration on the handle do appear to contain a higher concentration of silver, but their narrow profile or surface irregularity may be affecting the readings.

**18** The silver content of the bowl and handle of this tureen is somewhat higher than the sterling standard. The dome and finial of the lid are even higher in apparent silver content, suggesting surface enrichment by pickling. The gold and lead content of all parts are typical for eighteenth-century silver. Trace amounts of zinc in several parts may be due to silver solder.

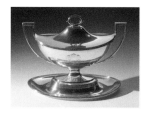

ROBERT MAKEPEACE
LONDON, ENGLAND, 1795–96
96.4.207

| | SILVER | COPPER | GOLD | LEAD | OTHER |
|---|---|---|---|---|---|
| *Tureen* | | | | | |
| side | 93.44 | 6.36 | 0.11 | 0.09 | zinc |
| side | 93.81 | 6.01 | 0.09 | 0.09 | zinc |
| handle-a | 93.30 | 6.47 | 0.11 | 0.12 | trace zinc and iron |
| handle-b | 93.36 | 6.41 | 0.11 | 0.12 | trace zinc |
| foot | 93.67 | 6.14 | 0.10 | 0.09 | zinc |
| | | | | | |
| *Stand* | 92.60 | 7.27 | 0.05 | 0.08 | zinc |
| | | | | | |
| *Lid* | | | | | |
| dome | 94.20 | 5.70 | 0.05 | 0.05 | |
| finial | 94.08 | 5.79 | 0.07 | 0.05 | |

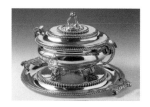

PAUL STORR
LONDON, ENGLAND, 1805–6
96.4.105

| | SILVER | COPPER | GOLD | LEAD | OTHER |
|---|---|---|---|---|---|
| *Tureen* | | | | | |
| side | 93.44 | 6.37 | 0.13 | 0.07 | |
| rim | 94.04 | 5.82 | 0.08 | 0.07 | |
| handle | 94.55 | 5.28 | 0.09 | 0.09 | trace iron |
| foot | 94.40 | 5.41 | 0.11 | 0.08 | |
| | | | | | |
| *Lid* | | | | | |
| dome | 94.75 | 5.12 | 0.07 | 0.06 | |
| decoration | 94.45 | 5.41 | 0.08 | 0.06 | |
| finial (arm) | 94.43 | 5.37 | 0.12 | 0.08 | |
| | | | | | |
| *Tray* | | | | | |
| handle | 95.07 | 4.78 | 0.09 | 0.07 | |
| edge | 94.36 | 5.45 | 0.12 | 0.07 | trace iron |
| | | | | | |
| *Liner* | | | | | |
| side | 93.30 | 6.46 | 0.14 | 0.10 | |

**19** All parts exceed the British sterling standard of 92.5% silver. Gold and lead content are typical of the period. There is little compositional variation from part to part, despite the number of individual pieces used to fabricate the whole. This may suggest a single source for the alloy.

**21** The silver content of all parts of this tureen is consistent, averaging about 94.4%, somewhat higher than the British sterling standard. Gold and lead are variable from part to part, compared to No. 22 (also by Storr), but are not inconsistent with such items from the early nineteenth century.

# 22

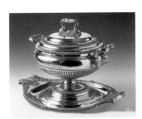

PAUL STORR
LONDON, ENGLAND, 1816–17
96.4.104

| | SILVER | COPPER | GOLD | LEAD | OTHER |
|---|---|---|---|---|---|
| *Tureen* | | | | | |
| handle | 92.38 | 7.43 | 0.07 | 0.12 | zinc |
| rim | 93.08 | 6.77 | 0.09 | 0.07 | |
| side (crest) | 92.98 | 6.80 | 0.09 | 0.13 | trace zinc |
| side (snout) | 92.91 | 6.93 | 0.05 | 0.11 | trace zinc |
| *Lid* | | | | | |
| dome | 93.29 | 6.58 | 0.07 | 0.07 | |
| rim | 93.27 | 6.60 | 0.06 | 0.07 | |
| finial | 94.47 | 5.36 | 0.08 | 0.10 | trace zinc |
| *Stand* | | | | | |
| handle | 93.81 | 6.01 | 0.07 | 0.11 | zinc |

# 23

THOMAS ALDERSON
LONDON, ENGLAND, 1821
96.4.100.1

| | TIN | COPPER | LEAD | OTHER |
|---|---|---|---|---|
| *Pewter Tureen* | | | | |
| foot | 95.97 | 1.52 | 2.30 | |
| side | 97.08 | 0.73 | 1.97 | |
| handle | 91.61 | 1.53 | 6.65 | |
| side | 97.30 | 0.78 | 1.64 | |
| *Lid* | | | | |
| dome | 97.14 | 0.85 | 1.59 | |
| finial | 94.03 | 1.21 | 4.38 | |
| | | | | *zinc, bismuth, and antimony all below detection limits* |

22 This tureen well represents the ability to adhere to the sterling standard of 92.5% silver. The silver content of all parts ranges from 92.38% to 94.47%. Gold and lead content are consistent with the tureen's age and are uniform from part to part, suggesting a single source for the alloy.

23 Except for the apparent low tin content of the handle (91.61%), all analyzed areas of this tureen conform to "superfine hardmetal" composition. The "superfine hardmetal" mark indicates that it should contain 94% tin, with the balance antimony. All analyzed areas meet or exceed the 94% tin standard, but antimony is virtually absent. The tin is alloyed with a varying mixture of lead and copper.

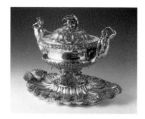

ROBERT GARRARD JR.
LONDON, ENGLAND, 1824–25
96.4.254

| | SILVER | COPPER | GOLD | LEAD | OTHER |
|---|---|---|---|---|---|
| *Tureen* | | | | | |
| support (fish) | 96.06 | 3.85 | 0.06 | 0.04 | trace zinc |
| lower scallop edge | 97.28 | 2.60 | 0.08 | 0.03 | |
| side | 96.29 | 3.63 | 0.06 | 0.02 | |
| rim | 96.11 | 3.73 | 0.08 | 0.08 | trace bismuth |
| handle, mermaid | 97.84 | 2.02 | 0.11 | 0.03 | trace bismuth |
| handle, triton | 97.05 | 2.85 | 0.06 | 0.04 | trace zinc |
| | | | | | |
| *Lid* | | | | | |
| finial (crustacea) | 96.15 | 3.75 | 0.09 | 0.01 | |
| finial (leaves) | 96.64 | 3.22 | 0.10 | 0.03 | |
| lid | 96.41 | 3.48 | 0.07 | 0.04 | |
| base | 94.97 | 4.92 | 0.06 | 0.05 | |
| | | | | | |
| *Liner* | | | | | |
| side | 93.82 | 6.05 | 0.07 | 0.07 | |
| side | 94.03 | 5.84 | 0.07 | 0.06 | |
| | | | | | |
| *Stand* | | | | | |
| edge | 95.65 | 4.18 | 0.06 | 0.10 | trace zinc |
| handle | 94.70 | 5.12 | 0.07 | 0.10 | trace zinc and bismuth |

**24** All parts exceed the British sterling standard; the silver content of the tureen and lid are high enough to suggest a recent pickling or electroplating. The silver content of the liner and stand are closer to sterling, containing about 94% to 95% silver. The gold and lead content of all parts are typical of the period, ranging from about 0.06% to 0.11% gold and 0.01% to 0.10% lead. The origin of the bismuth is unknown.

## 25

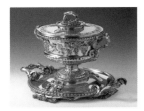

JOHN BRIDGE
LONDON, ENGLAND, 1828–29
96.4.252

| | SILVER | COPPER | GOLD | LEAD | OTHER |
|---|---|---|---|---|---|
| *Tureen* | | | | | |
| gadroon | 90.38 | 3.80 | 5.77 | 0.06 | gilt |
| side | 92.22 | 4.33 | 3.41 | 0.04 | gilt |
| side | 92.96 | 3.30 | 3.69 | 0.05 | gilt |
| leaf | 91.13 | 3.35 | 5.45 | 0.06 | gilt |
| handle | 84.68 | 3.55 | 11.72 | 0.06 | gilt |
| base | 87.41 | 3.86 | 8.63 | 0.10 | gilt |
| | | | | | |
| *Lid* | | | | | |
| edge | 87.43 | 2.98 | 9.49 | 0.10 | gilt |
| crest | 92.60 | 5.00 | 2.31 | 0.09 | gilt |
| finial (area 1) | 85.89 | 3.72 | 10.34 | 0.04 | gilt |
| finial (area 2) | 84.72 | 3.56 | 11.67 | 0.05 | gilt |
| | | | | | |
| *Stand* | | | | | |
| foot | 88.84 | 3.96 | 7.15 | 0.06 | gilt |
| handle | 90.42 | 2.89 | 6.64 | 0.05 | gilt |
| gadroon | 89.30 | 3.60 | 7.05 | 0.05 | gilt |
| coat of arms | 90.39 | 2.77 | 6.77 | 0.06 | gilt |
| inscription | 86.40 | 2.72 | 10.84 | 0.04 | gilt |
| | | | | | |
| *Liner* | | | | | |
| side | 91.17 | 5.18 | 3.49 | 0.16 | gilt |
| side | 90.33 | 5.17 | 4.34 | 0.16 | gilt |

APPENDIX B *Composition*

**25** The silver content of all parts appears to be well above the British sterling standard, but determining the precise silver content of this tureen is difficult because it is gilt. The gilding also masks trace amounts of gold in the alloy; however, trace amounts of lead are consistent with the tureen's nineteenth-century attribution. Mercury, indicative of mercury gilding, was not detected.

# 26

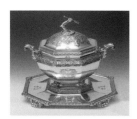

ROBERT GARRARD JR.
LONDON, ENGLAND, 1834–35
96.4.171

| | SILVER | COPPER | GOLD | LEAD | OTHER |
|---|---|---|---|---|---|
| *Tureen* | | | | | |
| side | 93.35 | 6.36 | 0.03 | 0.26 | |
| side | 93.28 | 6.46 | 0.03 | 0.24 | trace zinc |
| handle-a | 94.35 | 5.50 | 0.04 | 0.11 | |
| handle-b | 94.13 | 5.78 | 0.02 | 0.07 | |
| pedestal | 93.54 | 6.25 | 0.05 | 0.17 | |
| pedestal | 93.76 | 6.11 | 0.03 | 0.11 | |
| | | | | | |
| *Lid* | | | | | |
| finial (arm) | 95.00 | 4.86 | 0.03 | 0.11 | trace iron |
| finial (arm) | 94.49 | 5.31 | 0.03 | 0.17 | |
| dome (embossed) | 93.93 | 5.96 | 0.09 | 0.02 | |
| dome (flat) | 93.08 | 6.78 | 0.03 | 0.11 | |
| | | | | | |
| *Tray* | | | | | |
| edge | 92.64 | 7.14 | 0.06 | 0.17 | zinc |
| edge | 92.94 | 6.86 | 0.03 | 0.18 | zinc |
| foot-a | 94.29 | 5.60 | 0.05 | 0.06 | |
| foot-b | 93.38 | 6.51 | 0.02 | 0.08 | |
| | | | | | |
| *Liner* | | | | | |
| side | 93.12 | 6.76 | 0.03 | 0.10 | |
| side | 93.54 | 6.34 | 0.02 | 0.09 | |

**26** The silver content is consistent with the British sterling standard. Parts range from 92.6% to 95.0%. Some variation is expected; cast parts have a slightly higher apparent silver content than do wrought pieces. As this tureen dates from 1834, it is not surprising that the gold content is about 0.03% lower than the Garrard tureen of a decade earlier (No. 24). Lead content, however, is somewhat higher.

# 27

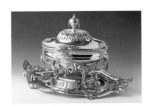

ENGELBART JOOSTEN
THE HAGUE, HOLLAND, 1772
96.4.256

| | SILVER | COPPER | GOLD | LEAD | OTHER |
|---|---|---|---|---|---|
| *Tureen* | | | | | |
| side | 94.99 | 4.81 | 0.09 | 0.11 | trace zinc and mercury |
| crest | 95.41 | 4.39 | 0.13 | 0.07 | trace zinc |
| handle (snout) | 94.88 | 4.95 | 0.10 | 0.07 | trace mercury |
| handle (ring) | 94.53 | 5.32 | 0.08 | 0.07 | trace zinc and mercury |
| swag | 95.15 | 4.63 | 0.11 | 0.12 | trace zinc |
| foot | 95.74 | 4.10 | 0.10 | 0.06 | trace zinc and mercury |
| *Lid* | | | | | |
| rim | 95.35 | 4.45 | 0.13 | 0.07 | trace zinc and mercury |
| dome (leaf) | 94.99 | 4.77 | 0.18 | 0.06 | trace zinc and mercury |
| finial | 94.55 | 5.25 | 0.17 | 0.04 | trace zinc and mercury |
| *Stand* | | | | | |
| rim | 94.06 | 5.77 | 0.10 | 0.07 | trace zinc and mercury |
| handle | 93.95 | 5.89 | 0.09 | 0.07 | trace zinc |
| *Liner* | | | | | |
| interior | 93.68 | 5.99 | 0.19 | 0.14 | trace zinc and mercury |
| interior | 93.89 | 5.78 | 0.20 | 0.14 | trace zinc, iron, and mercury |

27 The silver content of all parts of this tureen meets or exceeds the Dutch standard in effect at the time of its fabrication—75.0% to 93.3%. Gold and lead content are typical of the period. Zinc is present in many of the parts, suggesting the presence of solder. The trace mercury may suggest original mercury gilding. However, gold levels are lower than expected for residual gilding.

APPENDIX B  *Composition*

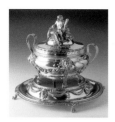

| | SILVER | COPPER | GOLD | LEAD | OTHER |
|---|---|---|---|---|---|
| *Tureen* | | | | | |
| side | 93.83 | 6.00 | 0.12 | 0.05 | |
| leaf decoration | 95.77 | 4.09 | 0.12 | 0.03 | |
| support (lion) | 95.66 | 4.17 | 0.14 | 0.03 | trace zinc |
| foot (claw) | 95.07 | 4.74 | 0.14 | 0.05 | |
| handle | 95.59 | 4.26 | 0.12 | 0.03 | |
| *Lid* | | | | | |
| wave design | 94.73 | 5.08 | 0.15 | 0.03 | |
| finial (lion nose) | 95.70 | 4.19 | 0.09 | 0.02 | |
| finial (dragon) | 96.53 | 3.35 | 0.11 | 0.02 | |
| finial (arm) | 94.93 | 4.96 | 0.10 | 0.02 | trace zinc |
| finial (club) | 95.12 | 4.74 | 0.12 | 0.02 | trace zinc |
| *Stand* | | | | | |
| rim | 95.25 | 4.68 | 0.04 | 0.03 | |
| side | 94.68 | 5.21 | 0.08 | 0.03 | |
| face decoration | 95.87 | 3.98 | 0.12 | 0.02 | |
| foot | 95.17 | 4.63 | 0.16 | 0.03 | |
| *Liner* | | | | | |
| side | 93.37 | 6.39 | 0.09 | 0.04 | gilt interior |

## 29

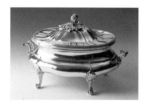

| | SILVER | COPPER | GOLD | LEAD | OTHER |
|---|---|---|---|---|---|
| *Tureen* | | | | | |
| side | 91.87 | 8.01 | 0.07 | 0.05 | |
| support (shell motif) | 94.53 | 5.17 | 0.21 | 0.08 | |
| handle | 94.41 | 5.29 | 0.25 | 0.05 | |
| *Lid* | | | | | |
| rim (interior) | 94.56 | 5.24 | 0.04 | 0.16 | trace zinc |
| finial | 95.06 | 4.83 | 0.08 | 0.03 | |

**28** The apparent silver content of the tureen is 93.8%, similar to the liner at 93.4%. The cast components and the base contain approximately 95% apparent silver, with little variability. This is well above the standard of 91.7% purity used in Italy at that time. (See Constantino G. Bulgari, *Argenteri, Gemmari,* *E Orafi d'Italia* [Rome: Lorenzo Del Turco, 1958], pp. 3–26. While the 91.7% standard was used in Italy, several varying standards were allowed at different times in different cities, as long as the object's purity was properly identified by its mark.)

**29** The nominal compositional standard for Mexican silver in the mid eighteenth century was 11 dineros, the equivalent of 91.67%. (Lawrence Anderson, *El Arte de la Plateria en Mexico, 1519–1936*, 2 vols. [New York: Oxford University Press, 1941], pp. 121–23). Pure silver was 12 dineros. The silver content of the wrought bowl of this tureen, at 91.9%, compares favorably to that standard, while the cast components are much higher, containing about 94.5% silver. A significant difference in the gold content between the shell motif and handle compared to the other parts suggests that perhaps the silver from which they were made originated in a different mine.

# 30

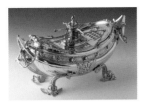

ZACHARIAS DEICHMANN
ST. PETERSBURG, RUSSIA, 1766
96.4.209

| *Tureen* | SILVER | COPPER | GOLD | LEAD | OTHER |
|---|---|---|---|---|---|
| circle decoration | 91.43 | 8.39 | 0.15 | 0.04 | trace zinc |
| eagle crest | 94.97 | 4.84 | 0.17 | 0.02 | |
| side | 94.34 | 5.50 | 0.13 | 0.04 | |
| anchor-a | 93.62 | 6.26 | 0.09 | 0.02 | trace mercury |
| anchor-b | 94.66 | 5.22 | 0.10 | 0.02 | |
| leg (fish lip) | 95.89 | 4.01 | 0.09 | 0.02 | |
| outer rim (flower) | 93.94 | 5.70 | 0.32 | 0.03 | mercury, possibly solder |
| | | | | | |
| *Lid* | | | | | |
| volute decoration | 93.54 | 6.32 | 0.12 | 0.02 | |
| rim | 94.56 | 5.24 | 0.17 | 0.03 | mercury, possibly solder |
| rim decoration | 81.26 | 12.71 | 6.00 | 0.04 | gilt; zinc and mercury |
| finial (arm) | 95.64 | 4.23 | 0.12 | 0.02 | |
| finial (tip) | 94.55 | 5.27 | 0.16 | 0.02 | trace zinc |

# 31

BENJAMIN HURD
BOSTON, MASSACHUSETTS, 1760–81
96.4.72

| *Ladle* | SILVER | COPPER | GOLD | LEAD | OTHER |
|---|---|---|---|---|---|
| handle (underside) | 92.12 | 7.60 | 0.24 | 0.04 | |
| bowl (underside) | 91.46 | 8.20 | 0.26 | 0.08 | trace zinc |

# 32

PAUL REVERE
BOSTON, MASSACHUSETTS, 1781–97
96.4.56

| *Ladle* | SILVER | COPPER | GOLD | LEAD | OTHER |
|---|---|---|---|---|---|
| handle | 89.80 | 10.04 | 0.08 | 0.07 | |
| join | 89.20 | 10.62 | 0.10 | 0.09 | zinc |
| bowl | 89.30 | 10.53 | 0.11 | 0.07 | |

**30** All examined areas contain an average apparent silver content of 94%, exceeding the Russian standard of 76 to 82 zol. by a considerable amount. The tureen carries a mark of 80 zol., or 83.3%. The results may suggest surface enrichment, or more likely, the use of a higher quality ore. The lid rim decoration, with an apparent silver content of 81.3%, does not accurately represent the silver alloy because of the gilded interior.

**31** The silver content of the bowl and handle is slightly less than the English sterling standard. These data, together with the average gold content of 0.25%, are consistent with the ladle's eighteenth-century attribution. The slight compositional differences in the two parts may indicate that two different alloys were used.

**32** Although this ladle is fabricated of two separate parts, the silver, copper, gold, and lead contents of each are similar and typical of previously analyzed Revere silver flatware. The presence of zinc in the area of the join is evidence of the use of silver solder.

## 33

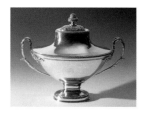

HUGH WISHART
NEW YORK, NEW YORK, 1793–1810
96.4.206

**Tureen**

| | SILVER | COPPER | GOLD | LEAD | OTHER |
|---|---|---|---|---|---|
| tureen (rim) | 93.59 | 6.23 | 0.12 | 0.06 | zinc, trace mercuy |
| side | 94.77 | 5.06 | 0.11 | 0.06 | zinc |
| handle-a | 95.93 | 3.86 | 0.15 | 0.06 | trace zinc and bismuth |
| handle-b | 96.04 | 3.71 | 0.18 | 0.07 | |
| pedestal (rim) | 94.45 | 5.38 | 0.10 | 0.07 | zinc |

**Lid**

| | SILVER | COPPER | GOLD | LEAD | OTHER |
|---|---|---|---|---|---|
| side | 94.21 | 5.60 | 0.12 | 0.07 | |
| finial (lower part) | 96.03 | 3.74 | 0.18 | 0.05 | trace bismuth |
| finial (upper part) | 95.22 | 4.53 | 0.19 | 0.05 | zinc |
| top of rim | 94.23 | 5.59 | 0.11 | 0.07 | zinc |

## 34

JOSEPH AND TEUNIS D. DUBOIS
NEW YORK, NEW YORK, 1795–97
96.4.70

**Ladle**

| | SILVER | COPPER | GOLD | LEAD | OTHER |
|---|---|---|---|---|---|
| bowl (underside) | 93.85 | 5.96 | 0.08 | 0.11 | trace zinc and iron |
| handle (underside) | 93.76 | 6.05 | 0.08 | 0.12 | trace zinc and iron |

## 35

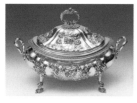

WILLIAM FORBES
NEW YORK, NEW YORK, 1839–51
96.4.190

**Tureen**

| | SILVER | COPPER | GOLD | LEAD | OTHER |
|---|---|---|---|---|---|
| side | 92.35 | 7.50 | 0.08 | 0.06 | |
| side | 92.67 | 7.19 | 0.07 | 0.06 | |
| foot (turtle underside) | 90.57 | 9.17 | 0.07 | 0.19 | |
| leg | 94.21 | 5.48 | 0.09 | 0.22 | |
| handle | 94.58 | 5.27 | 0.09 | 0.06 | trace zinc |

**Lid**

| | SILVER | COPPER | GOLD | LEAD | OTHER |
|---|---|---|---|---|---|
| floral decoration | 93.61 | 6.25 | 0.07 | 0.08 | |
| dome | 93.02 | 6.85 | 0.06 | 0.07 | |
| finial (side) | 93.93 | 5.92 | 0.07 | 0.07 | trace zinc |
| finial (top) | 95.40 | 4.47 | 0.07 | 0.06 | trace zinc |

**33** The apparent silver content, ranging between 93.6% and 96%, is unusually high for American silver of its date. The levels of gold and lead are, however, consistent with a late eighteenth-century date. Zinc is present in most areas, suggesting the presence of silver solder.

**34** Close agreement between the compositional data for the bowl and handle of this ladle strongly suggests its fabrication from one piece of metal. The silver content, averaging about 93.8%, is high for American silver of this period, but the gold and lead content are consistent with its late eighteenth-century date.

**35** The silver content in the majority of areas examined meets or exceeds the British sterling standard and is consistent with past examination of Forbes's silver at Winterthur. However, the analyzed foot is more consistent with American silver of the period.

# 36

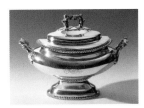

GEORGE B. JONES, TRUE M. BALL,
AND NATHANIEL C. POOR
BOSTON, MASSACHUSETTS, 1849
96.4.216

|  | SILVER | COPPER | GOLD | LEAD | OTHER |
|---|---|---|---|---|---|
| *Tureen* |  |  |  |  |  |
| rim | 93.18 | 6.67 | 0.08 | 0.07 | trace iron and zinc |
| side | 89.65 | 10.19 | 0.09 | 0.07 |  |
| side | 89.17 | 10.67 | 0.08 | 0.08 |  |
| handle | 95.56 | 4.28 | 0.08 | 0.08 |  |
| *Pedestal* | 91.72 | 8.17 | 0.06 | 0.05 |  |
| *Lid* |  |  |  |  |  |
| finial | 95.49 | 4.37 | 0.09 | 0.05 | trace zinc |
| dome | 92.30 | 7.57 | 0.07 | 0.06 |  |

# 37

DUHME AND COMPANY
CINCINNATI, OHIO, CIRCA 1863
96.4.68

|  | SILVER | COPPER | GOLD | LEAD |
|---|---|---|---|---|
| *Ladle* |  |  |  |  |
| bowl (underside) | 90.00 | 9.85 | 0.06 | 0.08 |
| bowl | 91.43 | 7.67 | 0.83 | 0.07 |
| handle (underside) | 91.65 | 8.22 | 0.08 | 0.06 |
| handle (underside) | 94.17 | 5.69 | 0.07 | 0.08 |
| medal | 94.13 | 5.73 | 0.08 | 0.06 |
| medal (underside) | 91.69 | 8.18 | 0.06 | 0.06 |

**36** The silver content of the wrought lid, side, and pedestal of this tureen is lower than the British sterling standard of 92.5%. The cast appendages, however, have a significantly higher silver content. These data, together with the gold and lead content, are consistent with the tureen's mid nineteenth-century American origin.

**37** Although this ladle was wrought from one piece of silver (the medallion excepted), considerable variation exists in its apparent silver content. This suggests that the ladle may have been subjected to over-polishing in several areas; that there may have been elemental enrichment during casting of the original silver billet; or that there may have been other alterations or surface treatments not visually evident. The high apparent gold content of the bowl interior confirms its gilding. However, the presence of mercury could not be confirmed above the instrumental background.

# *Endnotes*

1 A complete German travel set is pictured in Baumstark and Seling, *Silber und Gold*, p. 445. For examples of the pinwheel decoration, see Lightbrown, *French Silver*, p. 58; and Nocq, *Orfèvrerie Civile Française*, 1:pl. 20, fig. a.

2 The purpose and significance of the trophy in rococo design is explained by Kimball, *Creation of the Rococo*, pp. 27, 28. For a closely related tureen by Germain, see Ménard, *Histoire Artistique du Métal*, p. 85; for Auguste's work, see Dennis, *Three Centuries of French Domestic Silver*, 1:38–43; for Gogly's work, see Nocq, *Orfèvrerie Civile Française*, 2:pl. 48B.

3 French customs law stipulated that all imported gold and silver had to equal French work in purity. Imported objects from countries without customs conventions with France were stamped with a swan after 1893 once they were determined to be of proper purity.

4 They are itemized with 4 matching oval tureens as part of the collection at Altenburg; see Braun, *Tafelsilber*, p. 10.

5 See Percier and Fontaine, *Recueil des Décorations Intérieures*, pls. 2, 18, 34, 60, 71.

6 The tax was instituted in 1806 but repealed in 1824. In addition, Austria issued a proclamation on December 19, 1809, that owners of silverware were required to turn it in for melting to help finance the country's participation in the Napoleonic Wars. If owners chose to pay the full value of their silverware to the state, they could keep the silver, which would then be marked as being free from confiscation.

7 For more on the firm, see Wanscher, *A. Michelsen* (unpaginated English supplement). Christian Holmsted Olesen, curator, Danish Museum of Decorative Art, to Donald L. Fennimore, May 11, 1998; and Michael von Essen, historian, Royal Scandinavia, to Donald L. Fennimore, June 16, 1998, both in object folder, Registration Office, Winterthur.

8 Rees, *Cyclopaedia*, 5: s.v. "bear." For the Gram example, see *La Table d'un Roi*, pp. 202, 203, fig. 169.

9 Verlet, *Bronzes Dorés*, p. 419. It has been suggested by some that this tureen was made in the late nineteenth century. Pending future research, circumstantial evidence strongly suggests that it dates from the second quarter of the eighteenth century.

10 Pineau's design is published in Ottomeyer and Pröschel, *Vergoldete Bronzen*, p. 37. Related supports can be seen in Tardy, *Pendule Française*, 1:57, 64; and Metman, *Musée des Arts Décoratifs*, 2:pl. 32, fig. 334; pl. 67, fig. 634. The table is pictured in pl. 5 of an undated series of designs first published in Paris as *Nouveaux Desseins de Pieds de Tables et Vases et Consoles de Sculpture en bois Inventés par le Sieur Pineau*. It has been republished in *Recueil des Oeuvres de Nicolas Pineau*, pl. 5.

11 Nocq, *Poinçon de Paris*, 3:252–53.

12 Cauvet's designs for vases, which use these motifs, can be seen in Panier, *Recueil de Vases*.

13 Bimbenet-Privat and de Fontaines, *Datation de L'orfèvrerie Parisienne*, pp. 63–64.

14 *Enciclopedia Italiana* (Rome: Gioivanni Treccani, 1935–43), 27:69–70. This tureen is 1 of at least 4. One is in the Toledo Museum of Art; see *Toledo Treasures* (Toledo, Ohio: By the museum, 1995), p. 112; another is in the Gulbenkian Museum in Lisbon, Portugal; see Ferreira, "L'argenterie Gulbenkian," pp. 113, 178; another was offered by London silver dealer Frank Partridge; see "Silver at Partridge" (advertising circular) (London, October 1997), pp. 36–38.

15 Nocq, *Poinçon de Paris*, 1:314.

16 Percier's designs are pictured in *Desseins d'orfèverie de Percier*, pls. 7, 11; and Percier and Fontaine, *Recueil des Décorations Intérieures*, pl. 22, fig. 1. The Biennais and Auguste tureens are pictured in Dennis, *Three Centuries of French Domestic Silver*, 1:32, 33, 76.

17 The Paris standard established pure silver at 12 deniers, with 24 grains in 1 denier. Silver used in household artifacts, like this tureen, had to have 11 deniers and 8 grains of silver in their alloy to meet the minimum accepted standard, the equivalent of 94.45% pure. The mate to this tureen was offered at Sotheby's, London, February 5, 1970, lot 70.

18 Rosenberg, *Goldschmiede Merkzeichen*, 2:43.

19 Hogarth, *Analysis of Beauty*, pp. 50–51.

20 The mate to this tureen is pictured in Munthe, *Falk Simons Silversamling*, a

catalogue of a collection in Göteborg, Swed., pl. 172, no. 585. It is now owned by the Röhsska Museet in Göteborg.

21 This tureen, its mate, and 2 others en suite are shown in a 1904 photograph of the German Court Silver Chamber and discussed in Arnold, *Dresdner Hofsilber*, p. 19, fig. 9; see also Klaus Pechstein, *Deutsche Goldschmiedekunst* (Berlin: Verlag Willmuth Arenhövel, 1987), pp. 178, 179.

22 Grimwade, *London Goldsmiths*, pp. 703–4.

23 Fewer than 2 dozen English écuelles are known. Only 2 sets of English-made pairs are recorded: those illustrated here and another pair in the Ashmolean Museum, made by Isaac Liger in London in 1726. On the use of the scallop shell, see Mauriès, *Coquillages et Rocailles*. The Plot écuelle is illustrated in Dennis, *Three Centuries of French Domestic Silver*, 1:188, fig. 280.

24 The firm advertised the écuelles in *Antiques* 97, no. 2 (February 1970): 231.

25 Phillips, *Paul de Lamerie*, pp. 1, 15.

26 Van Somer was born in Holland and worked in Paris before settling in London, where he spent the remainder of his career. His cartouche designs can be seen in Bowles, *Compleat Book of Ornaments*. A closely related tureen by de Lamerie was offered at Sotheby Parke Bernet, London, November 11, 1982, lot 24.

27 Hartop, *Huguenot Legacy*, p. 115.

28 Berain's designs for strapwork decoration appear in Berain, *Ornements inventez par I. Berain*. Closely related strapwork designs for silver were published by Parisian silversmith Masson, *Nouveaux Desseins*. Identical strapwork

appears on a tureen made in London about 1726 by Simon Pantin, pictured in Jones, *Old English Plate*, pl. 39.

29 The Public Record Office in London owns the delivery book of the Jewel House, which records the issuance of silver to royal ambassadors and other representatives who were expected to entertain on the king's behalf. The page documenting delivery of this tureen to Lord Fitzwalter is pictured in Hartop, *Huguenot Legacy*, p. 112. This tureen's mate is pictured on p. 111.

30 Grimwade, *London Goldsmiths*, p. 501.

31 *Book of the Household*, 2:160. The best-known tureens depicting lobsters and boars are French. Thomas Germain made a pair for a member of the French royal family (part of the so-called Penthièvre-Orléans service) in 1733, and Juste-Aurèle Meissonier designed a pair for Evelyn Pierrepont, second duke of Kingston, between 1735 and 1740.

32 *Flower-Garden Display'd*, title page.

33 The specific individuals recorded in this coat of arms have not yet been identified, but the families were located in Wiltshire, Eng.; see Howard, *Chinese Armorial Porcelain*, p. 168.

34 Holme, *Academy of Armory*, vol. 1, bk. 2, p. 49.

35 Further work needs to be done to determine the identity of the owner of these arms. The engraving appears to be relatively recent, possibly in place of an earlier coat of arms.

36 Grimwade, *London Goldsmiths*, pp. 425, 596.

37 Marot's designs for the 4 seasons appear in *Werken van D. Marot*, pl. 19.

38 In 1770 Dawson married Miss Philadelphia Hannah Freame, granddaughter of William Penn.

39 Grimwade, *London Goldsmiths*, p. 523.

40 Identical handles appear on a tureen made by William Cripps in 1754 (Sotheby's, London, October 23, 1968, lot 135). More fully developed examples are present on a tureen made by George Wickes in 1739 (Sotheby's, London, July 1, 1970, lot 82) and one made by Edward Wakelin in 1757 (Sotheby's, London, July 27, 1977, lot 179).

41 Grimwade, *London Goldsmiths*, pp. 542–43.

42 *Book of the Household*, 2:251.

43 *Book of Ornaments*, pl. 8. The trade card is illustrated in Heal, *London Goldsmiths*, pl. 38.

44 David S. Howard, authority on English armorial material, to Donald L. Fennimore, May 29, 1998, object folder, Registration Office, Winterthur.

45 Burns, *Old Scottish Communion Plate*, pp. 564, 566.

46 A pair of ladles, virtually identical and bearing the mark of Peter Archambo I, is illustrated in Pickford, *Silver Flatware*, p. 193, fig. 340.

47 Sotheby's, New Bond Street, London, March 4, 1965, lot 56. *The Connoisseur* 161, no. 650 (April 1996): 33.

48 As quoted in Baker, "Patrick Robertson's Tea Urn," p. 290. Brigitte Winsor, Archives Dept., Birmingham City Library,

to Donald L. Fennimore, March 10, 1998, object folder, Registration Office, Winterthur.

49 Sotheby's, New Bond Street, London, March 4, 1965, lot 56. An advertisement appeared in *The Connoisseur* 161, no. 650 (April 1966): 33.

50 Grimwalde, *London Goldsmiths*, p. 589.

51 *Collection of Etruscan, Greek, and Roman Antiquities*, 1:xviii.

52 Maggie McKean, Collections Officer, Tatton Park, Knutsford, Cheshire, Eng., to Donald L. Fennimore, January 26, 1998, object folder, Registration Office, Winterthur.

53 This anomaly is explained in Bradbury, *History of Old Sheffield Plate*, pp. 425–40.

54 *Grocer's Companion*, p. 161.

55 The de Lamerie tureen is pictured and discussed in Christie's catalogue, London, July 9, 1997, lot 179. One fused plate turtle tureen each is pictured in Bradbury, *History of Old Sheffield Plate*, p. 389; Lowry Dale Kirby, "A Private Collection of Rare Sheffield Plate," *Antiques* 113, no. 1 (January 1978): 156; and an advertising brochure from S. J. Shrubsole, "Shrubsole" (New York, ca. 1997), p. 40. One is at Burghley House, Stamford, Eng. Another is at Weston Park Museum, Sheffield, Eng.

56 For a complete description of the process of making fused plate, see Bradbury, *History of Old Sheffield Plate*, pp. 11–12. The process was replaced by electroplating in the late 1830s.

57 Penzer, *Paul Storr*, pp. 51–65.

58 Hope, *Household Furniture*, pp. 9, 7. Both motifs are illustrated on pls. 49 and 52.

59 The mate to this tureen was offered by Christie's, New York, November 2, 1977, lot 151, from the estate of Elinor Dorrance Ingersoll.

60 Penzer, *Paul Storr*, pp. 51–65.

61 Sheraton, *Cabinet Dictionary*, 2:330–31. A closely related pair of tureens made by Storr in 1810 for Benjamin Hall and his wife, Charlotte Crawshay, is pictured in Christie's catalogue, London, June 23, 1971, lot 38.

62 John Alderson's trade card is pictured in Cotterell, *Old Pewter*, p. 69, pl. 7, fig. 1, and illustrates a pewter tureen similar to this one.

63 Hibbert, *George IV*, p. 195.

64 *The Observer* (London), July 30, 1821. Other pieces from this service are pictured in *Short History of the Worshipful Company of Pewterers*, p. 91.

65 Copper was the traditional alloying agent in pewter, but antimony became an important adjunct and even substitute during the eighteenth and nineteenth centuries.

66 Gere, Culme, and Summers, *Garrard*, p. 5; Pezner, *Paul Storr*, p. 63. One pair is illustrated in Christie's catalogue, London, June 25, 1958, lot 24; the second is in Christie's catalogue, Geneva, April 27, 1976, lot 196; the third is in Sotheby's catalogue, New York, October 28, 1988, lot 218.

67 A virtually identical example bearing Garrard's mark, dated 1827–28, is pictured and discussed in Bliss, *Jerome and Rita Gans Collection*, pp. 204–7.

68 Pezner, *Paul Storr*, pp. 67–79.

69 Sir William Hamilton to Charles Greville, January 2, 1776, quoted in Jenkins and Sloan, *Vases and Volcanoes*, p. 222.

70 Garrard and Co., *Royal Goldsmiths*, pp. 11, 28–29.

71 Grimwade, *London Goldsmiths*, pp. 519–20.

72 Cartier and Cartier, "Elie Pacot Surtout," pp. 296–301. Pacot was inspired by the designs of le Sieur Masson, which were published under the title *Nouveaux Desseins pour graver sur l'orfèverie* in Paris about 1700. Christie, Manson, and Woods, London, April 9, 10, 1829, lots 22–33. Sotheby's, Geneva, May 13, 1991, lot 118. A similar, though much more fully developed tureen of this style, marked in 1839 by Garrard, is pictured in Sotheby's catalogue, London, July 18, 1968, lot 207.

73 The engraved crests and perhaps the arms were added sometime after 1877, when the son assumed the surname McGarel.

74 The Auguste tureen is pictured in Sotheby Parke Bernet catalogue, Monaco, November 30, 1975, lot 85.

75 The mate is pictured in den Blaauwen, *Nederlands zilver*, pp. 290–91.

76 Bargoni, *Mastri orafi e argentieri*, p. 185.

77 Bargoni, *Mastri orafi e argentieri*, pp. 28–29.

78 Anderson, *Arte de la Platería*, 1:177–89. Martin, *Marcas de Platería*, p. xvii.

79 A related pair of tureens made in Madrid is pictured in Fernández, Munoa, and Rabasco, *Enciclopedia de la Plata española*, p. 356.

80 De la Cueva was the principal assayer in Mexico City between 1733 and 1778. The first 3 marks are recorded in Martin, *Marcas de Platería*, p. 50. The mark for Cádiz is illustrated in Fernández, Munoa, and Rabasco, *Enciclopedia de la Plata española*, p. 121.

81 *The Connoisseur* 164, no. 662 (April 1967): 55.

82 Von Solodkoff, *Russian Gold and Silverwork*, p. 35.

83 The motto actually reads "Ea liberté," likely a misspelling; other inconsistencies in the iconography of the coat of arms suggest that the engraver was working from a small or indistinct original.

84 In this instance the purity of the alloy is 80 zolotniki, equal to 83.3% silver. Two of this tureen's mates have been identified in England: see Christie's catalogue, London, June 22, 1843, lot 36, and Christie's catalogue, London, March 27, 1985, lot 206.

85 Most of these objects are listed in French, *Jacob Hurd and His Sons*, p. 53.

86 One other American soup ladle could vie for being the earliest. It was made by Philip Syng Jr. of Philadelphia, active between 1726 and 1789; it is pictured in Prime, *Three Centuries of Historic Silver*, p. 166, fig. 102.

87 Revere also made 7 punch ladles, which are recorded in his daybooks, Massachusetts Historical Society, Boston.

88 Federhen, "From Artisan to Entrepreneur," p. 85. For a closely related fused-plate ladle, see Bradbury, *History of Old Sheffield Plate*, p. 336.

89 All these forms are recorded in the Decorative Arts Photographic Collection at Winterthur.

90 A closely related example made in Paris about 1800 by Jean-Baptiste-Claude Odiot and owned by Robert M. Smith (1757–1842), secretary of state for the United States between 1809 and 1811, is pictured in Conger, *Treasures of State*, p. 353. A silver-plated example made in Paris at the same time by le Sieur Levrat is pictured in object folder, Registration Office, Winterthur. On Olive and other merchant/importers, see *Independent Journal; or, The General Advertiser* (New York), August 4, 1784, New-York Historical Society.

91 There are several branches of the Ball family in America. The best known is the Virginia branch, whose motto is *Coelum tueri* (look upward). There was also the Connecticut branch, with the motto *Semper cavete* (always be cautious). This variant probably belongs to the New York branch, as detailed in "George Washington and William Ball," *Union Record* (Keuka College, N.Y.), vol. 2, no. 2 (March 1903): 45, 46.

92 The mate was published in Miller, *Silver by New York Makers*, p. 37, no. 370. In addition to the coat of arms and motto, that tureen is engraved with the initials "WPL."

93 For more on the DuBois brothers, see Laidlaw, "Silver by the Dozen," pp. 25–50.

94 Laidlaw, "Silver by the Dozen," p. 34. Teunis D. DuBois account book, 1794–1816, Monmouth County Historical Association, Freehold, N.J.

95 See the following catalogues: Christie's, London, July 3, 1966, lot 82; Sotheby's, London, November 28, 1968, lot 310; and Sotheby's, London, January 23, 1964, lot 40.

96 The meaning of the spread eagle is presently unknown; however, numerous New York State silversmiths used a variety of secondary marks during the early to mid nineteenth century. These probably served as indicators of where and when an object was made and its purity.

97 *Boston City Directory* (Boston: George Adams, 1849), adv. supp., p. 4.

98 *Boston City Directory*, p. 336. Jones, Ball and Poor also commissioned silversmiths outside Boston to fabricate their wares, as evidenced by a pitcher that survives stamped with their names and that of the New York manufacturing firm of Woodward and Grosjean, on file in the Decorative Arts Photographic Collection at Winterthur.

99 This vase, an interpretation of the celebrated Warwick Vase, is owned by the Boston Public Library and is illustrated in Fales, *Early American Silver*, p. 119, fig. 116.

100 *Cincinnati Graphic News* (1884), as quoted in Beckman, *Cincinnati Silversmiths*, p. 53.

101 A full presentation of silver flatware in the medallion pattern is found in Soeffing, *Silver Medallion Flatware*, pp. 11–21.

102 Ayers, Impey, and Mallet, *Porcelain for Palaces*, p. 204.

103 Schmidt, *Early European Porcelain*, p. 55, pl. 13.

104 For similar decoration, see Haywood, *Viennese Porcelain*, pl. 16b; and Le Corbeiller, *China Trade Porcelain*, p. 58. On Danhöffer, see Haywood, *Viennese Porcelain*, pp. 201, 204, pls. 7b, 16b.

105 See No. 38.

106 Mrazek and Neuwirth, *Wiener Porzellan*, pp. 102–3, pl. 188.

107 Harrison-Hall, "Ding and Other Whitewares," p. 182.

108 See No. 47.

109 See No. 48.

110 Howard and Ayers, *China for the West*, p. 329.

111 Sargent, *Copeland Collection*, pp. 98–99.

112 For a tureen with a floral medallion painted on the Buddha's abdomen, see Beurdeley, *Chinese Trade Porcelain*, p. 162.

113 Howard, *Chinese Armorial Porcelain*, p. 616.

114 The identification of this animal as a water buffalo was confirmed in a letter from Frederick A. Ulmer, Curator of Mammals, Philadelphia Zoological Gardens, to the Campbell Museum, February 3, 1971, object folder, Registration Office, Winterthur.

115 Jörg, *Porcelain and the Dutch China Trade*, p. 190.

116 Howard and Ayers, *China for the West*, pp. 540–43.

117 Others in existence: tureen and stand, Espirito Santo Collection, Lisbon (see Beurdeley, *Chinese Trade Porcelain*, pl. 10); tureen and stand, Peabody Essex Museum, Salem, Mass. (see Sotheby's, Monaco, March 5, 1989, lot 427); pair of tureens and stands, with arms of Marliave and Fieubert of Languedoc (see Sotheby's, Monaco, June 23, 1985, lot 627); tureen (see *The Golden Age of China Trade Porcelain* [New York: Chinese Porcelain Co., 1994], pp. 64–65). On the Jacques Roëttiers tureen, see Davis, *French Silver*, pl. 56; Sotheby's, New York, June 16, 1960. On the Nicolas Roëttiers tureen, see Beurdeley, *Chinese Trade Porcelain*, p. 50, pl. 10.

118 Information about the tureen from Dr. Eugénio Andrea da Cuhna e Freitas of Portugal and a translation of details supplied about the Sobral family can be found in a letter from Robert C. Smith, Professor of Art History, University of Pennsylvania, to the Campbell Museum, September 16, 1971, object folder, Registration Office, Winterthur.

119 *Chinese Porcelain and the Heraldry of the Empire*, trans. Ana Madeira (Oporto, Port.: Civilizaçāo, 1988), pp. 136–44.

120 The service is illustrated in Dorman, *Captain Richard Dale*, fig. 5; a similar oval dish in the service is illustrated and discussed in Howard and Ayers, *China for the West*, p. 516. On Dale, see Johnson and D. Malone, eds., *Dictionary of American Biography* (New York: Charles Scribner's Sons, 1930).

121 Dorman, *Captain Richard Dale*.

122 Howard and Ayers, *China for the West*, p. 516.

123 Savill, *Wallace Collection*, p. 996; Peters, *Decorator and Date Marks*; the reference to Peters was kindly supplied by Letitia Roberts.

124 For details of early tureen models and extant examples, see Savill, *Wallace Collection*, pp. 736–37.

125 Eriksen and de Bellaigue, *Sèvres Porcelain*, p. 52.

126 Savill, *Wallace Collection*, pp. 1083, 1099.

127 Savill, *Wallace Collection*, pp. 643, 646–47.

128 Dauterman, *Sèvres Porcelain*, pp. 190–91.

129 Savill, *Wallace Collection*, p. 594. Dauterman, *Sèvres Porcelain*, p. 350, fig. 6.

130 The companion tureens are illustrated in de Villechenon, *Sèvres*, p. 136, and Préaud, *Sèvres Porcelain*, p. 70.

131 Böttger luster is named after Johann Friedrich Böttger, the Meissen factory administrator who developed the hard-paste porcelain body and introduced this decoration.

132 See den Blaauwen, "Keramik mit Chinoiserien." I thank Sheila K. Tabakoff for bringing this reference, the Codex reference, and the Englebrecht connection to my attention.

133 Allen, *Eighteenth-Century Meissen Porcelain*, p. 66; for a similar tureen, see Wark and Gristina, *Wark Collection*, pp. 200–201, no. 420.

134 Jenyns, *Japanese Porcelain*, pl. 77A.

135 Pazaurek, *Deutsche Fayence*, pl. 290, 334; Honey, *European Ceramic Art*, 2:224.

136 Allen, *Eighteenth-Century Meissen Porcelain*, p. 133; Syz, Miller, and Rückert, *Hans Syz Collection*, pp. 357–58.

137 Allen, *Eighteenth-Century Meissen Porcelain*, p. 133; Syz, Miller, and Rückert, *Hans Syz Collection*, pp. 357–58.

138 For a similar spoon, see Allen, *Eighteenth-Century Meissen Porcelain*, p. 140.

139 Information on the coat of arms was supplied by Victor Franco de Baux, a European heraldry consultant in London.

140 *Selections from the Campbell Museum Collection* 1983, no. 96; Wark and Gristina, *Wark Collection*, p. 229.

141 Allen, *Eighteenth-Century Meissen Porcelain*, pp. 98, 160.

142 Translation from the journal quotation was supplied to the Campbell Museum by William Haitian of the Victoria and Albert Museum, London, May 27, 1971.

143 Many pieces from this service exist; see Ziffer, *Nymphenburger Porzellan*, pp. 133–35.

144 Baer, *Along the Royal Road*, pp. 141–43.

145 Adams and Redstone, *Bow Porcelain*, pp. 16–17, 62.

146 Newman, "Rare Chelsea Adaptation," pp. 272–73; Newman, "English Adaptations," p. 113.

147 Branyan, French, and Sandon, *Worcester Blue and White Porcelain*, p. 159.

148 Branyan, French, and Sandon, *Worcester Blue and White Porcelain*, pp. 169, 288, 292.

149 Wills, "Worcester Blue and White," p. 254.

150 Branyan, French, and Sandon, *Worcester Blue and White Porcelain*, pp. 50–51. Watney, *English Blue and White Porcelain*, pl. b.

151 It is not generally known that at this time the collection was owned by Herbert Eccles, who had purchased it from Drane's estate. This information is courtesy of Jonathan Gray.

152 For a similar form with different decoration, see No. 76.

153 Spero and Sandon, *Worcester Porcelain*, pp. 184, 309–10, suggest that twig and flower handles might have been the work of factory modeler John Toulouse.

154 The provenance of the earl of Dudley cannot be confirmed. A Christie's catalogue for the sale of "The Splendid Collection of Old Porcelain formed by the Right Honorable the Late Earl of Dudley," May 21, 1886, contained no Worcester porcelain.

155 For a similar tureen with a different decoration, see No. 75.

156 Spero and Sandon, *Worcester Porcelain*, pp. 184, 309–10.

157 Covered bowls of this shape without a handle are more common and are generally referred to as sugar bowls.

158 Sandon, *Dictionary of Worcester Porcelain*, p. 273.

159 The garniture of 3 vases was given to George Washington by Samuel Vaughan in 1770. For a discussion of O'Neale, see Adams, *Chelsea Porcelain*.

160 See No. 12.

161 See Francis Barlow, *Aesop's Fables* (1687), pp. 129, 131. Honey, *European Ceramic Art*, p. 57.

162 Other Chelsea examples may be found in the British Museum collection and at the Fine Arts Museums of San Francisco (acc. no. 1945.581 a–b).

163 Other examples of this tureen may be seen in the Cecil Higgins Museum, Bedford, Eng. (no dish); Victoria and Albert Museum; Fitzwilliam Museum, Cambridge, Eng. (with sunflower dish); Museum of Fine Arts, Boston (with sunflower dish). For the Meissen examples, see Walcha, *Meissen Porcelain*, pl. 177; and Rückert, *Meissener Porzellan-Sammlung*, pl. 278, no. 1131. For the earthenware example, see Williams and Halfpenny, *Passion for Pottery*, p. x.

164 On the exhibition, see Mackenna, *Chelsea Porcelain*, p. 16; however, I have been unable to verify the facts of the exhibition from other sources (Amor's records no longer exist). On the queen's collection, see *Treasures from the Royal Collection*, p. 112.

165 Nightingale, *Contributions*, p. lvii.

166 Bimpson, Ainslie, and Watney, "West Pans Story," pp. 167–76.

167 Holdaway, "Moulded Porcelain Wares," pp. 22–34; Barker and Cole, *Archaeology of British Porcelain Factories*, pp. 35–39.

168 Examples of these types of handles have been found during excavations at Longton Hall. See No. 50. Barker and Cole, *Archaeology of British Porcelain Factories*, p. 39.

169 The panels may have been inspired by engravings from George Edwards's *Natural History of Uncommon Birds*. This book was published in 1743 and is known to have been used by the Chelsea and Derby porcelain manufactories.

170 See No. 75.

171 Holdaway, "Moulded Porcelain Wares," p. 27, fig. 9. Barker and Cole, *Archaeology of British Porcelain Factories*, p. 36.

172 Bradley, *Derby Porcelain*, p. 27.

173 Duesbury's partners at this time were John and Christopher Heath. The partnership was dissolved in 1779; see Bradshaw, *Derby Porcelain Figures*, p. 11.

174 Howard, *Chinese Armorial Porcelain*, pp. 46–47.

175 Howard, *Chinese Armorial Porcelain*, p. 586.

176 A single covered soup bowl is listed in the large Trapnell Collection; see Oxford, *Collection of Mr. Alfred Trapnell*, p. 56; see City Art Gallery, *Bristol Porcelain Bicentenary Exhibition*, p. 30, nos. 185, 186 for another example and for the companion piece to this one.

177 Lisci, *Porcellana di Doccia*, p. 49, pl. 33.

178 As quoted in Alice Wilson Frothingham, *Capodimonte and Buen Retiro Porcelain: Period of Charles III* (New York: Hispanic Society of America, 1955), pp. 2, 14. Le Corbeiller, *Eighteenth-Century Italian Porcelain*, p. 22.

179 A similar bowl in the Metropolitan Museum of Art is attributed to Doccia; see Le Corbeiller, *Eighteenth-Century Italian Porcelain*, pl. 8. See also No. 72.

180 Ayers, Impey, and Mallet, *Porcelain for Palaces*, p. 275.

181 See No. 65.

182 Ross, *Russian Porcelains*, pp. 75–76.

183 Ross, *Russian Porcelains*, p. 41.

184 Honey, *European Ceramic Art*, p. 98.

185 Tureens of this form are recorded in the collections of the Victoria and Albert Museum, London; Musée des Arts Décoratifs, Strasbourg; and Museum für Kunst und Gewerbe, Hamburg.

186 Giacometti, *French Faience*, p. 198; Lane, *French Faience*, pl. 67b; Sarah B. Sherrill, "Current and Coming," *Antiques* 99, no. 5 (May 1971): 622.

187 For an example of Tännich's work at Kiel, see No. 94.

188 Whitehead, *Designs for Sundry Articles*, no. 76; Towner, *Leeds Pottery*, no. 68; Grigsby, *Henry H. Weldon Collection*, p. 227.

189 Mountford, *Illustrated Guide*, pls. 63–64; Williams and Halfpenny, *Passion for Pottery*, p. x. Susan Gray Detweiler, *George Washington's Chinaware* (New York: Harry N. Abrams, 1982), pp. 200–201.

# Glossary

190 Noël Hume, "Rise and Fall of English White Salt-Glazed Stoneware," pp. 24–29.

191 Direct comparison was made with fragments at the City Museum and Art Gallery, Stoke-on-Trent; see also Barker, *William Greatbatch*, pp. 255–58, for Greatbatch cauliflower wares.

192 Reilly, *Wedgwood*, 1:333, pl. 427.

193 The patterns are listed in the factory's first pattern book as "Running Heath" and were available in different colors; see Reilly, *Wedgwood*, 1:285, pl. 338e.

194 Reilly, *Wedgwood*, 1:285–86, 329, pl. 338f.

195 Wedgwood archives E45 – 29107, courtesy Trustees of the Wedgwood Museum. On the duke of Clarence order, see Wedgwood, *Wedgwood in London*, p. 43.

196 Maureen Batkin, *Wedgwood Ceramics, 1846–1959* (London: Richard Dennis, 1982), pp. 89–93.

197 *Selections from the Campbell Museum Collection* 1983, no. 62.

198 Rates were a tax on property; the records usually list owners and occupiers.

199 Jörg, *Interaction in Ceramics*, p. 164.

200 Archer and Hickey, *Irish Delftware*, pp. 12–20, 41–45.

201 Archer, *Delftware*, pp. 178–79.

202 For a discussion of similar tureen and stands, see Archer, *Delftware*, pp. 339–41.

203 Ayers, Impey, and Mallet, *Porcelain for Palaces*, p. 236.

204 Shirley Dawson, "Bill Stewart," *Ceramics Monthly* (April 1995): 50.

## METALWORK

**ACANTHUS**
a prickly, spiky-leaved herb native to the Mediterranean area that has long been adapted as decoration on man-made objects

**ANTHEMION**
a stylized representation of a honeysuckle flower

**BANNOCK RACK**
used to hold flat circular pieces of unleavened bread after their removal from the griddle

**BEZEL**
the inside rim of the cover or lid of an object

**BRIGHT-CUT ENGRAVING**
small engraved facets that create a sparkling, glittering effect

**CARTOUCHE**
an ornate or ornamental frame that surrounds a coat of arms, initials, inscription, or pictorial element

**CARYATID**
a column in the form of a standing female figure

**CHASING**
indented decoration on metalwork created with a hammer and punches

**CHIMERA**
a mythological animal with a lion's head, goat's body, and serpent's tail

**CUT-CARD WORK**
a method of decorating silver by soldering shaped patterns, cut from flat sheets of silver, to the surface of an object

**CYMA RECTA**
an S-shape molding, concave at the top and convex at the bottom

**CYMA REVERSA**
an S-shape molding, convex at the top and concave at the bottom

**DIE ROLL**
to make an embossed decoration in a rolling mill

**DREDGER**
a container with a perforated lid, used to sprinkle flour or spices over food

GLOSSARY

**FUNT**
Russian weight equivalent of one Troy pound

**GADROONING**
an ornamental border of straight or curved segments, usually tapered, sometimes with alternating convex and concave profiles

**GRIFFIN**
a mythological animal with a lion's body and eagle's head and wings

**IMBRICATE**
to decorate the surface of an object with a repetitive overlapping pattern, like fish scales

**LÖTIGEM**
German term used to identify the purity of silver

**MERCURY GILDING PROCESS**
method of applying gold to a silver object by using mercury

**METOPE**
the space between triglyphs in an architectural frieze

**MONOPOD**
an ornamental figure with only one foot

**ORMOLU**
brass and bronze gilded by the mercury-gilding process; term also loosely applied to all gilt-bronze and gilt-brass objects, including those dipped in acid and lacquered

**PARCEL GILT**
partially gilded

**PIPKIN**
a saucepan

**REEDING**
a form of ornament consisting of slender, convex parallel lines that abut each other

**REPOUSSÉ**
the type of raised decoration on the surface of metalwork, made using a hammer and punches

**STRAPWORK**
a type of decoration consisting of plain and/or ornamental vertical strips that are applied to the surface of an object

**TOILET SET**
a matched group of personal grooming objects (usually of silver, silver-gilt, or gilt brass) that come in a fitted box for travel

**TRIGLYPH**
part of the architectural frieze in the Doric order that consists of two vertical channels alternating with three fillets, or flat bands

**VOLUTE**
a spiral scroll

**WROUGHT**
to make a metal object by hammering it to shape

**ZOLOTNIK**
Russian weight equivalent of one Troy ounce

## CERAMICS

**ACANTHUS**
(see Metalwork Glossary)

**ANTHEMION**
(see Metalwork Glossary)

**BISCUIT**
an unglazed ceramic body that has been fired once in a kiln

**BODY**
the raw materials that form a piece of pottery

**CAMAÏEU**
monochrome painting in various tones on porcelain, pottery, and enamel

**CARTOUCHE**
(see Metalwork Glossary)

**CARYATID**
(see Metalwork Glossary)

**CREAMWARE**
(also queensware, cream-colored earthenware) earthenware made from white ball-clay and flint, coated with a transparent lead glaze that is naturally contaminated with iron, producing a honey-color tint; first made in Staffordshire in the 1740s

**HARD-PASTE PORCELAIN**
a translucent ceramic made from china clay (kaolin) and china stone (petuntse) fired at a comparatively high temperature (about 1350–1400°C)

**ORMOLU**
(see Metalwork Glossary)

**PEARLWARE**
earthenware made from white ball-clay and flint, coated with a transparent lead glaze containing a small amount of cobalt, producing a white or gray-blue tint; first made in Staffordshire about 1775

**PRESS MOLDING**
forming a ceramic object by pressing thin sheets of clay over, or into, a mold

**SALT-GLAZED STONEWARE**
vitreous pottery that is glazed by putting salt into the oven at the height of firing. The salt vaporizes; sodium from the salt combines with alumina and silica in the clay to form a kind of soda glass on the surface. The resultant pottery is very hard and serviceable; it is characterized by a surface texture that resembles orange peel.

**SLIP CASTING**
forming a ceramic object by pouring liquid clay (slip) into an absorbent mold. As water from the slip is absorbed, a layer of clay is formed on the inside wall of the mold. When the clay reaches the desired thickness, the excess slip is poured away. The mold is opened to reveal the cast form.

**SOFT-PASTE PORCELAIN**
a translucent ceramic made in imitation of hard-paste porcelain using white clay and a variety of other materials such as soapstone or ground glass fired at a comparatively low temperature (about 1100°C)

**STRAPWORK**
(see Metalwork Glossary)

**THROWING**
forming a ceramic object using a potter's wheel

**TIN-GLAZED EARTHENWARE**
(also faience, maiolica, delftware) earthenware with lead glaze that is made white and opaque by the addition of tin oxide

**UNDERGLAZE-BLUE TRANSFER PRINTING**
printed decoration that is applied to a ceramic object by means of thin paper. Colored oil (cobalt and linseed oil) is printed onto tissue paper that is rubbed into a porous body, and the paper washes away. When heated, the oil evaporates, leaving the color behind. The decoration is sealed under a layer of glaze.

# *Bibliography*

**METALWORK**

Ackermann, Rudolph. *Selections of Ornaments in Forty Pages for the Use of Sculptors, Painters, Carvers, Modellers...* London: R. Ackermann's Lithographic Press, 1818.

Anderson, Lawrence. *El Arte de la Platería en Mexico, 1519–1936.* 2 vols. New York: Oxford University Press, 1941.

Arnold, Ulli. *Dresdner Hofsilber des 18. Jahrunderts.* Berlin and Dresden: KulturStiftung der Lander Bundesrepublik Deutschland, 1994.

Baker, Malcom. "Patrick Robertson's Tea Urn and the Late Eighteenth-Century Edinburgh Silver Trade." *The Connoisseur* 183, no. 738 (August 1973): 289–94.

Banister, Judith. "Silver Soup Tureens from the Campbell Collection." *The Antique Dealer and Collector's Guide* (September 1973): 102–5.

Bargoni, Augusto. *Mastri orafi e argentieri in Piemonte.* Turin: Biblioteca di Studi Piemontesi, 1976.

Baumstark, Reinhold, and Helmut Seling. *Silber und Gold.* Munich: Hirmer Verlag, 1994.

Beckman, Elisabeth D. *Cincinnati Silversmiths, Jewelers, Watch and Clockmakers.* Cincinnati: B. B. and Co., 1975.

Berain, Jean. *Ornements inventez par I. Berain.* Paris, 1710.

Bimbenet-Privat, Michèle, and Gabriel de Fontaines. *La Datation de L'orfèvrerie Parisienne sous L'ancien Régime.* Paris: Commission des travaux historiques de la Ville de Paris, 1995.

Bliss, Joseph R. *The Jerome and Rita Gans Collection of English Silver on Loan to the Virginia Museum of Fine Art.* New York: ARN Publishing Co., 1992.

*The Book of the Household.* 2 vols. London: London Printing and Publishing Co., ca. 1870.

*A Book of Ornaments Containing Divers Elegant Designs for the Use of Goldsmiths, Chasers, Carvers...* London: Printed for Thomas Bowles, n.d.

Bowles, Thomas A. *Compleat Book of Ornaments.* London, ca. 1740.

Bradbury, Frederick. *History of Old Sheffield Plate.* London: Macmillan, 1912.

Braun, Edmund Wilhelm. *Das Tafelsilber des Herzogs Albert von Sachsen-Teschen.* Vienna: Verlag Anton Schroll, 1910.

Buhler, Kathryn C. "Silver Tureens in the Campbell Museum Collection." *Antiques* 97, no. 6 (June 1970): 904–9.

Bulgari, Costantino G. *Argentieri, Gemmari, E Orafi d'Italia.* 2 vols. Rome: Lorenzo Del Turco, 1958.

Burns, Thomas. *Old Scottish Communion Plate.* Edinburgh: R and R Clark, 1892.

Cartier, Nicole, and Isabelle Cartier. "The Elie Pacot Surtout." *Silver Society Journal*, no. 6 (Winter 1994): 296–301.

Clayton, Michael. *The Collector's Dictionary of Silver and Gold of Great Britain and North America.* London: Country Life Books, 1971.

*Collection of Etruscan, Greek, and Roman Antiquities from the Cabinet of the Honourable William Hamilton.* 4 vols. Naples: F. Morelli, 1766–67.

Conger, Clement E., et al. *Treasures of State.* New York: Harry N. Abrams, 1991.

Cotterell, Howard H. *Old Pewter: Its Makers and Marks.* London: B. T. Batsford, 1929.

Culme, John. *Nineteenth-Century Silver.* London: Country Life Books, 1977.

den Blaauwen, A. L. *Nederlands zilver.* s'Gravenhage, Holland: Rijksmuseum, 1979.

Dennis, Faith. *Three Centuries of French Domestic Silver.* 2 vols. New York: Metropolitan Museum of Art, 1960.

*Desseins d'orfèvrerie de Percier.* Paris: E. Hessling, n.d.

Fales, Martha Gandy. *Early American Silver.* New York: E. P. Dutton, 1973.

Federhen, Deborah A. "From Artist to Entrepreneur: Paul Revere's Silver Shop Operation." In *Paul Revere: Artisan, Businessman, and Patriot,* compiled by Nina Zannieri. Boston: Paul Revere Memorial Assoc., 1988.

Fernández, Alejandro, Rafael Munoa, and Jorge Rabasco. *Enciclopedia de la Plata española y Virreinal americana*. Madrid: Edición de los autores, 1984.

Ferreira, Maria-Teresa Gomes. "L'argenterie Gulbenkian." *Connaissance des Arts*, no. 226 (December 1970): 106–115, 177, 178.

*The Flower-Garden Display'd*. London: Printed for J. Hazard, R. Montague, W. Bickerton, and R. Chandler, 1732.

Forrer, Robert. *Les Étains de la Collection Alfred Ritling a Strasbourg*. Strasbourg, Fr.: Édition de la Revue Alsacienne Illustrée, 1905.

Fox-Davies, Arthur Charles. *Fairbairn's Book of Crests*. Edinburgh: T. C. and E. C. Jack, 1892.

French, Hollis. *Jacob Hurd and His Sons, Nathaniel and Benjamin, Silversmiths, 1702–81*. Cambridge: Walpole Society, 1939.

Gans, M. H., and Th. M. Duyvené de Wit-Klinkhamer. *Dutch Silver*. London: Faber and Faber, 1961.

Garrard and Co. *Royal Goldsmiths: The Garrard Heritage*. London: By the company, 1991.

Gere, Charlotte, and John Culme, with William Summers. *Garrard: The Crown Jewellers for 150 Years, 1843–1993*. London: Quartet Books, 1993.

Grimwade, Arthur G. *London Goldsmiths, 1679–1837*. London: Faber and Faber, 1976.

*The Grocer's Companion*. Boston: Benjamin Johnson, 1883.

Halfpenny, Patricia A. "High Style, Fashionable Taste: The Campbell Collection of Soup Tureens at Winterthur." *Delaware Antiques Show Catalogue* (November 1997): 53–57.

Hammerslough, Philip H. *American Silver Collected by Philip H. Hammerslough*. 4 vols. Hartford, Conn.: Privately printed, 1960.

Hare, Susan, ed. *Paul de Lamerie: At the Sign of the Golden Ball*. London: Goldsmiths' Co., 1989.

Hartop, Christopher. *The Huguenot Legacy: English Silver, 1680–1760, from the Alan and Simone Hartman Collection*. London: Thomas Heneage, 1996.

Heal, Ambrose. *The London Goldsmiths, 1200–1800*. Cambridge, Eng.: University of Cambridge Press, 1935.

Helft, Jacques. *French Master Gold- and Silversmiths*. New York: French and European Publications, 1966.

Hibbert, Christopher. *George IV, Regent and King, 1811–1830*. New York: Harper and Row, 1973.

Hodgson, Beulah D. "Soup … Soup … Beautiful Soup Tureens." *Silver* 13, no. 2 (March–April 1980): 6–9.

Hogarth, William. *The Analysis of Beauty*. London, 1753.

Holme, Randle. *The Academy of Armory*. 2 vols. London, 1701.

Honour, Hugh. *Goldsmiths and Silversmiths*. London: Weidenfeld and Nicolson, 1971.

Hope, Thomas. *Household Furniture and Interior Decoration*. London: T. Bensley, 1807.

Howard, David S. *Chinese Armorial Porcelain*. London: Faber and Faber, 1974.

Jenkins, Ian, and Kim Sloan. *Vases and Volcanoes: Sir William Hamilton and His Collection*. London: British Museum Press, 1996.

Jones, E. Alfred. *The Old English Plate of the Emperor of Russia*. London: Privately printed, 1909.

Kimball, Fiske. *The Creation of the Rococo*. Philadelphia: Philadelphia Museum of Art, 1943.

Knight, Frederick. *Knight's Gems; or, Device Book*. London: J. Williams, 1836.

Laidlaw, Christine W. "Silver by the Dozen: The Wholesale Business of Teunis D. DuBois." *Winterthur Portfolio* 23, no. 1 (Spring 1988): 25–50.

Lever, Christopher. "Garrard and Co." *The Connoisseur* 186, no. 748 (June 1974): 94–99.

Lightbrown, R. W. *French Silver*. London: Her Majesty's Stationery Office, 1978.

Martin, Cristina Esteras. *Marcas de Platería Hispanoamericana*. Madrid: Ediciones Tuero, 1992.

Masson, le Sieur. *Nouveaux Desseins pour graver sur l'orfèvrerie*. Paris, ca. 1700.

Mauriès, Patrick. *Coquillages et Rocailles*. London: Thames and Hudson, 1994.

Ménard, René. *Histoire Artistique du Métal*. Paris: Société de Propagation des Livres d'Art, 1881.

Metman, Louis. *Le Musée des Arts Décoratifs: Le Métal*. 2 vols. Paris: Ateliers Photomécaniques D. A. Longuet, ca. 1880.

Miller, Isabelle V. *Silver by New York Makers*. New York: Women's Committee of the Museum of the City of New York, 1937.

Munthe, Gustaf. *Falk Simons Silversamling*. Stockholm: By the author, 1938.

Nocq, Henri. *Orfèvrerie Civile Française*. 2 vols. Paris: Éditions Albert Lévy, 1927.

———. *Le Poinçon de Paris*. 5 vols. Paris: Léon Laget, 1968.

Ottomeyer, Hans, and Peter Pröschel. *Vergoldete Bronzen*. Munich: Klinkhardt and Biermann, ca. 1986.

Panier, A. *Recueil de Vases de Differends Maitres*. Paris: Chez Bounet, ca. 1800.

Penzer, N. M. *Paul Storr: The Last of the Goldsmiths*. London: B. T. Batsford, 1954.

Percier, Charles, and Pierre F. L. Fontaine. *Recueil des Décorations Intérieures*. Paris, 1812.

Phillips, Philip A. S. *Paul de Lamerie: Citizen and Goldsmith of London*. London: Holland Press, 1968.

Pickford, Ian. *Silver Flatware: English, Irish, and Scottish, 1660–1980*. Woodbridge, Eng.: Antique Collectors' Club, 1983.

Prime, Alfred Coxe. *Three Centuries of Historic Silver*. Philadelphia: Pennsylvania Society of the Colonial Dames of America, 1938.

*Recueil des Oeuvres de Nicolas Pineau*. Paris: Edouard Rouveyere, 1889.

Rees, Abraham. *The Cyclopaedia; or, Universal Dictionary of Arts, Sciences, and Literature*. 41 vols. Philadelphia: Samuel T. Bradford, 1810–24.

Rosenberg, Marc. *Der Goldschmiede Merkzeichen*. 4 vols. Frankfurt: Frankfurter Verlags-Ansalt A. G., 1923.

Schroeder, Timothy. *The Gilbert Collection of Gold and Silver*. Los Angeles: Los Angeles County Museum of Art, 1988.

*Selections from the Campbell Museum Collection*. Camden, N.J.: By the museum, 1969. 2d ed., 1972; 3d ed., 1976; 4th ed., edited by John Francis Marion, 1978; 5th ed., edited by John Francis Marion, 1983; Reprint, 1992.

Sheraton, Thomas. *The Cabinet Dictionary*. London: W. Smith, 1803.

Sitwell, Major-General H. D. W. "The Jewel House and the Royal Goldsmiths." *The Archaeological Journal* 117 (May 1962): 131–55.

Soeffing, D. Albert. *Silver Medallion Flatware*. New York: New Books, 1988.

*La Table d'un Roi*. Paris: Musée dés Arts Décoratifs, 1987.

Tardy, le Sieur. *La Pendule Française*. 3 parts. Paris, 1961.

Taylor, Nora E. "The Campbell Collection." *National Antiques Review* 3, no. 9 (March 1973): 20–23.

Verlet, Pierre. *Les Bronzes Dorés Français du XVIIIe Siècle*. Paris: Picard, ca. 1987.

von Solodkoff, Alexander. *Russian Gold and Silverwork*. New York: Rizzoli, 1981.

Wanscher, Ole. *A. Michelsen og dansk Sølvsmedekunst*. Copenhagen: Fischers Forlag, 1941.

*Werken van D. Marot, Opperbuumeester van Zyne Maiesteit Willem Den Derden Koenig van Groot Britanje*. Amsterdam, ca. 1707.

Wills, Geoffrey. *Silver for Pleasure and Investment*. London: John Gifford, 1969.

Wollin, Nils G., ed. *Falk Simons Silversamling*. Göteborg, Swed.: Särtrcock ur Konsthantverkarnas Gilles Publikation, 1929.

Worshipful Company of Pewterers. *A Short History of the Worshipful Company of Pewterers in London and a Catalogue of Pewterers in Its Possession*. London: By the company, 1968.

## CERAMICS

Adams, Elizabeth. *Chelsea Porcelain*. London: Barrie and Jenkins, 1987.

Adams, Elizabeth, and David Redstone. *Bow Porcelain*. London: Faber and Faber, 1981.

Allen, Armin B. *Eighteenth-Century Meissen Porcelain from the Collection of Gertrude J. and Robert T. Anderson*. Orlando, Fla.: Orlando Museum of Art, 1988.

Archer, Michael. *Delftware: The Tin-Glazed Earthenware of the British Isles*. London: Victoria and Albert Museum, 1997.

Archer, Michael, and Patrick Hickey. *Irish Delftware*. Dublin: Castletown House, 1971.

Ayers, John, Oliver Impey, and J. V. G. Mallet. *Porcelain for Palaces: The Fashion for Japan in Europe, 1650–1750*. London: Oriental Ceramic Society, 1990.

Baer, Ilse, et al. *Along the Royal Road: Berlin and Potsdam in KPM Porcelain and Painting, 1815–1848*. New York: Bard Graduate Center for Studies in the Decorative Arts, 1993.

Barker, David. *William Greatbatch: A Staffordshire Potter*. London: Jonathan Horne, 1991.

Barker, David, and Sam Cole. *The Archaeology of Six Eighteenth-Century British Porcelain Factories*. Stoke-on-Trent: City Museum and Art Gallery, 1998.

Barrett, Franklin A. *Worcester Porcelain*. London: Faber and Faber, 1963.

Beurdeley, Michael. *Chinese Trade Porcelain*. Rutland, Vt.: Charles E. Tuttle, 1962.

Bimpson, Mavis, John Ainslie, and Bernard Watney. "The West Pans Story—The Scotland Manufactory." *Transactions* 6, pt. 2 (1966): 167–76.

Bradley, Gilbert. *Derby Porcelain, 1750–1798*. London: Thomas Heneage and Co., 1990.

Bradshaw, Peter. *Derby Porcelain Figures, 1750–1848*. London: Faber and Faber, 1990.

Branyan, Lawrence, Neal French, and John Sandon. *Worcester Blue and White Porcelain, 1751–1790*. London: Barrie and Jenkins, 1981.

City Art Gallery, *Bristol Porcelain Bicentenary Exhibition, 1770–1970*. Bristol, Eng.: By the gallery, 1970.

Dauterman, Carl C. "Porcelain in the Forsyth Wickes Collection." *Antiques* 94, no. 3 (September 1968): 344–54.

_____. *Sèvres Porcelain: Makers and Marks of the Eighteenth Century*. New York: Metropolitan Museum of Art, 1986.

Davis, Frank. *French Silver, 1450–1825*. New York: Praeger, 1970.

de Villechenon, Marie-Noëlle Pinot. *Sèvres: Une collection de porcelaines, 1740–1992*. Paris: Musée national de Céramique, 1993.

den Blaauwen, A. L. "Keramik mit Chinoiserien nach Stichen von Petrus Schenk, Jun." *Keramos* 31, no. 18 (1966).

De Young Museum, M. H. *Continental Table Porcelains of the Eighteenth Century.* San Francisco: By the museum, 1965.

Dorman, Charles G. *Captain Richard Dale at Canton.* Philadelphia: Independence National Historical Park, 1950.

Eriksen, Sven, and Geoffrey de Bellaigue. *Sèvres Porcelain: Vincennes and Sèvres, 1740–1800.* Boston: Faber and Faber, 1987.

Gardner, H. Bellamy. "Animals in Porcelain." *Transactions* 2 (1934): 17–21.

_____. "Chelsea Porcelain Rarities." *The Connoisseur* 110, no. 486 (December 1942): 126–29.

Giacometti, Jeanne. *French Faience.* London: Oldbourne Press, 1963.

Gordon, Horace W., and Elinor Gordon. *Oriental Lowestoft.* 3d ed. Villanova, Pa.: By the authors, 1963.

Grigsby, Leslie B. *The Henry H. Weldon Collection of English Pottery, 1650–1800.* London: Sotheby's Publications, 1990.

Grundy, C. Reginald. "Antique Art Treasures." *The Connoisseur* 90 (November 1932): 330.

Harrison-Hall, Jessica. "Ding and Other Whitewares of Northern China." In *Pottery in the Making: Ceramic Traditions,* edited by Ian Freestone and David Gaimster. London: British Museum, 1997.

Haywood, J. F. *Viennese Porcelain of the Du Paquier Period.* London: Rockliff, 1952.

Holdaway, Minnie. "Moulded Porcelain Wares Made by William Littler at West Pans." In *The Archaeology of Six Eighteenth-Century British Porcelain Factories.* Stoke-on-Trent: City Museum and Art Gallery, 1998.

Honey, William Bowyer. *European Ceramic Art from the End of the Middle Ages to about 1815: A Dictionary of Factories, Artists, Technical Terms et.* 2 vols. London: Faber and Faber, 1949.

_____. *Old English Porcelain: A Handbook for Collectors.* London: G. Bell and Sons, 1928.

Howard, David Sanctuary. *Chinese Armorial Porcelain.* London: Faber and Faber, 1974.

Howard, David Sanctuary, and John Ayers. *China for the West: Chinese Porcelain and Other Decorative Arts for Export Illustrated from the Mottahedeh Collection.* London: Sotheby Parke Bernet, 1978.

Jenyns, Soames. *Japanese Porcelain.* New York: Praeger, 1965.

Jörg, C. J. A. *Interaction in Ceramics: Oriental Porcelain and Delftware.* Hong Kong: Urban Council, 1984.

_____. *Porcelain and the Dutch China Trade.* The Hague: Martinus N. Jhoff, 1982.

Lane, Arthur. *French Faience.* London: Faber and Faber, 1948.

Le Corbeiller, Clare. *China Trade Porcelain: Patterns of Exchange.* New York: Metropolitan Museum of Art, 1974.

_____. *Eighteenth-Century Italian Porcelain.* New York: Metropolitan Museum of Art, 1985.

Lisci, Leonardo Ginori. *La Porcellana di Doccia.* Milan: Electra Editrice, 1963.

Mackenna, F. Severne. *Chelsea Porcelain: The Gold Anchor Wares.* Leigh-on-Sea, Eng.: F. Lewis, 1952.

_____. *Chelsea Porcelain: The Red Anchor Wares.* Leigh-on-Sea, Eng.: F. Lewis, 1951.

Mountford, Arnold. *The Illustrated Guide to Staffordshire Salt-Glazed Stoneware.* London: Barrie and Jenkins, 1971.

Mrazek, Wilhelm, and Waltraud Neuwirth. *Wiener Porzellan, 1718–1864.* Vienna: Österreichisches Museum, 1970.

Newman, Michael. "English Adaptations of an Early Meissen Basket." *The Antique Collector* 27 (June 1956): 113.

_____. "A Rare Chelsea Adaptation of an Early Meissen Basket." *The Antique Collector* 26 (December 1955): 272–73.

Nightingale, James Edward. *Contributions toward the History of Early English Porcelain.* 1881. Reprint, Yorkshire, Eng.: E. P. Publishing, 1973.

Noël-Hume, Ivor. "The Rise and Fall of English White Salt-Glazed Stoneware, Part II." *Antiques* 97, no. 3 (March 1970): 408–13. Reprint in *English Pottery and Porcelain,* edited by Paul Atterbury. New York: Universe Books, 1978.

Oxford, A. W. *Catalogue of the Bristol and Plymouth Porcelain... forming the Collection of Mr. Alfred Trapnell.* London: Amor, 1912.

Pazaurek, Gustav E. *Deutsche Fayence und Porzellan Hausmaler.* 2 vols. Leipzig: Karl W. Hiersemann, 1925.

Peters, David. *Decorator and Date Marks on Eighteenth-Century Vincennes and Sèvres Porcelain.* Privately printed, 1997.

Préaud, Tamara. *Sèvres Porcelain.* Washington, D.C.: Smithsonian Institution Press, 1980.

Reilly, Robin. *Wedgwood.* 2 vols. New York: Stockton Press, 1989.

Ross, Marvin C. *Russian Porcelains.* Norman: University of Oklahoma Press, 1968.

Rückert, Rainer. *Meissener Porzellan-Sammlung.* Munich: Bayerisches Nationalmuseum, 1972.

Sandon, John. *The Dictionary of Worcester Porcelain: Vol. 1, 1751–1851.* Woodbridge, Eng.: Antique Collectors' Club, 1993.

Sargent, William R. *The Copeland Collection: Chinese and Japanese Ceramic Figures.* Salem, Mass.: Peabody Museum, 1991.

Savill, Rosalind. *The Wallace Collection Catalogue of Sèvres Porcelain.* London: Trustees of the Wallace Collection, 1988.

Schmidt, Robert. *Early European Porcelain as Collected by Otto Blohm.* Munich: F. Bruckman Verlag, 1953.

*Selections from the Campbell Museum Collection.* Camden, N.J.: By the museum, 1969. 2d ed., 1972; 3d ed., 1976; 4th ed., edited by John Francis Marion, 1978; 5th ed., edited by John Francis Marion, 1983; Reprint, 1992.

# *Index*

Spero, Simon, and John Sandon. *Worcester Porcelain, 1751–1790: The Zorensky Collection*. Woodbridge, Eng.: Antique Collectors' Club, 1996.

Syz, Hans, J. Jefferson Miller II, and Rainer Rückert. *Catalogue of the Hans Syz Collection*. Washington, D. C.: Smithsonian Institution Press, 1979.

Towner, Donald C. *The Leeds Pottery*. London: Cory, Adams, and Mackay, 1963.

*Treasures from the Royal Collection*. London: Her Majesty Queen Elizabeth II, 1988.

Walcha, Otto. *Meissen Porcelain*. New York: G. P. Putnam's Sons, 1981.

Wark, Ralph, and Maria Gristina. *The Wark Collection of Early Meissen Porcelain*. Jacksonville, Fla.: Cummer Gallery of Art, 1984.

Watney, Bernard. *English Blue and White Porcelain of the Eighteenth Century*. London: Faber and Faber, 1963.

Wedgwood, Josiah, and Sons. *Wedgwood in London*. Staffordshire and London: By the company, 1984.

Whitehead, James. *Designs for Sundry Articles of Earthenware*. Birmingham, Eng.: Thomas Pearson, 1798.

Williams, Peter, and Pat Halfpenny. *A Passion for Pottery: Further Selections from the Henry H. Weldon Collection*. London: Sotheby's Publications, forthcoming.

Wills, Geoffrey. "Worcester Blue and White." *The Connoisseur* (December 1954): 254.

Ziffer, Alfred. *Nymphenburger Porzellan: Bauml Collection*. Arnoldsche, 1977.